Television Development

Development is a large and central part of the American TV industry, and yet the details of how it works – who makes development decisions and why, where ideas for new shows come from, even basics like the differences between what TV studios and TV networks do – remain elusive to many.

In this book, lecturer and acclaimed television producer Bob Levy offers a detailed introduction to television development, the process by which the Hollywood TV industry creates new scripted series. Written both for students and industry professionals, *Television Development* serves as a comprehensive introduction to all facets of the development process: the terminology, timelines, personnel and industrial processes that take a new TV project from idea to pitch to script to pilot to series. In addition to describing these processes, Levy also examines creative strategies for successful development, and teaches readers how to apply these strategies to their own careers and speak the language of development across all forms of visual storytelling.

Written by the renowned producer responsible for developing and executive producing *Gossip Girl* and *Pretty Little Liars*, *Television Development* is an essential starting point for students, executives, agents, producers, directors and writers to learn how new series are created. Accompanying online material includes sample pitches, pilot scripts, and other development documents.

Bob Levy has worked in television for more than 30 years and has been practicing development at the highest levels of the television industry for 25 years. He is best known for developing and executive producing the hit shows *Gossip Girl, The Vampire Diaries* and *Pretty Little Liars*. He also currently serves as a lecturer at UCLA, teaching TV development in the Producers Program of their graduate film school.

Television Development

How Hollywood Creates New TV Series

Bob Levy

LONDON AND NEW YORK

First published 2019
by Routledge
2 Park Square, Milton Park, Abingdon, Oxon, OX14 4RN
and by Routledge
52 Vanderbilt Avenue, New York, NY 10017

Routledge is an imprint of the Taylor & Francis Group, an informa business

© 2019 Bob Levy

The right of Bob Levy to be identified as author of this work has been asserted by him in accordance with Sections 77 and 78 of the Copyright, Designs and Patents Act 1988.

All rights reserved. No part of this book may be reprinted or reproduced or utilized in any form or by any electronic, mechanical, or other means, now known or hereafter invented, including photocopying and recording, or in any information storage or retrieval system, without permission in writing from the publishers.

Trademark notice: Product or corporate names may be trademarks or registered trademarks, and are used only for identification and explanation without intent to infringe.

Library of Congress Cataloging-in-Publication Data
Names: Levy, Bob (Producer), author.
Title: Television development : how Hollywood creates new TV series / Bob Levy.
Description: New York : Routledge, Taylor & Francis Group, 2019. | Includes index.
Identifiers: LCCN 2018047080| ISBN 9781138584228 (hardback) | ISBN 9781138584235 (paperback) | ISBN 9780429506147 (e-book)
Subjects: LCSH: Television series–Production and direction–United States. Television–Production and direction–United States.
Classification: LCC PN1992.8.S4 L48 2019 | DDC 791.4502/32–dc23
LC record available at https://lccn.loc.gov/2018047080

ISBN 13: 978-1-138-58422-8 (hbk)
ISBN 13: 978-1-138-58423-5 (pbk)

Typeset in WarnockPro
by Swales & Willis Ltd

Visit the [eResources]: www.routledge.com/9781138584235

**To my students,
who have taught me much**

To my students,
who have taught me so much

Contents

Introduction ... 1

1 Development and the Structure of the Hollywood TV Industry ... 5

2 The Industrial Process of TV Development ... 27

3 Format, Genre and Concept ... 65

4 What Make Series Go: "Story Engines," "Franchises" and "Series Drives" ... 91

5 Concept Ideation, "Areas" and "Takes" ... 100

6 Assessing the Marketplace ... 112

7 Pitching New Pilots and Series ... 130

8 Developing the Pilot Script ... 168

9 Packaging and Politics: The Role of Agents in TV Development ... 191

10 Other Development Strategies ... 206

11 Case Study: The Tortuous Five-Year Development of One Hit Show ... 221

12 The Culture of TV Development 237

13 Preparing for Careers in TV Development 246

14 Applying TV Development Strategies to Other Forms of Filmed Storytelling 272

15 What's Next? TV Development in the Age of Media Disruption 279

Appendix: Glossary of TV Development Terminology 286
Acknowledgments 295
Index 297

Introduction

When I moved to Los Angeles 30 years ago I arrived with little more than a vague Hollywood dream. I wasn't really sure what I wanted to do; I only knew that I loved TV and movies and wanted to see if I could find a career in entertainment.

I'd heard of "development," but I wasn't exactly sure what it was. I knew that people at movie studios and TV networks heard pitches and decided which ones to say yes and no to, and that people at those companies gave writers "notes," which I understood were some kind of creative feedback, suggestions for changes to the scripts. But I didn't know what kinds of notes they gave.

Nearly five years after arriving in LA I stumbled my way into becoming a development executive at NBC (it's a long story), and when I began the job I actually didn't know much more about development than the little I knew when I first arrived. Suffice to say, I experienced a steep and painful learning curve. There were no books about TV development. There wasn't much of an internet then, let alone websites, blogs and podcasts offering charts and lists and factoids about TV shows and movies in development. I learned how to do TV development on the job, and I was lucky to work with smart, talented and mostly patient people who unwittingly served as my film school.

As a network development executive for the next six years I bought some bad pilots, I probably gave some terrible notes, and yet I learned and survived, riding the wave of NBC's 1990s "Must-See TV" era (or, as I like to refer to it, the Last Great Network Heyday). After my run at NBC I stumbled into becoming a producer (also a long story), where I encountered another steep learning curve on the producing side of TV development. Again, I was lucky to work with extraordinarily smart and talented writers, directors, producers, actors, agents and executives with whom I developed and produced *Gossip Girl*, *The Vampire Diaries* and *Pretty Little Liars* (among other less successful TV shows and movies).

Looking back, I'd estimate that it took me two to three years to learn how to be a network development executive and another five years to learn how to be a producer, a job I continue to keep learning more about 18 years later.

My hope in writing this book is to provide readers with many of the basics of TV development and to spare them some of the pain of the steep learning curve I went through.

Like many others, I arrived in LA steeped in a mythology of Hollywood that did not serve me well. Hollywood has been the world's myth-maker for more than 100 years, and the most powerful of Hollywood's myths is the myth of Hollywood itself: a land of glamour, romance and magic. Students of entertainment and aspiring Hollywood professionals must cut through the myth and focus their studies on the realities, the industrial processes that Hollywood actually employs. The first step in my own fumbling learning curve was disabusing myself of the myth and opening my eyes to the realities. A good place for students of television to begin is to learn how new series are created.

Readers with a healthy dose of skepticism might wonder if this book won't be moot by the time they finish reading it, if the massive disruption we're seeing in the TV business today isn't changing the processes of development so quickly that a textbook can't keep up with them. The distribution of TV is being disrupted, but the development of TV isn't. With some notable exceptions (which I'll point out throughout the book), most TV development is practiced the same way it has been practiced for decades. The fact that the people hired to oversee scripted series development at Facebook, Apple, Hulu and YouTube are Hollywood broadcast and cable TV development veterans is evidence of this reality.

Development is a large and powerful part of the American TV industry, and yet the details of how it works – who makes development decisions and why, where ideas for new shows come from, even basics like the differences between what TV studios and TV networks do – remain elusive to many students of television.

Television development starts with an idea that becomes a script and, when it's successful, it becomes a series. The steps of that process haven't changed very much since before I arrived in Hollywood. I've been lucky to absorb many of the lessons of Hollywood TV development over the last 25 years, I've had the privilege to query numerous industry colleagues about their experiences and perspective working on this book, and I'm excited to share what I've seen and learned with the next generation.

This book is designed with several goals in mind. The first priority is to describe the processes, personnel, timelines and terminology of TV development, i.e., the facts of the TV development process. Second, I'll try to provide some historical context. There are many excellent books and much serious scholarship on broadcasting history, and this book can't hope to tell that story in nearly as much detail or with nearly as much academic rigor, but because so many of the basic concepts of TV development date back to the beginning of TV (and before), I'll attempt to offer readers enough TV history to appreciate the context of those concepts. Much of TV development is about looking at what's worked and figuring out how to reinvent it for a new audience. Much of "what's worked" has deep roots in the 70-year history of TV. Third, the book will analyze some of the creative strategies of successful TV development. Why does some development work and some doesn't? Why do some pitches sell and some don't? Fourth, the book will describe the culture of the TV business in Hollywood. Every industry has a unique culture – the TV industry in Los Angeles is "unique," to say the least. Understanding Hollywood's culture and all its cues and conventions is essential to thriving in an industry as highly competitive as this one. Next, the book will offer practical career advice to people aspiring to work in TV development. The paths that lead to careers in Hollywood, especially careers in TV development, can appear veiled in secrecy, and I'll try to demystify them. Lastly, I'll look for ways in which lessons of Hollywood TV development can be applied *outside* Hollywood, in marketing, advertising, in the rapidly growing world of "non-Hollywood" entertainment and in other related fields.

The myths of Hollywood are to be treasured, but if the 30 years I've spent here are any indication, the reality is pretty amazing too. The hope of this book is to pull back the curtain and reveal the actual processes Hollywood uses to develop new TV shows. They might not be especially glamorous, but they're as fun, exciting and often as creatively satisfying as the best of Hollywood's myths.

<div style="text-align: right;">
Bob Levy

Los Angeles
</div>

1
Development and the Structure of the Hollywood TV Industry

The word "development" means different things in different industries and in different contexts. In the Hollywood entertainment industry the term refers to one thing: the process of creating new movies and TV series.

Every TV series you've ever seen has gone through some kind of development process. Every writer, producer and aspiring network mogul who dreams of creating her own hit show will – if she's lucky – navigate her way through the tortuous development process.

Development is the process of originating and improving scripted material to serve as a blueprint for a TV pilot, series or feature film. It's primarily about creating that blueprint, a process that hones an idea, expands the idea into dramatic script form, improves – that is to say, "develops" – that script, and ultimately presents a company that has greenlight money and power (typically the company that paid for its development) with a detailed and polished blueprint to use to consider deepening its financial investment by putting the project into actual production. If the company's senior managers greenlight the project, the script they approved serves as the blueprint that an army of artists, craftspeople, technicians, managers, laborers and assistants follow to make a pilot, series or movie.

6 Development and Structure of the Industry

Development is the key that unlocks the door to making Hollywood dreams come true.

Nothing in Hollywood is cheap, but, relative to the costs of production, development is inexpensive. Developing a script requires only a small handful of people for one thing, rather than an army. The TV network and movie studio chiefs who greenlight shows and movies want polished templates to evaluate before committing extraordinary amounts of money to hire the army and produce a TV series or feature film. Networks and studios employ small teams of people, "development executives," to oversee the development of TV pilot and movie scripts, and who typically follow a standardized process for developing those scripts.

In the movie business development doesn't include production. The development phase of a movie ends when the production phase begins. (Production, of course, is preceded by pre-production or "prep," which is considered part of the production phase, not the development phase.) Movie development, therefore, is a strictly two-dimensional process. It doesn't involve lights, cameras, locations or actors. It focuses on ideas and words on paper (or computer screens).

Television development, on the other hand, does involve production because in television the development phase often includes the production of a pilot episode, the test episode that's typically produced to determine if the much greater expense of ordering a series is worthwhile. Once a project is ordered to series the development phase is over.

Most projects in television development never make it to pilot, though. At the legacy broadcast networks the ratio is about 10:1. Only about 10% of pilot scripts get ordered to production. The success rate for development at Hollywood movie studios is comparable. Most movie scripts never get made. Like most pilot scripts, they die in development. Graham Yost, creator and Executive Producer of *Justified*, calls this "the Pyramid of Death."[1] Another way of saying this is that the stuff we see, the movies and series that get produced and distributed, is the tip of the Hollywood iceberg. For the people in Hollywood who work with ideas and scripts, development is the rest of the iceberg.

EXPANDING THE DEFINITION OF DEVELOPMENT

While TV development does include the production of pilots, the great bulk of development is about working with "material," ideas, pitches, story treatments, scripts, series bibles and the intellectual property ("IP," i.e., books, plays, comic books) that a lot of TV is based on. Production is a "dirty fingernail" part of the entertainment industry: it takes place on soundstages, backlots and locations. It involves physical crafts like cinematography, sound recording and acting. It usually involves extremely long hours that vary from day to day and often a fair amount of physical discomfort (production on location is usually too hot, too cold, too wet or too dry). Development, on the other hand, is more of an "office job," one that's conducted in the business-casual environment of comfortable, temperature-controlled offices in LA during business hours (which typically run from around 10am to 7pm, and often begin after a business breakfast, include a break for a business lunch and are followed by a business drinks meeting and/or business dinner).

When we think of Hollywood most of us tend to think of production. We have a pretty good idea of what directors and actors and writers do, and we see their names in movie and TV show credits. But development is a huge part of the Hollywood entertainment business and employs thousands of workers whose names most of us never hear.

The first definition of development we offered above involved creating the blueprint – the movie or TV pilot script. A second definition of development is: the process of identifying commercial ideas and concepts and assembling the creative elements that turn those ideas into finished filmed entertainment.

What makes a good idea for a TV show or movie and who gets to decide? Identifying commercial ideas for movies and TV shows is an important part of development, and it's one of the responsibilities of development executives. When people walk into TV networks and pitch their ideas for new shows, network development executives get to decide if they think it's a good (or commercial) idea or not. Karey Burke, the President of ABC Entertainment, defines the qualities of a good TV development executive:

> Curiosity. Being a good listener. Loving television. Being a student of it. Loving writing, and being a student of writing. Understanding

collaboration. Understanding you're not the writer. Being able to lift somebody else up. Figuring out how to get the best work out of them, and then trying to guide that.[2]

We'll talk later in this chapter and throughout this book about exactly who development executives are and what informs their decisions and their tastes.

In addition to identifying great commercial ideas, another facet of development is figuring out the right creative elements that turn ideas into finished movie and TV pilot scripts. What do I mean by the "creative elements" of development? The first and most fundamental creative element of any development is the idea itself. An idea for a TV show or movie can be an original idea that springs from the mind of a screenwriter or a producer or other development participant, or it can come from existing IP like a book, play, comic book, video game, podcast or Twitter feed (yes, CBS developed and aired a series in 2010 called *$#*! My Dad Says* based on a Twitter feed).

The second essential creative element of all development is a writer, a screenwriter. The goal of development is to create and perfect a script. A screenwriter is necessary to transform the idea into dramatic, narrative form, into a script. An idea and a screenwriter are the two basic, essential creative elements of all development.

Warren Littlefield, the Executive Producer of *Fargo* and *The Handmaid's Tale*, defines the TV producer's fundamental job as "recognizing and protecting vision."[3] The producer identifies a writer with a unique vision for turning a great idea into a series and then helps protect that vision throughout the life of the project. Littlefield's definition could just as well be applied to the entire process of development.

Additional creative elements of TV development could include a producer, a director and potentially a star. (I'll explain in a moment why I say "star" rather than "actor.") Most TV development these days includes producers in addition to writers. It was more common in earlier periods of TV development for projects to include only an idea and a screenwriter, but, more and more often today, producers participate in the development process.

Directors become very important participants in the TV development process once a pilot script is greenlighted to pilot production, but directors

in TV don't commonly participate in script development. For one thing, they're usually too busy directing episodes or other pilots. Sometimes, however, the most successful, powerful and sought-after TV directors do participate in development. They may have ideas or IP that are personally important to them that they want to shepherd through the development process, or they may have their own production company that develops multiple pilot projects for them to potentially direct. In these cases the director is actually acting as a producer, and he or she may earn an Executive Producer credit along with a Director credit.

Like directors, actors usually only enter TV development once a project has been greenlighted to pilot production, when the casting process commences. Actors are typically reluctant to commit themselves to TV pilots until they can read a finished script and see the character they're considering playing printed in black and white, and until the director they're going to be working with has been hired. Most actors enter TV pilots via an extraordinarily competitive process involving multiple rounds of auditions to win a role in a TV pilot, and they consider themselves fortunate to land the job. But the most sought-after actors, the biggest stars who are interested in acting in TV series, can command deals from TV networks that guarantee them big upfront money and, in some cases, the opportunity to have a TV pilot specifically tailored for them. In some cases, a star may tentatively commit to a project at the outset of its development and earn a Producer or Executive Producer credit along with the starring acting role. The star then effectively works as a producer throughout the development phase, often with fulltime producer partners, helping to identify other creative elements and working with the rest of the team to focus and improve the material.

The list of creative elements that are part of TV development can include a director and an actor, but most pilot projects have only an idea and a screenwriter and possibly a producer. There's another element that's essential to all Hollywood development – although it's not really a "creative" element – money. Someone's got to pay the writer to write the pilot script. The writers that TV networks want to write pilots for them are the most talented and sought-after professional writers, and the most sought-after writers don't come cheap. In TV development the networks and studios pay the writer to write the pilot script. When people go into a TV network and pitch an idea for a TV show, what the network is actually deciding in most cases is whether to pay the writer to write a pilot script version of that idea.

They're not only paying for the idea that's being pitched (and if it's based on IP, they'll need to pay to license the IP – more on that later), fundamentally they're paying the screenwriter to write a pilot script. For most TV development, networks and studios together pay anywhere from $50,000 to $750,000 for a writer to write one 35–60-page pilot script. That's what the network is typically committing to when it "buys" a pitch.

In some cases a writer may write the pilot script on her own before approaching a network, rather than pitch her idea and ask the network to pay her to write it. This is called "spec'ing" a pilot script and the end product is referred to as a "spec pilot script" because it's based on the speculative effort of the writer. If the spec pilot script is great, though, and networks want to develop it, a network will still have to pay the writer for the finished script, and the script will then enter into the network development process. In most cases the network will likely ask the writer to make changes to the script (the network will "develop" the script further) and will be hands-on during the pilot production phase of the project's development. In some cases a spec pilot script may result in a "straight-to-series" order, bypassing pilot production. Whether the writer pitches her pilot or specs it and sells it to a network, the development of that script costs money that the network and studio pay.

Interestingly, producers don't get paid for development. Producers get paid when and if the development phase is successful and the project moves forward to pilot and/or series production. The producer then earns "producing fees." In the feature film business producers are paid a nominal amount for development, typically $25,000, to develop a feature film script. In TV, producers are paid zero for development. They work hard for months or years without any compensation in the hope that the project will get made and they'll be compensated for their efforts. The writer is paid handsomely to write the pilot script, but his producing partner works beside him on nothing more than hope and prayer.[4]

The process of assembling the various creative elements of development is known as "packaging." Putting projects together, marrying an idea with a writer, potentially partnering them with a producer, possibly adding a director and/or a star, figuring out which are the right elements to put together, the right members of the team to marry to the right ideas, is called packaging. The multiple creative elements of a development project are sometimes referred to as "a package." Producers sometimes put the pieces

of a TV development package together. Development executives at networks sometimes put the pieces of a package together. Talent agents sometimes put packages together, usually consisting of their agencies' various clients. For example, an agent might package a book his agency represents (by dint of representing the author) with a screenwriter the agency represents and possibly add a producer the agency represents for good measure.

Packaging is one of the fundamental arts of development. The goal is to marry creative elements that harmonize, that work together and off each other to make the best possible version of the project. Packaging the wrong creative element can sink a project.

To review: Identifying a great idea and packaging the right creative elements to translate that idea to pilot script form are the first two and most basic activities of TV development. The package can consist of the idea and one person, the screenwriter, or several people.

In the next chapter we're going to walk through the specific steps of developing a typical pilot script from idea to pitch to script to pilot to series, but before we dive into the details of that process there are a handful of important preambles, a few basic concepts about how the TV industry works today that are essential to understand.

PREAMBLE #1: THE CORPORATE STRUCTURE OF THE TV INDUSTRY

In the Hollywood movie business there is one fundamental corporate entity: the movie studio. In the TV business, on the other hand, there are *two* basic corporate entities: the TV network and the TV studio. Understanding the distinction between what TV networks and TV studios do is essential to understanding the American TV business and essential to understanding how TV development works.[5]

Most of us are familiar with the names of the companies that have long ruled Hollywood, the great old American movie studios like Disney, Warner Bros., Universal Pictures and others. If I'm a screenwriter with an idea for a Hollywood movie, I can get in my car and drive to one of these movie studios, let's say Warner Bros., which sits on a large studio lot in Burbank,

and pitch my movie (I'm making this sound like an effortless and easy thing to do for illustration's sake, but a pitch meeting is by invitation only and not easy to come by. We'll discuss later who gets these invitations in the TV business).

I sit down in the office of a Warner Bros. movie exec and pitch my idea. If she buys my idea, she puts it into development at the studio, then I write the movie script with her input, and when the script is finished she presents the script to her boss, the President of Production of Warner Bros. Pictures who decides whether or not to greenlight my movie to production. If the studio's production president greenlights the movie, then Warner Bros. makes the movie. Executives of the studio oversee physical production. I might shoot some of the movie in Warner Bros.' soundstages or on one of the faux-facade streets of the Warner Bros. backlot. The studio then oversees post-production of my movie, and possibly makes use of the studio's edit rooms and scoring stages on their lot. Once the movie is done, the film is turned over to the studio's marketing and distribution departments, executives of which have consulted on the project from greenlight through production and post-production. Once the Warner Bros. distribution department gets the DCP (digital cinema package) of my movie into the hands of exhibitors, the movie theatre chains, Warner Bros. is finally done with the many steps involved in making my movie.

In reality, most movie studios today involve financial and distribution partners, but the writers and producers typically deal only with executives from one corporate entity, most often the movie studio.

In TV, by contrast, there are typically *two* corporate entities involved in this series of steps, the TV studio and the TV network.

Most of us are more familiar with TV networks than TV studios, so let's look at networks first. By "network" I'm referring to any of the nearly 50 channels that distribute high quality, big-budget scripted series television. Those networks include the five legacy American broadcast networks, ABC, CBS, NBC, Fox and the CW, the basic cable networks like TNT, AMC and FX and premium cable networks like HBO, Showtime and Starz. There are also newer over-the-top (OTT) networks that stream shows to viewers online like Netflix, Amazon and Hulu. While cable channels and OTT streamers aren't technically networks, they all effectively act as networks and most professionals in Hollywood refer to them as "networks." For that

reason I'm going to shorthand the category and refer to them all as "networks" throughout this book.

All these companies perform the same primary role of the TV network corporate entity: they distribute content. They distribute shows to consumers. Second, to attract the largest possible audience to the content they distribute, TV networks market their shows. At their core, TV networks are giant distribution and marketing machines.

But the networks typically don't make the content. This is where it gets tricky. They rent it. Networks "license" the content they distribute. They license the shows for the privilege of being the first and, in many cases, the only network to distribute the shows. In other words, a license agreement allows a network to be the first channel to air new, original episodes of a TV series. It also allows the network to be the exclusive distributor of a finite number of repeats of those original episodes, defined either by a limited number of times an episode can be repeated (in broadcast and cable) or by a limited period of time the network can exclusively run or stream those episodes to consumers.

So the networks distribute and market content, but they don't make it. Who does the network license the content *from*? Networks license shows from TV studios.

The network pays the studio a "license fee" for the privilege of being the first exclusive distributor of the series. Traditionally, the license fee is equivalent to two-thirds of the actual cost of producing the episode. When NBC airs a new episode of *This is Us* it has paid the studio that produced the series a license fee of several million dollars for the privilege of being the network to air that episode first and to air new episodes of that series exclusively. NBC markets that episode with on-air promotion, online and print advertising and with various forms of publicity. It then distributes the episode to consumers via its TV stations and via cable, satellite and internet.

Because a TV network pays so much money to license so many episodes of so many series, it employs executives to oversee all that programming on its behalf and to protect its huge investment. Those execs are called "programming executives." At American TV networks there are two primary kinds of programming executives: development executives and current executives.

Network development executives develop new shows. They're the network employees who hear the pitches and decide which pitches the network buys and places into development. They then work with the writers and producers to focus, hone and improve the pilot scripts, to *develop* them, to make them as good as possible with an eye toward the kinds of shows that the network thinks work best for its audience. When a finished pilot is deemed successful and the network orders it to series, the network development executive's job is done and he hands the project off to a current executive.

The current executive is the network executive who oversees the network's interests in series that are *currently* on the air. The current executive has a say in the creative direction of the series, and also serves as the point person between the network and the senior staff of the show on behalf of all the network's various departments that have a need to interact with the show. Rather than many different departments interfacing with the show from many different corners of the network, all the network's requests are funneled through the current executive.

A network development executive's involvement with a show may be relatively brief, sometimes as short as only 9–12 months, while a current executive's relationship with the show can last the entire life of the series on the air, five years, seven years or longer. Notwithstanding, development executives are thought to have higher status within networks than current executives. The birthing of the series is considered the more crucial step in the overall process, and development executives tend to have a much more hands-on creative involvement in defining the direction of the series.

At smaller cable, satellite and streaming channels that develop and program only a handful of scripted series, programming executives tend to perform both development and current roles. They develop the pilots and then serve as the network's current executives, managing the network's interests in the show for the life of the series. For the purposes of this book we'll focus more on development executives' responsibilities than on those of the current executives.

So if TV networks license content from TV studios, what exactly do TV studios do?

Most importantly, TV studios make the shows. The network doesn't make the show – it just rents (i.e., licenses) it and distributes it. The studio

physically makes the show. The studio has soundstages and backlots and set construction departments and costume design studios and sound mixing stages. The studio is the corporate entity that physically *makes* the episodes.

Most American TV studios are divisions of the legendary old movie studios. Warner Bros. Entertainment, which was founded in 1923, operates a movie studio called Warner Bros. Pictures (which made my theoretical movie above) and also operates a TV studio called Warner Bros. Television. Beginning in the 1950s, all the major American movie studios created TV studio divisions that operate alongside the movie studio divisions. One of the many secrets of the Hollywood studio business is that while the movie studios have traditionally been considered the more glamorous and prestigious business – as opposed to the TV studio stepchild across the lot – it's the TV studios that have made the lion's share of the studios' profits over the years. Television has been an enormously lucrative business throughout its history, and the profits of most studios' TV divisions dwarf those of their more prestigious movie studio sister divisions.

Studios deploy their physical production assets – their soundstages, edit rooms, etc. – toward both their movie and TV productions as needed, but the studios employ separate teams of executives (including development executives) who work exclusively in either TV or features, but not in both.

As mentioned above, NBC doesn't make *This is Us*. It distributes the series, but licenses it from Twentieth Century Fox Television, the TV studio division of Twenty-First Century Fox, the company that actually makes the series. (Yes, strangely, one's been renamed "Twenty-First Century" and one hasn't.)

In addition to the TV studios that are divisions of the long-standing movie studios, there are a handful of newer, smaller TV studios. Lionsgate, which also has a movie studio division, has become a successful TV studio producing series like *Mad Men*, which was distributed by the AMC cable network. Media Rights Capital (MRC) is an even newer TV studio. It produced *House of Cards*, distributed by Netflix, and *Counterpart*, distributed by Starz.

But let's get back to focusing on what TV studios do and how they're different from networks. First, as we've said, TV studios make the shows. Second, TV studios *own* the shows. The network doesn't own a show – it

only licenses the series for a finite period of time and/or for a finite number of runs. It's the studio that owns the shows, and they own them forever.

This ownership entitles the studio to all ancillary revenue from the shows. A show's primary revenue comes from its domestic US network distribution. That network pays the studio the large license fee for first, exclusive, domestic distribution rights. The studio then sells the show to the rest of the world. The studio licenses the show to foreign TV networks that air the show internationally. All of those international fees go to the studio, not the network. Following the original first-run network window of distribution of a series, the studio licenses a second window of distribution of their series to a domestic streaming company like Netflix or Hulu. One-hundred percent of that streaming revenue goes to the studio, not the original network. In addition to (or instead of) a streaming distribution deal, the studio may strike a syndication deal for repeats of the show to air on local TV stations around the country or on a US cable network. The studio will also license foreign streaming and syndication if there's enough demand for the show. Home video and merchandising are two other forms of ancillary revenue TV studios earn from their ownership of series they make. All that ancillary revenue goes to the studio, the owner of the series, and not the network that first aired it.

Let's look at one classic TV series as an example of this network–studio dynamic. The series *Friends* generated 236 episodes from 1994 to 2004. For those of us old enough to have watched *Friends* when it first aired, we associate the show with NBC, the network that aired all those episodes as a pillar of its "Must-See TV" Thursday night lineup. But NBC didn't make the *Friends* episodes. It only distributed them. Those 236 episodes were made by Warner Bros. Television. They were all filmed on a Warner Bros. soundstage on the Warner Bros. lot a few blocks from NBC's offices in Burbank at the time.

Warner Bros. Television initiated *Friends* by first developing the project internally within the studio. The studio took the pitch they developed with the writing team Marta Kaufman and David Crane to TV networks, and NBC bought the pitch. NBC then developed the pilot in concert with the studio, and NBC ultimately ordered it to series. NBC paid Warner Bros. Television a license fee for 236 original episodes over ten years and the right to air reruns of each episode. From 1994 to 2004 NBC enjoyed the profits of being the exclusive first-run distributor of one of the biggest hit shows in

the history of American television. But, since the summer of 2004, when the final summer repeat of *Friends* aired on NBC for the last time, NBC has never aired another episode of *Friends* and most likely never will. *Friends* episodes have aired in syndication on American cable and local TV stations, and on TV stations around the world, every day ever since then, and Warner Bros. Television has earned every cent of those syndication deals. Beginning in 2015, Warner Bros. Television licensed the 236 *Friends* episodes to Netflix for an undisclosed but undoubtedly enormous sum of money. Warner Bros., not NBC, has earned every cent of that Netflix money. Warner Bros. Television has earned billions of dollars of profit from their ownership of those 236 episodes. One-hundred percent of all those ancillary revenues goes to Warner Bros. Television and will in perpetuity, as long as viewers want to watch those reruns (i.e., forever). NBC hasn't made a penny on *Friends* since 2004. For ten years *Friends* was extraordinarily profitable to NBC, and was central to its brand and public identity. But the network's relationship and financial interest in the series ended in 2004 when its last license fee deal expired.

Like networks that employ development and current executives to protect their investment in shows they license and distribute, TV studios employ development and current execs to protect *their* investment as well. These two layers of executives, network execs and studio execs, serve similar functions and both do everything they can to make the shows as successful as possible on behalf of their respective companies. (Studio execs also pay close attention to physical production and production budgets that network execs don't worry about because their companies' contributions are capped at the pre-negotiated license fees.) In other words, just about every TV series has two layers of executives overseeing it, network execs and studio execs. Similarly, and more importantly for the purposes of this book, almost all TV pilots have two layers of development executives evaluating and weighing in on every step of the process, a team of network development execs and a team of studio development execs. The costs of development are also shared between TV networks and TV studios, and the expenses of pilot scripts and pilot production are negotiated between the two companies.

The distinction between networks and studios used to be very clear-cut, but the boundaries between those two corporate entities have grown murky over the years. When *Friends* was being developed in 1993, US law kept TV networks and TV studios as distinct companies. Those regulations

(known as the Financial Interest and Syndication Rules, commonly referred to as "fin-syn rules") were repealed in late-1993, however, and now the large entertainment conglomerates that own TV networks also own TV studios. Disney owns ABC, for example, and it also owns ABC Studios. ABC Studios is the TV studio sibling of Walt Disney Studios, the movie studio it shares a studio lot with. The ABC network is geographically across the street from the Disney studio/ABC Studios lot in Burbank.

Since 1993 when fin-syn was repealed, the goal of most entertainment conglomerates has been "synergy," which translates in the TV business to TV studios creating, producing and selling its product to its sister network divisions, thereby providing the parent company with two ways to make money from one show (producing and owning the show and all the various revenue streams ownership provides, and distributing the show to a domestic US audience). Most shows produced by Twentieth Century Fox Television (known in the industry as "20th Television") are licensed to the Fox network, their corporate sibling. This is referred to as "vertical integration" in corporate terminology. All the large TV studios operate this way, but they all sell outside their corporate family as well. As mentioned, 20th Television's most successful series *This is Us* is licensed to its sister network division's rival NBC. Most of NBC's programming is produced by *its* sister studio Universal Television (they're both owned by Comcast), but Universal Television also produces *Brooklyn Nine-Nine* which, for many years, it licensed to Fox.

Whether a studio and a network that do business together are owned by the same parent company or not, there are still corporate distinctions between the roles they serve (even if they're only different divisions of the same company) and most pilots and series are still overseen by separate teams of network and studio executives. When a writer writes a pilot script he has to please his network development execs *and* his studio development execs. We'll explore this complicated dynamic throughout the book.

Several streaming networks have recently begun challenging these traditional network–studio distinctions. Netflix led the way, performing both roles without any corporate separation. With some of its shows Netflix serves only the role of network (like *Orange is the New Black*, made by the studio Lionsgate), but, beginning in 2015, Netflix began to produce and own some of its shows as well (like *Stranger Things* and *The OA*). Other online digital video distributors like Amazon, Facebook, Apple and YouTube also

both license shows from traditional studios as well as assume the studio role and make and retain ownership of the scripted series they distribute. Executives at these companies, talent agencies, producers and industry lawyers hammer away at new (and potentially transformative) deals on a daily basis, redefining Hollywood television's traditional rules of distribution, ownership and financial participation. In the meantime, the traditional network–studio distinction applies for the great majority of TV shows on the air and in development.

PREAMBLE #2: HOLLYWOOD'S CREATIVE PECKING ORDER

The second thing readers need to understand before diving into the next chapter is the power structure of the creative people who make movies versus the people who make TV shows.

In movies the director is top dog. The director has the most power and creative control of the movie she's making. Second in the pecking order of the creative staff in the movie business is the producer, who is in charge of the project until the director is brought on board, and, once that happens, the producer's job is largely to help the director achieve her vision. Lowest among the top creative staff that makes the movie is the writer. Screenwriters in the movie business are notoriously disrespected. In general their job is to do what the producer and director tell them to do, and feature screenwriters are hired and fired by producers and directors easily and often.

In TV, the pecking order is exactly the opposite. In TV the writer is the top dog. Writers have the most power and the most creative control of series they work on. Writers in TV serve in producing capacities as well and receive producing credits. When we see TV credits for Executive Producers, Co-Executive Producers, Producers, Co-Producers, Executive Story Editors, Story Editors and Staff Writers, we're actually looking at credits for writers who work on the writing staffs of the shows (in the order of authority listed above).

Creative producers who are not writers typically have the second most amount of power and creative control of TV series. Producers who are not

writers typically receive Executive Producer credits and are known in the business as "non-writing EPs." We'll talk more about the role of the non-writing EP in a moment.

The other key non-writing producer on a TV series is the line producer. The line producer, unlike the creative producers, oversees physical production, including the budgets, schedules, logistics and manpower. The line producer – there's almost always only one per show – is designated in TV credits with the title "Produced by." There might be three or four "Producer" credits – who are all writers – but only one "Produced by" credit. That's the line producer.

Directors in TV typically have relatively little power and creative control. They're in charge on set during production, of course, but they report to the writers (the exact opposite of the movie dynamic). They are hired and fired by the writers. The TV director's job is primarily to execute the writer's vision of the show; they work in service to writers.

It's this power dynamic that leads people to refer to TV as a "writer's medium."[6]

The most powerful writer and producer on a TV series is the showrunner, who is credited as one of the show's Executive Producers. We'll look at that role in a moment, but let's look at the non-writing Executive Producers first. Non-writing EPs tend to come in four categories.

One is the Executive Producer who runs a company that controls IP. Jeph Loeb is one of the Executive Producers of *Jessica Jones* on Netflix. He earns that title and senior-level creative control of the show because he runs the TV division of Marvel Entertainment, the company that owns the comic books the show is based on. His job is to work as an executive not a writer. As an executive responsible for managing an enormous library of extremely valuable IP, he earns a say in how that IP is executed in TV in the form of a non-writing EP role and EP credit.

Another kind of non-writing EP is the brand-name EP. Steven Spielberg is credited as an Executive Producer of the series *Bull* on CBS. He hasn't directed any episodes of the show, and his company employs executives who manage the day-to-day hands-on creative involvement with the show. Even though he's not really involved in the series he earns an Executive

Producer credit because his company owns a stake in it and because his name lends stature and prestige to the show. He has a household name that connotes quality and entertainment value to the audience and within the industry, and the value of his name merits crediting him and paying him fees for every episode even if he rarely, if ever, renders any actual producing services. Ridley Scott, J.J. Abrams and Brad Pitt are other brand-name non-writing EPs in TV today.

A third kind of non-writing EP are talent managers. All writers, actors and directors are represented by agents and many are represented by managers. While agents were traditionally prohibited from working as producers by California state law, managers were not. Managers of the most successful and valuable writers and actors sometimes serve as producers on behalf of their clients. In some cases the managers perform actual producing services on shows their clients work on, and in some cases they merely leverage their clients' value to earn credits and fees for themselves. If a manager's client adds enough value to a TV project, and if the manager has enough standing within the industry, he can be granted by the network and studio (who have contractual approval of all credits) an Executive Producer credit. Michael Rotenberg is a non-writing EP on the HBO series *Silicon Valley* and manages the career of Mike Judge, the most prominent of the show's co-creators.

Lastly, the fourth kind of non-writing EP are producers who serve a hands-on role of working to assemble the other creative elements of a show and help initiate and guide it through the development process and then serve in an executive capacity on the series, supporting and supplementing the showrunner. Warren Littlefield, *The Handmaid's Tale* Executive Producer I quoted earlier, is a non-writing EP working alongside fellow EP Bruce Miller who *is* a writer. Littlefield was a longtime development executive at NBC and its president in the 1990s before he transitioned to producing. Aaron Kaplan, one of the Executive Producers of *Life in Pieces* on CBS and one of the most prolific non-writing EPs working in TV today, worked as an agent at the William Morris Agency for 16 years before becoming a producer.

There might be two or six or more Executive Producers on a TV series, but the most important and most powerful of all of them is the showrunner (which is an industry term but not an official credit). The showrunner is the auteur of TV. The showrunner is the creative

visionary of the series, and literally every creative decision on a series is the showrunner's responsibility. Every word in every script is the showrunner's responsibility. Every edit in every episode is the showrunner's responsibility. Every stitch of every article of wardrobe in every scene of every episode is the showrunner's responsibility. And while the showrunner delegates much of the work to other writers and to his editors, wardrobe designers and other department heads, the showrunner weighs in on and approves all of their efforts.

The showrunner is almost always the head writer of a show's writing staff (which might number anywhere from four to twenty writers). There are a small number of non-writing EP showrunners, but they are few and far between. Almost all showrunners are seasoned TV writers. As head writer, the showrunner leads the writing staff in creating every story for every episode, assigns the writing of episode scripts to writers on the staff and to freelance writers, notes (gives creative feedback to) writers on all the many drafts of episodes and, when necessary, rewrites other writers' scripts herself. When a showrunner delivers an outline of a story to the network and studio current executives, or delivers a final draft of an episode script to the cast and crew of the series, the buck stops with the showrunner – he or she is responsible for its content and quality.

The showrunner is usually but not always the creator of the series. The word "creator" and by extension the phrase "created by" aren't just titles, credits and job descriptions; they have legal, contractual meaning and are important fundamental terms in TV development. The terms are defined by the Writers Guild of America, the union that represents screenwriters, whose contract (known as the WGA Minimum Basic Agreement) all American TV networks and studios are signatories to and abide by. By the WGA's definition, the "creator" of a show is the writer who writes the pilot episode.[7] That writer may never work on another episode of the series, but for the life of the series he will be credited as the creator and receive a "Created by" credit on every episode.

Almost always the writer who writes the pilot *does* continue to work on the series she created and most often serves as the showrunner. In some cases the creator is a writer without very much TV experience and therefore might not be deemed to have the producorial and managerial skills to serve as the showrunner by the network and studio, and in those cases an experienced showrunner will be hired over the creator to run the show,

and the creator will report to the showrunner. In most cases, however, the showrunner is the creator of the series.

The showrunner is also the manager of the cast, crew and staff, and in that capacity is responsible for ensuring that episodes are produced on schedule and on budget. The showrunner hires and is the report-to for all writers, producers (except some fellow Executive Producers who are the showrunner's partners), actors and department heads (production designer, costume designer, director of photography, editor, etc.). Managing a team of creative people and keeping them focused on her vision of the show is one of the many huge challenges of being a showrunner.

If all of these responsibilities aren't daunting enough, the showrunner is also a diplomat, serving as the show's primary interface with the network and studio executives who not only pay the showrunner's salary but also finance the entire production. The showrunner talks to the network and studio current executives on a regular basis, typically several times a week, and usually develops a close relationship with the presidents of both companies as well. The showrunner fields creative notes from the network and studio current executives (and occasionally the network and studio presidents) and disseminates them among her staff and cast as she sees fit.

Managing an enormous army of people, navigating the egos and foibles of actors and other artists, running a business with a budget of tens of millions of dollars per year and answering to hugely powerful multinational corporations is an overwhelming task and one of the hardest, most demanding and most time-consuming jobs in all of entertainment. It's known in the industry as "the worst job that everyone wants."

While the goal of almost all TV show creators is to be the showrunner of their own show, the focus of this book will be on the creator, the writer who enters the development process, writes a pilot script and lays out a vision for multiple seasons. If the creator's pilot script gets ordered to pilot production, the writer/creator then typically transitions into showrunner mode and effectively completes the development process as a producer. But for the purposes of this book we're going to focus mostly on the screenwriter as creator, one of the most essential – if not the single most important – members of the team that develops new shows.

Who else is on that team? Who are the other development professionals who participate in the TV development process in addition to the writer? Another member of the TV development team is often the producer. As we've discussed, "producer" is a word that can have many different meanings and refer to many different kinds of participants in TV, but the kind of producer who participates in the development process is the non-writing EP, the producer who works as a partner to the pilot writer and helps navigate the creative, strategic and diplomatic steps of the development process, the person who helps protect the writer's vision. Typically the producer initiates the project either by identifying and optioning a piece of IP or by coming up with a commercial idea for a new series. In some cases a producer may be partnered with a writer by the studio if executives think a writer could benefit from a seasoned producer's guidance.

The next participants among the team of development professionals are the executives, of which there are two and sometimes three kinds. Almost all TV pilots in development have a team of network development executives and a team of studio development executives (both teams typically consist of two or three execs each). Each team represents its company's interests in making the pilot as good as it can be and in tailoring the project as much as possible to its company's development and programming strategies.

A third kind of development executive is the production company development executive. The term "production company" is a bit misleading. The better term would probably be "development company." Many of us think of production companies doing what the phrase implies, overseeing the actual physical production of TV episodes. Outside of Hollywood that's what commercial and industrial production companies do. They *do* production. But in Hollywood "production company" usually means a company owned and run by a producer, typically an experienced and successful producer. Experienced and successful producers not only produce movies and TV shows, they also legally incorporate to make their own deals, rent office space and employ people including executives who do some of the day-to-day creative work for their employer, the producer. In most cases in TV the actual physical production of episodes is the job of the TV studio, as discussed above, not the so-called production company. The creative executives at production companies typically focus mostly on development, working on behalf of their producer employers alongside the network and studio development executives, shepherding the pilot through development.

Sometimes the producer at the head of a production company is a writer like Shonda Rhimes or Greg Berlanti. They're two of the most successful writers working in TV today and they have created numerous successful shows. They're so successful as writers, creators and showrunners that they expand the number of shows they can be involved with (a showrunner can't really run more than one or two shows at a time) by employing creative execs to develop and oversee the creation and production of more shows. Sometimes the producer at the head of a production company is a non-writing EP like Jerry Bruckheimer or Mark Gordon, who also run production companies to expand their ability to produce more than just a couple of shows.

Production company executives are effectively day-to-day representatives of the producer who heads their company. Their creative intellects are hired and trained to reflect the ideas, tastes and practices of their boss, the producer. On a day-to-day basis they'll rely on their own instincts and trust that those instincts will be in sync with their boss, but sometimes they'll let their development partners know they need to consult their boss to find out exactly what he or she thinks and wants to do in a given situation. In some cases, especially at smaller production companies, the producer will work hands-on during development, and in some cases, especially at larger production companies, the production company exec will perform the day-to-day duties on most of the company's development projects.

There's one last development professional in TV whose role is essential to the process but who typically isn't involved in the day-to-day work of development itself. The agent. Agents (and talent managers) who represent writers are the grease that keeps the machinery of development going, and agents tend to have close relationships with all the other development professionals, writers, producers and network and studio execs. One of the many things agents do is package their clients into development projects, as discussed earlier. While agents' primary job is to help their clients get work, agents can also initiate new shows by cleverly packaging the right creative elements that their agencies represent.

Once an agent's writer client is placed into a piece of development, the agent typically steps away from the day-to-day work of the project's development – receiving occasional updates from his writer client or a producer – and then only resumes hands-on contact with the project if and when it's

ordered to pilot production. At that point other potential clients of the agency (directors and actors) may have opportunities to find jobs on the pilot as well.

It's important to note that the phrase "development professionals" is a helpful one for the purposes of this book, but not actually a term used in the industry. When industry professionals refer to the writer, they say "writer." When they mean "network execs," they say "network execs." But the team of people involved in developing a new TV project is implicit and nobody refers to that group as the team of "development professionals" on a project. For the purposes of this book, however, it's a helpful academic term.

The development professionals who do the work of developing new series, then, are writers, producers, network development executives, studio development executives and production company executives, along with agents and managers who dip in and out of the project as talent (writers, actors and directors) is needed. In the next chapter we'll follow this team of entertainment professionals as they proceed through the development of a typical pilot.

NOTES

1 Author interview with Graham Yost.
2 Author interview with Karey Burke.
3 Author interview with Warren Littlefield.
4 The most successful producers can be compensated in the form of development deals at TV studios where the producer is paid a salary to develop a number of projects for a specific period of time rather than on a per-project basis. Studio deals with non-writing TV producers are known as "POD deals" (pronounced "pod" as in "peapod"), short for production overhead deal. Many producers, however, do develop TV projects without any upfront salary or fees.
5 The traditional network–studio corporate structure described here has applied to the American TV business for nearly 70 years, but, interestingly, the last several years have witnessed the first cracks in the wall separating the two corporate entities.
6 We'll continue to occasionally reference the feature film business throughout the book to compare and contrast the way movies are developed versus TV, but from here on in our primary focus will be on television.
7 If a series is based on existing IP, the writer of the pilot typically receives a "Developed by" credit rather than a "Created by" credit per the WGA. Unofficially, these writers are still often referred to within the industry as the "creator" of the series.

2

The Industrial Process of TV Development

In this chapter we're going to walk through the steps of typical script development. This process describes how most TV pilots are developed at traditional broadcast networks, cable channels and streaming platforms. While this chapter describes an industrial process that's used industry-wide, every pilot project is unique and handmade; variations to this process may occur at every step, and we'll discuss many of those variations and other TV development strategies in Chapter 10.[1] But the steps outlined in this chapter reflect the process that's used in the great majority of series development.

STEP 1: THE IDEA BECOMES A PITCH

The first step is to develop a pitch. The pitch is the tool that will be used to sell the project to a network. As we discussed in the last chapter, someone's got to pay the writer to write the pilot script, and those someones are the network and studio. Networks and studios have large development budgets (comparable with other industries' R&D – research and development – budgets). While networks hope all the series they have on the air become big hits, they plan for the future by anticipating failure and for successful series to grow old and eventually retire. Networks that program scripted

series and intend to continue programming scripted series always develop new projects behind their schedule of current programming.

Not only does the team that initiates a new series need the network's and studio's money (to pay the writer to write the pilot), they also want the network's partnership. If a network buys a pitch and puts the project into active development, the network becomes a member of the team, their development executives become part of the birthing of the project and become professionally and emotionally invested in the project and its success. They become true partners in the project and share a sense of creative "ownership" (if not true financial ownership – remember, that belongs to the studio). That sense of partnership, of group investment, is one of the things writers and producers seek – along with the network's development money – when they bring their pitch into a network.

Every project starts with an idea. The idea can be an original idea or an idea based on an existing property like a book. An original idea can come from a writer, a producer, an agent, a studio development executive or even a network development executive, and a work of IP that becomes the basis of development can be found by any member of this group.

Whoever identifies an idea and however it's found, it needs to be developed into a pitch. In the American entertainment industry writers deliver pitches (in both TV and features), and it's the writer who does most of the heavy lifting of creating the pitch. (We'll discuss some of the specifics of what constitutes a typical TV pitch in a moment, and we'll discuss them in greater detail in Chapter 7.) The writer delivers the pitch orally, live, "in the room" at the network. Most TV pitches run at between 15 and 25 minutes (though pitches for straight-to-series projects may run much longer). The writer creates the pitch and then seeks the creative input of her producer partner and her studio. The writer almost always scripts her pitch in written form and shares her pitch script with her partners who give her notes, i.e., specific creative feedback. The writer rewrites the pitch over and over, usually emailing revisions back and forth, until everyone – the writer herself, the producer and the studio development execs – are all confident it's as strong as it can possibly be.

Every TV series is unique – or should be – and, as I said earlier, every development experience is unique. For the purposes of this chapter, this tour through the development cycle, I'm going to imagine a typical scenario

in which a TV writer has partnered with a producer and they've agreed to work with a studio. Those three partner entities – writer, producer and studio development team – will travel through the journey of this process together. The writer and producer may have been packaged together by their mutual agency, or they may have found each other through other development processes we'll describe later. In real-world scenarios a writer might not have a producing partner during development at all. Or he might have four producing partners who each employ production company execs. They might set up their pilot at a network without a studio and develop the pilot script directly with the network. There are many different possible configurations of this process, but the team of development professionals I'm describing in this chapter is typical today.

When everyone's happy with the pitch "script" the writer typically meets in person with her producer and studio development execs to run a dress rehearsal performance of the pitch so the writer can practice delivering it orally in front of a group and everyone can see how it plays live. Final notes are given to the writer, addressed and the pitch is set.

STEP 2: NETWORK PITCH MEETING

Networks hear pitches. They're the final target audience for the pitch. They're the "buyer." Once the pitch is in great shape, the studio development execs call their development exec counterparts at all the networks that might be interested in hearing the pitch and might make an appropriate home for the series. The studio execs preview the concept and the "auspices" (the creative elements behind the project, namely the writer, the producer and any underlying IP and its creators), and the network execs who respond to the concept and auspices ask to hear the pitch. Studio development assistants then coordinate with network development assistants and the producer's assistant (who then coordinates with the writer) to schedule the round of pitch meetings.

The writer, producer and studio development execs meet at each network at the scheduled time and are typically shown to a network conference room where the network execs welcome them and everyone settles in for the pitch.

In the movie business pitches are relatively simple. In movie pitches the screenwriter tells the story of the movie from beginning to end. He may

spend a little time introducing the characters and the world of the movie (the setting and time period), but the great bulk of the pitch is telling the story of the movie from beginning to end. Television pitches are more complex. Here are the sections of a typical TV pitch:

1. Writer's Personal Way In (I'll explain what this means in Chapter 7)

2. Concept of the Series

3. World of the Series

4. Character Descriptions

5. Pilot Story

6. Arc of the First Season/Arc of the Series

7. Tone

8. Sample Episodes Beyond the Pilot.

Pitch meetings are inevitably quite tense. The writer and producer are typically excited and nervous. A pitch meeting can potentially result in hundreds of millions of dollars of business – even billions of dollars theoretically – to the various parties in the room in the long term (and/or their companies). The writer and producer have enormous personal and professional investment in the project, have done months or years of work to get to this moment and desperately want to impress the network execs. At the end of the day, though, it's a small group of experienced professionals talking about an idea for a TV show and, despite the energy and anxiety in the room, all the people involved do the best they can to make it feel like a human-scale, friendly, fun and conversational interaction.

There are usually two or three network development executives in the meeting to hear the pitch and usually one or two studio development execs supporting their writer and producer partners. There might be no producers or as many as three or four producers and production company execs (and sometimes more). There may be one or two writers.[2] If the writer is very experienced and successful, the writer's agent might attend the pitch to show his support, loyalty and agency muscle in order to try to

impress the potential network buyers. In sum, there might be up to a dozen people sitting in a network conference room with all eyes zeroed in on the writer, who then effectively performs a monologue for 15 to 25 minutes, describing what his show is, how it works and why it's going to be awesome (without ever actually saying "My show's going to be awesome!" – the content of the pitch should speak for itself and *be* awesome).

Some writers memorize their entire pitch and recite it from start to finish like an actor reciting a long monologue. Some writers memorize an outline of their pitch (or glance at their outline on note cards) and extemporize the words of the pitch, hitting all the bullet points of the outline. Most writers simply read their pitch scripts. This is the least interesting to watch but the most common. It's really hard to talk non-stop for 25 minutes without notes or without reading a script, but some of the best pitchers can do it. When I was a development executive at NBC the movie writer Christopher McQuarrie (who wrote and directed *Mission: Impossible – Fallout*) pitched a show and spoke for 40 minutes straight, never glancing at a note, never pausing for more than a breath, never having to say, "Whoops, I meant to mention earlier" It was a spectacular pitch performance (needless to say, he sold the pitch, but alas the pilot never got made). That level of pitch performance is hard to pull off and quite rare.

After the writer finishes her pitch the network execs ask the writer a few follow-up questions, thank the writer and others for coming, then typically say something along the lines of "Give us a chance to discuss the pitch internally, and we'll get back to you." When I began my career, network development execs usually got back to studio execs within 48 hours, but these days it's more often within two weeks (though sometimes quicker). The network either says yes and "buys" the project or says no and "passes" on the project. Writers, producers and studio development execs take their pitches to as many networks as might be interested to hear the pitch in the hope that several networks want it and create a bidding war, but also to cast as wide a net as possible in the hope that at least one network buyer bites. As a producer, I've brought pitches to as few as three networks and as many as 12.

STEP 3: THE DEAL

If the writer and her partners have done a great job and a network buys their pitch, the next step is making a deal. All the parties – network, studio,

writer and producer – have representatives who figure out the specific terms of their clients' deals amongst the various parties.

Writers have agents and often have entertainment lawyers, producers almost always have lawyers and sometimes agents, and networks and studios have "business affairs executives." Business affairs executives are full-time negotiators employed by large entertainment companies. All they do, all day every day, is negotiate deals on behalf of the companies they work for. Frequently they're lawyers, but not always. Once the network commits to buy a pitch the agents, lawyers and "BA" execs representing the various parties of the project talk on the phone and exchange numerous emails back and forth to work out the details of the specific deal points.

During the deal-making phase the reps for the various parties negotiate how much the writer is paid to write the pilot script, what his fee is if the project moves forward to pilot production, his credit should the project move forward to pilot and series production (usually Executive Producer, but not always as discussed earlier), his producing fee per episode should the project move forward to series, and how much backend ownership of the series the creator will receive.

The producer's reps negotiate the terms of the same deal points (minus writing the pilot script) for their client.

In the last chapter we discussed how studios own the shows in perpetuity and earn all the ancillary profits of the shows they produce. While the studio earns all the profits for successful TV series, they typically share a portion of the profits with key creative partners who are defined as "profit participants" and who receive a share of "backend," the show's long-term profits after all the studio's expenses. The profit participants typically include the writer/creator of the series, who might receive anywhere from 10–20% of all profits (or "points" – one "point" equals 1% of profit), the non-writing Executive Producer/s who are present at the creation of the series who might receive anywhere from 5–15 points (or divide that share amongst themselves if there's more than one), and the director of the pilot (who, as mentioned earlier, usually isn't a member of the team until later when the pilot script is greenlighted), who might receive 1 or 2 points. Studios typically hang on to a minimum of 65% of ownership of the all profits derived from a show, and their business affairs execs, in consultation with senior management, negotiate the shares of ownership of the remaining

35% amongst the other participants whose roles in the process entitle them to backend participation.

Talent agencies can also receive a share of profit participation. If an agency contributes key packaging elements to a project, it can receive an "agency package," which we'll discuss in detail later.

The two corporate entities, the network and studio, also hammer out a detailed deal between themselves. The studio pays the lion's share of the cost of pilot script development, the fee the writer is paid to write the pilot. The network caps its investment in pilot scripts (like it does with episodic license fees) with what's known as "network script coverage." The writer might command up to half-a-million dollars or more to write the pilot, but the network script coverage is limited to $50–75k and the studio pays the remaining share.

Not only are all of these development terms negotiated during the deal-making phase of the process, but also frequently the network and studio actually negotiate the financial relationship between their two companies for the potential series. The network and studio may negotiate the specific license fee the network will pay the studio for episodes of the series should the pilot succeed and be ordered to series.

If the writer and producer have partnered with a studio prior to pitching the show to networks (as in my example), they most likely will have already worked out the terms of their deals directly with the studio before the studio sets network pitch meetings, in which case this network deal-making phase is quicker and easier. If a network buys a pitch from a writer and producer who have *not* already partnered with a studio, the network will typically "lay off" the project at a studio, usually a sister studio division of the corporate parent (e.g., ABC Studios at ABC network, A&E Studios at Lifetime, etc.), if one exists.

If a studio deal is not in place when a network buys a pilot script, the deal-making phase can take anywhere from several weeks to many, many months. I sold a project to a broadcast network a few years ago that involved a tricky rights situation and the various deals among all the parties took five months to close. If a studio deal is in place before the project is pitched, the deals can usually be wrapped up in a couple of weeks.

For writers and producers this deal-making phase is often maddening. All the creative excitement and momentum of the pitch development process, all the anxiety and nervous energy that went into shopping the pitch to multiple networks and the thrill of making a sale suddenly come to a screeching standstill. No creative work can happen during the deal-making phase. Agents and lawyers specifically tell their writer and producer clients: "Don't do any work on the project! Don't send the network or studio any of your work until I have an assurance we're going to get an advantageous deal from them." The rep doesn't want to undermine his leverage by having his client let the buyer know they're willing to do work before the buyer has committed to a fair deal.

When the deals are finally closed the various reps notify their clients that creative work can resume, and the project can finally move to the next step.

STEP 4: THE PILOT STORY

The first step of a project in active development is to deliver the pilot story in writing to the network. The writer has already told the network development execs what the pilot story is in her pitch. In fact the pilot story is usually the single longest section of a TV pitch. But now that the project is real, now that the network is actually committing real money to the project, the network development execs want to see it again and they want to see it in writing. It's no longer just experienced professionals talking about an idea for a TV show; now it's business. Now it's real.

Remember, what the network is paying for in most cases when they "buy" a pitch is a pilot script. It may lead to years and years of a TV series, but all they're committing to at this stage, all the network is paying for at this point, is one script, the pilot script, and they want to be able to examine the story of that pilot script in detail and in writing before they allow the writer to move to the next step and begin actually writing the script. It's much easier to make big changes to a story in outline form than to a story once it's actually been written as a script.

Each network prefers its own story document format, but most expect the writer to deliver it in outline form. Some networks turn the pilot story step into a two-stage process, requesting a "story area," a short prose description of the story in one or two pages, before asking the

writer to move on to write a full outline. While the pilot story that was described orally in the network pitch meeting was an overview of the general shape of the story that might have included several key moments, the pilot story outline the network wants in the outline phase is the whole thing in detail. The writer typically lists every scene of the pilot, in order, and provides a brief description of the action of each scene. Outlines are usually 7–10 pages for a half-hour comedy and 10–12 pages for a one-hour drama.

Figure 2.1 is the first page of I. Marlene King's story outline for the *Pretty Little Liars* pilot. King's outline was eight pages long and listed all 45 scenes of the pilot.

The writer writes a draft of her pilot story outline and sends it first to her producer who reads it, then calls or emails the writer with notes. The writer then rewrites to address her producer's notes. She might do two or three rewrites as she and the producer go back and forth with drafts and notes until both are satisfied that the story is in strong shape, at which point the producer delivers the pilot story document (typically via email) to the studio development executives. The studio execs read the pilot story, then call the writer and producer and deliver their notes. The writer does two or three rewrites until the studio development execs are confident the story is in strong shape, then the studio execs email the story document on to the network development execs. Now it's the network's turn to weigh in. The network execs have their own creative thoughts on how to make the story clearer and stronger, and they set a call with the writer, producer and studio development execs to deliver their notes. The writer does two or three more rewrites in response to two or three rounds of network story notes until the network execs are satisfied and offer final approval of the pilot story. The network execs then "send the writer to draft," officially commencing the writer to move forward and begin writing the pilot script.

In other words, the writer writes eight, ten or twelve drafts of the pilot story and she hasn't even begun writing the script yet! The cycle I just described: A writer creates something, a producer notes it, the writer revises, the studio notes it, the writer revises, the network notes it and the writer revises ... will be repeated throughout the pilot development process over and over, and then – in success – every story, every script and every rough cut of every episode of the series will repeat this dynamic for the rest of the show's existence.

PRETTY LITTLE LIARS
Marlene King
March , 2009

"Pilot Episode"

COLD OPEN

Establishing shots of Rosewood. A picture perfect, quaint community. It's a white picket fence, Americana world.

1. INT. EMILY'S KITCHEN - DAY (D-1)
PAM FIELDS (39), a conservative, hands-on Mom, announces that someone finally bought the DiLaurentises' old house. The news stirs up a lot of emotion for Pam's daughter, EMILY (16). Emily, a competitive swimmer, maintains an athlete's body and an athlete's sense of style. In her room, Emily looks through an old photo album. The photos are of five girls, happy times, the summer of their sisterhood. Pam has prepared a "lovely" welcome-to-the-neighborhood basket. Emily protests, but like always, does what her mother asks of her and agrees to take the basket to the new neighbor's house.

2. EXT. MAYA'S HOUSE - DAY (D-1)
ALISON'S stuff is thrown out on the curb along with the trash. Emily arrives and recognizes her old friend's books, notebooks, clothes, papers and swimming medals. Emily meets MAYA ST. GERMAIN (16), the new girl who just moved into town from California. Maya, an attractive African-American, is different than anyone Emily has ever met. She's a free spirit, exotic, and doesn't care about what other's think. Maya asks Emily if she knew the girl who used to live here. Emily answers, "Yes, her name was Alison." Maya pushes for more info and Emily finally reveals, " There were five of us who used to hang out. But we all grew apart." Maya invites Emily up to her room.

3. INT. MAYA'S BEDROOM - DAY (D-1)
Emily looks around Maya's room. It's Alison's old room. So much has changed but this room feels the same. Maya lights a joint. She offers it to Emily. Normally, she would say no, but something about Maya brings out the rebel in Emily. Maya makes it look so appealing and sexy. It's Emily's first time. She inhales. She likes it. A feeling of excitement fills up Emily.

FIGURE 2.1 *Pretty Little Liars* **pilot story outline by I. Marlene King, page 1, March 2009. Reproduced with permission from Warner Bros. Television. All rights reserved.**

Television is a team sport. If you're a writer who is not open to input, not comfortable with compromise and not willing to consider and incorporate the ideas of others, my suggestion is to go be a poet. Go be a novelist. Television writers have to be willing to be team players and find ways to respect the creative input of many layers of producers and executive colleagues. If a show becomes very successful or if a writer has a proven track record of writing great and successful shows, the input from all the various partners decreases. But in TV even the best and most successful writers need to be open to the thoughts of their powerful partners and corporate masters.

There's an old expression, "He who pays the piper calls the tune." The screenwriter is the piper, and the network and studio are the ones paying him to play. They get to call the tune. The heart of development beats to this fundamental, age-old dynamic.

Every layer of input – the producer, the studio development execs, the network development execs – has the project's best interest at heart, and works hard to make a positive contribution to improve the material. Susan Rovner, the Executive Vice President of Development at Warner Bros. Television, says, "Being a great development executive is being the first audience. You're the first person to look at that material, and you should really look at it like an audience: Does this make sense, do I care, am I invested?"[3]

I used the term "approval" when I referenced the moment network development executives sign off on the last rewrite of a pilot story and instruct the writer to begin writing the actual script. The network execs literally have legal, contractual approval of this and every major step of the process. Because they're paying and because their business affairs execs sweated the details of formal contracts that spell out creative approvals along with who gets paid what and when, the network and studio development execs have contractual approval of both the pilot story and the pilot script. The studio won't pass along to the network anything it doesn't believe in (pilot story outlines, pilot scripts, pilot rough cuts). The studio will note them and demand fixes until they're happy with them before the network ever sees them and has the opportunity to approve them. They also have formal, contractual approval of the director chosen to direct the pilot (if the script is greenlighted) and approval of all actors cast as series regulars.

While the many parties of the process – the writer, the producer and the various development execs – all know the network and studio have

contractual approvals, executives rarely speak in those terms. The culture of TV development, the culture of the TV industry in general, tends to be warm, friendly, supportive and collegial. Network development executives never say, "I have legal approval, and I now choose to deem the pilot story satisfactory to my expectations. I now officially approve this story and authorize you to move on to the next phase of the process." Everyone in the process knows they have that power, but it's considered uncool for execs to throw their contractual weight around. Instead, the network development execs typically express their approvals in a friendly, positive, even cheerleading way:

> Your latest story rewrite is awesome, and we're thrilled with all your great work, thank you. We can't wait to see what you do with the pilot script, so please let us know if you have any questions as you dive into it, but we're super-excited to read it when you're ready!

Everyone knows that this means, "Your pilot story is now approved, and you are officially commenced to script."

The goal of a pilot story outline, like any story outline, is to offer the reader a clear view of the shape of the story – the beginning, middle and end of the story – to put the characters into action, to hint at the tone of the project via both the writer's voice and snippets of dialogue that punctuate the descriptions of scenes, and, most importantly, to create an emotional drive through the story, a sense of urgency or swelling feelings in a drama or a humorous or wry delight in a comedy. The outline should pull readers in and make them care about what happens to the characters. The work is the work – in this case the work of illustrating the scenes of the story – but every step of the pilot process is also a sales step, another chance to sell the network executives on why the project is special and, in the long run, a winner for their company.

STEP 5: PILOT SCRIPT

Once her story is approved, the writer gets to work writing the pilot script. A one-hour drama pilot script is usually 60 pages or slightly fewer, a single-camera half-hour comedy pilot script is usually in the mid-30s and a multi-camera half-hour pilot script is in the upper-40s. Typically the network expects to see a pilot script within eight–ten weeks of sending the writer to draft. Which means the producer expects to see a draft within five–six

weeks so he and the studio have time to give the writer feedback and turn around rewrites.

The writer writes a draft of the pilot script, the producer reads and notes, the writer does rewrites, the studio reads and notes, the writer does rewrites, then the network development execs read and note, and the writer does more rewrites. As with the pilot story, the writer typically writes six, eight, ten, twelve drafts of the pilot script to please her several layers of partners. Or more drafts than that.

As a producer, the first time I read the first draft of the *Pretty Little Liars* pilot script I knew we had something special. When creator Marlene King's script described the climax of one of its six stories (yes, the *Pretty Little Liars* pilot had six distinct stories) where the long-separated friendship of the four lead characters was reunited at (spoiler alert) the funeral of their fifth best friend, I literally got chills. I knew if the development execs and ultimately the audience had the same kind of reaction, I was looking at the foundation of a hit show.

When the network development execs are happy or their script development clock has run out (or both), the network execs hand the pilot script, along with all other pilot scripts their department has developed that season, up to their boss, the president of the network.

STEP 6: THE NETWORK PRESIDENT READS THE PILOT SCRIPTS

Like clockwork every year at the broadcast networks, and on a rolling basis at cable and streaming companies, the network president reads all the finished pilot scripts and decides their fate. The network president either passes on a pilot script, in which case it's dead, or greenlights it to pilot production. The network president is the player in this process who has pilot greenlight power.

If the president is inclined to "pick up" the pilot to production (i.e., to greenlight it, meaning the network commits to paying millions of dollars of a pre-negotiated pilot episode license fee to cover most of the cost of production for the purpose of considering ordering it to series), inevitably she has creative notes like every other exec in the process. (Many network presidents come up through the ranks of development executives and are

experienced at developing and noting pilot scripts.) While the writer can deflect some of the network and studio development execs' notes, the writer knows he pretty much has to do the president's notes. He's come this far and the network president holds the brass ring of a pilot greenlight. Chances are he's so creatively drained and emotionally exhausted from writing multiple drafts of story and script that he'll pretty much do whatever the president asks.

If a network president passes on a pilot script, the team that worked so hard to develop it might find failure hard to accept. The studio executives, the writer's agents and the producer might try to strategize whether there's another network they can take the finished script to that might consider ordering it to production. Shopping the finished script to competing networks is occasionally tried but rarely successful, and there are several reasons why. First, there's probably a good creative reason why the first network passed. While the writer and producer may be proud of their work, the script most likely failed to make the cut because it wasn't good enough. Second, networks that didn't buy the project initially and didn't spend months developing it tend to look at the development of their competition with skepticism. They tend not to feel the same affection for the project as the people who worked so hard to birth it. Once in a great while this strategy works and a "dead" pilot script gets ordered by another network. The *Breaking Bad* pilot script was developed by FX and passed on. The project's studio, Sony Pictures Television, took the script to AMC, which loved it, bought the pilot script and ordered it to production. The rest, as they say, is history. But that's a very rare success story at this stage of the game.

STEP 7: PILOT PRE-PRODUCTION ("PREP")

Congratulations, your pilot's been ordered to production, now get to work!

The writer and producer take a moment to celebrate their success and then jump into pilot prep. While there may be some final polish work to do on the script, the writer's job as writer is essentially over, and he switches into producer mode. The writer typically transitions into pilot showrunner, the lead Executive Producer and visionary of the pilot production. The writer/showrunner works along with the non-writing EP to prep, shoot and post the pilot. For that reason we'll refer to the writer/creator as one of the "producers" throughout the rest of this description of the pilot process.

The first step in prep is usually casting. Casting a pilot is an arduous process and, of all the steps of pilot prep, it usually takes the longest and therefore is the first to be initiated. Additionally, all the broadcast network pilots enter prep at the same time so there are literally dozens and dozens of pilots competing for the same finite pool of top acting talent. If you're a producer and your pilot gets picked up, you want to dive into casting and get first dibs on the best available actors as soon as possible before other pilots come along and snap them up.

The first step of the casting process is hiring a casting director who will spearhead the casting process. The casting director doesn't make the casting decisions, as is sometimes assumed, but rather the casting director's jobs are to 1) organize and manage the entire casting process on behalf of the producers, 2) serve as the primary liaison between the pilot and the acting talent community within the industry (agents, managers and actors themselves), 3) interface on behalf of the pilot with the network and studio casting departments, and 4) share her taste, expertise and inside knowledge with the producers and director about the best possible actor choices for each role in the pilot.

The networks and studios have casting departments that employ full-time casting executives. The network and studio casting execs serve as the point people at those companies throughout the casting process, circulating information and opinions among their development execs and president, monitoring day-to-day (and frequently moment-by-moment) progress, and relaying a steady stream of info and opinions (often multiple times a day) to the casting director.

As soon as a pilot is picked up to production, network and studio casting execs make recommendations to pilot producers about which casting directors they like and think would be suitable for the pilot. The producers consider the network and studio recommendations and meet or speak by phone with various candidates, or they might have a long-term professional relationship with a casting director of their own preference. After careful (but quick) consideration of the options, the producers select a casting director for their pilot, request approval of their choice by the network and studio casting departments, and the studio quickly negotiates a short-term contract to hire the chosen casting director for the duration of the pilot, with an option on their services should the pilot go to series. (Casting-director deals typically allow ten weeks to cast a pilot.)

Once a casting director is on board, the first step of the process is usually a "casting concept call." The casting director organizes a conference call with the pilot producers and network and studio casting executives to discuss each lead role of the pilot. The producers lead this conversation and articulate their vision for the types of actors they think are most appropriate for each character and the specific qualities they're looking for. "This character needs to be played by a beautiful actress, but she also needs to have enormous warmth and likability," one of the producers might say, or "The most important quality of this character is his cunning; we need an actor whose wheels are always turning behind his eyes."

The casting concept call is one of the many steps of the pilot production process that helps to unify a large group of people and keep them all focused on one consistent vision. If the network and studio casting execs have questions or concerns about how the producers see a role, this is a chance to air those concerns and get everyone back on the same page. One of the producers' jobs throughout the entire pilot production process is keeping all their many partners and creative collaborators aiming at the same creative target.

After the casting concept call the casting director writes short descriptions of all the roles and runs them by the producers for their approval. These character descriptions are then disseminated to the entire industry via the Breakdown Service (a private company the entire industry uses). Talent agents who represent actors subscribe to the Breakdown Service and read new postings on its (password-protected) website each morning so they know which roles are being cast, and they consider which actor clients could be right for those jobs. During "pilot season," the time of year when all the broadcast networks' pilots prep and shoot (I'll spell out exactly when that is later in this chapter), there's a frantic flurry of activity at talent agencies as they scramble to match their clients with roles that could change the clients' lives and potentially earn the actors huge fortunes (and the agency commensurately large commissions). The talent agents read the Breakdown Service, read all the pilot scripts (which all the talent agencies in LA and New York get their hands on the moment pilots are greenlighted), and then agents meet within their agencies to discuss which of their many clients are best suited for each available role. One agent at each agency is typically then deployed to call the pilot's casting director and submit a handful of the agency's clients for each role.

The casting director on the other end of this process fields calls from dozens of agents pitching their clients. She keeps lists of all the agency actor submissions, and also creates lists of her own ideas of possible actors for each role. Creating and updating these lists is one of a casting director's primary responsibilities. These lists of hundreds of possible actors for each role are based on more general lists that the casting director keeps and updates on an ongoing basis year-round. She'll keep one running list of "ingénue" actresses, a running list of "mom" actresses, a running list of "male comedic leads," etc. Maintaining a constant eye on the entire acting talent labor pool is one of a casting director's fundamental tasks, as it is of the casting departments at networks and studios.

Development executives at networks, studios and production companies keep the same kind of running lists of writers, typically divided by writers' specializations, like comedy versus drama. Hollywood companies of all kinds, talent agencies, networks, studios and production companies, keep constant track of talent (writers, directors and actors), and place bets on who's got potential, who's on the rise, who's ready to break out and become a star. Evaluating talent, assessing potential and keeping tabs on hundreds (or thousands) of working writers, directors and actors are among the most important facets of the role of development professionals and their casting director colleagues.

Typically, the casting director creates two lists for each lead role, an "offer-only" list and a "to-read" list. The offer-only list is the list of the biggest star actors who might be appropriate for a role but who won't audition. Stars typically won't audition. They and their reps believe the star's body of work speaks for itself, and any producer or executive can easily imagine the star's unique talents applied to a given character. Most stars who won't audition will only consider a pilot, will literally only even take the time to read a pilot script, if they are made a firm, exclusive financial offer to play a role. Because the number of star actors is quite limited, the names of the same stars show up on offer-only lists for numerous characters at numerous networks and studios during pilot season, and these top actors have their choice of the best pilot roles.

The second list the casting director makes for each role are the to-read lists, the lists of actors who *will* audition who might be right for a role. An offer-only list might include the top 10–20 ideal actor candidates for each role, and the to-read list might include hundreds and hundreds of actors who

could potentially be appropriate. (Needless to say, most actors on the "to-read" lists aspire to be "offer-only" actors as soon as possible.)

The initial casting concept call might include discussion of a small number of stars at the top of the offer-only list or who might be on the producers' own mental offer-only list. The writer may have actually written a role with an ideal actor in mind and dreamed throughout the entire development process of that actor in her pilot. The writer/showrunner might bring that up on the casting concept call, and the group will discuss the possibility of pursuing that star first or, at the very least, consider that actor as a prototype for the character. If the parties on the casting concept call agree that a specific star is ideal for a role, the network and studio casting execs might need to get approval from their bosses, the network or studio president, before authorizing an offer, but in most cases the casting execs will know their bosses' tastes and opinions and make a determination on their behalf. Casting execs and casting directors will also usually know which stars are "open to TV" (as opposed to only willing to consider feature film acting work) and which stars are available. There are few things sadder for a writer than dreaming of a star throughout the lengthy development process and then learning that the star of their dreams is in rehearsal on Broadway or off shooting a feature in Madagascar during the exact dates of pilot production and isn't available.

Once all the pilot's roles are posted on the Breakdown Service and actor submissions are pouring in from agencies and the casting concept call has happened, the casting director begins the audition process with "pre-reads," casting sessions for each role that only the casting director attends (typically along with a casting assistant who operates a video camera to record each audition). Actors come in and audition with "sides," the script pages for just the two or three scenes of the pilot script that the casting director and producers have selected as the best audition scenes for each role, and the casting director reads the character opposite the auditioning actor. The casting director uses the pre-read phase of auditions to cull actors who in theory might have been appropriate for a role, but in actuality aren't right enough or good enough to make it to the next round of the casting process. The pre-reads might run concurrently (as a backup) while the casting director puts offers out to stars on the offer-only list (typically one at a time) as agreed upon via constant phone and email communication with the producers, and network and studio casting departments.

The next phase of the casting process is the "producer sessions" where the pilot producers join the casting director to audition actors who have survived the pre-read round. Again, the casting director typically reads the character opposite the actor auditioning and a casting assistant records the audition on video, while the producers watch the audition and interact with the actor. Typically both the pre-reads and the producer sessions are held in a room at the casting director's offices. (Zane/Pillsbury Casting, the casting company that cast the pilot and series run of *Pretty Little Liars*, rents a converted bungalow in an old neighborhood of Los Angeles and holds their auditions in what used to be a back bedroom of the old house, an odd but surprisingly friendly place to hold auditions.)

A casting director might pre-read hundreds, possibly a thousand, actors for each role. The producers typically audition anywhere from 60–100 actors for each role. Sometimes more, sometimes fewer.

Meanwhile, other facets of prep commence. As the casting director gets to work, the studio's physical production department makes line producer recommendations to the producers. The showrunner is ultimately responsible for delivering the pilot on budget and on schedule, but the line producer manages those facets of the production on a day-to-day basis so the showrunner and other EPs can spend most of their energy focusing on creative issues.

The producers meet with a handful of line producer candidates, hear their thoughts about the feasibility of production and ideas to address any production challenges the pilot script presents, and the EPs select a line producer. The studio's physical production department then hires the line producer for the run of the pilot. The network development execs generally like to be FYI'd on who the line producer is, but physical production isn't their domain so that decision isn't a priority for them. If the pilot comes in over-budget, the money comes out of the studio's pocket, not that of the network, which has a closed license fee deal.

Once a line producer is on board, the line producer and studio physical production department strategize on where to shoot the pilot. Most pilot production occurs in places that offer tax incentives for movie and TV production to reduce the studio's costs (and hedge their investment in the pilot). These cities tend to attract and keep the skilled labor that's needed for production. Favorite cities for pilot and series production these days

include Vancouver, Toronto, Atlanta, New York City, New Orleans and of course LA. The line producer and studio execs try to find a locale that offers the best financial opportunities, the best native crew and equipment, and that also offers the right look for the pilot. Once the line producer and studio agree on a locale for production, the line producer advises the creative producers of the choice, and the producers sign off or ask for other options. Once the production locale is agreed upon, the line producer relocates to that city and begins local prep, hiring a unit production manager, location scout and other key local crew, and making deals for equipment, transportation, catering and the long list of production requirements.

The producers, meanwhile, remain back in LA, continuing the casting process and beginning the next phase of prep, which is selecting the pilot director. As soon as the pilot is greenlighted and talent agencies receive the pilot script, agents who rep TV directors comb through their lists of clients to consider which clients might be right, in the same way that actor reps begin thinking of their clients for each of the pilot's roles. Agents then send the script to their director clients, the directors read the script and let their agents know if they respond to a script and are interested in being "put up" for the pilot. Agents then call the producers and pitch the director clients that responded to the script. Producers keep a running list of director names, ideas of their own based on their experience producing episodes of other series, or directors whose work they've seen and admired, and directors who are pitched for the pilot by the network and studio development execs. The producers discuss director candidates among themselves, then with their network and studio development execs, and then cull the list to the top handful of director candidates. They'll then meet with the top handful of director candidates.

In these meetings the producers focus on three main questions: 1) Is the director fundamentally in sync with the producers' vision for the pilot, 2) has the director come to the meeting with interesting and original ideas – e.g., visual, thematic or interpretive ideas – that elevate the project, and 3) does the director feel like a personality the producers can work well with in the heat of battle?

When the two co-creators of *The Vampire Diaries* and I met with one top pilot director candidate he spoke excitedly about ideas to make the pilot as scary as possible, but he never brought up an element we producers thought

was the single most important creative quality of the pilot (and series), the romance among the three lead characters. When we asked him about it, he said, "Oh, yes, romance is important too." But we knew his heart wasn't in the romance. Another director candidate walked in the door and the first thing he brought up was how romantic the pilot was and how that was the most important quality to realize during production, and we knew we'd found our director. We guessed right and that director, Marcos Siega, nailed it, getting all the romance as well as the scares and other qualities we hoped for.

Once the producers agree on their director choice, they call their network and studio development execs to request their approval (remember, the network and studio have contractual approval of the pilot director). Chances are the producers have already cleared the director names and received pre-approval before meeting with candidates so as not to waste anybody's time, but once they come to a final decision they call to get a final sign off and ask the studio to make an offer.

A studio business affairs exec reaches out to the director's agent to make a deal for the director's services, and the director dives into prep, typically first joining the producers in the ongoing casting process.

The director and producers then work in consultation with their line producer and studio physical production and post-production departments to staff key department heads for the pilot, hiring a director of photography, a production designer and an editor.

Once the producers, director and casting director have found their top handful of actor choices for each series regular role, they alert the network and studio casting departments that they are ready to bring actors in for "tests." The "studio test" followed by the "network test" are the last two rounds of the casting process. The producers, director and casting director bring their top four to six favorite actors for each series regular role to the studio test, where the studio president, studio development executives and studio casting executives gather in a large office or conference room and watch the top actor choices come in and audition live, one by one. Typically, two or three different roles test at a studio on a given day, and the same team regroups again several times to test actors for the next batch of two or three of the pilot's lead roles.

As with the pre-reads and producer sessions, the casting director sits opposite the auditioning actor who stands before the studio execs, producers

and director and auditions. When an actress finishes her test, the studio president thanks her, she leaves and the next actress enters the room. When the last actress testing exits and the door has swung shut behind her, the studio president typically turns to the producers and director and says, "Who do you like?" The producers and director articulate their preferences and a conversation about the various choices for the role ensues, culminating with the studio president making a final decision to choose the best two or three actresses out of the four to six actresses who tested.

This process is then repeated at the network test where the producers, director, casting director, studio president, studio development execs and studio casting execs join the network president, network development execs and network casting execs to watch the studio's top two or three actor choices for each role test at the network. After the last actor has finished his audition and the door has swung shut behind him, it's now the network president's turn to ask the producers and director, "Who do you like?" A conversation among this now very large group ensues, at the end of which the network president makes the final decision about which one actor actually, finally gets the part. Sometimes there's disagreement and the network president agrees to hold off making a final decision until further thought and discussion can happen. Sometimes a decision is made and producers or a studio exec follows up immediately after the group separates and tries to persuade the network president to change her mind. Sometimes, surprisingly not infrequently, the network execs patiently watch a network test and then tell their assembled guests, "We don't like anybody you brought us, start over," and no one is approved.

The opinions of many people, many of them powerful, egotistical and confident of their tastes and opinions, are involved in pilot casting, and the process can become unwieldy and political. A network president once pleaded with a very powerful writer/creator on a pilot I produced to cast a pop star in a lead role that the writer was completely convinced the singer was unqualified for, and the writer/showrunner succeeded in deflecting the network president's pressure. Another time a network president flat out refused to cast the producers' and director's top choice for a lead role, and then finally, after days of pleading from the creator and studio president, relented. That actor went on to become a breakout star in the role in what became a hit show. To borrow the expression of a writer I cast a pilot with, pilot casting is often one huge "fustercluck."

By this point in pilot prep the producers and director have probably begun shuttling back and forth between casting and other responsibilities in LA and the pilot production locale, where they scout locations with the line producer and oversee local casting (roles with one or two lines that aren't worth the cost of traveling an actor from LA) and crew hiring.

While prep continues on multiple fronts, the director creates a "look-book" in consultation with her producers and delivers it first to the studio, then to the network. All the parties involved in a pilot at this point have agreed upon the script and the cast; what they don't know is what the pilot will look and feel like. The producers and director want to avoid surprising their network and studio execs once production begins, and so use a look-book to give them as clear an idea as they can of how they intend to spend the network and studio's money.

The director typically finds images (often simply borrowed from the internet or magazines) of the lighting and film quality the cinematographer will try to capture, actual photos of the locations that have been chosen and borrowed images of how they'll be decorated (Figures 2.2 and 2.3) and costume fitting photos of the actors to show the style of wardrobe to be used for each lead role. Hair and makeup test photos might be included, or inspiration photos that the hair and makeup departments have found. First the studio and then the network president and development execs review the look-book and deliver feedback.

The final and quite fraught step of prep is typically a table-read, where the entire cast gathers for the first time in a large conference room at the studio offices in LA or sometimes in a hotel or temporary office in the city of pilot production, and the producers, director, casting director, line producer (if it's held in the city of production), network and studio presidents (if it's held in LA), along with their development execs and casting execs, gather to watch the pilot script read by the cast from beginning to end. The actors sit at a large table in civilian attire. The writer/showrunner welcomes everyone, expresses his excitement and optimism at their joint project, then turns the room over to the director who reads the script's shot description as the actors perform the dialogue to the room.

The table-read is fraught because, while it's invariably exciting and celebratory, it can also be a moment of danger for the writer and actors. Immediately following the table-read the cast is thanked and dismissed, the network execs huddle together in one corner, the studio execs huddle in

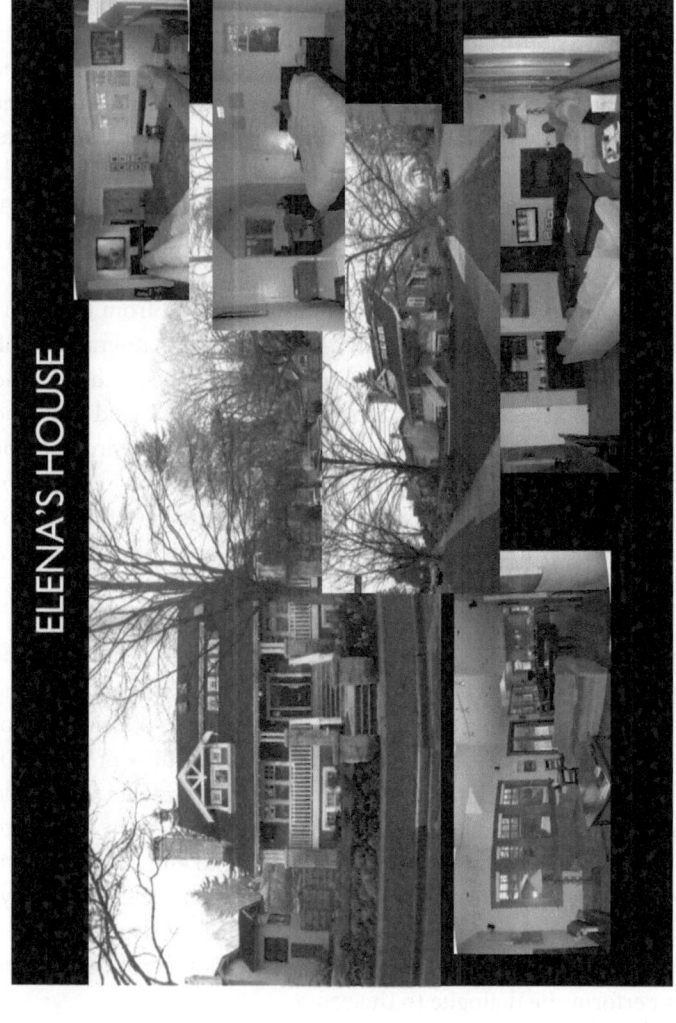

FIGURE 2.2 *The Vampire Diaries* pilot look-book page illustrating the location intended for Elena's house, a private residence in Vancouver, British Columbia. Interior photos depict rooms prior to art direction and set decoration to give network and studio executives a sense of the layout and architectural details of the rooms. Photo by Marcos Siega. Reproduced with permission from Warner Bros. Television. All rights reserved.

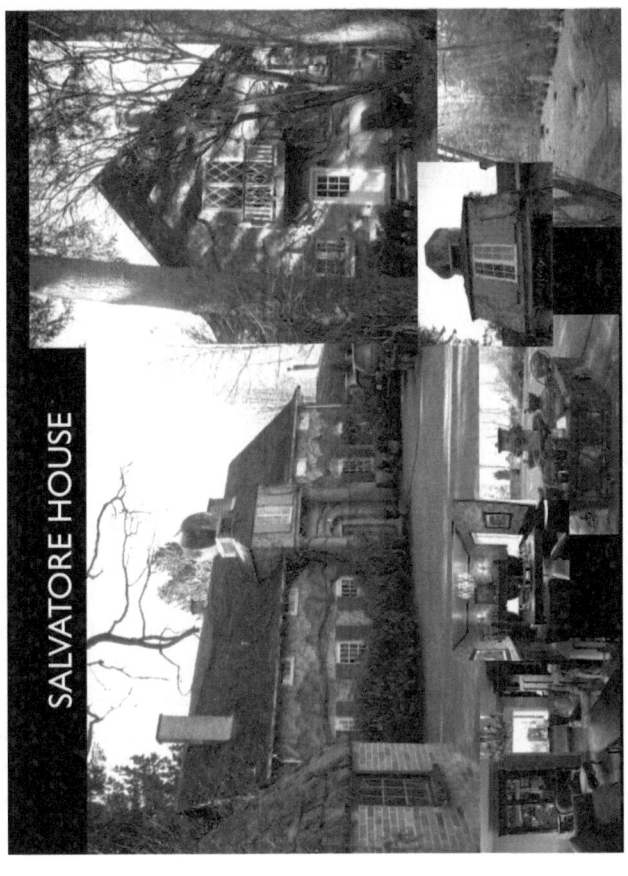

FIGURE 2.3 *The Vampire Diaries* pilot look-book page showing the location for the Salvatore brothers' house on a farm in Langley, British Columbia. Interiors for both the Salvatore house and Elena's house were recreated as sets on soundstages in Decatur, Georgia, once the pilot was ordered to series, and the entire production moved to Atlanta for the duration of its run. Photo by Marcos Siega. Reproduced with permission from Warner Bros. Television. All rights reserved.

another corner, and when they're ready a small contingent representing the two companies, usually the two presidents and their development execs, sit down with the producers and director and deliver a final round of notes. If the table read has not gone well, drastic script notes may be delivered and actors may be fired.

Development executives are skilled at imagining how scenes written on a page will play when brought to their feet by actors and directors, but sometimes, hard as they've worked to develop the best possible pilot script, hearing the entire episode read aloud by actual actors reveals weaknesses no one noticed or might have only silently suspected. The network president has greenlighted only the strongest pilot scripts to production, and yet sometimes the table read on the eve of production demonstrates deficiencies in the storytelling no one foresaw.

Likewise, rigorous as the casting process is, mistakes are made and occasionally discovered at the table read. Sometimes the table read is used to reintroduce a simmering disagreement amongst the large contingent of people who share a deciding role in casting the pilot, and the intensity of this moment can be leveraged to request or demand a change. (Did I mention the term "fustercluck?")

If casting changes are made at this late date just about everyone involved feels a pang of sadness for the actor who has come so far and gotten so close, only to receive a call (frequently the night before boarding a flight) that they won't be joining the pilot after all. (The fired actor will be paid his full fee for the pilot episode, but obviously won't earn any of the potential years of episodic acting fees and residuals if the pilot is successful and goes to series.) If a network fires an actor at the last minute they often have a backup candidate in mind, possibly a runner-up from the network test, and the change is made swiftly. The casting director relays the sad news to the actor's reps who then make the painful call and let down their client as gently as possible.

Painful as it is in the moment, most actors who are good enough to be cast as series regulars in pilots tend to have careers that survive and thrive despite the setback. Sarah Silverman was fired after the table read of one of her first pilots. Her career took a different direction and has thrived ever since. In TV development, as often in life, things tend to find a natural equilibrium.

STEP 8: PILOT PRODUCTION

Following the table read, the cast, producers and director travel to the city of production and begin shooting the pilot. One-hour drama pilots shoot anywhere from 10–20 days, half-hour single camera pilots shoot in seven–eight days, and multi-camera half-hour comedy pilots rehearse for six–seven days and then shoot in front of a live studio audience during one evening on a soundstage on a studio lot in LA.

If the pilot shoots on location (as most single-camera pilots do), the network and studio development executives and studio physical production executives might visit for a day or two or might remain in their offices in LA and screen dailies, which they stream via password-protected websites each day following production. The development execs may call the producers on location and deliver notes on the footage they've viewed. Notes can range from performance notes, direction notes (regarding shot selection, camera movement, staging or any number of issues) or styling notes about hair, makeup or wardrobe. The producers relay relevant notes to the director and appropriate cast members or department heads as shooting continues. In rare instances "pick ups," individual shots or portions of scenes already filmed, may be shot or entire scenes reshot if concerns from the dailies are large enough and either the network or studio is willing to pay for additional production time. Network and studio development execs usually have multiple pilots shooting at a given time so they're screening dailies and speaking to producers on multiple pilots.

While the development execs focus on performance, visual style and storytelling, the studio's physical production department monitors schedules and budgets. The producers focus primarily on the creative progress of the pilot, but they're also in communication with the studio back home about the budget and schedule, and figuring out with the director and line producer how to ensure they land the plane on time and on budget.

Actors, typically offered precious little rehearsal time and usually none before filming begins, often take a few days of production before they settle into their roles. An astute director and producer can spot the day or even the exact scene when an actor locks into her character.

While the pilot shoots, the editor and her team of assistants and technicians are back in an edit room in LA, cutting together scenes as dailies come in, sometimes calling the director with feedback about how his footage is cutting together. Experienced producers and directors usually know if a pilot is working or not, if it will come together or not, but whatever doubts or fears they may have during production, they soldier on and do the best possible work within their limited production schedule, understanding that they won't know for absolute sure what they have until they see it cut together.

STEP 9: PILOT POST PRODUCTION

When the producers and director wrap production and return to LA their exhaustion from weeks on location usually coincides with their editor's need for a few days to finish her "assembly," the editor's first cut of the whole pilot episode. When the pilot assembly is done, either the director views it with the producers or alone with the editor. The director is guaranteed first cut by the Directors Guild of America basic agreement. For a Hollywood studio feature a director is guaranteed ten weeks alone with her editor to deliver her first cut to producers or the studio. For a one-hour TV pilot, the director is guaranteed four days. (While almost all pilots are much shorter than feature films and the pace of production and post is much faster in TV than movies, that single fact might be the best evidence of the place directors hold in the TV pecking order versus feature pecking order, as discussed earlier.) In some cases the director and producers have a friendly professional rapport and the director says, "We have very little time to get this pilot in shape, let's pool our edit time and do it together," or the director may not feel a creative kinship with the producers and insist on screening the pilot assembly alone with the editor and doing her cut before the producers see it and put their editorial stamp on it. It all depends on how well the team has gelled during prep and production and if the producers and director have a history together. But, most likely, they all behave respectfully and professionally and figure out some arrangement among themselves that more or less satisfies everyone. If the director uses her four days to do her director's cut in concert with the editor, she then hands over her cut to the producers who have about seven days to do their producer cut.

Both the producers and the director typically edit to temp score, usually scored music from an existing series or movie that has a similar vibe. (No one's concerned about music rights at this stage; the pilot is for internal

screening, not for air. That's a long way away, and there will be plenty of time to compose and record a score and license music cues if the pilot is ordered to series and receives a premiere date.)

When the deadline arrives and their edit is finished, the producers deliver their cut to the studio development execs who view it with their president and give the producers edit notes. The producers then recut and redeliver to the studio, addressing their notes to the best of their abilities. Studios know that the network's first viewing of the pilot is crucial to the likelihood of the show getting picked up to series, and they know the network will perform some kind of quantitative research on the pilot episode (to be discussed later in this chapter), so some studios perform research tests of pilot rough cuts themselves to anticipate potential network executive and network research feedback.

The studio uses its own research department or hires an external research company to recruit typical viewers (based on the demographics that the studio believes the network has in mind for the project's ultimate audience), who then view the pilot and answer a battery of questions and/or perform "dial tests," where sample civilian viewers hold a dial and turn it clockwise if they like what they're seeing and turn it counter-clockwise if they don't like what they're seeing. Producers sometimes watch dial-test results live in a room adjacent to the test viewers, while a graph illustrating "like" and "don't like," one color representing male test viewers and one color representing female test viewers, is superimposed over the pilot video as the episode plays on a monitor. If the test audience reaction graph starts heading down and then down further, producers' hopes go with it.

Sample viewer feedback that emerges from the studio research test is digested by the studio research execs (larger TV studios and TV networks employ entire research departments), development execs and producers, and producers go back into the edit room to make adjustments to the pilot to try to address whatever creative concerns they believe they can. While most producers and industry creatives tend to be skeptical of corporate research, one category of feedback that often emerges from rough-cut research that many creatives find helpful is clarity. The producers and development execs who work on pilots know every word and shot and moment of the pilot. They've talked about every aspect of the script and story for months or years and know them backwards and forwards, and it's often easy to overlook the forest for the trees. The fresh eyes of sample viewers can sometimes be useful

to flag problem areas, things the producers assumed would be clear but instead cause viewers confusion and frustration. New dialogue can be written and actors called in to "ADR" (automatic dialogue replacement) to help explain things. Dialogue can't be put into an actor's mouth because the lips won't match, but places can be found to insert short pieces of dialogue over character's shoulders or during reaction shots. Another common solution to test-audience confusion is to add voice-over narration. (The voice-over narration by the character Stefan that begins *The Vampire Diaries* pilot was added in post-production to address viewer confusion.) Text messages and emails (which play such a large role in many TV pilots and series these days) are frequently rewritten and digitally recreated during post production to help clarify or otherwise fix story problems that producers and development executives discover require repair.

When the studio is satisfied with the cut of the pilot, they "temp" complete it with color correction and a full temp sound mix. They want the first network screening of the pilot to look and sound as much like a finished TV episode as possible, rather than looking like a sloppy rough cut. Often the network president and development executives travel to the studio and view the pilot in a studio screening room. The network execs then deliver notes to the producers and studio development execs, and producers go back into the edit room yet again to make more changes to address the network's notes, until the network is satisfied and signs off on the cut. At that point the episode is locked and finished for real, with final color correction, audio mix and titling.

STEP 10: NETWORK SCREENINGS

After the network president and development execs sign off on all a development cycle's batch of pilots, screenings are convened for the top executives of the network to view the pilots and weigh in. When I was a development exec at NBC about 60 of the company's top executives from both its LA and New York offices would gather in a large conference room in LA and watch and discuss all the new pilots over the course of a week. Senior brass from marketing and promotion, scheduling, network sales and affiliate relations would be there; even the heads of the network's news, sports and daytime divisions would be part of the process of screening the network's new crop of pilots for the first time. A much smaller group of senior executives makes the final decisions about the fate of the network's

batch of pilots, but most network presidents like hearing the perspective of trusted executives outside the company's programming department as a reality check on the work that her small team of development executives have worked on for many months.

The large group of network executives has a robust discussion after screening each pilot, debating its strengths and weaknesses. A much smaller subset of this large group then convenes to make the final decisions about which pilots are ordered to series and which are not.

STEP 11: NETWORK RESEARCH

Almost every TV network uses some kind of research process to try to calculate how their targeted viewers will receive the pilot and potential series. Creating a "sample episode" to test is one of the traditional purposes of developing and shooting a pilot. Larger networks have their own in-house research departments and smaller networks hire independent research firms or borrow the services of their larger parent company. While the artists who make TV often cringe at the thought of their painstaking work being "focus-grouped" and tested in these ways, networks – as everyone knows – are businesses, and, like most businesses, TV networks try to quantify the likelihood of a product's potential success. Translating audience reaction into data, assigning numbers to how much a test audience likes or doesn't like a pilot, is also a way for networks to compare pilots against each other and across many years of pilot development. When a pilot tests better or worse than benchmark series that went on to perform well (or badly) in the real world, the team of businessmen and women who make the final decisions want to know.

Typically, the head of the network's research department delivers a research presentation reporting his department's data and their conclusions to the small group of executives who make the final programming decisions. This small, elite group usually includes the president of the network, the senior development executives, the head of scheduling (if the network has one), the head of sales (if a network has one), the heads of marketing whose job will be to sell the new series to the public, and often a senior executive from the network's parent corporation. Karey Burke is the President of ABC at time of writing, and in that role she's in charge of all the network's day-to-day decisions, but she reports to Dana Walden, Chairman of Disney

Television Studios and ABC Entertainment, which includes not only ABC but ABC Studios, Freeform and the ABC-owned TV Stations Group. The network president has a very large say, but the network's corporate parent company executive weighs in and approves all series orders.

When this small group of senior network executives decides the fate of a crop of pilots they take into consideration many factors. They consider the research data, the opinions of their sales executives about whether advertisers will be excited to buy time in the series, the opinions of their marketing execs about whether they see exciting ways to sell a series to its intended audience and if the pilot's concept can "cut through the clutter" of an extraordinarily crowded marketplace of shows. The senior network execs also consider the politics of series pick ups: If they have a writer who's generated many hit shows for them but whose current pilot might not appear as promising as her earlier hits, they'll be inclined to want to give that creator the benefit of the doubt, in part as a vote of confidence and in part as a gesture of genuine faith that that creator is so talented that she will be able to "find the show" once it's in series production even if she didn't completely nail it in pilot form. The network also takes into consideration the ownership stake of its parent company in a show. While two pilots that test comparably might appear to offer equal promise, the show that is owned by the network's sister studio division will ultimately prove more valuable financially to the network's parent company and therefore takes priority over the comparable pilot produced by a rival studio.

While various considerations go into formulating these evaluations, at the end of the day the people who make these decisions tend to listen to their gut creative instincts. To climb the ladder to become a network president or a top exec at a major entertainment conglomerate an executive has usually logged years of work at various levels of the TV industry and has seen numerous pilots and shows come and go. One of the reasons execs get these kinds of jobs is because they've developed a reputation for having good taste, for having an eye and a strong instinct for what works for their audience and what doesn't. Networks want hit shows, and as a multitude of factors and powerful interests weigh on these decision-making executives, they usually ultimately follow their best instincts to try to pick the pilots they believe will be hits. All network presidents know at the end of the day that they are judged by whether their network scores hit shows or not.

STEP 12: NETWORK UPFRONTS

Television networks that are advertiser-supported, broadcast, cable and online, participate each spring in the upfronts.[4] The networks unveil new upcoming programming schedules at these events, announcing which shows will air on which days and beginning when. For development professionals who've developed and produced pilots, the upfronts are the culmination of all their work:[5] Pilots are either ordered to series and placed on the network schedule or officially passed on and most likely dead and buried. Months or years of work are either rewarded with a series production order, a place on the network's schedule and the commitment of the network to spend millions of dollars to market the show to the viewers, or all that work has been for naught and the pilot will never see the light of day. Producers, directors and cast members might not find out until just a couple of days before the upfronts if their pilot is picked up to series, or they might find out a week or two before, but rarely more than a couple of weeks before.

The odd term "upfronts" is an advertising industry term. Advertisers, advertising agencies and media buyers buy commercial time from TV networks in two ways, in the upfront market or in the scatter market. Most commercial time is sold upfront, wherein advertisers pay the networks for large blocks of commercial time months before the new programming season begins. In a sense, they're placing a bet on how a network's schedule of programming will perform. Most commercial time is bought and sold upfront, but networks hold back a fraction of their commercial time for the scatter market, which commences after the new schedule begins airing and networks and advertisers can see how individual shows actually perform, allowing advertisers to buy time in a more targeted way (but also potentially at higher prices). While the upfronts mark the end of the development cycle, they're also the beginning of the new advertising cycle, as the networks unveil their new product line to their customers, the advertisers.

The American advertising industry is based in New York City so the upfronts are always held there. The larger networks rent huge spaces like Carnegie Hall and Lincoln Center to hold their upfront presentations before thousands of advertising execs and entertainment press. Networks unveil their new programming lineups not only to the advertising industry, but to the world. While the networks want their scheduling information disseminated to the public, only advertising

execs, accredited media and invited TV industry guests (including many LA-based agents) are invited into the halls to watch the network spectacles live. Network presidents typically host the events. They stand on stage before their large audiences and unveil their new series, show a trailer for each new series (edited from pilot footage), and introduce the lead actors who are flown to New York to walk across the stage, wave at the audience and inject a dose of glamour into the business proceedings. Networks, TV studios and talent agencies typically host parties and formal dinners to celebrate the end of one season and the beginning of the next. For development executives and producers who've won the development lottery and had their pilots picked up to series, it feels like a big party after taking the last final exam of spring, a chance to finally breathe a sigh of relief after a long, hard effort and to celebrate a brief victory before much more hard work begins.

The effort to turn a simple idea into a TV series that began months or years earlier is over. The upfronts and a series production order mark the end of the development process.

THE DEVELOPMENT CALENDAR

The broadcast networks' development calendar is based on the longstanding American tradition that the new TV season begins in late September, after summer holidays are over, kids are back in school, and Americans move leisure activities indoors as the days grow shorter and colder. The entire broadcast network development cycle is built around this tradition of fall premieres. Most cable channels and streaming platforms don't follow the broadcast network development calendar but *do* conform a calendar similar to this one to their own distribution schedules. For many years the cable channels that programmed scripted series employed a "counter-programming" strategy to offer new programming when the broadcast networks didn't (e.g., during the summer when most broadcast network shows were in repeats), but cable and satellite networks now schedule their scripted series year-round, and non-linear streaming programming is obviously available anytime, anywhere. The five broadcast networks, however, work within the same development calendar that's informed their workflow for decades. Even though there are now many more cable, satellite and over-the-top streamers than broadcast networks, the broadcast

networks still develop and program a huge number of scripted series, order a large number of pilots, and, to this day, a hit show on a broadcast network is more profitable than a comparable hit on a cable or streaming channel. For those reasons, the TV industry is still very much attuned to the annual broadcast network development calendar.

The five broadcast networks, their dozens of development executives, the many studio development executives who sell to them, the talent agents who package projects for them and the hundreds of writers and producers who participate in the network development process each year live by the network development calendar below:

July: Networks brainstorm "network needs"

July–October: Pitch season

September–December: Writers write pilots

Christmas–January: Network presidents read pilots

January–February: Networks announce pilot pick ups

February–March: Pilot casting

March–April: Pilot production and post

April–May: Networks screen pilots

Mid-May: Networks announce series orders at upfronts.

July: Networks Brainstorm "Network Needs"

Most broadcast network development execs take their annual vacations in mid- to late June and return to their offices following the 4th of July holiday. July 5 effectively commences the start of the new broadcast network development season, which typically begins with network development executives, under the leadership of their network presidents, assessing their previous year's development, evaluating the strengths and weaknesses of their upcoming fall programming and devising strategies for the new development season. Many networks and TV studios go on development retreats to brainstorm

new development targets for the upcoming development season and create what are known as "network needs," a list of the kinds of shows a network will look to develop that coming year. When the network development execs return to their offices following their development retreats they codify their network needs lists and disseminate them to TV studios and talent agencies. The agencies share the various networks' network needs with their writer and producer clients, while TV studio development executives brainstorm their own series ideas in hope of appealing to the new sets of network needs.

July–October: Pitch Season

"Pitch season" occurs in summer and early fall when writers, producers and TV studios descend upon the broadcast networks to pitch their new TV pilot and series ideas. While the networks have invested time determining and disseminating their network needs to the development community, they're also open to the many ideas they never imagined that writers, producers and studios have been working on for months in anticipation of the new development cycle.

September–December: Writers Write Pilot Scripts

After the summer's over and the networks have bought all the pitches they're going to buy, usually in October or November, they inform agents and studios they're "bought up," that their development budgets are spent and they're "closed," i.e., done hearing new pitches for the season. This period is the prime script development phase of the annual process. Writers write multiple drafts of their pilot stories and scripts, receive notes from producers, studio and network executives, and development execs of all stripes work with writers to make the season's pilot scripts as strong as possible.

Christmas–January: Network Presidents Read Pilot Scripts

The network development execs receive final rewrites from their studio counterparts and deliver them to their respective network presidents by Christmas. The presidents read all the pilot scripts their comedy development and drama development departments have developed that season to decide which pilots to pick up to pilot production.

January–February: Networks Announce Pilot Pick Ups

Network presidents return from Christmas/New Year vacations and sit down with their development execs to discuss which pilots to order to production. The development execs make their recommendations and lobby for their favorite projects, but, at the end of the day, it's the network presidents' decisions that count and, one by one, they begin announcing (to studio execs, writers, producers, agents and the industry press) the pilot scripts they're greenlighting. This is known as a "pilot pick up," as opposed to a "series pick up" that may or may not happen a few months down the road.

February–March: Pilot Season – Casting

For actors, casting directors and talent agents February and March is known as "pilot season," the time of year that working actors spend most weekdays driving from one casting office to another, auditioning for pilot after pilot. Casting directors hold their pre-reads and producer sessions, followed by studio and network tests. At the broadcast networks about 100 pilots are picked up each year, so there's a mad scramble to cast all the pilots and connect all the dots between casting directors, agents, actors and available (and potentially life-changing) pilot roles.

March–April: Pilot Season – Production

Pilot season continues as network pilots shoot all over North America and sometimes places as far flung as Hawaii and South Africa. Local crews in film production centers like Vancouver and Atlanta shift from shooting series episodes to shooting pilots.

April–May: Network Screenings

Network executives gather together to screen and assess the season's crop of pilots as they also evaluate which older shows will return for another season or get cancelled.

Mid-May: Network Upfronts

The annual development cycle concludes as network presidents host upfront presentations in New York City, announcing to the world and to

the many development professionals which pilots move forward to series and which ones don't make the cut, dying a painful, bitter death.

NOTES

1 At some streaming networks like Netflix, "straight-to-series" orders have supplanted the process of producing and evaluating pilots. Most of the steps described in this chapter still apply to that process, however, and we'll discuss how "straight-to-series" and "script-to-series" development differs from typical pilot development in Chapter 10.
2 When I say two writers, I mean a writing team, not two different writers both delivering a pitch. Most TV writers work solo but writing teams consisting of two writers who form a strong partnership and always work together are not uncommon. Writing teams of three writers are very uncommon but not unheard of. A writing team is considered one writing "entity," the equivalent of one writer, and is paid as one writer. Writing teams are always noted in credits with an ampersand – like Shaw & Thomason who co-created *Castle Rock* – while two separate writers who co-write a script but have not joined together to permanently form a team are credited with the full word "and" – like David Benioff and D.B. Weiss who co-created *Game of Thrones*. Writing teams typically alternate delivery of the pitch, passing back and forth as they work through the pitch's various sections.
3 Author interview with Susan Rovner.
4 The online space instituted its own "upfronts," dubbed the "NewFronts," in 2008.
5 Returning shows that haven't already been renewed learn their fate at the upfronts as well; they might be renewed, moved to new time periods, or cancelled.

3

Format, Genre and Concept

In this chapter I'm going to press pause on the nitty-gritty of series development (which I'll get back to in the next chapter) and shift to a more macro perspective. We all watch TV, and we're all eager consumers of TV, but while people working professionally in development approach television as its biggest fans – and passionate advocates for the audience – they also approach their work as pragmatic professionals.

In this chapter I'll look at three of the basic units of TV programming that industry pros use to describe, differentiate and evaluate their work of developing TV shows: format, genre and concept. Every TV series fits into one of a handful of standard TV formats, many series fit into one of a number of TV genres (while other series invent new genres or intentionally eschew traditional genre conventions altogether) and every TV series has a unique concept that distinguishes it from other series within its format and genre (if it's part of one).

These subjects – format, genre and concept – will probably be familiar to anyone who watches a lot of TV. Some of this stuff might even seem a bit obvious. These ideas are worth a close look, though, because they're essential to the thought processes nearly all development professionals use (whether or not they use these exact terms) in their daily work. I hesitate to invoke one of

the great textbook clichés, but the subjects of this chapter are the true building blocks of TV development. As I examine how development professionals use them you'll hopefully uncover new and constructive ways to think about them.

In professional practice many of the ideas discussed in this chapter are so fundamental that they go without saying in the actual exercise of TV development. Working development professionals don't necessarily need to articulate them because they're often implicit. Some of these ideas, on the other hand, are so essential to development that they're explicitly referenced over and over throughout the development process. All TV development professionals understand these ideas as second nature; they understand them and refer to them intuitively, sometimes implicitly and sometimes explicitly, often in shorthand ways.

The culture of TV development as practiced in Hollywood, like the entertainment industry in general, is not an especially intellectual one and definitely not an academic one. Terms like the ones used in this chapter are not uniformly applied in actual practice or used with academic precision. The words for these ideas that industry professionals use in actual practice vary from company to company and from development exec to development exec, yet somehow everyone seems to understand what everyone else is talking about. An agent won't ask a writer client, "What TV format and genre is the new series concept you're working on?" Instead the agent might ask, "What kind of show are you thinking about?" and the client intuitively understands that her agent is inquiring about format, genre and concept and answers in terms that address them.

The three terms at the heart of this chapter are accurate but instructional. While different development professionals in the real world use different words, it's helpful for the purposes of this book to have a consistent terminology. Understanding these ideas is essential to the professional practice of TV development, and picking up on the various cues that ask for them in the real world becomes second nature as young development professionals absorb the culture of their companies and their industry. I'll try to point out some of these cues as we go. To add to the confusion, the words "format" and "genre" also have *other* common usages in the TV industry today, and I'll point those out as well.

The history of format and genre in television and their continuing evolution today are subjects of significant academic analysis among media studies

scholars. There's a vast wealth of scholarly writing on these subjects that readers may be interested in exploring, and I'll reference some of it as we go and I have provided a list of further reading at the end of the chapter.[1] Practitioners working in the industry approach these topics very differently, though, from a different perspective and with a completely different vocabulary. I'll try to point out some of these differences as we go.

The progression from format to genre to concept is a progression from the general to the specific. Format is the most general. Genre is more specific and effectively a subset of format. Concept is more specific yet. To risk delving into the genuinely academic for a moment, it's the entertainment field's equivalent of biology's progression from family to genus to species (if I remember my high school biology correctly).

I'll use real-world examples to talk about these ideas and observe how they've been used over time. Most TV professionals are TV geeks at heart and deeply steeped in the history of the medium – if only by dint of childhoods spent watching countless "reruns" of favorite old shows. It behooves young, aspiring TV professionals to screen and study as much TV history as possible and to read widely about the medium's past.

The first part of this chapter is a brief and straightforward look at format. The second section focuses on genre, looking back at the most successful TV genres of the first 50 years from the practitioner's perspective and setting the table for the chapter's last section on concept, where I'll pick up the story of the progression of TV programming and development over the last two decades, highlighting recent trends that deliver us to the present day.

FORMAT

Format refers to a category of entertainment product typically defined by medium, production style, length and general genre. In scripted television the two most basic formats are the one-hour drama and the half-hour comedy, but there are several more worth exploring.

This fundamental distinction – one-hour drama versus half-hour comedy – is so central to TV development that most larger TV networks and studios have separate drama development and comedy development departments. Some development execs and many writers spend their entire careers

working exclusively in one format or the other. That's one reason why something as important as format often goes unspoken in professional exchanges: if you're talking to or about certain writers, producers or execs, your conversation doesn't need to specify format because you're probably talking about the format those people work in.

The entertainment industry in general offers a multitude of formats. Feature film is an example of another common entertainment format in another entertainment business. A feature film is a scripted, narrative, performative, filmed story anywhere from 70 minutes to three hours or more. A "TV movie" (sometimes referred to as a "MOW," short for "movie of the week," a once-common but now outdated broadcast network format) is another longform, scripted, narrative, performative, filmed story, yet it's considered a very different format than a feature film. In many respects they're exactly the same thing – they're both roughly two-hour movies – but most of us understand how different in cultural terms those two formats are. The definitions of those two formats overlap in many ways, yet result in two clearly, distinctly different formats.

But let's get back to scripted television. As mentioned above, one of the most common scripted TV formats is the one-hour drama, which is about 42 minutes if it's distributed on advertiser-supported TV, around 56 minutes if it's distributed on premium cable and anywhere from 45 to 75 minutes or more on streaming platforms. Linear TV has depended since its inception on dependable, structured programming schedules, which helped define traditional series formats. More recently, the proliferation of non-linear TV distribution makes those traditional scheduling imperatives irrelevant, and for that reason and others traditional format rules are slowly becoming less ironclad. General format rules continue to exist for now, however, and continue to serve as cornerstones of development – even as some of the traditional format definitions begin to blur.

Whether they're 42 minutes or 75 minutes, these shows are still referred to as "one-hour dramas" (which points to the fact that other format distinctions are more important than actual running times).

The other dominant scripted TV format is the half-hour comedy, an umbrella term that includes two formats, the multi-camera half-hour comedy and the single-camera half-hour comedy. The multi-camera half-hour comedy is filmed with three or four cameras, live, in-sequence

(the scenes are performed and shot in the order they occur in the story – like a play) in front of a studio audience and uses the audience's recorded live laughter on the soundtrack. *The Big Bang Theory* is a multi-camera half-hour comedy, one of TV's most traditional formats, as were *Friends, Seinfeld, The Cosby Show, The Mary Tyler Moore Show* and *I Love Lucy*, the last of which actually invented the format in the early 1950s.

A single-camera half-hour comedy employs "single-camera" film production methods, which actually also uses multiple cameras (typically two), is filmed out of sequence, without a studio audience and typically without a laugh-track (or "sweetening," as it's often called) in its final audio mix. While multi-cam comedies are typically limited by a handful of soundstage-bound sets and studio backlot exteriors, single-cam comedies are shot on more extensive sets (that don't need to accommodate live audience sightlines) and on location. *Modern Family* is a single-camera half-hour comedy as was *Malcolm in the Middle* (the series that helped reintroduce the format to American TV at the beginning of the 2000s) and shows like *Gilligan's Island* and *Bewitched* back in the 1960s.

Both formats are sometimes popularly referred to as "sitcoms" (short for "situation comedy," of course), but that term is used less often in the industry than the more specific "single-cam comedy" and "multi-cam comedy" or even simply "half-hour," which means "comedy."

Formats tend to have their own cycles of popularity. The multi-cam comedy was the most dominant TV format from the 1970s through to the 1990s, but began to feel outdated at the turn of the millennium and hasn't been as popular as single-camera comedies since. Single-camera comedies were the more common half-hour comedy format *before* the 1970s, however, including shows like *Father Knows Best* and *Leave it to Beaver* in the 1950s, and *The Andy Griffith Show, The Dick Van Dyke Show, I Dream of Jeannie* and *Room 222* in the 1960s. There were notable multi-camera comedies in that period too, though, like the aforementioned and formative *I Love Lucy*, as well as the similarly influential *The Honeymooners* in the 1950s.

Half-hour comedies, both multi-cam and single-cam, dominated the TV landscape from the beginning of the network television era in 1948 and into the 1990s (with one notable dry spell in the late 1970s and early 1980s,

during which the one-hour drama was ascendant), and one-hour dramas have been more popular than comedies since the early 2000s.

Beginning in the 1990s a variation on the one-hour drama format took root. *Ally McBeal* paved the way for the one-hour dramedy format when it premiered in 1997 and used many of the format elements (longer running-time, more plot-driven storytelling) and genre conventions of the one-hour drama, but included more comedic tonal notes than the format typically allowed. Series like *Shameless, Orange is the New Black* and *Jane the Virgin* are more recent examples of the one-hour dramedy and heirs to *Ally McBeal's* format innovations.

Half-hour dramedies are an even more recent format. *Weeds, Nurse Jackie* and *Girls* were early half-hour dramedies, and *Transparent* and *Atlanta* are more recent examples. All the half-hour dramedies have been single-camera half-hours with one interesting exception. HBO experimented with a multi-cam half-hour dramedy in 2006 called *Lucky Louie* that starred Louis C.K. It was cancelled after one 13-episode season, and its failure probably shut the door on whatever chances the multi-cam half-hour dramedy format might have had.

Formats, and the rules and conventions that characterize them, are not defined by any industry governing body or written into law. Formats exist because they help networks schedule and market their programming and because they work; they succeed in attracting and holding large audiences. The TV industry, like all of Hollywood, gravitates towards products that work, that succeed in the marketplace, and then reiterates and innovates on examples of success. The popular formats are not etched in stone, and format experimentation and variation occurs over time and will, no doubt, continue into the future.

Another scripted format is worth mentioning as both a historical footnote and a recent example of format experimentation. Half-hour dramas were commonplace nearly 70 years ago and they are witnessing a rediscovery in our era today. The first TV dramas in the early 1950s borrowed the half-hour drama format from radio where it had been the standard drama format for decades. *Dragnet* was the first hit drama series on American TV, beginning in 1951, and it was a half-hour drama.[2] It wasn't until 1957 that TV dramas expanded to hour-long episodes that became the dominant drama form. The half-hour drama

format had been quiescent since the 1960s, and virtually no TV network developed any until the past couple years. Recent series like *The Girlfriend Experience*, *Homecoming* and *Sorry for Your Loss* have rediscovered this once dormant format.

The limited series is the last format that's considered a scripted series format in some corners of the industry. Though where the "mini-series" ends and the "limited series" begins is somewhat open to interpretation.[3] The limited series appears to be defined by shows that are formatted as (roughly) one-hour episodes rather than the more traditional 90-minute to three-hour movies. Limited series also tend to run a total of eight, ten or twelve episodes per season rather than the traditional two or three "episodes" of 90-minute to three-hour movie chapters, the latter of which tends more to characterize the "mini-series" movie format.

There are two kinds of limited series formats, the finite limited series and the anthological limited series. *Band of Brothers*, which ran on HBO as ten (roughly) one-hour episodes, is an example of a finite limited series. It lasted one finite season. An anthological limited series is also usually ten or twelve episodes per season, but returns season after season with new casts of characters in new (but often similar) settings. *American Horror Story* on FX is an anthological limited series. It began in 2011 with 12 episodes featuring one ensemble of characters and has returned for additional 12-episode seasons each year since featuring new casts of characters (sometimes played by a rotating ensemble of the same actors) in completely new settings.

Where regular one-hour dramas and half-hour comedies employ a unity of world and character from episode to episode and season to season, anthologies introduce new worlds and entirely new ensembles of characters. Anthological limited series like *American Horror Story* and *True Detective* introduce new worlds (the setting and time period of the show) and new character ensembles each season. Anthology series (as opposed to anthological *limited* series) like the original 1960s *Twilight Zone* and the more recent *Black Mirror* introduce new worlds and entirely new characters in each *episode*.

Sometimes series that are intended to be finite limited series get "promoted" to anthological series. *Fargo* was developed as a finite,

one-season limited series but was so successful that FX ordered subsequent seasons with new characters and new, anthological Fargo-esque settings.

Alternately, one-hour drama series are sometimes "demoted" to limited series. *Flesh and Bone*, an edgy one-hour drama series set in the New York City ballet world, was developed as a returning one-hour drama series, but after Starz saw cuts of the first few episodes the series was recategorized and launched by the network in 2015 as a finite one-season "limited series."

All TV is format-based. I've discussed scripted series formats here, but there are many other kinds of formats – reality TV formats, sports formats, a multitude of news formats and many others. For the purposes of this book I'll focus on the dominant Hollywood scripted TV formats: one hour-dramas, half-hour comedies (both multi-cam and single-cam), one-hour dramedies, half-hour dramedies and limited series.

Before I move on, it's important to point out two alternative meanings of the word "format" that are commonly used in the industry today. "Format" also refers to an underlying concept, world and character set of a produced show. The Showtime series *Homeland* is based on an Israeli "format," the series *Prisoners of War*. *Homeland*'s studio Fox 21 purchased the "format rights" from the Israeli owner of *Prisoners of War* to allow it to adapt the series into its new American iteration. If you hear the phrase "foreign format" in the Hollywood TV industry, that's the definition of "format" that's being used. A "format" is also a shorter series bible document that's sometimes included in the package of materials that's submitted to networks for straight-to-series consideration. A format document describes story arcs and character journeys over several seasons.

GENRE

Within the major TV formats exist numerous genres. Genres are categories of TV series defined by the world of the series, the profession of characters or the subject matter. Genre is a subset of format. There are numerous one-hour drama genres and half-hour comedy genres.

Format, Genre and Concept 73

The "cop show" is an example of a one-hour drama genre. That *kind* of show, that kind of one-hour drama, is its genre.

To state the obvious, cop shows are typically set in the world of cops, the police department station houses and police detective bullpens that cops work in. The subject matter of cop shows focuses on the jobs that cops perform, investigating and solving crimes, and the lead characters are (you guessed it) cops. These simple elements offer a basic definition of the genre, one I'll supplement as I continue to expand the definition of TV genre throughout this chapter and throughout the book.

Like formats, TV genres are not written in stone. They come and go and rise and ebb in popularity. Some genres thrive for 30 years then go out of fashion for reasons no one can definitively explain. Television development professionals are heat-seekers; they tend to avoid cold genres, gravitate toward thriving ones and, with increasing frequency in recent years, experiment with innovations they have a hunch may work.[4]

Television in the twentieth century was more genre-driven than today. While the last 20 years have represented a period of extraordinary genre experimentation, genre hybridization and downright genre avoidance, the first 50 years of American TV (from roughly the late 1940s to the end of the century) tended to offer programming that fitted into tidy and predictable genre boxes. Of the multitude of genres that flourished in this period, four drama genres – the cop show, the medical show, the legal show and the PI (private investigator) show – and one comedy genre – the family comedy (also known as the "domestic comedy") – were the most prolific and successful.

Why? What did (and to a great extent still do) these genres have that made them so successful and ripe for reiteration throughout the long history of American TV? What lessons can we borrow from their success and apply to other genres and to new genre-bending or genre-upending ideas today?

There are many factors that contributed to the success of the twentieth century's four most dominant one-hour drama genres (often referred to as "procedurals"; I'll discuss that term more in a bit), but, from the perspective of practicing development professionals, four key elements are worth noting.

First, these drama genres provide an infinite number of cases. There will always be another murder for cops to solve. There will always be another sick person for doctors to heal. In TV, cases equal stories. Stories constitute episodes, and the goal of the scripted television business in the twentieth century, and at many networks and studios today, is to develop series that generate many episodes, a hundred or even hundreds of episodes (*Grey's Anatomy* has produced more than 300 episodes and is still going strong). The professions at the center of the "big four" twentieth-century drama genres will always offer literally an infinite number of cases, a never-ending supply of stories. In theory a show in one of these genres could go on forever, and some of them almost have.

The second element these four drama genres offer is life-and-death stakes. Stakes are a hugely important element of all TV storytelling (of all storytelling), and we'll talk about stakes throughout this book, reflecting the enormous emphasis that development professionals place on them during the development process. In storytelling terms, stakes are what's at risk if the main character doesn't achieve his goal. What happens if the cop doesn't find the killer and the murderer remains at large, potentially killing more people? What happens if Dr. Ross doesn't rescue the boy caught in a flash flood in the "Hell and High Water" episode of *ER* (the episode that's widely considered to have won George Clooney an Emmy)? What's *at stake* in that episode is the life of the kid that Dr. Ross cares about and the viewer has grown to care about in just a few minutes of screentime. We care because we understand the stakes of the story.

Effective TV stories almost always have stakes and some stakes are bigger than others. Life-and-death stakes are among the biggest of TV stakes. Most TV shows rely on smaller, emotional stakes. Will the young woman get the guy of her dreams? Will the family members forgive each other and reunite despite the latest crisis that threw them into conflict? Comedy is just as dependent on story stakes as drama. Comedic stakes are also typically emotional stakes – embarrassment and humiliation are common comedy stakes.

Stakes larger than life-and-death stakes are found in comic book superhero stories. Those stories sometimes offer save-the-world stakes, save-*everyone's*-lives stakes. If Superman doesn't spin the earth backwards and rewind time, all humanity will die! "We're all doomed" is about as big as story stakes get.

The big four one-hour drama genres deliver dependable life-and-death stakes. Cops solve and prevent murders. Doctors save lives. Lawyers protect society from murderers and sometimes doom guilty characters to death sentences. Private investigators solve murders. Providing big story stakes is a crucial element in these genres' success.

Another important element these drama genres offer is moral complexity and moral choices. In most stories in these four genres someone has to make a big moral decision. Should the cop bend the law because he's sure the bad guy is guilty even though he hasn't found all the evidence that's required? Should the doctor try an untested drug because there's no other remedy and the girl will die if the doctor doesn't?

Introducing moral complexity to the decisions a protagonist has to make to achieve her goal helps make stories more interesting, dramatic, heroic and surprising. Good storytelling often finds a way for the protagonist to confront difficult moral choices and reason his way to a surprising decision that leads to climactic, decisive action. The jobs at the center of the big four drama genres provide those kinds of complex moral choices on a regular basis.

A final element of the big four drama genres worth pointing out is fundamental to all drama and to all storytelling: conflict. The cop wants to find the murderer and the murderer doesn't want to be found. The conflict in medical shows is frequently man versus nature; the doctor is in conflict with an illness. The very picture of a courtroom – the defense sitting at one table and the prosecution sitting at the opposing table – couldn't externalize conflict more clearly. In many PI series the bad guy is aware he's being followed by the PI hero and a cat-and-mouse game of conflict ensues. Cops, doctors, lawyers and PIs are jobs that define TV genres that can deliver reliable, inherent conflict.

Three of these four genres – cops, doctors and lawyers – are still vibrant today. From *Chicago P.D.* to *The Good Doctor* to *The Good Fight*, these genres still generate successful new series. The PI genre, however, which peaked in the 1970s and 1980s with shows like *The Rockford Files*, *Mannix* and *Moonlighting*, effectively ended in the 1990s with the retirement of *Magnum P.I.* The few successful iterations since then, like the British *Sherlock* reboot, rejigger the genre, casting the PI as a freelance investigator working with or for the police department, effectively converting the genre

into an extension of the still thriving cop show. Time will tell if the *Magnum P.I.* reboot revives the dormant genre.

While our current era of sophisticated premium cable and streaming series often eschews traditional genre conventions, some of these shows are actually contemporary variations on decades-old traditional genres. As fresh and edgy as Steven Soderbergh's one-hour drama *The Knick* may have looked (it lasted two critically lauded seasons on Cinemax in 2014–2015), it was a contemporary iteration of the decades-old medical genre. Not only was it set in a medical world, it used medical cases to inform stories, just as *ER, Marcus Welby, M.D.* and *Dr. Kildare* did before it. *The Knick* looked and felt vastly different from those earlier shows (employing graphic gore, nudity and R-rated language, in stark contrast to its genre ancestors), but it also hewed to many of the genre conventions those earlier series helped invent.

Let's look at one other drama genre that will help expand our definition. One of the shows that I developed and produced, *Gossip Girl*, belongs to another successful one-hour genre, the primetime soap. The genre earned that name because it appropriated many of its storytelling devices and structures from daytime soap operas (a whole other TV format with its own distinct genres).

The primetime soap genre was spawned in the 1960s with the successful half-hour drama series *Peyton Place*, which was adapted from a successful 1957 novel and movie, and which transformed two young actors, 19-year-old Mia Farrow and 23-year-old Ryan O'Neal, into stars. While *Peyton Place* introduced the primetime soap genre, the most successful and arguably influential primetime soap was the original *Dallas*, which aired for 14 seasons beginning in 1978. In 1990 the Fox network developed a variation on the genre targeted specifically at its young audience, *Beverly Hills 90210*, spawning the primetime teen soap genre, a sub-genre of the primetime soap. *Dawson's Creek, One Tree Hill, The OC* and *Gossip Girl* are all heirs to the relatively recent TV genre that *Beverly Hills 90210* originated.

One of the structural devices that primetime soaps appropriated from daytime soaps was "serialized storytelling," stories told over the course of multiple episodes or even multiple seasons.[5] Most TV series in the 1960s told stories that began and ended within each episode, known as "closed-ended storytelling." Daytime soaps and primetime soaps like *Peyton Place* used "open-ended" or serialized storytelling that spun out continuing

stories over many episodes. Most TV series until relatively recently employed closed-ended storytelling structures – with the exception of the primetime soap genre – but that changed around the turn of the millennium. For the past 15 to 20 years almost all TV series have used serialized storytelling to a greater or lesser extent. Even today's most traditional cop shows that tell "case-of-the-week" closed-ended stories often introduce story threads that take many episodes to weave to a resolution. For the bulk of the history of American scripted television, though, serialized storytelling was the domain of the primetime soap genre.

A show like *Gossip Girl* clearly didn't have "cases" in the same way cop shows or medical shows do. And it only very rarely told stories that generated life-and-death stakes. What then are the elements that define the primetime soap genre and make the genre thrive?

The primetime soap is a genre that's primarily about relationships, the complexities and vagaries of contemporary relationships: romantic relationships, sexual relationships, friendship relationships, family relationships and sometimes work relationships. Whereas a cop show often poses the dramatic question, "Who is the killer?" and the medical show asks, "Can we save the sick patient?" primetime soap stories pose dramatic questions like, "Who wants to sleep with whom?" "Who *is* sleeping with whom?" "Who's cheating on whom?" "Who's lying to whom?" and "Who's keeping secrets from whom?"

While primetime soaps don't offer "cases" per se (let alone an infinite number of them), and generally don't involve life-and-death stakes, their stories do often involve moral complexity, moral choices and conflict. Unique to the primetime soap genre are two subject matter ingredients not essential to the traditional big four genres: romance and sex. If there isn't romance and sex, it ain't a primetime soap.

Another defining component of primetime soaps is a large ensemble of characters. There are two reasons for this. The first is so there are enough possible configurations of romance and sex relationships within the ensemble of series regulars to avoid running out of new pairings within the first few seasons, and, second, so they can implement another important storytelling device borrowed from the daytime soap opera form: multiple stories told concurrently. This episodic structure intercuts among two or three (or more) different storylines within a given episode. Each story involves a different series

regular or two, requiring enough characters to populate the multiple storylines within a given episode. In the first 50-year period of TV history (and rarely today) most series told one story per episode. Primetime soaps, however (like the daytime soap formats that inspired them), always tell multiple stories in each episode.

Almost all TV today incorporates some elements of the primetime soap genre (in ways most shows in the past did not), including traditional genres like cop shows. The arc of TV history is one toward increasing sophistication and complexity. While most series in the twentieth century hewed to the conventions of a single genre, most TV today involves mixing genres, the hybridization of genres. I'll explore when and why that began to happen in TV in the next part of this chapter.

In the comedy space, the domestic comedy genre that ruled the broadcasting era, the first 50 years of TV, continues to dominate today in the form of *Modern Family, Mom, Black-ish, Speechless, The Goldbergs* and many others. Family may be the single most universally relatable subject matter. We all have family experiences of some kind – for better or worse. Scripted series television, especially half-hour comedy, has mined that infinitely relatable material with enormous success for 70 years. In the next chapter I'll look at ways family subject matter has been used in TV drama.

Before I move on to concept, it's important to point out another common meaning of the term "genre" in use today. While the use of the term here is academically apt (and I'll use it in this sense throughout the book), the expression "genre show" refers to shows that have some kind of supernatural element. "Genre show" is really a super-genre, a category of shows that include many sub-genres. All "monster" shows (like vampire shows and werewolf shows), all fairy-tale reboot shows, all sci-fi shows, and all superhero shows are "genre shows." Shows that don't use any supernatural elements, like cop shows or primetime soaps, are not "genre shows." In reality most shows falls into some kind of genre category, but the expression "genre show" currently denotes supernatural genre shows.

CONCEPT

At its simplest, the term "concept" refers to an idea for a show. When development professionals talk about concept, though, they're usually

talking about an idea with more meat on the bone, with enough detail to suggest the promise of a TV series. An "idea" might be, "Let's do a show about a high school chemistry teacher who uses his expertise to make great drugs." That's a good idea. But applying more mental elbow grease to that idea brings it to a higher level of creativity:

> When a nerdy high school chemistry teacher learns he's dying of cancer he decides to provide for his pregnant wife and handicapped teenage son after he dies (because they'll be impoverished if he doesn't) by secretly using his advanced chemistry knowledge to manufacture the best methamphetamine and become a drug lord.

Now that's a concept!

Claude Levi-Strauss, the father of modern anthropology, believed the work of civilization is to transform the raw into the cooked, nature into culture.[6] That's what development is: taking raw ideas and *developing* them into products of popular culture, identifying good, raw ideas and figuring out the additional creative ideas that turn them into series that can tell great stories for several years.[7]

In TV a concept includes the most specific but elemental parts of a series that make the series unique, that make it go and that make it distinct from every other TV show and every other show within its genre.

There are different ways that development professionals might describe a TV series concept, but most of them include three basic elements. First, a concept usually identifies the lead character or characters. Who is at the center of the series? Who's the show about? Whose action defines the primary action of the series? The character/s at the center of a series concept may be "a nerdy high school chemistry teacher" or "a group of police detectives who work at"

Next, TV concepts usually define the world the series is set in, the setting and time period the action takes place. Where is home base for the lead characters? When is the show set? In the present-day, the past or the future?

Third is the "goal," the thing the lead character is trying to achieve, the thing the lead character *does* in the series. In most cop shows the goal of the

lead characters is to solve crimes. The lead character's (or characters') goal defines the action of a series.

In the *Breaking Bad* example above, the lead character is the nerdy high school chemistry teacher. We also have a glimpse of other characters essential to the concept, his wife and son, but it's clear the driving force of the series is the high school chemistry teacher. The world of the concept is more implicit, but it's there: the school, the family home and the criminal world of drug makers and drug dealers. The lead character's goal is to make money for his family by making and selling good drugs. That's the action that drives the series.

Those few story elements – the lead character, the world of the action and the kind of action the lead character takes in pursuit of his goal – define the concept of the show and are the essential conceptual elements to understand what the show is and what makes it go.

In the real world, over time, most shows expand beyond what's circumscribed in their initial concept. In many ways, that occurred with *Breaking Bad*. But our focus is on development. Development is about creating a compelling concept that can be pitched in a network conference room and then dramatized and demonstrated in a pilot. In effect, a successful pilot *proves* the concept. After the development phase most TV series take on a life of their own. They grow and evolve, shaped by the team that steers them toward perceived strengths and away from perceived weaknesses. Before that can happen, though, the project must undergo (and survive) the development process, and almost all successful TV series begin with a simple but strong concept that suggests the promise of many episodes. A good concept that undergoes effective development can be strong enough – despite its simplicity – that it continues to serve as the creative foundation of many episodes and many seasons, as the concept of *Breaking Bad* did. While the series grew beyond its original, simple, foundational concept, it stayed true to that concept and continued to mine stories directly emanating from it throughout the life of the series and ultimately resolved – answered if and how the lead character achieved his goal – in the series finale episode. Most good, successful, long-lasting TV series are based on concepts as strong (and simple) as that.

Creative executives at networks and studios sometimes try to reinvent a show's concept during the run of the series, and the effort almost always

fails. As we defined it in the first pages of this book, development is partly about identifying good, strong concepts, and one thing that means is determining at the outset if a concept has the inherent creative strength to sustain many episodes and many seasons.

FORMAT, GENRE AND CONCEPT: THEN AND NOW

In the middle section of this chapter I talked about the dominant TV genres in the twentieth century, and I offered the observation that TV programming has evolved toward increasing sophistication and complexity over time. How did that happen? The short answer is that artists, namely TV writers, innovated on existing forms (formats and genres), and other development professionals were smart enough to empower them and capitalize on their genius.

In 1981 *Hill Street Blues* (1981–1987) changed the cop show genre and changed American scripted television in ways that are still felt today.[8]

Cop shows before *Hill Street* were typically simple police procedurals like *Dragnet* (1951–1959, 1967–1970), shows that emphasized the process steps cops take to solve crimes over dimensionalized characterization of heroic cop characters. By the late 1960s and 1970s the cop show genre expanded to portray heroic cop characters solving crimes in exotic and sexy worlds like the original *Hawaii Five-O* (1967–1980) or *Vegas* (1978–1981), or they focused on outsized (but heroic) lead characters like the shaved-head, Tootsie-Pop chomping *Kojak* (1973–1978) or the street-wise *Baretta* (1975–1978).

Hill Street Blues creator and showrunner Steven Bochco (who died in 2018) was as interested in the personal lives of cops – their characters and their relationships, both among each other and outside the police force – as he was in cop cases. Cops for the first time stepped off the hero's pedestal and were depicted as complex and sometimes flawed characters. Who and how they loved was as important to the stories as how they solved crimes. The style and tone of the series followed Bochco's interest in character and relationships. He employed a cinéma-vérité production style, and the show's tone was more adult and more honest than what the audience had come to expect from the genre. While *Hill Street* is appropriately revered in TV history (and was both commercially successful and critically honored in

its day – it received 98 Emmy nominations), its lasting impact stems from one of its structural innovations. It was the first cop show to appropriate soap storytelling structure, crosscutting among three or more storylines per episode and utilizing serialized storytelling. Both devices were unheard of in cop shows and most other one-hour drama genres at that time. Almost all dramas today employ those storytelling techniques, a legacy of the innovation and success of *Hill Street Blues*.

If *Hill Street Blues* revolutionized TV's dominant drama genre in 1981, another show nearly 20 years later upended all the rules of TV genre that had defined the first 50 years of American TV.

The Sopranos (1999–2007) was the first successful TV series in American history about a criminal. There had been criminal lead characters in movies for almost as long as there had been movies. James Cagney became a movie star in 1931 playing a criminal in *Public Enemy*. *The Godfather* (1972), in the pantheon of most critics' greatest American movies, is about a criminal. But in its first 50 years American TV had never centered a successful series on a criminal. By earning both enormous commercial and critical success, *The Sopranos* redefined American television's rulebook. Upending TV genre conventions was an essential part of its appeal – it felt unlike any show anyone had seen.

The Sopranos offered a revolutionary approach to genre, but not by ignoring it. From a genre perspective, *The Sopranos* was a cop show from the criminal's point of view. *The Sopranos* flipped the script and made the antagonist the protagonist. In a sense, *The Sopranos* was an inverted cop show, a reinvention of a decades-old TV genre that effectively created a new genre by folding the old genre inside out.[9]

Success in Hollywood breeds imitation and variation, and development professionals wasted little time. In 2002 *The Shield* more directly inverted the cop show by making the criminal lead character an actual cop. In 2006 *Dexter* depicted an ingenious variation on the cop-as-criminal lead, a cop as psychopathic serial killer who only kills worse criminals. In 2007 *Breaking Bad* took a nebbish character and tracked his journey to becoming a criminal mastermind. Broadcast network television (which has coveted the critical success of cable's innovations since *The Sopranos* and looked for ways to appropriate them) finally caught up with the trend in 2013 with *The Blacklist* – but hedged the genre-flip by making the criminal character a

consultant to the FBI, effectively making the criminal a consultant to the cops (the FBI are federal police) or, in other words, taking the new criminal-lead genre and bending it back into the original thing itself, a cop show.

While the first 50 years of TV were marked by clear and compartmentalized genre programming, *The Sopranos* opened the door to a new era of enormous genre creativity and experimentation that we live in today. Characters, subject matter and concepts that never would have been considered fodder for development in TV's first 50 years are today not only fair game but in demand.[10]

A show like *Transparent* about a middle-aged man undergoing gender transition never would have been developed on American TV five years before Amazon launched it in 2014, let alone 10 or 20 years before. And yet *Transparent* in many ways borrows elements of the family comedy genre. While its tone and subject matter are light years from *The Adventures of Ozzie and Harriet* or *Father Knows Best*, two enormously successful 1950s half-hour comedy hits, *Transparent* tells stories about family relationships just as those earlier domestic comedies did. Another of Amazon's successful, cutting edge shows, *Bosch*, while edgy and built around an anti-hero like so many post-*Sopranos* series, is, at the end of the day, a cop show.

Genre is central to the way TV development professionals think about their work, even in our genre-bending, genre-defying times. What genre does a new pitch fall within? What are the traditional rules of that genre and do we want our new project to hew to those rules or defy them? Does a project fall completely outside traditional TV genres? Is there a new vein of programming emerging that appears to be defining a new genre? These kinds of questions are part of the daily work of development execs, writers and producers in Hollywood today.

A QUESTION

Before I move on to the next section of the book – while I'm still in macro mode – let me pose one last basic question: Why do we watch scripted TV?

As I talk about the steps of TV development it's easy to lose sight of the big picture. Let's not. Let's zoom out to the widest possible perspective and ask the most basic question: Why do people watch scripted series on TV? What

commodity are they seeking when they make the choice to sit in front of a screen and search for a scripted show? Why do we watch TV?

The easiest and most obvious answer is that we want to be entertained. But what does that mean, "The viewer wants to be entertained?" That's *too* easy. We can think harder than that: what specific experiences are we referring to as "being entertained?"

I'm going to offer several reasons why we watch scripted television. There are many more, and I encourage readers to reflect on their own personal connection to scripted television. Why do you watch TV? What do you take from the experience? What qualities, what commodities are you seeking when you watch the end product of TV development?

First and most simply, I would argue, we turn to TV for wish fulfillment. We want to see a fantasy version of our lives, a "better" version. This is probably closest to what we mean when we say, "The function of TV is to entertain." Most TV offers some kind of positive fantasy (there are also negative or nightmare fantasies, and entertainment products including TV sometimes offers those too). At its simplest, most people on TV are like us, but prettier. Most people on TV are like us, but a little richer. They live in houses that look like ours, but are probably a little bigger and nicer. Where most of our lives are simple and mundane and offer few and infrequent triumphs, TV offers a fantasy view of life filled with frequent, regular victories. Life, which resembles our lives, looks better on TV.

Television, as we know, has grown darker and more pessimistic in the last 15 to 20 years, but even edgy, cynical twenty-first-century TV usually offers viewers a healthy dose of fantasy along with its cynicism. *Game of Thrones* is dark and edgy, but what's more fantastical (literally) than riding across the sky on the back of a powerful, loyal dragon? *Mad Men* was a landmark series that helped define the current generation of edgy, sophisticated, adult programming, but, boy, didn't those 1960s clothes and hairstyles look awesome! Don Draper's penchant for cheating on his wife with young, attractive women helped define his morally flawed anti-hero character, but among the nearly infinite number of potential flaws to attribute to a flawed anti-hero, it was no accident that creator Matthew Weiner assigned a character flaw to his lead that also serves as a fantasy for many viewers. *Breaking Bad* depicted a decent man's moral descent into criminality; it also offered the wish fulfillment fantasy of a 50-year-old nerd overpowering

younger, stronger, violent men with his intellect. If we look closely, we'll see that almost all successful scripted television – dark and realistic as it might appear on the surface – offers some kind of wish fulfillment fantasy. Almost all of us wish to escape our mundane reality by taking a brief flight of fantasy.

Second, most of us look to TV for emotional stimulation. We love going on an emotional roller coaster. We enjoy empathizing with a character, rooting for a character, and then feeling exhilarated when the character is victorious or feeling heartbroken when the character is defeated. Again, think of *Game of Thrones* and the enormous emotional highs and lows (more often lows) the show takes us on. It puts us through the emotional wringer, and we love it! We love those characters and *feel* so much when they're crushed or, on rare, special occasions, when they triumph. To a great extent, scripted television is like an emotional treadmill; we place ourselves in front of a screen and exercise our emotions.

In a sense, TV is a giant rooting interest machine. "Rooting interest" is an important concept in Hollywood entertainment. It's when a show or movie compels us, the viewer, to care deeply about whether a character gets what he wants or not, to root strongly for the character to achieve her goal. A show might spend scenes, episodes or even seasons ratcheting up our rooting interest like the roller coaster car slowly climbing the long, steep lift hill, inch by inch, foreboding click by foreboding click, before all that rooting interest is flung down the track, careening our emotions around and around and up and down. After the intense emotional catharsis of a well-earned story payoff, we feel as rung out as we are when we stumble out of the roller-coaster car and step back onto solid earth.

Third, TV serves as spectacle. Even before the current era of widescreen cinematic high definition TV filmmaking (again, think of *Game of Thrones*), TV thrived on car chases, explosions and beautiful actresses wearing glamorous gowns. Television has always delivered visual spectacle into our homes and into our mundane and mostly spectacle-free lives.

Another quality many viewers turn to scripted series television for is the "process" of procedural shows, the sensation that we're learning something, that we're learning how people like cops and doctors do their jobs. Sometimes the procedural elements of TV stories are based on fact, but very often they're completely made up. A lot of the DNA "science" in shows like

CSI: Crime Scene Investigation was completely fabricated for entertainment purposes. Even though it's made up, viewers still enjoy the entertainment experience of feeling like they're seeing how something works, that they're learning something.

There are many kinds of TV procedurals. There are police procedurals, medical procedurals, legal procedurals and even criminal procedurals. *Breaking Bad* was, among other things, a criminal procedural. The show made a point of depicting, often in explicit detail, how drugs were made and how the show's criminals avoided detection or defeated their enemies. Creator/showrunner Vince Gilligan chose to provide so many details of the criminal exploits of his characters both because they lent the show verisimilitude, the appearance of being real and true, but also because they delivered a kind of procedural entertainment kick to the show. We've all seen lots of police procedurals and enjoyed feeling like we were learning how cops catch criminals. *Breaking Bad* delivered the unique fun of showing how criminals pull off crimes and get away with them.

One of the themes of an enormous amount of TV storytelling, one central to traditional genres like cop shows and lawyer shows, remains so fundamental to so much TV that it's worth including in this list. The theme of justice. Most cop show and lawyer show stories are basic morality tales: The social compact is violated, justice is threatened, and ultimately the forces of good and the rule of law wins out and justice is restored. The real world, we all know, is not always just. For many of us there is little fairness in life, and for that reason we find it deeply satisfying to see clear-cut examples of justice depicted in our entertainment. Good guys winning and bad guys getting their just desserts feels so satisfying to us that we turn to TV (and other forms of entertainment) to watch stories that dramatize justice. In addition to shows set in the criminal justice system, other TV series provide that same justice high by telling stories that punish the morally bad and reward the morally good.

Conversely, our current era of dark, cynical programming often plants expectations of a just resolution but then subverts those expectations to deliver the more surprising, and cynically satisfying resolution of justice stumbling and bad triumphing. That kind of resolution feels more "realistic" and more contemporary to many of us, but often, while it seems more honest and truthful, it's actually just setting us up for a bigger justice payoff later in the series. Consider the number of times viewers' rooting interest in

watching Ramsey Bolton, the baddest of all the bad guys on *Game of Thrones*, get his just desserts was upset, and Ramsey turned the tables and crushed a rootable "good guy" character.[11] While all those justice-thwarted episodes seemed satisfyingly cynical in the moment, they only made us feel even more thoroughly delighted when Ramsey finally *did* get his brutal and deeply satisfying comeuppance.

Another one of the commodities many of us turn to TV for is what I'll call "travelogue." We enjoy discovering new worlds. Television shows us new worlds in a literal "spectacle" sense, but TV also provides a travelogue function in showing us new sub-cultures that we've never seen. *Sons of Anarchy* was about a family in a California motorcycle gang sub-culture. Most viewers of *Sons of Anarchy*, it's safe to say, were not motorcycle gang members. They were mostly law-abiding citizens who enjoyed being taken into an unfamiliar world and shown the real-seeming (but no doubt highly fictionalized) world of that sub-culture. The travelogue function of TV can also extend to completely imaginary worlds. The *Star Trek* franchise introduced viewers to an incredibly highly developed and completely fictional world. Some viewers take enormous entertainment satisfaction from immersing themselves in these worlds, traveling via their screens into the depths of well-developed and thoroughly detailed imaginary worlds. Traveling into a new world is one of the many satisfying and entertaining experiences of watching scripted television.

In many ways, another role of scripted television (and entertainment in general) is to affirm its consumers' worldviews. We look to our popular culture to examine our beliefs and attitudes about our world, challenge them, play them out in story form, and ultimately affirm them. For decades the central message of broadcast network television was to affirm American middle-class biases and values. Stories served to effectively say to viewers, "You know that view of the world you have? Well guess what? You're right, that is how the world works. You were right all along." Today's expanded marketplace of TV content distribution allows, among other things, for "narrowcasting," shows designed to target smaller cohorts of viewers, and in many cases they are designed to affirm the tastes, values and beliefs of smaller subsets of American entertainment consumers. Some networks, in fact, are largely branded by their specific and sometimes narrow set of values and beliefs.

There are many more reasons why we turn to TV for entertainment, and I encourage readers to think about more of them. Why do we love TV? Why

do we think viewers love TV and what do they look for in the work we provide them? Developers of TV series need to be thoughtful about what their end-users really want, in addition to merely "being entertained."

I'll offer one last value that scripted TV delivers, and it's an important one: We look to TV for validation. This is different from philosophical affirmation. We turn to TV to see people who look like we do, who live like we do and who experience challenges like we do. There is something enormously comforting, something incredibly validating to see ourselves reflected in cultural expressions. Pop culture (scripted TV in particular) has been an important tool for society to provide that. "That's me! That's my family! We're not alone. We're not that different from other people. See, we're on TV, too!" These are powerful feelings that people turn to TV to experience.

For a long time American TV validated the majority audience. White middle-class and upper-middle-class America saw itself reflected in TV series and other Americans did not. More recently, the Hollywood TV industry has discovered that American TV viewers are more diverse than it once believed, and it's now serving to offer validation to people of different ethnic and racial minorities, to people of differing levels of physical ability, different gender identifications and to people of different shapes and sizes, most of whom were excluded for a very long time from experiencing the powerful validation TV can provide. Another way of saying this is that Hollywood's traditional definitions of wish fulfillment have been in conflict with many viewers' desire for validation. For a long time many entertainment professionals viewed a traditional Hollywood character type – attractive, tall, thin, more affluent than average, straight and white – as every American's wish fulfillment character ideal. But many viewers actually rejected that Hollywood prototype, and instead wished for characters who looked and lived more like they did. They sought validation more than they sought Hollywood's definition of wish fulfillment.

The demographics of American society and its TV audiences have been changing and continue to change. America continues to grow more racially and ethnically diverse. In the past 20 years American TV has entered a new era of greater creative experimentation, including a desire to break traditional rules and definitions. These phenomena, along with a proliferation of channels of distribution that free networks from the business requirements of trying to appeal to everyone by depicting Hollywood's idea of idealized

American types, have aligned to slowly begin to make the world depicted on American TV a more inclusive world that serves to validate more and more of its audience. American TV still has a long way to go, but at least it's a start.

NOTES

1 For an excellent introduction to the scholarly approach to these subjects see Jason Mittell, *Genre and Television: From Cop Shows to Cartoons in American Culture* (Routledge, 2004).
2 *Dragnet* was a landmark series in many ways, which I will explore throughout the book. For a detailed history and cultural studies analysis of the series see Mittell, *Genre and Television*, 121–152.
3 The distinction is relevant at larger networks and studios that have longform development departments separate from drama development departments. Longform departments typically develop TV movies and mini-series but not continuing drama series. Whether a limited series is developed at a company's longform department or at its drama development department may depend on how a company defines these formats.
4 Cultural studies scholars tend to group format and genre together under the "genre" rubric. In this approach, one-hour dramas and cop shows are both considered genres. Some scholars, like Trisha Dunleavy, distinguish the larger category of one-hour dramas and half-hour comedies as "meta-genres." In practice, Hollywood TV professionals approach these categories differently (though the terms they use may vary) and view genre as a subset of format. See Trisha Dunleavy, *Complex Serial Drama and Multiplatform Television* (Routledge, 2018).
5 Mittell makes a compelling case that primetime soaps owe more to "comics, classic films serials, and nineteenth century serial literature" than to daytime soap operas in *Complex TV* (New York University Press, 2015). I'll continue my examination of serialized storytelling and its roots in the next chapter.
6 Claude Levi-Strauss, *The Raw and the Cooked*, translated by John and Doreen Weightman (Plon, 1964).
7 The 1977 movie *Annie Hall* effectively parodied this idea–concept distinction (albeit in reverse) when it eavesdropped on a "Hollywood player" at a Beverly Hills party: "Right now, it's only a notion. But I think I can get money to make it into a concept. And later turn it into an idea."
8 Dunleavy describes *Hill Street Blues* as "a harbinger of American TV drama's future," and offers a comprehensive history and scholarly analysis of the series. Dunleavy, *Complex Serial Drama and Multiplatform Television*, 49–54.
9 The argument that *The Sopranos* is an inverted cop show is a case I'm making to illustrate the centrality and fluidity of genre in television, in other words, a case I'm making for mostly dramatic effect. If *The Sopranos* was truly an inverted cop show, it would have primarily told stories about how Tony and his crew avoided being caught by the police. In other words, it would have told

90 Format, Genre and Concept

cop show stories – the investigating and catching of criminals – from the criminal's POV, but *The Sopranos* didn't tell those kinds of stories more than a handful of times in six seasons. *The Sopranos* is an inverted cop show only in a very loose sense.

10 *The Sopranos* broke any number of traditional TV rules. While TV had explored flawed characters ever since *Hill Street Blues*, Tony Soprano was American TV's first true anti-hero, a rootable protagonist the audience finds sympathetic despite deeply immoral behavior, which in Tony's case included murder, lying and serially cheating on his wife. American TV has enjoyed a love affair with the anti-hero ever since.

11 "Rootable" is not a word in the English language but is a word in Hollywood (Hollywood-lish?). When a writer crafts a story that engenders the audience's rooting interest in a character, he's created a "rootable" character.

FURTHER ACADEMIC READING

John Caughie, "Adorno's Reproach: Repetition, Difference and Television Genre," *Screen* 32, no. 2 (1991).

Glen Creeber, *The Television Genre Book* (British Film Institute, 2001).

Jane Feuer, "Genre Study and Television," in *Channels of Discourse, Reassembled*, ed. Robert C. Allen (University of North Carolina Press, 1992), 138–60.

Stuart M. Kaminsky and Jeffrey H. Mahan, *American Television Genres* (Nelson-Hall, 1985).

Amanda D. Lotz, *The Television Will be Revolutionized* (NYU Press, 2007).

Brian G. Rose, ed., *TV Genres: A Handbook and Reference Guide* (Greenwood Press, 1985).

Gregory A. Waller, "Flow, Genre and the Television Text," *Journal of Popular Film and Television* 16, no. 1 (1988).

Mimi White, "Television Genres: Intertextuality," *Journal of Film and Video* 37, no. 3 (1985).

4

What Make Series Go

"Story Engines," "Franchises" and "Series Drives"

For a movie to work it needs one great story. For a TV series to work it needs many. Dozens or even hundreds.

One of the most common reasons that network development executives give for passing on a series pitch is, "It felt more like a movie." They'll go on to say,

> They pitched an interesting character and a great pilot story, but it feels like that's the beginning and end of the concept, and there really aren't many more stories beyond it that live up to the promise of the pilot story.

To generate the number of stories TV series need, most series have some kind of "story engine." Thinking back to our traditional "big four" one-hour drama genres, those genres all offer great story engines. The infinite number of cases inherent to those genres derives from the story engines built into them. Remember: cases = stories, and stories = episodes. There's a term used in TV development for the kind of story engine at work in these genres: "Franchise." It's one of the stranger terms in the TV development lexicon (it sounds like a fast-food restaurant), and it has a meaning different from the more familiar use of the term in entertainment. A "movie

franchise" refers to a concept, character or brand that sustains a series of several movies. X-Men is a movie franchise. James Bond is a movie franchise. This kind of franchise exists in TV too. CBS has a NCIS franchise. In TV development "franchise" has another meaning, and it's one of the trickier terms to define and wrap one's head around. Be patient, stay with me and I'll make it clear. It's a really important idea in development and one that's used all the time.

A franchise is the central element of a genre or concept – frequently a vocation or avocation (i.e., a job or a hobby) – that generates a number of stories; a kind of story engine.

Cop shows have a cop franchise. That sounds obvious and circular. But let's drill down further. The cop franchise within a cop show is specifically the acquisition and investigation of cases within stories. It's the *mechanism* at the heart of cop-show stories. It's the part of the cop-show genre that generates the stories. The cop-show genre is comprised of several elements including the characters (the cops) and the world (the police station, the detective bullpen, the city streets), but also the franchise, the mechanism at the heart of the genre that serves as its story engine and that provides a simple and fundamental structure to its stories.

In a cop show the cops get new cases (their boss assigns them cases or a victim walks in off the street and drops a case on their desks or – more simply and commonly in today's TV language – someone's murdered and the cops begin investigating, i.e., the assigning of the case is implicit and occurs off-screen) and the cops perform their investigation of the crime. Those facets of the genre's standard storytelling – getting cases and doing the work of cases, i.e., investigating – is the franchise.

So what's the difference between the cop-show genre and the cop franchise? One is a category of TV shows and one is the mechanism at the center of the category that makes it go, that actually generates and drives stories and the action within stories.

Let me throw out a crazy scenario that would never happen in the real world but that helps illustrate the difference. Imagine a show about the professional and personal relationships among cops. There's an ensemble of cop characters working in a cop world, a precinct station, but the only kinds of stories the show tells are stories about the cops' relationships, their

interrelationships among each other, relationships with their romantic partners and their families at home. The series never focuses on the cases, just the relationships. The cops solve crimes in the background of episodes because that's their job, but the stories the series tells are never about the cases, never about them solving the crimes. That would be a cop show (a show within the cop genre) *without* a cop franchise. A show in the real world would never do that because the cop franchise is the most functional and valuable part of the cop show genre.

There are many kinds of franchises. The franchises of the other three major drama genres are fairly obvious. Medical shows have a medical franchise: the acquisition of cases and the diagnosing and healing of sick people. Legal shows have a legal franchise: the acquisition, investigation and prosecution of legal cases. Private investigator shows have a PI franchise: the PIs acquire, investigate and solve cases. I'll look at other kinds of franchises in a moment.

Another way of looking at franchise is that it gives the characters of the series something to do. Most TV shows aren't simply character studies. The characters need to do something, they need to take action, and because audiences expect a consistency of the kinds of stories a show tells, shows depict characters taking a specific kind of action. A franchise can provide that. Another important quality of franchise is that it often introduces new guest characters into the series, and it's frequently these guest characters that bring new stories with them.

All of the "big four" drama genres are case-of-the-week genres. The cop show franchise typically introduces a new case in each episode. There are other case-of-the-week franchises. *Buffy the Vampire Slayer* had what might be called a "monster hunter franchise." The series *Supernatural* today uses a "monster hunter franchise." Introducing new monster characters, hunting and eradicating them are at the heart of most stories and most of the action of the series, and that's the show's franchise.

As with formats and genres, franchises aren't something dictated somewhere by the TV gods or defined in stone. Franchises, like genres, occur organically as the result of the imagination of writers and other development professionals who experiment and try new ideas. When they work, other development pros notice and try to repeat their success. They create new concepts that harness a successful new franchise and, if more iterations

of that franchise thrive, the franchise might enter the TV development canon and be thought of as routinely as cop franchises or legal franchises. In other words, franchises become franchises because they work. If they don't work, they go away until new development professionals come along willing to experiment again.

Let's look at a vocation one might think would make a good TV franchise but hasn't. Journalism has proved *not* to be a successful TV drama franchise. You'd think it should: Journalism provides an unlimited number of cases, big stakes (though rarely life-and-death stakes), plenty of moral complexity and unending conflict. Yet journalism hasn't proved to be a reliable TV franchise. *The Newsroom* on HBO lasted only three seasons (25 episodes) from 2012–2014. *Pepper Dennis* starring Rebecca Romijn attempted a journalism franchise on the WB network in 2006 and lasted only 13 episodes. *The Name of the Game* on NBC from 1968–1971 worked to a modest degree, lasting three seasons and 76 episodes. The only really successful series that used a journalism franchise in the last 70 years was *Lou Grant*, which lasted five seasons and 114 episodes from 1977–1982. That show succeeded, though, largely because it was a spinoff of one of the biggest hits of its day, the half-hour comedy *The Mary Tyler Moore Show*. Lou Grant was one of the breakout characters on *The Mary Tyler Moore Show*, and when that series retired after seven seasons, CBS spun off Lou Grant's character into his own show, transposing the character from a half-hour comedy into a one-hour drama, recasting him from a Minneapolis TV news boss into the editor-in-chief of a Los Angeles newspaper. Unlike its half-hour predecessor, which was partly set in a TV newsroom, the one-hour drama *Lou Grant* made frequent use of its journalism franchise and succeeded in telling actual journalism stories. But one successful show in 70 years, a show that relied on a hit character the audience already knew and loved, does not a successful franchise make.

Why? Why does one franchise work and become a staple of TV and another franchise does *not* work? Most development professionals are too busy working with franchises that *do* work to spend time guessing. But I can offer a couple of theories. One reason journalism has never become a reliable TV franchise may be because journalists tend not to be that well respected by American viewers. Polls that rank various professions rank cops, doctors and even lawyers much higher than journalists.[1] A second reason might be that while journalists are active investigators, they're not active in effecting outcomes. Cops put murderers behind bars. Doctors save lives. The climax of a

journalism story is publishing or posting a story. While people's lives may be affected by making the story public, the outcome is more an indirect byproduct of the journalist's work than the immediate, hands-on way that lives are changed by cops, doctors and lawyers.

Most Hollywood development executives are reluctant to develop journalism concepts, shying away from investing their limited development budgets to buy a pitch with a journalism franchise, or from trying to convince their network's president and other corporate bosses to greenlight journalism shows to pilot or series. It takes a writer of Aaron Sorkin's stature to get a journalism show like *The Newsroom* through a network's development machinery. But then it serves as another cautionary tale when it limps to a modest handful of critical plaudits and underwhelming ratings. Development professionals look to recent experience and back through TV history to evaluate which formats, genres and franchises work. Depending on what kind of company they work for and that company's appetite for experimentation and risk, they try new or traditionally unsuccessful formats, genres and franchises cautiously or not at all.

Let's go back to my weird, not-real-world example of a cop show about the relationships among cops and their friends, families and lovers but never about actual criminal cases. What kind of franchise does that hypothetical cop show have? (Remember, the point of the exercise was that it *doesn't* have a cop franchise.) It has a soap franchise. While my initial definition of franchise referenced a vocation or avocation of its lead characters, the soap franchise is rooted in neither a job nor a hobby. It busts my definition, but it works, so it's smack dab in the center of the canon of successful TV franchises. Relationships – romantic relationships, friendship relationships, family relationships and work relationships – generate stories and serve as the core of the soap franchise, a tested, proven and fruitfully prolific TV franchise. We might say that my hypothetical cop show is "a cop show with a soap franchise."

Returning to the real world, *Hill Street Blues* was a cop show with elements of a soap franchise. But because the balance of cop stories to relationship stories was tilted so far toward cop stories on *Hill Street*, because the actual cop franchise was so much more dominant, it wouldn't be fair to say the show had "a soap franchise." It's probably more accurate to temper the analysis and say it "used elements of a soap franchise." A more recent example, the legal show *The Good Wife*, similarly used elements of a soap franchise. While most

of the show's episodes featured main stories ("A-stories," as they're called) that employed a legal franchise, episodes also frequently told smaller B- and C-stories that emerged from the soap franchise.

Most shows today employ multiple franchises. *Game of Thrones* is a great example. It employs at least four franchises. Two franchises are more dominant: a power franchise and a family franchise. A power franchise pits characters and groups of characters against each other in a prolonged battle for power. *The Sopranos* employed a power franchise. Many of the show's stories were about Tony and his crew battling other crime families or factions for criminal control of their territory. A show as vastly different from *The Sopranos* as *Gossip Girl* also used a power franchise.[2] While a soap franchise was clearly more dominant in *Gossip Girl* than the power franchise, many of the show's stories dramatized Blair Waldorf battling for control of Queen Bee status, fighting for power over her schoolmates and social group, utilizing elements of a power franchise.

Family is a second vital franchise in *Game of Thrones* and works hand-in-glove with the power franchise. The show's battle for power is centered among families. The Starks versus the Lannisters is the central conflict in the series. In addition to stories of family power battles, however, stories emerge from timeless family issues like loyalty, trust and love as well as family dysfunctions like incest. Members of various families are separated from their clans or killed, and surrogate family units emerge, like the unlikely father–daughter bond between Sandor Clegane ("the Hound") and Arya Stark. *The Sopranos* also employed a family franchise. While *Game of Thrones* intertwines its family and power franchises, pitting families against other families for power, *The Sopranos* used its family franchise in a different way, testing Tony's paternal responsibilities with his external pursuit of criminal power. *Breaking Bad* employed a family franchise as well, along with its central criminal procedural and power franchises. It's no coincidence that Walter White's primary cop antagonist was his brother-in-law. Shows like *Friday Night Lights, Parenthood, This is Us* and *Empire* have utilized strong family franchises in a variety of ways.

A third franchise at work in *Game of Thrones* is, like most one-hour dramas today, a soap franchise. Who's in love with whom? Who wants to sleep with whom? Who's cheating on whom? These and other relationship/romantic/sexual questions drive the action of numerous stories. Think of the effective Jon Snow–Ygritte story arc in seasons two and three. That storyline

combined elements of the power franchise (the characters came from warring factions), but at the end of the day it was pure, delicious, sexy soap.

Lastly, the series uses a fantasy franchise. The show uses "genre elements" (in the other sense of "genre," the supernatural and fantastical sense) like dragons, direwolves and sorceress spells to tell and advance story.

Game of Thrones' unique balance of franchise elements – power, family, soap and fantasy – has proven to be an extremely powerful TV formula. It's also a very high-degree-of-difficulty formula, one that requires not only extremely large budgets and highly skilled talent at every level to execute successfully, but also one that requires an extremely solid and well-developed creative concept at its core. Increasingly in recent years TV development professionals have turned to IP for concepts as strong and proven as this one.

One thing development professionals do when evaluating concepts, pitches, story outlines and pilot scripts is to assess the balance of genre elements and franchises. Is there enough going on in a given concept to generate a sufficient number of stories and episodes, or do we need to introduce another franchise? Is there a franchise inherent to the concept but only modestly exploited that can be dialed up even further? Is there enough entertainment value being generated by the concept to keep viewers satisfied, or do we need to recalibrate the balance of franchise and genre elements? Figuring out the right balance for success requires development professionals to know numerous TV genres and franchises and to understand how they work.

SERIES DRIVE

A second kind of story engine is "series drive." A series drive is a specific goal that the main character wants and strives for throughout the life of the series and that the audience roots for him to get. An ongoing, overarching drive can generate many (though probably not an unlimited number of) stories.

Breaking Bad offers a great example of series drive. Walter White spent almost the entire series trying to make money to provide for his family. After he made enough money to take care of his family (achieving his series drive) he had to convince his wife to accept his ill-gotten fortune

(expanding the original series drive), and the series finale delivered a satisfying and definitive resolution to the series drive that had been introduced in the pilot several years earlier. In the series finale (spoiler alert) Walter White deployed a plan that effectively tricked his wife and family into accepting the money he had worked so hard and risked so much to accrue. Walter had a goal, a series drive, to provide for his family that not only lasted seven seasons but that *generated stories* for seven seasons as well. The series drive didn't generate every story of the series, but it succeeded in generating many stories throughout the life of the series.

Series drives that function as story engines are a relatively recent phenomenon on the TV landscape. Case-of-the-week cop shows and doctor shows 50 years ago didn't employ series drives. In a sense, the drive of the characters in those shows was implicit and general. One could say that Detective Joe Friday's series drive in *Dragnet* was simply to solve crimes, to keep the streets of Los Angeles safe. But series drives as we think of them today are much more concrete and specific than that.

Creating a series drive that can succeed as a story engine for many seasons is very challenging. A show like *Revenge* is a good case in point. That show placed so much emphasis on its series drive that it actually used it as its title: revenge was the lead character Amanda Clarke/Emily Thorne's series drive.[3] But one of the reasons the show couldn't sustain its audience much beyond its first successful season was that it couldn't sustain its series drive. The show demonstrated that an audience would root for a character to achieve revenge (an idea that common TV development wisdom thought unlikely), but the series discovered that the audience wouldn't keep rooting for her to achieve it forever. If Emily Thorne was going to set out to get revenge, the audience expected her to get it within a reasonable period of time. When faithful viewers returned for the second season and it became clear Emily Thorne wouldn't fully achieve her series drive anytime soon, viewers began to lose interest. The show tried to adapt to the diminishing appeal of its waning series drive by dialing up soap elements of the series. The concept of the series depended on a strong series drive, however, and the show's audience eroded during an attempt to dial up one story engine to bail out another.

Pretty Little Liars relied on a frothy mix of series drive and soap franchise beginning with its pilot, and the series managed to sustain that healthy balance and achieve success. The series drive was rooted in the lead

characters' search for answers to mysteries that the show slowly paid off. The mysteries included questions like who was "A," the unseen character who threatened and taunted the four lead "liar" characters, and who killed the four girls' best friend Alison and why? The interplay between stories generated by these series mysteries (finding answers that resolved the mysteries was the show's series drive) and the various characters' soap storylines proved to be a successful entertainment formula.

One of a showrunner's jobs during the life of a series is to make creative adjustments that emphasize a show's strengths and de-emphasize its weaknesses. Often the strengths and weaknesses of a show aren't apparent until after the development phase, when the show has had a chance to "find itself" over the course of episodes or even seasons on the air. Other executive producers, network and studio current executives, and sometimes network and studio presidents assist the showrunner in the process of identifying strengths and weaknesses. But truly reinventing a show once it's on the air is very difficult and rarely successful. Abandoning a series-defining series drive and replacing it with a different story engine can risk alienating the audience's expectations and rooting interest. One reason that creators are so handsomely rewarded financially and that development executives command elite stature at networks and studios is because the crucial opportunity to align the various elements that comprise a successful show, the time to get the basics right, is during development.

NOTES

1 Harris Insights & Analytics has conducted Harris Polls over the years, studying America's most prestigious occupations, and doctors, police officers and lawyers consistently rank higher than journalists. The most recent poll was conducted in 2014: https://theharrispoll.com/when-shown-a-list-of-occupations-and-asked-how-much-prestige-each-job-possesses-doctors-top-the-harris-polls-list-with-88-of-u-s-adults-considering-it-to-have-either-a-great-deal-of-prestige-45-2/.
2 Fun-fact: *Gossip Girl* inherited *The Sopranos*' soundstages at Silvercup Studios in Queens, New York, when the crime series retired in 2007. The Waldorf family apartment interiors stood where *The Sopranos*' New Jersey MacMansion interiors had stood for seven years.
3 The lead character in *Revenge* played by Emily VanCamp had two identities: her true identity at birth, Amanda Clarke, and an identity she created for the purposes of her revenge scheme, Emily Thorne.

5
Concept Ideation, "Areas" and "Takes"

Most TV series are based on original ideas created by TV writers, despite the fact that television has become more interested in IP in recent years than ever before. This is one of the qualities of the American television industry that has distinguished it from the movie industry. While the feature film industry from its beginnings has relied heavily on adaptations of pre-existing intellectual property like books, plays and true-life stories, for most of its 70-year history TV has depended on original ideas sprung from the minds of TV writers.

Following the first decade of American TV when many early scripted series were adapted from successful radio series, the next 40 years were structured to encourage experienced TV writers to create shows based on their own original ideas. Young writers would work their way up the writing staffs of other writers' shows, observing and learning from more experienced creators and showrunners, absorbing lessons about producing, TV storytelling, and strategies to sustain series for many seasons. After a writer had earned veteran status by staffing on shows for five or seven years, he or she (although mostly "he" in that era) would be encouraged by his agent to come up with an original idea for a show. Many writers looked to proven genres and wondered,

How can I update this genre? How can I mine the things that make this genre so successful but change them up in a way that makes it feel a little fresher, a bit more modern and relevant? How can I take it in a slightly new direction?

The most talented, successful and experienced writers were welcomed by network and studio development executives to pitch their ideas. In that era it was extremely rare for anyone other than a highly experienced veteran TV writer to be given a chance to pitch a TV network.

In the past 20 years two major changes have occurred in TV development. First, adaptation has become much more attractive to development professionals. From *Game of Thrones* to *A Series of Unfortunate Events* (both based on novel series), from *House of Cards* to *Jane the Virgin* (both based on foreign TV formats), from *The Walking Dead* (based on a comic book series) to *Scandal* (based on the life rights of a real person), networks and studios have turned to IP for source material for new shows. There are many reasons for this. Leslie Morgenstein, the President of Alloy Entertainment, a division of Warner Bros. Television that develops books and produces the adaptions of their IP into TV and movies, identifies one important reason, "Building a show is really hard. When there is a bunch of creative material pre-existing it makes it a little bit easier."[1]

The second important change is that network and studio development executives are now far more open to fresh voices, to hearing pitches from less experienced TV writers and from writers who may have no experience in TV but have proven themselves in ancillary fields like features, theatre, journalism and even podcasting. Talent agencies and studios may pair less-experienced TV writers with veteran TV writers to help the less experienced writer navigate TV development and production and to assure network development executives that an experienced hand is helping steer the ship.

Despite the recent upswing in IP adaption, however, most new shows still emanate from writers' original ideas. And while it's the writer of the pilot episode who receives the "created by" credit (as we've discussed), an underlying idea that informs a pilot and a series – even a kernel of an idea – sometimes originates with other members of the development team. Many TV producers spend a lot of time searching for IP to adapt, but producers (and staffs of their production companies) also spend time trying to originate new ideas for shows. Network and studio development executives also

brainstorm ideas for new shows, hoping to identify even a kernel of an idea that might inspire a writer to develop it into a full-blown TV show concept.

In 2003 the president of ABC, Lloyd Braun, had a simple but unique idea. His favorite movie of recent years was *Cast Away* with Tom Hanks, and he told his team of executives that they should develop a one-hour drama about an ensemble of castaways on a deserted island. The reality show *Survivor* was still new at the time and an enormously popular hit; some of his executives referred to the idea as "scripted *Survivor*." ABC's drama development department followed through on their boss's pitch, and that development process resulted in the series *Lost*. A TV executive, in this case the president of a network, had the kernel of an idea for a series, and his development executives developed that idea into a huge hit show.

AREAS

These simple kernels of ideas are sometimes referred to informally as "areas."[2] Producers, agents and development executives pitch areas they're excited about to TV writers they think have the right skillset to develop the ideas, and the writers then decide if they're sufficiently inspired to imagine a show emerging from them.

While network presidents sometimes experience sudden light-bulb moments, producers, development executives and others also employ more formal processes to generate new ideas for potential TV development. A word for this process is "ideation," the process of creating ideas. (Although there is a word for it, no one in the industry actually calls it that.)

If you remember the broadcast network development calendar discussed at the end of Chapter 2, you'll recall that the development cycle begins each new season with network brainstorming. Network development executives typically begin each new cycle with development retreats in which execs travel off-site, away from their offices for several days, frequently holing up in fancy hotels, to brainstorm new development strategies, generate new ideas and in some cases ideate specific development areas. Lloyd Braun pitched "ensemble TV *Cast Away*" at an ABC development retreat.

Network execs typically begin this process by reviewing their most recent development cycle and assessing the successes and disappointments that

emerged from it. They then look at their upcoming schedule of programming (in part the results of that last development cycle) and assess *its* strengths and weaknesses. Based on these assessments and their prognosis of competing networks' upcoming programming schedules, they spend their retreat devising a new development strategy for the new development cycle. They might look at their fall schedule of shows and say, "Superhero shows are really working on our network. Let's think about looking for more of those." Or, "Let's see if a writer can come up with a completely fresh take on a dysfunctional family comedy that no one's ever seen before." At the end of the development retreat the network development execs codify the specifics of their new game plan and share them with the rest of the industry so writers, producers, agents and studio development executives have an idea of what kinds of shows to target for that network. These lists of development targets are known as "network needs." Each network disseminates its network needs to the rest of the industry, and producers, studio development executives and agents gather all the networks' network needs information to help guide them as they develop their slates of new projects, steering projects they're working on to the specific needs of prospective buyers.

Many development professionals have long been skeptical of chasing network needs in the belief that network execs toss aside official strategies once they start hearing ideas better than they have ever considered. Network needs have also grown less relevant in recent years as networks look for more "out of the box" ideas that execs never imagined or anticipated. Most networks still disseminate network needs, but they're often less specific and detailed than they used to be and tend more to be a list of types of shows a network is *not* interested in developing.

Writers who are interested in network needs information get it from their agents. Unrepresented writers and others outside the industry will find it difficult if not impossible to find current networks needs intel. It's considered proprietary industry information and usually doesn't show up on the internet. The reality is that unrepresented writers will find it virtually impossible to book actual network pitch meetings (we'll discuss this dynamic in more detail in Chapter 9 on agents), but unrepped writers can best approach thinking about targeting pilot ideas to specific networks by studying networks' current programming, the genres, styles, tones and subject matter a network has developed in recent years.

Network development execs sometimes brainstorm more specific creative ideas and areas themselves. Typically these more specific ideas won't be disseminated widely along with the general network needs, but rather are targeted to specific writers that execs want to work with. A network development exec might, for example, reach out to a writer via her agent to 1) inquire if the writer is planning to develop that year (a writer may be prevented from developing by a writing staff contract that requires her to work exclusively on a show and precludes the distractions of development), 2) inquire if the writer has her own ideas that she's already developing and 3) ask if she's open to hearing the network's ideas. If the writer is available to develop and open to hearing new ideas, the network development exec invites the writer in to meet at the exec's office, asks what kinds of shows she's interested in developing and then potentially pitches her the area that emerged from the recent network development retreat.

Development execs and producers also regularly meet with writers in what are known as "generals," meetings in which there's no specific agenda (like hearing a formal pilot pitch), but rather they are merely general meetings, opportunities for execs to get to know writers' personalities (and vice versa) and meet them personally after reading and responding to their written work. (Producers, directors and actors also go on generals, laying the foundation for potential future professional collaborations.) Sometimes development execs and producers use writer generals to float areas or IP and see if a writer might be interested in potentially pursuing the ideas with them in the near future.

CONCEPT IDEATION

The ideas that execs come up with sometimes just pop into their minds in moments of inspiration, but often ideas and areas that development professionals create result from more formal ideation techniques. These techniques are used at network and studio development retreats, by production companies and by other entertainment companies to spur the concept ideation process.[3]

The first and most fundamental ideation technique emerges from a simple question that begins many TV development brainstorming sessions: "What's in the Zeitgeist?" "Zeitgeist" is a German word that literally means "ghost of the time" or, more loosely, "spirit of the age."[4] The Zeitgeist (pronounced

"zite," rhyming with "might," and "geist," beginning with a hard-g like "guest" and rhyming with "heist") is what's going on in the deepest currents of a society at a given time. The Zeitgeist doesn't refer to a trend or a fad. It's bigger and deeper than that. The Zeitgeist isn't something that lasts for a couple of years. The Zeitgeist is something that lasts at least a generation.

Bitcoin is a fad. Income inequality, on the other hand, is in the Zeitgeist. Income inequality has been a phenomenon developing in our society for several decades and most likely something we'll be living with for a long time to come. It's a deeply rooted issue with many causes and factors, but its effects are relatively recent and touch almost all of our lives in one way or another.

Income inequality emerged at a development ideation session at Alloy Entertainment, the company I used to work for that created the book series *Gossip Girl* that was adapted into the TV series. The Alloy team brainstormed new ideas at a development session in the year 2000 and discussed how America was living in a "second Gilded Age." (That the company identified a genuine current of the Zeitgeist is underscored by the fact that we're still very much living in the second Gilded Age nearly 20 years later.) The first Gilded Age occurred in the US in the late nineteenth century when the original generation of industrial robber barons, the Rockefellers, Carnegies and Vanderbilts, displayed their extraordinary wealth (the extreme affluence of their own period of income inequality) with opulent homes and extravagant fashions lavished on the women in their lives. The wives and daughters of the richest of the rich managed the social hierarchy of these mega-rich families, sometimes scheming and manipulating against their social rivals. Ground zero of the first Gilded Age was New York City.

The development team at Alloy believed income inequality was "in the Zeitgeist" and that the second Gilded Age, the new era of extravagant wealth of Wall Street hedge-fund billionaires and tech entrepreneurs, could be an exciting area for entertainment development. Because Alloy's publishing arm focuses on the young adult (YA) segment of the commercial fiction business (books aimed primarily at teen girl readers and usually based on stories about teen girls), the result of that development process was *Gossip Girl*, an entertainment concept about the teenage children of the ultra-rich and the middle-class kids who attend fancy private schools on scholarship. The world of New York City's second Gilded Age served as the backdrop for what became a 15-book novel series and eventually the

TV series. While the TV version never actually drew a large audience, the show struck a cultural nerve. When development professionals succeed in tapping into the Zeitgeist in the right way, a cultural phenomenon like *Gossip Girl* is possible.

All development professionals aim to develop series that are relevant to their times and, as a result, the term "Zeitgeist" has become a bit of a development cliché. It's a cliché, though, because it's what just about all development is chasing. It gets to basic questions like "Who are we?" and "What defines our times?" What will the cultural expression (that is to say, the storytelling expression, the TV expression) of our times be?

Think about it: what's in the air, what's in the Zeitgeist today? Not trends that might be around for a couple of months or a couple of years. What's really going on at the deepest levels of our society that will mark our times when historians look back on us in 100 years? The best TV finds ways to dramatize our deepest social and cultural currents, to question, examine and challenge them, sometimes quite literally and sometimes indirectly or even metaphorically.

Another question TV development ideation sessions often use is: "What TV genres *aren't* on TV right now?" In other words, "What has succeeded on TV in the past but is being overlooked now?" As I mentioned earlier, most development professionals are students of TV history. "What's worked in the past that isn't on now" leads to a follow-up question: "How do we update what's worked in the past for our own times?" Private investigator shows thrived on TV for 40 years. Maybe there's a way to reinvent the genre for a new audience in a new era. What else worked in the past that isn't on TV now and how can it be reinvented or rebooted for a new audience?

Another question used to jumpstart series concept ideation is, "What's taboo in our culture right now?" This is really a smart variation on, "What's in the Zeitgeist?" The question asks, "What are we afraid of? What are we *not* talking about? What is our society in denial about?" The undercurrents of society that make people nervous can be the stuff of powerful concepts and stories.

Another good team ideation technique is to look at what's popping, what's blowing up in other facets of American culture. Lloyd Braun looked to feature films and applied one of its biggest recent successes to scripted TV. It's hard not

to imagine that TV development professionals all over Los Angeles are trying to figure out how to appropriate some of the creative elements that made the Broadway phenomenon *Hamilton* so successful and apply them to TV.

What else? What else is blowing up in other corners of our popular culture? How can we mine them for TV?

Inspiration for TV development often occurs in unexpected ways. At the CW's 2017 network retreat a guest speaker addressed the company's gathered employees about a charity the network's philanthropic arm supports, Guide Dogs of America, the non-profit organization that trains guide dogs for blind and visually impaired people. The speaker herself was blind, and the CW development execs who heard her speak felt profoundly inspired by her talk and her personality, particularly her confident, unself-pitying sense of humor. After the talk they agreed that the speaker had left such a strong impression on them that she could serve as an inspiration for a great TV character on their network.

They also remembered one of their network needs: They knew that the network's two female-driven one-hour dramedy series, *Jane the Virgin* and *Crazy Ex-Girlfriend*, were nearing the end of their series runs, and they were beginning to look for female-driven dramedy replacements. A strong, confident, unself-pitying blind woman character with a great sense of humor became a development target at the CW that season. Network execs shared the area with studios and producers. One production company loved the idea and knew the perfect writer for it, Corinne Kingsbury, a young writer who'd staffed on a few series including *The Newsroom* and the short-lived *Back in the Game* on ABC. Kingsbury connected to the idea and developed her vision for a series based on the area with the production company, Red Hour Films (Ben Stiller's production company).

Kingsbury imagined a show about a 20-something blind woman, Murphy, who works at her parents' guide dog school. When a friend is murdered, Murphy winds up being the only witness, albeit a sightless one. The police dismiss her account, and Murphy sets out with her dog to find her friend's killer, juggling the search with her day job at the guide dog school and an eventful dating life.

Red Hour and CBS Television Studios brought Kingsbury's pitch into the network, and the CW execs loved her vision for a series inspired by the target

area they had identified. They bought the pitch, developed a pilot script, ordered it to pilot production and that May picked it up to series. *In the Dark* premiered in the 2018–2019 season, inspired by an area the network execs identified from a serendipitous encounter.

TAKES

Ideating an area, targeting the area for development, identifying the right writers to expose the area to, waiting until the right writer responds to the area, then commencing active development of the area – these steps are a routine TV development strategy. It happens at all levels of the development food chain: network development execs, studio development execs, producers and, to an extent, agents all do it. The next step is for a writer who responds to an area to go off and do the creative heavy lifting of fleshing out the area into the beginnings of a pitch for a show. We call what the writer creates in that next step a "take," as in, "Here's my take on the area you pitched me."

The writer comes back to the development pro – network or studio exec, producer or production company development exec – with his take on how to turn the area into an actual show. It won't include all the elements of a full-blown pitch (which we'll explore in detail in Chapter 7). It'll typically just be fleshed out enough for the development professional to have more of a sense of the direction the writer would take the idea. In a "take" a writer typically articulates the world she wants to set the show in, a rough sketch of a few of the lead characters she envisions, the kind of action that will drive the series and a general sense of the tone of the series. In other words, the writer's take turns the raw area into the beginnings of a true TV concept.

The writer begins the intellectual and creative process of transforming something "raw" into something "cooked." The various development professionals all play important roles in development, but it's usually the writer who performs this crucial work of turning "nature" into "culture" (to use Levi-Strauss's paradigm).

The writer comes back with a take rather than a full pitch because, at a project's outset, development is typically done in small steps. The writer and the person she's pitching the take to want to make sure they're in sync,

that they're both thinking about the same kind of show, before the writer rolls up her sleeves and does the huge amount of work to flesh out the take into the next step, the full-blown pitch of the show. If the initial take isn't heading in a direction the exec or producer is happy with, it's better to know early, before the writer invests a significant amount of time and energy to flesh out the full pitch.

In some cases multiple writers might be pitched an area and all asked to come back with takes. In that case, the development professional will pick the take he likes the most and thank the other writers for their time. Writers understand that this is a standard part of the process and are willing to rough out a take on spec knowing their take might not be chosen.

In 2002 director McG's producing partner, Stephanie Savage, targeted an area for their production company to pursue that TV development season. She brainstormed ideas and came up with a simple area for a show. McG had grown up in Newport Beach, California, and Savage and McG agreed that world could be a fun, original setting for a new teen ensemble series. That was the extent of the area: teen ensemble in Newport Beach for their production company, Wonderland Sound and Vision, to produce and McG to direct.

Savage had a general that year with a young writer who had dropped out of USC film school after selling two pilot scripts, and she pitched him the Newport Beach teen ensemble area. Twenty-five year-old Josh Schwartz was intrigued by the area, figured out a vision for a show and came back to Savage with his take. Schwartz pitched a teen soap about a poor kid from downscale Chino, California, who winds up being taken in by a lawyer and his family at their beautiful Newport Beach home. Savage and McG liked the take and committed to work with Schwartz to develop it into a fleshed-out network pitch. That take turned into *The O.C.* and lasted four seasons and 92 episodes. Schwartz and Savage teamed up five years later to co-create their second hit show, *Gossip Girl*. Today Schwartz and Savage run a successful production company, Fake Empire, and are busy writing and producing new series.

It all began with a simple area and a great take. Schwartz took a raw idea and turned it into a fully developed TV concept.

Writers also work up takes on IP. If a network, studio or producer controls the rights to a book, for example, a development exec at the company might

identify a number of well respected, proven TV writers whose body of work suggests they could be good candidates to adapt the property to TV, select the top writer candidates they want to approach first, confirm with the writers' agents that their clients are available to tackle new development, pitch the writers' agents the general idea of the IP to ensure it might be something the client could potentially be interested in considering, then submit the IP to the agents for their writers' consideration. The writers read the submission and let their agents know if they "respond" to the material enough to engage in the process and work up takes. ("Respond" is the typical industry term – it doesn't imply too much commitment; all sides, the writer, the writer's agent and the development exec, move cautiously, no one committing too eagerly or prematurely at the early stages of a project.) The writers who generate takes then meet with the development exec, pitch their takes and begin a potentially long and fruitful partnership.

As clearly as a book (or any other IP) might appear to lay itself out as a TV show, every writer will have his or her own unique take on turning it into a TV series. The development exec wants to hear a take that succeeds in translating what worked in one medium into an effective TV translation. After hearing multiple takes from different writers, a development exec might believe that none of the writers have "cracked" it. To "crack" an idea or a property means to figure out just the right creative pieces in just the right combination that sound like they hold the promise of successful TV series. A writer "cracks" an idea when he figures out a way to build it into a true TV concept that will hold water and make sense to everyone in the process and ultimately to an audience. In the case of McG's Newport Beach teen ensemble drama, Josh Schwartz's take cracked it. His take sounded like it held the promise of a successful show, and he and his take were chosen to move forward to the next step. If a development exec hears several takes and none of them crack an idea, the exec might go out to another group of writers until he finds the writer with the right take that does crack it. If a development exec hears from many writers and none of them crack it, the exec might begin to consider the possibility that, despite his initial optimism, the idea might not lend itself to TV adaption after all and give up on the project.

Alternatively, a development exec or producer might have an idea exactly who the one perfect writer for her project is and target that one writer, not needing to expose the area or IP to several writers. If that writer responds and the writer and exec agree they're in sync on the project creatively,

they'll move forward together, obviating any need to go out to multiple writers.

At any given moment the development sector of the LA TV industry teems with development execs pitching areas and submitting IP to writers, writers pitching back their takes, with agents brokering the process at every step. The industry pulses with a steady flow of ideas – development execs saying, "Here's something I'd like to turn into a TV show, how would you do it?" and writers responding, "I agree it's a good idea, here's how I'd turn it into a show." Development execs, writers and the agents who mediate between them work day-in and day-out to connect the dots, to find great ideas and the best creative takes to make development marriages and turn ideas into hit TV shows.

NOTES

1 Author interview with Leslie Morgenstein.
2 Not to be confused with "story areas," the short prose treatment format that writers sometimes use to deliver pilot stories to network development executives described in Chapter 2.
3 TV studio development executives often have their own development retreats while their network counterparts are off at theirs – assistants sometimes even have to coordinate to ensure two groups of execs don't wind up retreating at the same fancy hotels.
4 Because Zeitgeist is a German noun it's typically capitalized when written in English.

6

Assessing the Marketplace

The first priority of TV studios, producers, production company development execs and talent agencies is to build new projects. (I'm excluding network execs from that statement because their first priority is to seek out the most promising new projects that studios, producers and agents are busy putting together. Beyond that first priority, network execs might initiate their own projects too.) Studios, producers and agents focus on ways to create new ideas or areas for potential TV series, to find IP for potential adaptation, and then to marry those ideas, areas or IP with writers. Their next priority is the focus of this chapter: to figure out the right potential home for their new projects, the right networks to which to pitch them. This second priority requires studios, producers and agents to constantly assess the marketplace.

Like most industries, the TV development business supports a marketplace. A marketplace consists of buyers and sellers. Buyers look for new products to purchase to satisfy their needs. Sellers create products or broker products created by others and shop them to buyers.

In TV development the networks are the buyers. They are the end-use buyer of all TV development. If a network buys a "piece of development" (a potential TV pilot and series), the project is then considered "in active

development," it's "set up." If a project is shopped to networks and the networks all pass, the project is dead for the time being.[1]

In TV development the sellers are TV studios, producers and agents. They all put new TV projects together and shop them to buyers, the TV networks. (Remember, I'm using the term "network" as it's often used in industry practice to refer to all distributors of big-budget scripted series, i.e., the broadcast networks, cable and satellite channels and over-the-top streaming companies.)

Networks look for new TV projects, potential new series to develop, that can blossom into shows they can program for their viewers, and TV studios, producers and agents look for networks to buy their projects. Buyers look to sellers for new products, and sellers look for buyers of their wares.

Notice that I'm omitting writers from the list of sellers. This may sound counter-intuitive. After all, it's the writers who pitch new pilots to the networks. Technically, writers are not sellers but rather a *commodity* that sellers sell. A development project consists of an idea for a show and a writer to execute the idea (in the form of a pilot script) and to provide a guiding vision for the series beyond the pilot. Most working Hollywood writers don't think of themselves as mere commodities, of course, and many have entrepreneurial instincts of their own. Some writers think like sellers. In this sense, writers frequently act like producers, which, we'll remember, is a role most TV writers officially serve in addition to writing. So, technically, when writers do the work described in this chapter, assessing the marketplace and thinking about which networks might buy their pilot pitches, writers wear their producer hats. Many writers, though, choose to focus exclusively on the creative, and leave the work of identifying the best potential buyers for their projects to their producer, studio and/or agent partners.

Most sellers spend a good deal of time studying the marketplace of buyers. They want to make sure that, if they're going to invest their time, energy and financial resources into developing a project, there will be a network interested in buying it. If a seller creates a project no network is interested in, it's most likely worthless. Sellers hedge their bets against that loss by constantly assessing the marketplace to ensure there are going to be buyers for their projects.

A second reason sellers assess the wants and needs of their potential buyers is to tailor their development specifically to address target buyers' tastes. Several years ago the CW and ABC Family both developed and

programmed shows centered on teen lead characters, typically around 16 years old. But, with the arrival of new presidents in 2011 and 2013 respectively, both networks decided to shift the age of their preferred, ideal lead characters from mid-teens to mid-20s. The era of *Gossip Girl* on the CW transitioned to the era of *Arrow*. The era of *The Secret Life of an American Teenager* and *Pretty Little Liars* on ABC Family transitioned into the era of *The Bold Type*, as the network rebranded itself from ABC Family into Freeform. Sellers who create projects for those networks needed to know to stop building projects around teen leads and to start building projects around 20-something leads. When IP with teen leads crosses the purview of those sellers, for example, the sellers might consider whether the concept underlying the IP can still work creatively if the lead characters are aged up into their 20s.

As of this writing, there are 49 network buyers that develop and program big-budget, high-production-value scripted series, the kind of content we think of as "TV shows," whatever type of screen viewers might watch them on. When I was a kid there were three, only three networks that developed and programmed scripted series. Three total buyers. Those days are long gone and sellers are glad of it. The number of cable channels that offer scripted series and the number of internet companies entering into the business of programming and distributing big-budget scripted series has continued to grow in recent years and most likely will continue to grow in coming years. For sellers, this means more and new buyers. Below is a list of the 49 network buyers of scripted series television as of this writing. I keep this running list, as most sellers do, to keep tabs on the marketplace of buyers.

- ABC
- Adult Swim
- AMC
- Amazon
- Apple
- Audience Network
- BBC America
- BET
- Bounce TV
- Bravo
- CBS
- CBS All Access
- Cinemax
- Crackle
- The CW
- Comedy Central
- DC Universe
- Disney Channel

- E!
- EPIX
- Facebook Watch
- Freeform
- Fox
- FX
- Hallmark Channel
- HBO
- History
- Hulu
- Lifetime
- MTV
- National Geographic
- NBC
- Netflix
- Nickelodeon
- Paramount Network
- PBS
- PlayStation Network
- Pop
- Showtime
- Starz
- Sundance Now
- SundanceTV
- SyFy
- TBS
- TNT
- TV Land
- USA
- WeTV
- YouTube Premium

This list is constantly in flux. For example, A&E programmed scripted series for several years (like *Bates Motel* and *Unforgettable* – which I've already forgotten) but management at its parent companies (Hearst Corporation and the Walt Disney Company) changed the network's corporate strategy in 2017, and A&E stopped developing and programming scripted series. WGN America abandoned its short-lived original scripted series venture (which included *Salem, Underground,* and *Outsiders*) in 2017 as well.[2]

Disney's new streaming service, intended to rival Netflix, launches in late 2019, adding another major distributor of original scripted content to the list. Quibi, a streaming service designed to distribute content developed primarily for viewing on mobile devices, is also expected to launch in 2019. Quibi plans to experiment with a unique format, scripted series comprised of 15-minute episodes. (The name 'Quibi' is short for 'quick bites,' reflecting the novel format of the platform's episodes.)

As time passes some channels may decide scripted series isn't the right business for them, and new channels will enter the business to replace them. The current trend suggests more companies are emerging that develop and program scripted series (that buy development) than companies reversing course. We'll see how long this trend continues. For the moment, there are so many buyers (and so many new buyers each year) and so much demand for new shows, the business looks in many ways like a sellers' market. Some sellers see it differently though. Jay Sures, the Co-President of UTA (United Talent Agency) and its Head of Television, puts it this way:

> The power that Netflix and some of the other buyers in the marketplace hold right now is extraordinary. They offer a unique and special platform that's commercial-free, somewhat standards-free, that gives creators the ability to do what they want to do and not have all the constraints that we saw several years ago. That's a big difference, and that difference makes it a buyers' market also.[3]

THE BUYERS

Let's look more closely at the marketplace of buyers. As mentioned earlier, there are three primary kinds of network buyers, legacy broadcast networks, cable and satellite channels and online video distributors.

There are five broadcast networks:

- ABC
- CBS
- The CW
- Fox
- NBC.

The oldest of this category of networks, NBC, is almost 100 years old. ABC, CBS and NBC originated as radio networks, programming news, music, sports and scripted series to American radio listeners beginning in the 1920s. NBC aired the first hit scripted series on radio, *Amos 'n' Andy*,

beginning in 1930. The three radio networks experimented with television broadcasting during the 1930s, put their TV endeavors on hold during World War II and began programming their first scripted TV series in the late 1940s. Fox (also known as Fox Broadcasting Company and commonly referred to in the industry as FBC to distinguish it from the Fox-branded cable channels) launched in 1986. The CW network formed in 2006 as a result of the merger of their predecessor networks, The WB and UPN, which both began in 1995.

The broadcast networks, as we know, are advertiser-supported (meaning the shows are interrupted by commercials and therefore episodes are broken into "acts" that are divided by commercial breaks, a.k.a. "commercial pods" in industry parlance). The broadcast networks were and still are literally networks. They are networks of many local TV stations in cities and towns (a.k.a. "markets") across the country. The stations are either owned by the parent network (known as "O and Os," meaning the stations are owned and operated by the parent network), or they're owned by a syndicate than owns a group of stations, or they're individually owned by a local company. Stations that aren't owned by the parent network are known as "affiliated" stations or "affiliates." The networks are therefore comprised of the network headquarters (which are all in New York City, while the entertainment divisions that develop scripted series are all in Los Angeles), the O and Os and affiliates.

While most consumers of broadcast network programming pay for the channels as part of a basic cable or satellite package, the broadcast networks still actually broadcast their programming for free nationwide. This is known as "terrestrial broadcasting," and during the first several decades of TV history it was the only way to receive network programming.

Because the programming is broadcast everywhere to all Americans who own TVs and uses publicly owned radio waves, the content of broadcast network programming is regulated by the Federal Communications Commission (FCC) and is expected to be appropriate for consumption by all Americans of all ages and tastes. That's why broadcast network programming tends to be safer and less "adult" in content, avoiding the coarse language, graphic sexuality and extreme violence offered by other programming distributors.

In the old days, when only the three original broadcast networks, ABC, CBS and NBC, distributed scripted series, each of them commanded enormous viewership, and individual shows were regularly watched by

20–30 million viewers. Today, the broadcast networks' audiences have fragmented into relatively tiny numbers as the networks face continually increasing competition, not only from more cable, satellite and streaming networks but from other media as well. But, importantly for the development side of the business, as small as the broadcast networks' audiences have shrunk, those buyers are still seen within the industry as an important force. The "big three" original broadcast networks still program 21 hours of mostly original programming seven nights a week, nine months a year or more. (Fox and the CW program slightly fewer hours of original programming per week, but for the same nine months each year.) While AMC programmed eight scripted series in 2018, CBS programmed 23. The broadcast networks continue to buy more development than other categories of network buyers, and a hit series on broadcast TV continues to be the most lucrative opportunity in all of TV. Although broadcast TV hits are becoming fewer and farther between, the pot of gold at the end of the broadcast network rainbow continues to be an attractive target to many sellers and talent (writers, directors and actors) throughout the development business.

The cable landscape is divided into two main categories, basic cable and premium cable. Basic cable channels like AMC, FX and TNT are referred to as "basic" because they're typically offered in the basic programming packages that most cable and satellite providers offer. They're advertiser-supported and their programming is interrupted by commercials. Traditionally, basic cable channels limited the language, sexuality and violence of their content because their programming was in the homes of many consumers who didn't actively consent to more adult programming, but the content of much basic cable programming has become increasingly adult, and in recent years has come very close to what we would consider R-rated.

Currently there are 27 basic cable channels that develop and program scripted series:

- Adult Swim
- AMC
- Audience Network
- BBC America
- BET
- Bravo
- Comedy Central
- Disney Channel
- E!
- Freeform
- FX
- Hallmark Channel

- History
- Lifetime
- MTV
- NatGeo
- Nickelodeon
- Paramount Network
- Pop
- SundanceTV
- SyFy
- TBS
- TNT
- TV Land
- USA
- VH1
- WeTV

Premium cable channels are "premium" because cable customers pay an extra monthly fee, a "premium," to receive each of these channels. Premium cable channels therefore are fee-supported rather than advertiser-supported and their programming is not interrupted by commercials. Premium cable shows that are aimed at audiences older than children are typically more "edgy" and often feature R-rated language, sexuality and violence. There are currently five premium cable channels that program scripted series:

- Cinemax
- EPIX
- HBO
- Showtime
- Starz.

The last category of network buyers are the online video companies that distribute TV shows via the internet:

- Amazon
- Apple[4]
- CBS All Access

- DC Universe
- Disney+[5]
- Facebook Watch
- Hulu
- Netflix
- Sony Crackle
- Sundance Now.

I used the phrase "that distribute TV shows via the internet" for a reason. As I move into a discussion of online video distributors it's important to remember that the focus of this book is the creation of TV shows. While there are myriad forms and formats of online video entertainment, my focus in this book is on the online video distribution companies that develop and program big-budget, high-production-value scripted series. What we still continue to think of and refer to as "TV shows."

The distinctions between "TV shows" and "web series" grow fuzzier and fuzzier. For the time being, though, most of us recognize the differences: TV shows enjoy bigger budgets, more sophisticated production methods and production values, longer running times and typically more traditional programming formats. Some web series are being adapted into big-budget network scripted series like *High Maintenance*, while some other web series serve as launching pads for talent who are given opportunities by networks to create TV series in the way creators of other media (indie features, books, comic books) are given opportunities to translate their voices and visions to scripted television. Development executives at HBO noticed Issa Rae's web series *The Mis-Adventures of Awkward Black Girl* had the same kind of potential they'd seen in Lena Dunham's indie feature *Tiny Furniture*, and gave its creator the opportunity to develop a new TV series (resulting in the development of *Insecure*), rather than simply adapting the original web series into a TV series itself.

At TV studios and talent agencies (and other Hollywood companies) lawyers and business affairs executives are working hard to figure out

new kinds of deals to sell programming to online TV distributors whose business models are intent on disrupting content distribution. But down the hallways and across the lots at those companies development executives take a different tack; they tend to be platform agnostic. If a distributor (a network) pays the license fees that cover the cost of high-quality development and production – the fees of the best writers, producers, actors and directors, along with the rest of high-production-value budgets – and guarantees national or international distribution, a TV show is a TV show however it's distributed, whatever technology the network uses.

Development execs and producers are cognizant of changing deal structures, but they primarily view the streaming platforms as they view other networks: will they buy my pitch, run my show, support it with marketing and distribution muscle and give my show the chance to become a hit?

The interplay between technology and commerce combined to transition scripted series storytelling from radio to television in the 1940s and 1950s. Technology and commerce evolved the distribution of TV from terrestrial broadcasting to cable and satellite to streaming, and that transformation of distribution will continue, at both evolutionary and disruptive rates. But, for now, content creators focus most of their time on originating new shows and finding new homes for them. For now, it's all TV.

What distinguishes the 49 networks from each other and what kind of shows do they buy? How do sellers (studios, producers and agents) think about them as they approach the TV buyer landscape?

HOW SELLERS ASSESS BUYERS

As we look at the list of buyers, assessing the current development marketplace, much of what differentiates buyers from one another is fairly obvious. We all know how the Disney Channel differs from Showtime. To a great extent the thought process of sellers in the development marketplace is intuitive: If a producer is developing a show for little kids, the producer knows her market for that project is the Disney Channel, Nickelodeon, HBO, Amazon and Netflix. That's it. That's the marketplace of shows for little kids. Forget the list of 49 networks. The list of buyers for

that kind of development consists of five buyers. But sellers also study their target buyers more closely than that.

The first and most general way sellers assess buyers is by the kinds of formats they program. Some networks only program one-hour dramas and some only program half-hour comedies. Some networks program limited series, and some don't. If you're a producer or a studio exec and you're going to develop a new one-hour drama project, you want to know which networks develop and program one-hour dramas and which don't. In other words, which networks might be open to even consider buying your new project.

The list below shows the 49 buyers and the formats they program. I've created this list for illustration purposes, but most sellers know it like the backs of their hands. It's their business to keep abreast of this info.

- ABC: C, D, L
- Adult Swim: C
- AMC: D, L
- Amazon: C, D
- Apple: C, D
- Audience Network: C, D
- BBC America: D
- BET: C
- Bounce TV: C, D
- Bravo: D
- CBS: C, D, L
- CBS All Access: C, D
- Cinemax: D
- Crackle: C, D
- The CW: D
- Comedy Central: C
- DC Universe: D
- Disney Channel: C
- Disney+: C, D
- E!: D
- EPIX: C, D
- Facebook: C, D
- Fox (FBC): C, D, L
- Freeform: C, D
- FX: C, D
- Hallmark Channel: D
- HBO: C, D, L
- History: D, L
- Hulu: C, D, L
- Lifetime: D, L
- MTV: C, D
- NatGeo: L
- NBC: C, D, L
- Netflix: C, D, L
- Nickelodeon: C

- Paramount Network: C, D, L
- PBS: D, L
- PlayStation Network: D
- Pop: C, D
- Showtime: C, D, L
- Starz: C, D
- Sundance Now: C, D
- Sundance TV: D
- SyFy: D
- TBS: C
- TNT: D
- TV Land: C
- USA: D
- WeTV: D

D = one-hour dramas, C = half-hour comedies (either single or multi-cam), L = limited series.

As mentioned earlier, the traditional format definitions are blurring and becoming less relevant as TV shifts toward non-linear distribution and increased creative experimentation. But, whether one-hour drama episodes run 42 minutes or 75 minutes, or half-hour dramedies veer close to becoming 34-minute dramas, the traditional TV format distinctions are still used by all networks, and the networks by and large still continue to define their programming strategies by the formats they program.

The second way networks define themselves is by their demographics, the "demos" of the audiences they target. Networks are largely defined by the question: What segment of the audience are we trying to attract?

The Disney Channel targets kids and Showtime targets adults. That's pretty obvious. More specifically, the Disney Channel targets kids ages 6–11 and Showtime targets adults 18–49. Those numbers aren't estimates; they're demographic categories defined by Nielsen, the ratings firm that was founded in the 1920s and that began analyzing the size and "quality" (I'll discuss more about what that means in a moment) of radio audiences in the 1930s, and that has monopolized the analytics of broadcast, cable and satellite TV ratings since the 1950s. While writers and producers have scorned the power of Nielsen from the beginning of TV (and probably radio before then), and twenty-first-century media critics assume Nielsen's data is becoming increasingly irrelevant, the data Nielsen generates continues to determine the

exchange of billions of dollars between TV networks and advertisers. For the purposes of development professionals, the demographic categories Nielsen defined decades ago continue to serve as the metrics all industry professionals use to delineate the different audience segments their shows target.

ASSESSING BUYERS BY TARGET DEMOGRAPHICS

No single network creates shows aimed at everyone – not even the broadcast networks. Netflix appears to be coming close. All shows are designed for some segment or segments of the audience, and we use Nielsen's demographic categories to define those segments. (One dead giveaway that students haven't picked up the walk-and-talk of TV industry lingo is when they reference non-standard demographic categories. If you're going to talk or write about TV demos, it's important to use the accepted industry demographic categories defined by Nielsen listed below.)

Below are scripted TV's most commonly used Nielsen demographic categories:

- ▶ Boys, Girls, Kids 6–11
- ▶ Boys, Girls, Teens 12–17
- ▶ Men, Women, Adults 18–34
- ▶ Men, Women, Adults 18–49
- ▶ Men, Women, Adults 25–54
- ▶ Men, Women, Adults 55+

"Kids" (that's Nielsen's actual term) refers to the sum total of viewers 6–11 of both genders. The same with "Teens" and "Adults." Network programmers will say that they're targeting Adults 18–49 or Women 18–34. When written, these demos are often abbreviated as A18–49, W18–34, etc.

Another way networks refer to this is to say they "sell" a specific demo. Freeform, for example, "sells W18–34." That's their bottom-line business: They sell the attention of Women 18–34 to advertisers. Executives at Freeform, together with executives at their parent company Disney,

determined that that's the segment of the TV audience they want to target, their intended slice of the TV audience pie. Once the business minds of a network have determined which segments of the audience they want to sell to advertisers, the programming executives then translate that business strategy into a programming strategy. If we want to "sell" W18–34, in other words to attract an audience of women 18–34 years old and sell their attention (a.k.a. "eyeballs"; yes, that's the actual TV industry shorthand for the viewers they sell to advertisers), what kind of programming, what kind of shows, will attract that demographic, will attract those eyeballs? Once senior programming execs at a network set a programming strategy, development execs are then tasked with finding and developing new shows to implement that programming strategy.

Non-advertiser-supported networks follow a similar process. What audience segment or segments do we want to target and what kind of programming will attract that audience? HBO traditionally targeted Adults 18–49 (a certain "quality" of A18–49 viewers actually, which I'll get to momentarily) and created programming designed to attract and satisfy that target audience. In 2015 it expanded its demographic reach to include kids, and it made a deal to license *Sesame Street* and other kids' shows. HBO did this in part to compete with Netflix's strategy, which has been to target every demographic segment. Netflix targets Adults 18–49, they target Females 12–34, and they target Kids 6–11. And like the advertiser-supported networks, Netflix has created programming strategies their development execs follow to find and develop new shows designed to attract and satisfy those different audience segments (and many others).

ASSESSING BUYERS BY TONE

Another key way networks define themselves is by tone. The Disney Channel programs a female-centered half-hour comedy called *Andi Mack*, and Showtime programs a female-centered half-hour comedy called *SMILF*. The two networks both employ similar traditional TV formats, but no one's going to confuse the two shows or their networks. The key difference is tone. *Andi Mack* is warm and safe and *SMILF* is super-edgy. If you think about the shows on the Disney Channel, all their scripted live-action shows have almost exactly the same tone. Tone is one of the defining elements of

the Disney Channel's programming strategy. Its programming tone might be described as "safe, fun, warm, a little silly, a little scatological, non-sexualized, but a little puppy-love romantic." Tone is so fundamental to all the Disney Channel's programming that executives and producers know it without even needing to talk about it. Variations to this tone might occur in very small degrees.

Showtime's network tone isn't as uniform as the Disney Channel's, but it's fairly consistent. The subject matter on Showtime varies enormously, but there's a well-defined tonal range that all Showtime comedies and all Showtime dramas fall within. Terms to describe Showtime's tone include "edgy, adult, smart, sophisticated, sometimes cynical and dark."

Tone, notably, is largely a function of demos. The Disney Channel tone is designed to appeal to Kids 6–11. The tonal range of Showtime's series are designed to appeal to Adults 18–49. But tone isn't only a function of the age and gender of audience members.

Let's take another example and compare the USA Network and AMC. They're both basic cable networks that program the same format, one-hour dramas, and for the same demographic cohort, Adults 18–49. But the tonal ranges of these two networks are quite different. Why? Because AMC targets more upscale and more educated adults aged 18–49 than the USA Network. Nielsen's demographic data don't include just age and gender, they specify the relative affluence (defined by ranges of annual income) and education levels of viewers. This is what ratings analysts refer to as the "quality" of viewers. There's a larger number of potential viewers with lower incomes and less education so that particular audience can deliver higher overall ratings (more viewers), but viewers with higher incomes and more education, while fewer, are worth more to advertisers (in part because they're more scarce, in part because they have more money to spend), so networks can charge more for commercial time in shows that attract that audience.

The programming strategy at USA Network is designed to attract a large number of middle-class, modestly educated viewers, and the programming strategy at AMC is designed to attract a smaller but more valuable audience of upscale, highly educated viewers. Nielsen and TV industry execs refer to this more affluent and educated audience as "higher indexing" or "over indexing."

USA and AMC determined which audience segment – by gender, age, wealth and education – to target, and they defined programming strategies to appeal to those viewers. The senior programming and development execs at those networks then determined the kinds of shows and the tones of shows that would achieve that programming strategy. The USA Network programs one-hour dramas within mostly traditional genres like the legal show *Suits*, and the tones of their shows tend to be generally safe, sunny and not all that demanding. AMC programs less traditional drama genres like *Mad Men*, which might be described as a period/family/business/character study, and the zombie horror series *The Walking Dead*. The tone of AMC's shows is much darker, edgier, more violent and generally more demanding and sophisticated than that of USA.[6]

The tonal range of these networks is a reflection of their business strategies, programming strategies and overall brands. It's the job of their development executives, on the one hand, to find new projects that fit within their programming strategies and then, on the other, to guide the development of those shows to fit their company's tonal zones. Sellers targeting these networks, conversely, assess the genre and tonal ranges of these buyers, then tailor their projects to meets their buyers' creative expectations.

ASSESSING BUYERS BY MANAGEMENT

Another factor that often defines network tastes and that sellers keep a close eye on is personnel. Changes in network leadership can cue the marketplace that a network's development strategy – and therefore its purchasing appetites – is changing.

In 2014, for example, TNT hired Kevin Riley as its new president. Many development professionals saw Riley's hire as a signal that the network's programming strategy and development tastes were about to change. Riley is known as the executive who developed *The Shield* and *Nip/Tuck*, two groundbreaking and sophisticated adult shows, when he was president of FX in the early 2000s, and as the network chief who ordered *Friday Night Lights* to series when he was the president of NBC in the mid-2000s. Unsurprisingly, after Riley came on board at TNT, word came from the network's development execs that they were looking for more sophisticated,

adult, edgy, smart shows. The era of shows like *Rizzoli & Isles* (sexy lady cops!) and the *Dallas* reboot (sexy primetime soap!) was over, supplanted by new shows like *Animal Kingdom*, an edgy family crime drama based on an award-winning foreign feature. Riley's development tastes, the kinds of shows he likes, is well known in the industry, and development professionals throughout the industry knew what his hiring meant and responded in kind.

Network development execs typically announce major programming and development strategy changes like TNT's as they disseminate their annual network needs to studios, producers and agents. However, changes can occur within network development suites between official network needs statements, and sharp-eyed sellers keep in touch with buyers to learn of new and changing needs. Networks sometimes change development goals midstream because new shows they expected to work don't or shows they expected not to become hits do, because their competitors have breakout hits in unexpected genres or formats, or because of major personnel changes. The best sellers don't leave good timing only to chance and work hard to stay as informed about the marketplace as possible.

Junior entertainment professionals making their way in TV development, including assistants, coordinators and entry-level executives, can earn the attention of their bosses by keeping an ear to the ground for network needs news. Typical conversations at the steady cycle of breakfasts, lunches, drinks and dinners among Hollywood development professionals at all levels are, "What are you guys looking for these days?" "Any new needs before your buying season closes?" "Anything you guys looking for you're having trouble finding?"

The marketplace of information, like the development marketplace at large, works in both directions. Aggressive buyers quiz their seller counterparts about upcoming projects and packages. Network execs try to learn as early as possible what new projects agencies, producers and studios are preparing to bring to market.

Who's looking for what and who's got what is central to the daily stream of communication within the TV development business. The marketplace of TV development hums with constant chatter, connecting buyers and sellers year round and year-in and year-out.

NOTES

1 Emphasis on "for the time being." A seller finding the right buyer for a project is often a function of timing. If the timing isn't right now, it might be better later.
2 WGN stopped developing original new programming and instead switched to licensing scripted series developed by foreign networks, like the Swedish series *100 Code* and the Canadian *Bellevue*.
3 Author interview with Jay Sures.
4 Apple launches its online video distribution service and begins programming its first scripted series in 2019, but it's been developing its first shows since 2017.
5 Disney launches its online video distribution service and begins programming its first scripted series in 2019, but it's been developing its first shows since 2018.
6 Sometimes networks stray out of their defined programming lanes, however, as USA did with *Mr. Robot*, either by accident, intentional experimentation or programming strategy overhaul, which we'll talk more about in this chapter.

7

Pitching New Pilots and Series

While American TV has changed significantly in the past 15 to 20 years, the way new ideas for TV series are bought and sold at most TV networks has not. Television programming has grown increasingly more sophisticated and complex over that period, but the way TV shows are pitched to networks, cable channels and streaming platforms has remained mostly the same for a very long time. In this chapter I'll examine how Hollywood professionals pitch new shows, and I'll drill down in detail on the typical pitch format that's de rigueur in Hollywood today. This pitch format has remained fairly consistent over the past several decades (with minor adjustments) and network development executives have come to more or less expect it. I'll also look at some of the strategies and techniques that development professionals use to create effective and successful pitches.

First, let's begin with "who?" In Hollywood the writer delivers the pitch. This has been true in feature films in Hollywood since before television, and it has always been true in TV. The writer does the pitching. Not the producer, not anyone else. The writer looks the buyers in the eye and talks uninterrupted for 15 to 25 minutes pitching her vision of the show.

Pitches for feature films in Hollywood are generally quite simple. The movie writer pitches the story of the movie from beginning to end. He may

dedicate some portion of his pitch to discussions of character, theme and tone, but the vast bulk of his pitch is "telling the movie" from fade-in to fade-out. The feature film writer might begin his pitch:

"We fade in on a star-filled night sky. Trumpets announce an epic fanfare. A title rolls up the screen, 'A long time ago in a galaxy far, far away . . .'."

And we're off.

TV pitches are generally more complex. One very common TV pitch format includes eight major sections:

1. Personal Way into Series

2. Concept of Series

3. World of Series

4. Characters

5. Pilot Story

6. Arc of First Season/Arc of Series

7. Tone

8. Sample Episodes.

Most TV pitches in Hollywood utilize this format or one very similar to it – or consciously depart from it for effect. The writer, accompanied by his producers, and studio development executives (if they exist, which may or may not be the case at this stage), sits down in a conference room at the network's offices and pitches the idea to the network execs.

The network development executives have the option to say yes to (to "buy") the pitch, or to say no to (to "pass on") the pitch. If the network chooses to buy the pitch, they'll typically make a deal to pay the writer to write just one script, the pilot episode. (This deal is known as a "pilot commitment" even though the network is actually committing to order only a pilot script. The decision on whether the pilot script will

be ordered to pilot production won't be made until later.) If the writer pitches the project to several networks and more than one decides to buy the project, bidding for the project can become competitive, and the writer (and his partners) can demand more than just payment for the pilot script. They could demand that the network commits in advance to spend millions of dollars to actually produce the pilot episode. This is known in Hollywood as a "put pilot commitment" (pronounced like the verb "put," as in, "She put him in his place."). Beyond that, the sellers could demand that the network not only commits to buy the pilot script and produce the pilot episode, but also commits to produce and air a specific number of episodes of the series. This is known as an "on-the-air commitment." These two larger production commitments are rare, however, and most successful pitches result only in the sale of a pilot script.[1]

"Straight-to-series" orders, an even greater level of network commitment, are becoming more common, especially at the streaming networks. However, network commitments for one or even two full seasons of episodes generally occur in response to more than simple pitches, and I'll discuss that level of network commitment in more detail in Chapter 10: "Other Development Strategies."

If the network buys the pitch and orders a pilot script, the writer is paid in a few installments to write the pilot and the producer is paid nothing. As mentioned earlier, the producer may work for many months (or even years) to develop the pilot script but is only paid if the project moves beyond script development and into production (pilot production and/or series production).

Before there can be a pilot or series to produce, however, there has to be a pitch. Let's get back to looking at the pitch and examine the eight sections of the typical Hollywood TV pitch format in detail.

SECTION 1: PERSONAL WAY INTO SERIES

Most Hollywood TV pitches begin with a personal way into the series. In this section the writer begins the pitch by relating a true anecdote from his life that explains to the listeners why the writer has a special interest in the project. For example, a writer might begin a pitch by saying:

When I was growing up my dad was a high school chemistry teacher. My dad loved teaching chemistry, and when he got home from work he would explain to us kids that everything we encountered was composed of chemicals. He would explain that the water in the swimming pool in our backyard was composed of chemicals and that we had to add more water to the pool each week because of a chemical process called "evaporation" – water turns from a liquid state to a gas state. Years later, as an adult, as I thought about my dad, I wondered what would happen if a high school chemistry teacher, who loved chemistry as much as my dad and who was as knowledgeable about chemistry as my dad, chose to use his expertise for bad instead of for good. What could he do? What could he be capable of? And I realized he could use his expert chemistry knowledge to make very, very good illegal drugs.

As far as I know the creator of *Breaking Bad*, Vince Gilligan, did not open his pitch with that story, but he could have. There are several reasons why most American TV pitches begin with a Personal Way into the Series section.

First, a personal anecdote helps breaks the ice. The pitch meeting is a very tense situation. The writer is very nervous about getting his pitch right and talking for 20 minutes or more in front of a room full of people he may not know very well. A lot is riding on this meeting. The pitch meeting is also essentially a "sales call." One party is trying to sell a product to another party. It is not that dissimilar from a vacuum cleaner salesman trying to sell his wares. "Look at how well it cleans! This new vacuum cleaner is the best vacuum cleaner ever made!" To reframe a sales call into a more human interaction, the writer can use the "personal way in." It shifts the dynamic of the meeting from a transactional one to a personal and human one. It's a way of saying,

> Hey, I know I'm here to try to sell you a product, but let's remember that we're all just people, and the product I'm selling you is a story about the emotional journeys of some people I hope you care about, and I care about this product and have a personal connection to this product that makes it more than just a commodity to me and I hope to you too.

The second reason writers typically begin pitches with a personal way in is that it demonstrates to the buyer that *this* writer – of the thousands of qualified TV writers in Hollywood – *this* writer is the exact right one to write *this* story. Many writers *could* write this pilot. But most of them will be doing

it because it's their job. But this particular writer has a special, personal connection, has personal up-close experience with the subject matter that all the rest of the other writers don't have. The implicit argument made by the Personal Way into the Series section is that it offers the buyer an extra degree of assurance that this project – written by this guy who's pitching me the project – is worthy of the investment of his company's money.

The Personal Way into the Series also serves to introduce some of the themes of the show that the writer will discuss more directly and in greater detail later in the pitch. In the personal way into the *Breaking Bad* pitch I created above, the writer imagines what would have happened if his father had used his expert chemistry knowledge for bad instead of good. That question is at the heart of one of the themes of *Breaking Bad*: What happens when a good man is forced to do a bad thing for a good reason? Without talking explicitly about "themes" or "the meaning of the show," the Personal Way into the Series can begin to introduce some of the thematic layers of the series in a gentle and indirect way. Later, when the writer discusses his thematic intentions for the series more explicitly, the listener will unconsciously (or perhaps consciously) connect these themes to the writer's actual lived experiences and the themes will come alive in a deeper, more human and more personal way.

SECTION 2: CONCEPT OF SERIES

After the writer has set the stage for her pitch with her Personal Way into the Series, the next section of the pitch is the Concept of Series. Now that the writer has broken the ice, warmed up the room, told an interesting personal anecdote that has succeeded in getting everyone's attention, it's time to state very clearly exactly what product she's come to sell. "This is a show about X...." The writer explains exactly what the concept of her show is in the simplest, clearest and most economical possible terms. If I were pitching *Breaking Bad*, I might say,

> *Breaking Bad* is a show about a nerdy high school chemistry teacher who finds out he's dying of cancer, and, when he realizes that because he's paid so poorly to teach high school that his family will be impoverished after he dies, he decides to use his expert chemistry knowledge to manufacture the best possible crystal meth and make a lot of money so his family won't starve after he's died.[2]

That's the concept! Everything that makes the show unique, everything that makes the show function for what turned out to be seven seasons is in that one long sentence.

The Concept of Series section of a pitch should ideally be that simple. A writer should be able to state the concept of her show in one or two sentences, and the listeners should be able to understand exactly why the show is distinct from any other TV show they have ever seen and why it sounds intriguing based on this simple, clear statement of concept. If the writer and producer creating the pitch can't figure out how to come up with a clear and compelling sentence or two that defines the concept of their show, then there's probably a big problem with the concept they're working on.

Let's look at the Concept of Series more closely. What specific elements are in the *Breaking Bad* concept statement I pitched?

The first and most important element in this concept statement is the lead character of the series: the "nerdy high school chemistry teacher." Every Concept of Series statement in a TV pitch should clearly identify who the lead character or characters is/are.

The second most important part of the Concept of Series statement is: "... he decides to use his expert knowledge of chemistry to manufacture the best possible crystal meth and make a lot of money so his family won't starve after he's died." This part of the sentence offers the listener two key elements of the concept, the "plan" and the "goal." Every Concept of Series statement needs to make clear what the goal or goals of the lead character/s are. The lead character's goal in *Breaking Bad* is to make money to save his family from poverty after he's dead. That one goal drove seven seasons of the show, and it's stated clearly and economically in our Concept of Series statement. The goal answers the buyer's unspoken questions: "What is the lead character doing in this show and why's he doing it? Will my audience understand and relate to what the lead character is doing?"

In addition to explaining the goal, the *Breaking Bad* Concept of Series statement I've offered also spells out the lead character's plan, the "how" of his goal, the way in which he is going to go about achieving his goal. In this case, the lead character's plan is to use his expert chemistry knowledge to manufacture high quality drugs that he can

charge a lot of money for. That's a pretty inventive (and dangerous) plan. Stating the lead character's plan and goal addresses the buyer's basic, tacit question about any TV series pitch: "What am I looking at in episodes of this show? What's happening? What action is taking place on the screen?" In the case of the *Breaking Bad* Concept of Series statement, the buyer understands that what he's looking at in episodes is manufacturing and selling drugs to make money (and all of the conflicts and complications that arise from those pursuits).

The final point worth making about the Concept of Series is not really an element of the statement, but a quality of the statement: The statement should demonstrate ingenuity. The phrase I like to use is "entertainment delight." We should hear the words of the Concept of Series and sense that the show sounds entertaining. The words themselves should offer an entertaining sensation. In the case of this *Breaking Bad* Concept of Series the entertainment delight emerges from the transformation of a "nerdy" teacher into a drug dealer. There's an irony to that transformation. Most nerdy high school teachers spend their lives being nerdy high school teachers. We don't expect them to become drug dealers. When the Concept of Series tells us that this particular nerdy high school teacher becomes a criminal mastermind we experience a moment of entertainment delight because we're surprised by the irony of the character's transformation, which emerges from the unexpected plan the character devises to achieve his goal.

What's so brilliant about the *Breaking Bad* concept (the actual concept that the show's creator Vince Gilligan created, not the statement I've offered here) is that the lead character's plan is bold, dangerous and surprising, but it also sounds completely credible and comprehensible. His plan sounds surprising and not a plan most of us would ever choose to make, but the plan to leverage his chemistry expertise sounds very clever, and devising the plan to benefit his family sounds perfectly laudable. We understand he is a good man doing a bad thing for a good reason. That's a great concept for a TV show and the Concept of Series statement here makes it sound both clear and entertaining.

After stating the Concept of Series, the writer describes the themes of the series. "The show is about X, but what it's *really* about is Y." In other words, the writer implicitly says, "I've told you what the concept of the series is, now let me tell you what the major themes of the series are." The writer explains the deeper, subtextual meaning and significance of the show.

When the creator of *Pretty Little Liars*, Marlene King, pitched the show to networks she stated the concept simply and clearly, then she described the key theme of the show: "We'll explore the theme *what appears to be isn't.*" "Like the film *American Beauty*," she told them, "our characters live in this seemingly typical white picket fence world. But behind closed doors . . . We discover *that what appears to be isn't.*"

Most network TV development executives who hear pitches are looking for ideas that sound entertaining. They want to buy shows that function not only as entertainment, though, but that also have something to say. Network development executives want to develop shows that make their network money by attracting large audiences, but they also aspire to develop shows that work on a higher level and elevate their audience's lives. They want to use the power of the medium of TV to say something important, to make a contribution to society. Even in Hollywood, where the goal is to reach the largest possible audiences and make the most money, executives want to believe they're contributing to society in some way, and speaking to the development execs' hopes to say something meaningful about our world is one way that writers pitching shows can flatter development executives' loftier ambitions.

It's not just that development executives want their shows to have deeper meaning, the audience does too. Yes, we all want to feel like we're enjoying a nice, sweet dessert when we're watching a fun TV show, but we also want to feel like we're getting some meat with our meal as well. Consciously or unconsciously, audiences want to believe what they're watching is about something relevant, that it has some kind of meaningfulness to them along with the entertainment.

Another reason it's important for the pitch to state the themes of the show is that it's an opportunity for the writer to explain to the buyer why the show is especially relevant at this moment in time. Most buyers want to put shows into development that feel timely, that feel fresh and new, and not like something the networks might have programmed ten or fifteen (or even five) years ago. Networks want shows that feel like they're saying something about our world *right now.*

Hollywood entertainment professionals refer to shows and ideas like that being "zeitgeisty," turning the noun Zeitgeist into an adjective. Most network development executives who hear pitches are looking

for zeitgeisty shows. Describing the themes of the show allows the pitch to discuss explicitly how and why the show is tapping into the Zeitgeist, how it is "of the moment," how it is especially relevant today, right now.

SECTION 3: WORLD OF SERIES

The third major section of the TV pitch is the World of Series. The World of Series refers to the setting of the series, but in a good pitch the description of the world of the series can sound more significant than merely naming a town or a district of a town. It should paint a picture of a world.

The key elements of the World of Series are place, time and "vibe." Where does the series take place? A specific city, town or village? A specific district of a city or town? An unnamed, unspecified but nevertheless familiar kind of place? A made up place? *The Simpsons* is set in Springfield, but we have no idea what state or region of the US Springfield is in. In reality Springfield is one of the most common town names in America. There are 38 different cities or towns in America named Springfield. The creators of *The Simpsons* wanted audiences to feel like the Springfield of the show could be the Springfield near them. Not specifying exactly which Springfield the show is set in makes the world of *The Simpsons* feel more familiar to viewers, closer to their own lives.

The second element writers pitch to define the World of Series is time. Is the show set now, today? (Writers use the phrase "set in the present day" to refer to shows set now.) Or is it set in some historic period? Or the future? Sometimes writers pitch time very specifically. The action of the show *Mad Men* began in March 1960. The creator of *Mad Men* had a very specific time in mind for the beginning of his show. Television shows set in the Old West, on the other hand, don't usually pinpoint an exact time, but rather are more generally set in the period after the American Civil War and before the automobile became ubiquitous on American roads in the early 1900s. Most Western TV series are set some time in the 1870s or 1880s.

Some futuristic shows are set in a specific year in the distant future. The original *Star Trek* was set in the year 2265. A current trend in American TV is to set shows "five minutes in the future." Shows set five minutes in the future occur in a world that resembles our familiar everyday world today but it is a world in which technology is capable of things not quite possible

today. *Westworld* on HBO and the British anthology series *Black Mirror* are both set "five minutes in the future."

Good writers pitching the place and time of their series try to use language that also conveys a "vibe," a feeling of the world they imagine. Writers ask themselves if the World of the Series they're imagining is scary or happy? Would the viewer want to live in that world or would they be afraid to live in that world? Is it a cruel world or a generous and forgiving world?

In her *Pretty Little Liars* pitch Marlene King described the World of her Series, the fictional town of Rosewood, Pennsylvania, as, "A quaint, small town outside of Philadelphia. These are middle and upper-middle class people living in what appears to be a safe, sane world. But what appears to be isn't."

The listeners learn that the World of the Series is a "quaint" and "small" town outside of the big city of Philadelphia. The word "quaint" implies old, traditional, well-kept and attractive. ("Pretty" doesn't only describe the lead characters of the show. It describes the town the liars live in as well.) We also learn that the town is small and apparently safe. From the way King describes the world of *Pretty Little Liars*, it sounds like a very attractive, traditional, historic, and somewhat idyllic American suburb. Even though she uses very few words to describe her setting, the listener is able to create a specific and rich mental image in her mind. That's the goal of describing the World of the Series.

While we're discussing King's description of the world of *Pretty Little Liars*, let's take note of two other interesting things. First, observe the brevity of her description. Most writers who pitch TV shows are tempted to say too much. They want to go to great lengths to make sure that the listener sees and understands everything they see. This frequently leads writers to create pitches that are too long. Writers, producers and creative execs developing pitches should resist this temptation. Network television development executives (at least in Hollywood) are famous for having short attention spans. They hear lots and lots of pitches and are bored easily. There was a network development executive in Hollywood who was well known for her occasional cruel honesty. When she got bored with a section of a pitch she would say to the writer pitching, "I *get* it, move on."

The goal of every section of every TV pitch should be economy. Writers pitching TV shows should choose words and sentence

constructions that say as much as possible in as few words as possible. In just a couple of short, simple sentences Marlene King says as much about Rosewood, Pennsylvania, as the network development executive needs to hear, and she manages to paint a very clear picture. Writers pitching pilots should figure out the descriptions and images that allow the listeners to use their imaginations to see the whole world the writer wants to create. When pitching a TV show writers should say too little rather than too much. The goal is to intrigue the listeners, to make them want to learn more about the show, to whet their appetite rather than overload them with too many details that overwhelm them, bore them or make their minds begin to think of other things. Less is more.

In addition to speaking economically, another thing King's pitch does is to speak simply. Hollywood writers typically write a script for their pitches. It's easy for a writer to forget that he's not writing something to be read, but that, with a pitch, he's writing a script to deliver orally to someone who will hear it spoken. Even though most network development executives are educated and smart, pitches that are crafted in a way that is easy to hear and easy to understand tend to be more effective.

There's a great expression, "Keep it simple, stupid." ("Stupid" being one's self, the person to whom the statement is addressed.) We're all tempted to expound at length, to show off our brilliance and to write in highly complex ways. But when creating pitches for people who listen to pitches all day long, it's worth remembering that 1) less is more and 2) keep it simple, stupid.

One last thing King did in her brief but effective World of Series section that's worth noting is that she used it to reinforce her main theme, "what appears to be isn't." She implemented an age-old tool of salesmanship (remember, pitching is a form of selling), namely repetition. Pitchers don't want to bore their listeners by repeating factual information, but important things like themes can be made more impactful in the pitch through the use of repetition.

The World of Series should describe what it would be like for the listeners (and ultimately the viewers of the show) to walk through that world.

SECTION 4: CHARACTERS

The next two sections of the TV pitch are the most important sections and the hardest to craft and pitch. The first of these two is the Character section of the pitch. This section lists and describes the most important characters of the show, one by one.

Writing great characters is hard. In script form, writers have all the tools of dialogue, action, story and shot description to bring the characters to life. In a pitch, the writer has an even more limited toolbox. Pitching great characters is hard.

The reason the Character section is one of the most important sections of the pitch is because what hooks a viewer into a TV series more than anything else, and correspondingly what hooks a TV development executive into wanting to buy a pitch more than anything else, is falling in love with the characters. When the viewer of a show or the listener to a pitch falls in love with the characters, they begin to care about what happens to those characters. They want to know what happens to them in future episodes. They want to find out if they achieve their goal and turn out ok in the end. If the pitcher can make the listeners care about the characters and want to know what happens to them, she has travelled a great distance toward successfully selling the pitch.

How do writers make listeners fall in love with a character and care about what happens to them? That is part of the great art of pitching. Pitching, like most things, is a talent. Talent can be developed, encouraged, trained and to some extent taught. But to a great extent it's innate. Some people are great pitchers. Others will always struggle. Producers try to find the best available writer for a project, but producers also look for writers who are talented pitchers. It may not be as important a skill as actually writing great scripts, but it makes selling a lot easier. Writers need to be realistic in their assessment of their own pitching talents, and if they need training and practice, they're usually wise to invest in learning how to become better pitchers.

One technique writers use to pitch character is to take a two-step approach, to start with the general then move to the specific. Character pitches like these begin with the basics: name, gender, age, occupation and general appearance. Most pitches don't get hung up on too many specific details of

the character's appearance. At the end of the day, the actual appearance of a character as the audience sees him will come down to casting, and the pitch is a long way from that step of the process. Pitches usually keep physical description fairly general. The character is "tall" or "chubby" or "hot."

After providing the quick basics about a character, pitches then frequently define the character's "type." In *Gossip Girl* Serena might be described as the "ingénue" type. Blair would be described as the "jealous best friend" type. And Chuck Bass would be described as the "guy you love to hate." Descriptions like these are known in pitching as "handles." By defining the type a character is, the pitch provides the listeners with a "handle" to grab onto to place the character in context within the ensemble of characters that's being pitched. The listener understands the character's role in the show.

It's crucially important that each character pitched sounds distinct from the other characters. Providing the listeners with these kinds of handles helps distinguish all the characters from one another in very simple and memorable terms. The development execs listening to the pitch are learning of these characters for the first time; they want to be able to get a clear picture of the ensemble of lead characters. Who are the characters the audience is supposed to root for? Who are the characters the audience is supposed to root against? Who are the lead characters' allies? Who are her enemies? Which characters are potential love-interests? Before the rich details and complexities of characterization can be digested, the listeners want to be able to grasp the basics. *Pretty Little Liars* featured four lead characters, four sixteen-year-old girls who were equally important within the show. Marlene King's pitch described each lead girl's type so the listener had an easy "handle" to hold on to each of the girls' distinct characters: Aria was the "artsy girl," Hanna the "blonde hottie," Spencer the "overachieving nerd" and Emily was the "jock." These are four very general character types that make each of the four lead characters distinct from one another.

Once the pitch has provided a basic description of a character and placed the character within a character type, the second layer of description offers details that make the character unique and distinct from others *within* her type. There are lots of "blonde hotties" in teen shows. What makes *this* blonde hottie unique and distinct from all the other blonde hotties we've seen before? *Pretty Little Liars* was a show about secrets. Each girl had her own dirty secret that she kept from her friends and family. In pitching the

Pretty Little Liars characters, King used the girls' secrets to make each unique and distinct from her type. Hanna, the blonde hottie, had a big secret: She was a kleptomaniac, a shoplifter, who stole luxury items to try to keep up appearances because she lived in a competitive, upscale community and her parents had recently divorced, reducing Hanna's mother's ability to afford expensive clothes and accessories. Hanna stole them to make herself feel like she could fit in with her rich, attractive friends. She was a "blonde hottie" type that was then made unique, distinct and specific by also being characterized as a shoplifter.

To be crystal clear, pitches discuss each character individually and thoroughly before moving on to the next character. I'm using the examples here of the four *Pretty Little Liars* lead characters, but in the pitch each character would be discussed completely before moving on to the next character. Hanna's basic facts, type and her unique secret – along with other details of character – were described before moving on to the next lead character.

Spencer was an overachieving nerd who studied all hours of the day and night to get good grades, but what motivated her to do this was that she was competitive with her older sister. Spencer's older sister Melissa was a high school Miss Perfect who got straight As. Spencer worked hard to keep up with her sister's legacy. Those "facts" defined Spencer's type: the academic overachiever. They provided context and motivation for her type: She overachieved to keep up with her competitive big sister. But Spencer had a secret too: She was secretly deceiving her perfect older sister by having an affair with her sister's fiancé. Now that's a fun secret! Her type was "high school overachiever." But what made her distinct from all the other high school overachievers we've seen on TV was that she was having a secret affair with her big sister's fiancé. Her secret made her unique and distinct and helped define the extremes of her character. She was a "good girl" because she studied hard and got good grades. But she was a bad girl because she betrayed her sister. Those two simple details about the character made her familiar and relatable on the one hand (the handles), but unique and surprising on the other hand.

"Surprise" is an important quality in pitching TV shows (or any form of entertainment). The paradox that a good girl like Spencer could also be a bad girl who cheated with her sister's fiancé is surprising. We think we know Spencer when we hear she's an academic overachiever who studies

hard to get good grades. Then we're surprised when we learn she's secretly a sex cheat (who betrays her own sister no less!). The surprise of that paradox is fun and provides a moment of entertainment delight. The perfect girl has a major flaw. The good girl has a moral weakness. The paradox of her character is surprising and fun.

This two-part approach to pitching characters (describing a character's "type" followed by describing what makes the character *distinct* from her type) attributes complexity to the character, offers the opportunity to introduce small doses of surprise to the pitch, and, in the examples used above, provides a third effective element of character definition: victimhood. Everybody roots for an underdog and, interestingly, most of us sympathize with and identify with victims.

Let's look again at some of the characters in *Pretty Little Liars*. Spencer was an academic overachiever. We don't usually think of overachievers as victims and we're not usually drawn to liking overachievers. In fact, we usually find them annoying. But Marlene King told us why Spencer was an overachiever: because she was living in the shadow of her perfect older sister, because she was trying to keep up with her big sister's image. In effect, she was the victim of her big sister's perfection. Hanna was a shoplifter. Again, not typically a very appealing quality. But King told us *why* Hanna was a shoplifter: because her father divorced her mother, abandoning Hanna and leaving her mom with a reduced income. Hanna is embarrassed by her family's failures, and she struggled to keep up appearances in their affluent social circle. In the simplest of terms, Hanna wasn't loved by her father. As Hanna said to her mom in the pilot script, "We got dumped." In other words, she was a victim.

These simple character definitions, requiring only a few sentences of description, managed to 1) attribute complexity to the characters, 2) offered the listener a delightful small dose of surprise about each character and 3) engendered sympathy for each character by hinting at some form of victimization.

Another common strategy many writers use to pitch character is to suggest a well-known actor whose screen persona resembles the character. Writers might describe a character as a "Jennifer Lawrence type" or say about a male lead, "Think Ryan Gosling." The listeners know Jennifer Lawrence will never actually play that role. She's one of the biggest movie stars in the

world. But associating the character being pitched with Jennifer Lawrence plants a specific mental image in the listeners' minds. The reference to the movie star elevates the character being pitched. As the pitch is delivered the listeners think of Jennifer Lawrence (and all the wonderful qualities that make her such a big star) every time that character is referenced.

This technique can also be a helpful way of addressing race. Race is a very sensitive issue in Hollywood these days (as it is in much of our society). Network development executives are appropriately concerned with presenting ethnically diverse ensembles within the shows they develop. Frequently it will be necessary for a pitch to address this issue directly. The show *Underground* was about African Americans escaping slavery in the American South in the 1850s. The lead characters had to be African American and it was crucial in pitching the characters to identify which characters were black and which characters were white. In other cases, describing one character as "a Kevin Hart type" and another as "a Maggie Q type" can suggest the writer's and producer's intention to cast a diverse ensemble of actors.

Beyond description, character is largely defined by story. In the next section of the pitch the characters will be placed in motion. They'll be confronted with obstacles, make choices and take action. The choices they make within stories will largely define who they really are, and that's where the listeners will get a chance to discover what they're really made of. I'll get to that soon. The Character section for the most part is used to describe the characters at the outset of the story, at the outset of the series. The "before picture," if you will. As the pitch continues into the following sections the characters will be put into action and become who they'll be at the outset of the series.

It's easy for TV viewers to keep characters straight. They're played by actors who look different and wear distinct wardrobe that helps define them. But it's hard for executives listening to a pitch to remember which character is which. They're hearing the characters' names for the first time. Because of this, pitches tend to describe as few characters as possible. Keeping straight more than five or six characters that you're hearing about for the first time is difficult. Good TV pitches generally make very clear which characters are the lead characters that viewers will see in every episode, which characters are supporting characters who appear in fewer than all episodes, and which characters are what are known as "recurring" characters (not "re-occuring" characters; the correct term is "recurring"), characters who may appear in

only a small fraction of the episodes. Successful pitches typically avoid pitching recurring characters unless absolutely necessary. Less is more. Most pitches only include the characters the listeners need to know to understand the concept of the series and how it works.

When pitching characters, good pitches build an ensemble of interrelated characters rather than just listing individual characters. With *Gossip Girl*, for example, we could simply list the lead characters:

> Serena is an effortless blonde beauty with a wild streak and a heart of gold. Blair is the queen bee of her private high school, Constance Billard School for Girls. Nate is a handsome boy who goes to St. Jude's School for Boys.

But the stronger way to pitch this ensemble is to tie them all back to the first character, to build from one to the next, defining their interconnections:

> Serena is an effortless blonde beauty who moves home from boarding school and returns to Constance Billard, her old fancy private high school on New York's Upper East Side. Blair was Serena's best friend at Constance whose queen bee status in school is now threatened by Serena's return. Nate is Blair's boyfriend, and Serena's return rekindles old feelings in Nate, reminding him of a secret fling he and Serena had behind Blair's back before Serena left for boarding school.

See how much stronger the second version is? And how much easier it is to follow a list of characters when their interrelationships are clearly defined and built one to the next?

Speaking of interrelationships, while it's essential for pitches to give listeners a sense of the personality of all the individual characters, almost as important is to describe key dynamics between lead characters. Ross's secret, unrequited love for Rachel and her indifferent recollection of him as her high school friend's brother was just about as important to *Friends* as the characters themselves (at the outset of the series – that dynamic between the two characters would grow and evolve over time, of course). That crucial dynamic was both highly entertaining and a wellspring of numerous stories. "Relationships" describe connections between characters. "Dynamics" refers to how characters think and behave toward each

other, the externalization of feelings between characters that viewers can see on the screen.

Lastly, a simple but important rule of thumb in TV pitches is to choose character names for the series regulars that begin with different first letters. "Karen" and "Tracy" are easier for both audiences and development executives to keep straight than "Karen" and "Kelly."

SECTION 5: PILOT STORY

The next section of the typical TV pitch format is the Pilot Story. As in all other parts of the pitch, brevity is key. Effective pitches only pitch as much of the pilot story as is needed to make the story clear, to put the characters into action, to demonstrate how the series works and to have an emotional impact on listeners. Good pitches use the pilot story to make listeners feel something. To surprise them. To make them laugh if it's a comedy, to make them cry or feel tension if it's a drama.

As mentioned earlier, the ideal length for an oral TV pitch is about 15 to 25 minutes, and the Pilot Story section is usually the longest section and typically takes roughly five to seven minutes of the total pitch, sometimes a bit more if necessary.

The Pilot Story is pitched in the present tense. Pitchers don't say, "He did this and then he did that." Use the present tense: "He does this and he does that." "Is" not "was." Pitching story in the present tense makes the story feel more immediate. The past tense sounds like a fairy tale you might read in a book. The present tense sounds like something we're watching right now, right in front of our eyes.

Writers typically begin the Pilot Story by pitching the set-up, the starting place, the part of the story that's known as the "status quo." They pitch the lead character or characters occupying their world before the story's major events occur.

A handy technique many pitchers use as they mention characters in the Pilot Story section that they've introduced earlier in the Character section is to remind listeners who each one is. If it's a single-lead show like *Breaking Bad*, that's not necessary. Everyone will remember who Walter White is

from the description of him a few minutes earlier. If the series has more than one lead character like *Pretty Little Liars*, however, writers usually offer reminders about which character is which. If the writer doesn't do that, a listener might think to herself, "I remember the names Aria, Spencer, Emily and Hanna, but I can't remember which is which. Is Aria the shoplifter?" Marlene King offered short, parenthetical reminders as she pitched her pilot story. The first time she referenced Aria in the Pilot Story (after introducing her in the Character section) she reminded the listeners that "she's the artsy one," and when she switched over to Spencer's storyline she reminded listeners that Spencer is the "competitive cheater."

In some pitches, the Character section of the pitch will have sufficiently described the lead characters' starting places so the Pilot Story section can pick up later in the story. Even though the status quo part of the pilot story might account for the first 20% of the actual pilot script once it's written, there's no need to pitch it again if the Character section of the pitch has already described the starting place of the lead characters. In that case, the pitch can begin the Pilot Story section with the first story turn, the first major, dramatic event that occurs to the lead characters that alters their status quo.

In *Breaking Bad*, the status quo occupies two areas of Walter White's life, his home life with his family and his work life at school. At home he's a husband and father. He's loved by his family but is also the butt of his wife's and son's jokes. At work, in his job as a high school teacher, his status is even lower. While it's clear Walter loves the subject he teaches and takes the instruction of chemistry very seriously, his students don't appreciate what he has to offer them, and they treat him with disrespect. While his family's jokes are affectionate, his students' jokes are cruel and abusive. Walter's life is a little pathetic. He's emasculated at both home and work. That's Walter's status quo. (In other words, he's characterized as something of a victim.) If that kind of set-up is included in the Character description section, there's no need to repeat it in the Pilot Story section.

The Pilot Story section for a *Breaking Bad* pitch would begin with the first major "turn" of the story, the first major plot point. The first major turn of the pilot story is when Walter gets taken to a doctor after fainting, and the doctor tells him he's dying of cancer. He's got about a year to live. This news is the pilot story's first major turn. This is the event in the pilot story that sets the story (and the series) into motion, the pilot story's inciting incident.

Even though *Breaking Bad* was a far more sophisticated show than *Pretty Little Liars*, aimed at a more mature and demanding audience, *Pretty Little Liars* actually had a more complex pilot story. The *Breaking Bad* pilot told one story, the story of how Walter White became a drug maker. The *Pretty Little Liars* pilot actually told six stories, one small story for each lead character and two overarching stories that affected all four girls. Five of the six stories were pitched in the Pilot Story section of Marlene King's pitch.

Because the status quo of each lead character was described in the Character section of the pitch, the *Pretty Little Liars* Pilot Story section began with the first major story turns of Aria's story and the overarching story. Aria, the artsy one (see, I just reminded you which one Aria is, and I bet you were grateful for the reminder!), meets Ezra at a local college bar, allows him to assume she's a college student rather than the high school student she actually is, they share an immediate attraction and kiss passionately in the bar bathroom, and the next day – the first day of the school year – Aria discovers that Ezra is her new English teacher. That discovery is the first major turn of Aria's story. The next major event of the pilot story is the first major turn of the first overarching story: Aria receives her first text from the unseen character "A" threatening to tell everyone that Aria kissed her teacher. King's *Pretty Little Liars* Pilot Story section goes on to pitch the first major story turns for the remaining three lead characters. (I told you the pitch was complex!) That's another reason King used such simple language in her pitch. The stories themselves were complex enough – she didn't want to confuse her listeners with unnecessarily florid language as they listened to her five-part, intricate Pilot Story section.

While the Character Section of TV pitches examines each character, one at a time, typically in order of importance, a Pilot Story section that pitches more than one story (like the *Pretty Little Liars* Pilot Story pitch) can handle multiple storylines in either of two ways: It can "cross-cut" between multiple stories (beginning the A-story, then shifting to the beginning of the B-story, then beginning the C-story, then shifting back to the next major event of the A-story, etc.) or it can tell all of the A-story from beginning to end, then all of the B-story from beginning to end, then all of the C-story. Deciding how to structure the Pilot Story pitch is up to the pitcher and her partners, and typically the two main issues they consider when determining the structure are 1) clarity and 2) dramatic impact. What's the most effective way to tell these multiple stories and make sure the listeners can follow the pitch?

As I mentioned earlier, story defines character. The pitch will introduce the characters in the Character section, but listeners will really grow to understand them in much greater detail when they hear what the characters *do in action* in the pilot story.

The most important thing the development executives listening to the pitch need to learn about the lead characters in the Pilot Story section is their goal. What are the lead characters' goals in the pilot story? What do the lead characters want? What do they spend the pilot episode – and potentially the entire series – pursuing?

During or after the description of the first major turn of the pilot story, effective pitches tell the listeners what the lead character wants. In *Breaking Bad* Walter's goal is introduced in the scene after he learns he's dying of cancer. At his 50th birthday party Walter sees a news report on TV about a local drug-bust, and the report shows stacks of cash that the cops confiscated at the bust, hundreds of thousands of dollars. A light bulb goes off in Walter's head. Walter doesn't say it out loud but thinks to himself, "If uneducated guys manufacturing methamphetamine can make hundreds of thousands of dollars, a guy with my knowledge of chemistry could make a fortune!"

That moment defines the entire series. It defines Walter's goal for both the pilot story and beyond: manufacture drugs to make money to provide for his family after he dies of cancer.

Once we're told what a character wants, what his goal is, we really understand the character. That's usually when we truly *get* the character. Nothing crystalizes a character more clearly than learning what he wants. If the lead character's goal in the pilot story is believable and relatable (if we can imagine ourselves wanting the same thing if we were in his shoes), we connect to him and begin to care about him and root for him. This is what we mean by "story defines character."

In *Pretty Little Liars*, Aria wants Ezra. Ezra is her pilot story goal. Winning Ezra's love, despite the moral and practical complications that he's her teacher, is her goal in the pilot story and her goal for much of the run of the entire series. Each of the lead characters' goals in *Pretty Little Liars* is defined clearly in the Pilot Story section of King's pitch. Writers work hard to figure out what parts of their pilot stories define their characters and include those parts of the story in their Pilot Story sections. A writer asks

Pitching New Pilots and Series 151

herself, "What does my lead character want in the pilot episode, what is he trying to get?" Writers need to know the answer to that question and make sure to set their characters' goals in motion in clear terms in the Pilot Story section. Story defines character.

Writers usually mention act breaks in their Pilot Story section. The story content of act breaks includes twists, surprises and cliffhangers. The story content of act breaks is designed to make sure the audience doesn't change the channel when the commercial comes on. Act breaks are designed to make the viewer think, "Oh my god, what's going to happen next?!" or "How will that character ever get out of that situation when we come back from the commercial?!"

Writers and producers study the formats of the networks they're pitching and figure out how many acts their shows include. They try to create big act-break twists and surprises for some or all of the act breaks of their pilot story and pitch those act breaks. If a writer can create them, they pitch those big twists and surprises. Studying potential buyers' formats and tailoring the delivery of their pitch to those specific formats impresses executives and demonstrates to them that the writer watches that network's shows and knows what its programming brand is about. Even with shows at networks that don't have commercials, writers still typically structure their stories in acts and pitch act breaks.

Pitching the ending of the pilot story can be tricky. Writers want to pitch an ending that feels satisfying, that feels like the resolution of the story, but pilot episodes can't resolve *everything* or there's no series that can follow it. That story feels like a movie, not a TV pilot. The endings of pilot stories need to feel like satisfying resolutions but resolutions that also promise more drama, comedy and/or complications to come. "That's the end of this chapter, but only the beginning of a much larger story!" That's what the ending of the pilot episode should suggest and what the ending of the Pilot Story section of the pitch should convey.

In the *Breaking Bad* pilot story, Walter White makes his first batch of drugs, tries to sell it to drug dealers, almost gets murdered by the drug dealers who try to steal the drugs and kill him (rather than pay him for the drugs as they had agreed earlier), but then Walter outwits his attackers and manages to kill them and take their money. Walter wins! The pilot story ends with a big victory for Walter. He's succeeded in beginning to achieve his goal of

making money by manufacturing drugs. Even though the ending of the *Breaking Bad* pilot episode delivers a surprising and satisfyingly victorious ending, we know it's only the beginning of Walter's journey. He needs to manufacture a lot more meth and make a lot more money to be able to provide for his family after he's dead. We know that the thrill of becoming a criminal has only whetted his appetite for more mayhem. This chapter has concluded, but it's only the beginning for Walter White! That's how writers typically try to craft the ending of their pilot stories and the ending of the Pilot Story section of their pitches.

Here are a few more ideas to keep in mind when developing successful pilot story pitches.

Other than reminding listeners of which character is which (e.g., "Aria's the artsy one"), pitchers usually avoid repeating themselves. They build on information they've delivered earlier. Reminders can help listeners avoid confusion, but pitchers try to create a strong sense of forward momentum as they pitch the story of the pilot, and repetition slows that momentum and bores the listeners.

Another thing the best pitchers do is to connect emotionally to the Pilot Story they're telling. As I've already discussed, one of the primary goals of all TV storytelling is to convey and arouse emotion. To take the viewer on an emotional journey. To make viewers care about the characters and to make them feel something when good things or bad things happen to those characters. The same applies to the Pilot Story pitch. Ideally the writer wants the listeners to *feel* something as he tells his pilot story. An important technique to make the listeners feel something is for *the pitcher* to feel something. The emotion the pitcher displays as he pitches the pilot story cues the listeners to experience the same emotion.

How does a writer "display" emotion as she pitches her story? She feels it. We can't fake a display of emotion. Actors aren't faking emotion when they display the emotions of their characters. They're actually feeling the emotions. Actors use the emotional context of the scenes and stories they're playing to find a way to feel the emotion of a scene. Even though writers aren't actors, when they're telling their stories they need to do the same thing that actors do. When writers pitch emotionally resonant stories they need to use the emotional power of the story they're telling to emotionally connect to it. They need to *believe* the story they're telling. They need to feel

it. They need to feel it so the listeners they're pitching to see them feel it and get swept into feeling it too.

Don't get me wrong: This is hard to do. The writer is basically reciting a speech he's memorized. He's struggling to remember his speech. We all get nervous when we have to speak in public to people we don't know very well. A lot is riding on this pitch meeting going well – we feel the pressure of trying to make the meeting a success. All these factors make it very difficult to emotionally connect to the story we're telling. Sometimes we even forget we're supposed to do that. Pitching is one of the writer's jobs, and he or she needs to work on it. They need to practice it. Remember that telling stories is why we got into this business. It's why we're here, why we want to make the TV series we're pitching.

Writers need to believe in the story they're telling and figure out what it is about the story they're pitching that makes them care, what touches their hearts or what makes them smile or laugh. When a writer tells the story of her pilot, she needs to remember to connect to that thing. To enjoy the fun and drama of her story as she tells it. To enjoy the opportunity to share her story with the people to whom she's telling it. If she can tell her story with the emotion and enthusiasm she feels for her story, she'll be on her way to a successful sale.

Here's an important gut-check: If a writer isn't connecting emotionally when pitching his pilot story, he and his partners should stop and ask themselves why. I'm not referring to when the writer's pitching to buyers. That's very hard to do (though not impossible) for the reasons described above. But if the writer can't pitch it into the mirror, or to his friends, spouse or business partners, and emotionally connect to his pilot story, he and his partners need to ask themselves if the pilot story is really working. Is it emotional enough? Is it good enough? If he can't tell his pilot story and get emotionally connected to it, it's probably because the story itself isn't emotional enough. That's a big problem. That's probably not a problem with the pitch, but rather a problem with the pilot story itself. Sellers (producers, studio development executives and agents) need to make sure what they're pitching is ready to pitch, and, if it isn't, they need to stop, go back and work on it. They need to make sure all of the pitch is great – with interesting characters the audience will care about and a pilot story that will make the listeners feel like they're riding a roller coaster – or they shouldn't pitch it. Fix it first.

SECTION 6: ARC OF FIRST SEASON/ARC OF SERIES

The next section of the pitch is the Arc of the First Season and/or the Arc of the Series. An "arc," as we know, is a story told over multiple episodes or multiple seasons. The Blair-and-Chuck romance was a story arc in *Gossip Girl*. That arc had many ups and downs and lasted several seasons. There were shorter romantic story arcs in *Gossip Girl* too, like the romantic arc between Dan Humphrey and his teacher Rachel Carr that lasted three episodes in Season 2. Both of these are romantic story arcs. Walter White's conflict with Gus Fring was a story arc that lasted two and a half seasons on *Breaking Bad*.

Television series are designed to last several seasons. Seasons (which are defined by the number of episodes the network chooses to program during a given year) are frequently shaped by season-long story arcs. The primary story arc of Season 1 of *Game of Thrones* focused on Eddard Stark, the character played by Sean Bean. Eddard Stark's Season 1 arc followed him as he investigated who killed the previous "hand" of the king of Westeros (as in "right-hand man") and followed Stark trying to protect his family in a dangerous world.

(Needless to point out, a series like *Game of Thrones* offers many story arcs that intertwine within episodes and play out concurrently. The Eddard Stark/who-killed-the-hand arc was one of many story arcs of Season 1.)

Writers may have plans for story arcs for several seasons of their series, but the network development executives listening to the pitch want to hear primarily about the arc of the first season of the series (if one exists) and whether or not there is an overall arc to the series as a whole. The overall series arc of *Breaking Bad* was pitched by creator Vince Gilligan as "Walter White goes from Mr. Chips to Scarface."[3] In other words, Gilligan suggested his series would track the transformation of its lead character from a friendly, kind-hearted teacher to a completely amoral criminal mastermind. That's how Gilligan pitched the overall arc of the entire *Breaking Bad* series, and that's exactly what he spent the next seven seasons of the show dramatizing. He had a clear game plan from the outset of his series, and he ultimately delivered exactly what his pitch promised.

Many shows don't have season arcs or series arcs at all. Many procedural shows like cop shows or medical shows focus on the "case of the week" rather than stories that continue beyond one episode. *CSI: Crime Scene Investigation* lasted 14 seasons and offered very few story arcs. Each episode of the show (there were 337 of them) introduced a new case, a new murder mystery that it solved by the end of each episode. The creator of *CSI: Crime Scene Investigation* didn't pitch Season 1 arcs or series arcs because they weren't part of the design of his series.

Today, however, most American shows do arc out stories over the course of multiple episodes. If the design of a series includes a major story arc that will last most or all of the first season, or if the project has in mind – as Vince Gilligan did for Walter White – a series-long arc, the writer delivers that in this section of the pitch.

When Marlene King pitched *Pretty Little Liars* she described several Season 1 arcs, including an arc for Aria's parents (including yet another reminder of which character Aria was):

> Aria (mature girl who makes out with teacher) discovers her father, Byron, is cheating on her mother again with Meredith, a college art teacher. Byron leaves the family and moves in with Meredith. Ella, Aria's mother, finds out that her daughter knew about the affair and kept it from her. Ella doesn't know if she can ever forgive Aria.

A common strategy these days for arcing seasons of TV is to create an antagonist (also known as a "nemesis" or "bad guy") that the lead character defeats at the end of the season. *Buffy the Vampire Slayer* referred to this kind of character as a "big bad," and the expression has stuck within the industry. The season-long antagonist "big bad" often defines a season-long story arc. Series that use this structure will typically then introduce a new "big bad" the following season and again the season after that and so on. *Breaking Bad* offered a revolving door of bad guys who came and went, always defeated by Walter White. Tuco, Gus Fring and the White Supremacist Group were a few of the antagonists that lasted one or two seasons (constituting one or two season-long arcs) on the show. If a writer imagines an antagonist that the lead character defeats at the end of the first season, the writer will typically pitch that arc in this section of the pitch.

SECTION 7: TONE

In the next section of the pitch the writer describes the tone of the series. Once the pitch has explained the concept of the series, introduced the major characters and laid out the pilot story, the network development executive wants to know what the show will feel like and how that "feel" will be different from other shows like it. This is tone.

I offer the following definition of tone: the style of writing and overall execution that suggests the writer's attitude toward his subject; typically defined by serious versus light-hearted, dramatic versus comedic, "soft" versus "edgy," sophisticated versus simple.

A technique that many writers use is to compare the tone being pitched with the tone of another show that's already on the air. The tone of *Breaking Bad* could be pitched as the tone of *The Sopranos* but with a bit more black humor. Like *The Sopranos, Breaking Bad* was naturalistic, edgy, sophisticated and sometimes brutal but offered slightly more black comedy than *The Sopranos. The Sopranos* had a comedic strain of its own, but the comedy of *The Sopranos* came more from mocking the ignorance and crudeness of its provincial criminal characters.

When Marlene King pitched *Pretty Little Liars* she couldn't think of another series that employed a tone similar to what she planned for her show. In many ways *Pretty Little Liars* was inspired by the show *Desperate Housewives*, but King imagined that the tone of her new show would be quite distinct from that earlier series. She came up with a single word that isn't used very often to describe the tone of TV series, but it proved effective in giving network development executives a very clear idea of the unique tone she planned. King told executives that the tone of *Pretty Little Liars* was "delicious." Network executives smiled when they heard that word, and after seven seasons it's safe to say that "delicious" was exactly what King delivered.

There have been many cop shows and many medical shows over the years. Tone is one of the key elements that distinguishes shows in these genres from one another. *ER* and *Grey's Anatomy* are both medical shows set in hospitals. But the tone of the two shows couldn't be more different. *ER* was intense, raw, realistic, propulsive and often seriously dramatic. *Grey's*

Anatomy is lighter, more fun, flirtier, sexier, more playful, more of a soap opera. Writers work hard to make sure they're pitching the tone of their shows in a way that helps the development executives understand exactly how the show will be unique and distinct from others like it that have come before.

SECTION 8: SAMPLE EPISODES

The final section of the typical TV pitch is the Sample Episodes section. In this section writers typically pitch short summaries of the storylines of three potential episodes of their series.

By this point in the pitch the network execs may be convinced they've heard a great pilot story but might still not be able to imagine how the series can sustain multiple episodes beyond the pilot. Pitching three sample episode storylines can help demonstrate how the series will work after the pilot. Three one- or two-sentence story pitches that sound (in short form) as compelling as the pilot episode story can prove to the listeners that the concept of the show can work beyond the first episode. Even short pitches like these can prove to the listeners that the series being pitched "has legs" and can sustain for the long haul.

The three episodes don't necessarily need to be the next three episodes that will immediately follow the pilot. They can be three episodes that might occur anywhere in the first season. The pitch can specify exactly where the three episodes would come in the air order. The writer could say, for example, "This first episode I'm pitching will be the next episode after the pilot, the second episode will come midway through Season 1, and the third episode will be the Season 1 finale." Or, if the air order isn't that clearly defined, the writer could simply say, "Here are three typical episodes of the series." This implies they might occur anywhere in the run of the series.

The kinds of stories a series chooses to tell help define the series and clarify how it's unique and distinct. *CSI: Crime Scene Investigation* was basically a cop show (like the dozens and dozens of other cop shows that preceded it on American TV), but one of the things that distinguished *CSI* was the kind of cop stories, the kind of murder mystery cases it chose to tell. *CSI* usually told odd, kinky, frequently highly sexualized kinds of murder cases. Taking advantage of the show's Las

Vegas setting, the show distinguished itself from other murder mystery cop shows by focusing on very "Vegas-y" types of weird, sexy murder stories. Pitching three specific examples of these kinds of stories helps illustrate to the listeners how a writer plans to make his series different from others like it. The sample episode storylines can also help convey the specific vibe of the show, building on the tone of the show just described in the previous section of the pitch. "Oh," a listener might say to himself after hearing three sample episode storylines, "they're not going to tell typical, run-of-the-mill murder stories in this series. They're going to tell kinky, weird, Las Vegas Strip kinds of murder stories! I get it!"

Some shows are based on a unique storytelling device. Think of the series *24*. Each of the 24 one-hour long episodes of a season of *24* was told in real time over the course of one hour in the life of the lead character who worked as a counter-terrorism agent for a secret government agency. The 24 episodes of the season told the story of one incredibly intense 24-hour day in the lives of its characters. The writers who pitched this series must have explained how the unique storytelling device would work, then pitched the pilot story to demonstrate in detail how the first episode would work. The development executives were probably still skeptical that the device could sustain beyond the first episode until they heard the device illustrated again and again in specific sample episodes.

Writers generally try to keep the Sample Episodes section of story pitches brief. The listeners know that the pitch is coming toward its conclusion. They've been listening to the writer talk for 20 minutes or so and are beginning to feel antsy. Once they sense that a pitch is entering the home stretch they tend to grow eager to get to the finish line and wrap it up. The Pilot Story section is the heart of the pitch. Everything after that is icing on the cake. Writers try to keep these last two sections concise and avoid wearing out their welcome by belaboring their point. Writers often try to employ a "get in and get out" approach to pitching. Less is more.

Q&A

After the writer has finished the pitch, the network execs will inevitably have questions. In Hollywood it's actually considered rude if they don't. If

the network executives simply say, "Thank you, we'll think about it," that's an indication of disinterest on their part. If the pitch has truly engaged them, they'll come alive with several questions about how things work in the series or ask for more information about the characters.

Questions from listeners don't mean that the writer hasn't addressed what they wanted to hear about. It means the writer has succeeded in intriguing them. The writer wants them to ask questions. The writer wants them to lean forward in their chairs and ask for more information. It's an expression of interest, an indication of genuine engagement.

At this point the pitch meeting becomes a conversation instead of a monologue. If the writer has producing partners present and the writer has delivered all of the pitch (as is standard), this is an opportunity for the producers to speak up and help the writer answer the network executives' questions (and give the writer a chance to catch his breath or take a sip of water).

Most pitch meetings (following a few minutes of conversation about what's just been pitched) will end with the network executives thanking the writer and producers for the pitch, and letting them know they will think the pitch over, discuss it with their colleagues and get back to them with an answer soon. The decision can take anywhere from a day to two weeks.

On rare occasions the network will "buy it in the room," meaning they will say "yes, we want it" before the writer leaves. This is because the network execs are 100% convinced their bosses will like the idea, and because they're afraid that it's such a good pitch that if the writer walks out the door and drives to a competing network and they hear the pitch, *they* will buy it in the room. "We love it, we want it, we'll commit to it right now!" are the best possible words a writer, producer and studio exec can hear when they finish a pitch.

TV PITCH STRATEGY

So far I've talked about the structure of the typical American TV series pitch. I've focused on the eight different sections of the standard pitch structure. Now let's talk about strategy.

First, remember that at the beginning of this chapter I said most writers adhere to this format when they pitch, but some consciously depart from it

for effect. Let's look at that. The eight sections of the pitch described in this chapter, organized in the order described here, represent the most common pitch format. But, like every TV show, every TV pitch is different. The best rule for structuring a TV pitch is to figure out what works best for *that* show, for *that* pitch.

I recently heard an excellent pitch from a writer who put the Personal Way into the Series section in the middle of her pitch, and it worked great. She did it for two reasons, both of which were smart. First, she had come up with a really compelling cold open scene for her pilot story, and she chose to open her pitch with that. Beginning her pitch with a strong cold open put the listener right into the show, right into the pilot. She had the goods (a highly dramatic, surprising, emotional, action-packed scene) that grabbed the listener's attention, and she put it front and center. It was extremely effective, and that strategy – opening with an attention-getting cold open – is another common pitch strategy. After she pitched the cold open, she stepped away from the action of the story and articulated the concept of the series, plugging into the format and order described above with the Concept of Series section.

She put her Personal Way into the Series about halfway through her pitch, after her Pilot Story section. Placing it there worked very well. For one, it was a surprising switch-up – the listener wasn't expecting to hear it there. Television writers know that savvy viewers are keenly aware of TV storytelling structure and frequently subvert viewers' expectations to surprise them, to keep them on their toes. The same goes for network development executives. They hear so many pitches that they expect to hear things in a certain order. Writers sometimes intentionally subvert those expectations when they organize their pitches to surprise their highly attuned development exec listeners.

Second, she effectively repositioned her Personal Way into the Series section to divide the two main halves of the pitch. The first half of the pitch – the Concept of Series, World of Series, Characters and Pilot Story sections – is the meat of the pitch, the "this is my show" part of the pitch. The sections that come after are an elaboration on the first half of the pitch. In a sense, the first half of the pitch is the guts of the pitch, and the second half is commentary on it. The writer chose to break up the two halves of her pitch with her Personal Way into the Series, and it worked almost as a brief break from the pitch. After a frank elucidation of her personal connection to the subject of the series she resumed her

discussion of the specifics of her show, and that structure proved extremely effective (she sold the pitch!).

This example demonstrates that while network executives may expect to hear shows pitched in specific ways, they're open to hearing it done any way that works. Writers need to ask themselves, "What's the best, most effective way to communicate my vision for this show?" Departing from the order described in this chapter, omitting sections, incorporating material that isn't described here – whatever works best for that writer and that show and that pitch is what she should pitch. The only question that matters is, "Is it working?" If following the standard format works, great. If it doesn't work, the writer needs to figure out how to change it to make it work.

The goal of any pitch, of course, is to sell the pitch, to convince a TV network to put the new project into active development and pay the writer to write the pilot script. It goes without saying that the best way to achieve this goal is to create the best, most interesting, most entertaining TV show idea possible and then create the best, most interesting, most entertaining pitch for that idea.

But let's talk more specifically: Beyond creating the best possible presentation of the idea, what are the specific goals of a TV pitch? In addition to structuring the pitch in an effective way that TV buyers will find compelling and pleasing, what are the primary qualities of the pitch that writers, producers and development execs should focus on?

Almost as important as the content of the pitch is the way the writer expresses it. Marlene King tells writers,

> Your voice has to come out in the pitch, whether it's lines of dialogue, or – if it's funny or sad or dramatic or thrilling – the tone of the story you're trying to tell has to come out in your words and the way you're delivering the words.[4]

Network execs want projects that represent an authentic and original vision, and the writer's voice in her pitch needs to embody the promise of that unique vision.

Beyond a unique voice, the next most important goal of any TV pitch is clarity. Pitches must be clear. Writers need to figure out the words, the

sentences, the ideas and the structure for explaining what their series is and how it works as simply, economically and clearly as possible. Writers should ask themselves, "What are the essential ingredients of my concept that someone needs to comprehend to understand how my series works and how can I articulate them as simply and clearly as possible?" This is much harder than it sounds.

Writers who've been working on an idea for weeks, months or years "get" their idea. They understand it. They understand every facet of it. The person the writer is telling it to has never heard of it before and has no idea what it is or how it works. Industry professionals developing the pitch need to ask what are the bare essentials – of concept, character and story – that will make their concept crystal clear.

Most of us comprehend ideas better when we read them than when we hear them told to us orally. There's an argument that TV pitches should be written documents. Unfortunately, however, it's not done that way. American entertainment pitches have long been verbal, oral, face-to-face. One of the reasons it's done that way is because the buyer wants to hear it directly from the artist's mouth. They want to meet the writer, get a sense of her personality and get a read on her level of passion and commitment. They're not just buying an idea; they're buying the services of the person who's going to execute the idea. Pitching live "in the room" is a personal experience. As I've said, at the end of the day it's a business transaction, but it's not a business transaction based on spreadsheets, charts and data. It's a human interaction.

Writers rehearse their pitches for colleagues, friends and family to see if the listeners understand exactly what they're trying to communicate and if anything confuses them. Confusion is the enemy of the pitch. When a listener begins to get confused, his mind tends to focus on his confusion, and he becomes distracted from hearing the rest of the pitch as new information and ideas keep coming at him. He gets tripped up on his confusion. The first confusing thing he hears might cause him to make a mental note to ask a question at the end of the pitch or to write down his question on a notepad as the pitch continues. But a second or third instance of confusion might cause him to lose focus and lose track of what's being said. He might get so frustrated that he's not able to follow what's being said that he bails on the pitch altogether and just nods politely until the writer stops talking.

The last thing a writer wants their listeners to be thinking as he pitches is, "What is this guy talking about? I don't even understand what he's saying!" I have heard pitches like that.

> Wait, which character is he talking about now? The first character he mentioned or some other character? Is this a new character he hasn't introduced yet? Wait, is this taking place now, or is what he's talking about some kind of flashback? I'm completely confused!

The Hippocratic Oath doctors take when they begin practicing medicine is: "First, do no harm." The oath of pitching a TV show should be: "First, do not confuse."

The next crucial goal of every TV pitch, and probably the most important goal of all, is to create an emotional response in the listener. To arouse some kind of emotion. To make them *feel* something. If a writer is pitching a comedy, he should make them laugh. Laughter is a physiological expression of emotion. If a writer's pitching a drama, she should make them cry (that's very hard to do, but I've seen it done). Or make them scared. Or make them feel surprise.

As mentioned earlier, surprise is an essential ingredient of most entertainment, one as common to comedy as drama. Most comedy, most jokes, are based on surprise. We expect one thing to happen but are surprised when something completely different and unexpected happens. Writers should ask themselves if there are surprises in their pilot stories and then find ways to incorporate them into the pitch and surprise their listeners. Surprise arouses emotion.

The Pilot Story section is the part of the pitch where the writer has the best chance to make the listener feel something. With luck the character descriptions and the first parts of the pilot story pitch have succeeded in compelling the listener to feel some sense of empathy or connection to the lead characters. Once listeners have grown to care about the characters, hearing the events of the pilot story, its twists and turns, should succeed in making them feel something. Will the listeners feel fear for the lead character? "Oh no, the drug dealers have turned the tables on Walter White and are going to kill him and steal his drugs! Is Walter really going to die? How's Walter going to get out of this?!" Or

> Poor Aria! She fell really hard for her new teacher, but he told her he can't risk losing his career to be with her! She's going to be broken-hearted, poor girl! I know he really cares about her as much as she cares about him – I wish they could be together!

If the pilot story can make listeners feel those kinds of reactions, that's the beginning of getting them hooked into the pitch.

Buying a new TV project and making the decision to put it into active development is a business decision. Intelligent, experienced development professionals will mull over and discuss as a group whether buying a project is the right business decision for their company. But the first and most important step in guiding a potential buyer to decide to buy a project is to make them feel something in a completely non-rational, non-intellectual, emotional way. They're making a business decision, but they're not robots. They're people, and we're all subject to being guided by our emotions. The end goal of all entertainment is to make an audience feel something, to take them on an emotional roller coaster. Making a potential buyer – the first gatekeeper of access to the audience – *feel something* is a crucial step toward getting the chance to put a show in front of an audience and to make *them* feel something.

These are two of the most important goals of any TV pitch: Make sure listeners understand what's being pitched and make sure they feel something. The pitch needs to appeal to both their head and their heart. Their intellect needs to comprehend the show and their emotions need to feel stimulated. They need to understand who the characters are and what they want, and they need to care about them. If the writer and producers don't feel confident that their concept is clear, that their characters and what those characters want is clear, and that the listener will care and want to find out what happens to them, then the writer and producers should stop and rework their pitch. They should rework the concept, the characters and the pilot story if necessary, and then rework and revise their pitch.

On pages 152–153 above I discussed one organic strategy that writers delivering TV pitches use to create an emotional reaction among their listeners – demonstrating their own emotional experience of what they're pitching. If the lead character gets her heart broken in the pilot story, the writer should show her own emotional reaction to that heartbreak as she

describes it. Emotions are contagious. The writer conveys her emotion not by "acting" it. She conveys her emotion by actually feeling it.

Writers are storytellers. When the writer is pitching his show he is a storyteller in the sense of traditional oral storytellers of earlier times. Long before there was TV or movies there were storytellers who told stories around campfires and in front of hearths of homes. They used the power of their voices to articulate the words that took their listeners on a journey. They used the power of their voices to convey an emotional experience of their story that cued their listeners in to the kinds of emotions they might feel in response to the events of the story that was being told. In a TV pitch, the writer is now that storyteller. Her job is to grab her listeners by the hand and take them on a journey into the world of her series. To make them see what she sees, to make them know the characters she has created, to make them care about those characters and to care about what becomes of them as they move forward in time, as they move forward in the story, and to make them feel the emotions of the characters and the emotions that the writer experiences and conveys as she empathizes with the experiences of her characters as she describes them. That's what storytellers do, and that's now the TV writer's job.

No one's saying it's easy. But it's doable and it gets more doable with practice, experience and confidence.

The writer doesn't have to weep rivers of tears and tear his hair out as he describes his characters' emotional journeys. No one is expecting a kabuki performance as the writer pitches his show. Emotions can speak very loudly when they're conveyed subtly. Writers need to allow themselves to connect to the emotions of their characters as they describe them and that subtle emotional connection will be enough. If the writer feels it, chances are the people he's talking to will feel it too. That's the goal.

A big buzzword in Hollywood these days is "passion." Hollywood development executives want to work with writers and producers who are "passionate" about their ideas. If they're going to plunk down tens or hundreds of thousands of dollars and countless hours of their time on a project, they want to believe the people they're working with are truly passionate about their ideas. Writers need to believe in their projects deeply and sincerely, and to let that passion come alive as they pitch them. Passion speaks volumes. Passion can't sell a weak pitch, but it can tip the balance if the buyer is on the fence, if the buyer isn't sure he wants to commit to the project or not.

Writers need to show passion in the pitch. Again, I'm not suggesting they fake it. The writer doesn't have to act like a cheerleader, jumping up and down and arguing how many millions of viewers will love his idea. That's not passion, that's puffery. The buyers want to believe that the writer believes in her idea in a real, sincere and passionate way. That she's genuinely passionate about her idea, not merely the business potential of her idea.

How does the writer demonstrate passion? Again, not by "acting" it. But rather by actually feeling it.

Where does that feeling come from? A good place for the writer to find it is in the themes of the series that we discussed earlier on pages 136–138. What is the show *really* about? What does it mean to the writer on the deepest levels? How does the writer really connect to her show (beyond its potential to make a lot of money)?

Figuring out what the show really means and how and why the writer really connects to those themes can lead the writer to a deeper connection to his project. That deepest faith in the project is where the writer's passion will come from. If the writer genuinely feels that true belief, it will show. He will exude it when he talks about his show. He will glow with belief and enthusiasm. People will see it on his face and hear it in his voice without him ever having to utter the words, "I really believe in my show! I'm passionate about this idea!"

Everyone wants to feel inspired. We want someone who believes in something passionately to inspire us. The writer should knock the buyer off his feet with her faith, with her passion for her project. That passion, applied to a genuinely great idea, will resonate with buyers and ultimately with a vast array of collaborators, it will infuse the show with life, energy and emotion, and may ultimately motivate a giant audience to love the show with the same passion, faith and belief as the writer's original inspiration.

NOTES

1 Just because a network commits to a put pilot or makes an on-the-air series commitment, doesn't mean the pilot or series will actually get made and aired. Despite these substantial commitments, if the network doesn't believe in the final pilot script once it's delivered they can back out of their commitment by

paying a pre-negotiated penalty payment, which is typically quite substantial but not nearly as much as paying for the production of the pilot or several episodes.
2 Yes, that's an unmitigated run-on sentence. Remember, though, that the verbiage of pitches is written with the intention of being delivered orally so there's no reason to hold pitch scripts (even the imaginary ones I'm creating for the purpose of this analysis) to the traditional rules of written grammar.
3 Mr. Chips was a character originated in the 1934 novel *Goodbye, Mr. Chips* written by James Hilton and made into a successful film with the same title in 1939. Scarface is the nickname of the character Tony Montana played by Al Pacino in the 1983 Brian DePalma film *Scarface*, which was inspired by the 1932 film of the same title.
4 Author interview with Marlene King.

8

Developing the Pilot Script

It goes without saying that among the handful of entertainment professionals who contribute to the process of developing a pilot script the writer bears the largest brunt of labor. The writer does the "heavy lifting" (a phrase I've used throughout the book and a common one in TV development, almost always referring to work performed by the writer). In short: The writer writes the pilot. There are numerous books about screenwriting and writing for television, and developing pilot scripts from the writer's point of view is examined extensively in those works. I'm going to use this opportunity to look at script development from the point of view of the other development professionals who develop the pilot script in partnership with the writer. I'll focus on the ways network and studio development execs, producers and production company execs approach this eventful step. With hope, information in this chapter is beneficial to writers too.

The business goal at this stage is to develop a pilot script that earns a greenlight, gets the project ordered to production, makes a great pilot episode and gets the project ordered to series. In the case of a spec pilot script, the business goal is to sell the script to a network and/or studio, to get paid for having written it and get it into active development – toward the further goal of having it greenlighted to pilot production. In the case of a straight-to-series project, the spec pilot script is typically the most

important element of the package of materials that's shopped to networks, and therefore the goal of the pilot script is similarly to get ordered to production.[1] Those are the business goals of the pilot script. The *creative* goals of the pilot script are to make it great, to make people love it and want it and want to make it. But what does that mean? And are there more specific creative goals development professionals should have in mind to make a pilot script "great?"

First, let's back up and review the process steps we covered in Chapter 2 that have gotten us to this step: The writer and her partners (studio execs, producing partner, possible production company development execs) deliver a written version of the pilot story to the network execs and get their feedback and approval. The writer does the heavy lifting (there it is again) of creating the beats and scenes that tell the pilot story/stories, structures them into acts (if the network uses them) and writes them into outline or prose form.[2] She typically writes many drafts of the story to incorporate the notes of her producer, studio and network partners. Once the story is approved, the writer is officially commenced to draft.

CREATIVE GOALS OF DEVELOPING THE PILOT SCRIPT

Beyond making it "great," the primary creative goals of the pilot script are:

1. to make us fall in love with the lead characters;

2. to tell a great story;

3. to dramatize the series concept.

I put "make us fall in love with the lead characters" first because, as discussed in the last chapter, the characters are generally thought to be the single most important reason why TV series work. The audience falls in love with the lead characters and wants to spend more time with them. Or, at the very least, the audience develops a deep and emotional concern for them, and cares enough about them to want to come back to future episodes to find out what happens to them. Even if the pilot story doesn't introduce a series drive that gives us a specific question to which we want to know the answer (will Walter White earn enough money to provide for his family before he dies?), effective pilots make us love the characters, care

about the characters or simply enjoy them enough to want to come back and spend more time watching them. Does the pilot script achieve those things? Many industry professionals agree that those are the most important questions to ask of a pilot script because those are the most important factors that make TV series work.

Another term for this is "rooting interest." Does the pilot succeed in generating rooting interest in the reader/viewer for any of the lead characters. That's usually why we come back for episodes two and three and beyond. We develop a rooting interest in the characters and we root for them, often unconsciously, to get what they want.

When I began my career as a network development executive I had to learn how to read scripts. My colleagues, most of whom were women, were better at reading scripts and evaluating material than I was (even my younger colleagues), and I came to the realization that it was because they were able to perform their work closer to their emotions than I was. The execs I worked with were better able to read a script and know how it made them feel. I realized from listening to them talk about material that I needed to learn to read with my heart and not just my head. As I evaluated scripts, I needed to read with my heart open and listen to my own feelings. Did I care emotionally about anything I read in a script? Did I care about the characters? Did I care what happened to them? If I didn't care, why? The writer wanted me to care – why didn't I care and what changes to the characters or the events that happened to them or the actions they took would make me care more?

Does the reader care about the characters? Does the reader finish the script with a rooting interest for any of the characters (ideally the character/s closest to the center of the series, the leads)? Those are the most important questions in evaluating a pilot script. Does the reader care? When I close a pilot script that's the first question I ask myself: Do I care? If a pilot script can make the reader (and ultimately the viewer) love the characters and root for them in 35 pages (if it's a comedy script) or 60 pages (if it's a drama script), it has a good chance of succeeding.

How do writers do that? How do pilot scripts create characters we love? Two ways pilots do that were introduced in the last chapter, and I'll expand on them here: "victimizing" the lead characters and giving them a goal.

"VICTIMIZATION"

I know the idea of "victimizing" a character may sound extreme. The word "victim" has accrued an unfortunate (and possibly political) stigma in recent years. People don't like to think of themselves as "victims"; we sometimes refer to them as "survivors" instead. In the new connotation of the term, "victims" are defeated losers who expect others to help them. Victims ask for our pity and wait until they get it. Set aside that stigma for a moment. The victimization strategy I'm referring to isn't about "playing the victim card." By victim I simply mean one who has been wronged. Someone who has been hurt or mistreated through no fault of their own.

We all know that audiences root for underdogs. Lead characters who are underdogs are a truism of entertainment. But what's an underdog? What makes a character an underdog? How do we show that someone is an underdog? Presenting action that victimizes a character or presenting "facts" about a character that frames him as a victim are the easiest and most effective ways to establish a character as an underdog and to begin to earn the viewer's sympathy, empathy, caring concern and love for that character.[3]

In the paradigmatic Hero's Journey, the hero is often characterized as an orphan. One reason is because his journey will be about the character discovering who he really is. Another reason he's an orphan is because even though the character is effectively a blank slate, an empty vessel just beginning his life and life's journey, he's already a victim. Life has already victimized him. Life has delivered the mostly unformed hero the single cruelest blow that can befall a young person, the death of his parents. Don't we automatically sympathize with an orphan? Don't we automatically want to give him the benefit of the doubt and root for him to thrive?

Let's pick up my analysis of *Breaking Bad* that I began in the last chapter. It's an especially effective pilot that I can continue to use in this chapter to help illustrate successful techniques of pilot script writing and development.

The first third of the *Breaking Bad* pilot script (as I also described in the last chapter) is effectively a sequence of steadily increasing victimization. As Walter White's story slowly begins, the pilot script goes to enormous lengths to establish him as a victim.

Following a flash-forward sequence that begins the pilot with action, one that also quickly establishes tones of both serious jeopardy and humor, tantalizing the viewer with numerous questions (chiefly why's the lead character in his underwear?), the pilot leaps back to the beginning of the story as Walter sits down to breakfast on his 50th birthday. Most of us expect special treats on our birthday, but Walter's wife Skyler gives him the opposite – she gives him fake bacon because he needs to watch his cholesterol now that he's getting "old." She gives him some loving, wifely jabs about turning 50. His son Walter Jr. joins them and continues making friendly fun of his dad's old-man milestone. Skyler and Junior's jabs serve as loving abuse, beginning the sequence with the gentlest of victimization.

Then Walter goes to work where he teaches chemistry to high school students who not only couldn't care less about a subject Walter clearly loves, but who openly mock him in class. The victimization escalates.

After school Walter goes to his second job (he makes so little money as a teacher that he has to moonlight to make ends meet – a professional injustice inflicted on him), where his boss orders him to drop his actual job as cashier and wash cars. This educated man is reduced to scrubbing tires, and, adding insult to injury, his rude teenage students happen to arrive at the car wash and belittle him further when they see him on his hands and knees. The victimization intensifies. Our hearts break for the poor man.

At the car wash one day Walter faints, and an EMT rushes him to the hospital. A doctor hits Walter with what turns out to be series-defining news: He's got cancer, and it's terminal. He's got a couple of years to live. This revelation caps off a 19-minute sequence of victimization.

This long sequence performs other story functions than just victimizing Walter. Pilot episode real estate is limited, and every inch has to be used to maximum value. This sequence introduces other lead characters and many supporting characters. It introduces the world and establishes several notes of the tonal range of the series. It introduces the lead character's starting place (his "status quo") in the pilot story and series. But the most important facet of Walter's starting place, the most emotionally resonant quality of his status quo, is his quality of being a victim.

One of the reasons writer Vince Gilligan went to such extreme lengths and devoted so many pages of the script to depicting his hero as a victim is

because this hero is going to very quickly transform into an anti-hero. Very soon he's going to choose to do very bad things, and, as fans of the show know, he's going to spend the next several seasons doing increasingly bad things. For us to sympathize with him, to allow ourselves to follow him doing bad things and to forgive him enough to go along and find his behavior entertaining and even rootable, Gilligan needed to dig an enormous foundation of victimization and build up a big enough reserve of victimization sympathy.[4]

Let's now look at the granddaddy of TV anti-heroes, Tony Soprano. How did David Chase, the creator of *The Sopranos*, figure out how to make a stone cold criminal, a man we would see murder people with his bare hands in an early episode of the series, rootable? What technique did Chase use to introduce this character as a sympathetic and rootable lead? He made him a victim. The pilot story is about Tony suffering from a bout of anxiety. We meet Tony in therapy. This strong, brutal man is at his weakest. In the pilot he cries to his therapist, Dr. Melfi. The audience accepts Tony and begins to fall in love with him because we meet him as the victim of his own anxiety.

Why do we root for victims? I don't know, but I know it works. My hunch is it has something to do with the instinct for fairness most of us have that I talked about earlier. Most of us feel treated unfairly – if unconsciously – and we identify with those life has treated unfairly. We instinctively root for them to find some kind of justice for their unfair treatment, as we would wish for fair treatment in our own lives. Victimizing a character in a script, especially a pilot script as we're just getting to know a character, endears us to him, makes us begin to root for him and makes us begin to love him.

A journalist once asked Clint Eastwood how he's able to get audiences to care about his iconic Western movie heroes when he gives them so little dialogue. How is the audience even supposed to know to root for the hero? "In the fifth minute of the film," Eastwood answered, "some people will kill his wife and his children and burn his house down."[5] In other words, Eastwood takes strong men and makes them victims, and that simple technique allows us to love them and root for them.

The second character-defining technique we mentioned in the last chapter is to assign characters a want or, more importantly, to assign them a goal. Once we know what a character wants, we understand them. That's why Disney-animated movie musicals always deliver what's known as the

"I Want" song at the outset of the story. Snow White sings "Some Day My Prince Will Come" so the audience knows what she wants. Once we hear that she's looking for love we understand her, identify with her ("I want love too, I'm just like her!" we think unconsciously), connect to her and begin to root for her.

In the *Breaking Bad* pilot, as I discussed in the last chapter, Walter White's goal emerges toward the end of the sequence of victimization, about a third of the way into the pilot script: Walter sees a huge pile of cash on TV that cops had confiscated at a drug bust, and, after the reality of his terminal diagnosis lands on him, he decides to apply his expert knowledge of chemistry to make great drugs to earn his own huge pile of cash. That becomes the hero's goal, his goal in both the pilot and the series.

GOALS

The goal assigned to a character in a pilot story may introduce a series drive (in pilots these days it often does) or it may only serve the one pilot episode. Goals of effective pilot story lead characters have three important qualities. First, the best pilot story goals are concrete and specific. They're a tangible thing, not merely a vague, amorphous, theoretical desire.

I once had an awkward conversation with a senior member of a pilot I was working on while at lunch during location scouting. I realized he didn't have the best handle on what our pilot story was. I asked him what he thought our lead character's pilot story goal was, and he said her goal was to discover who she is. I agreed that she does want to find out who she is, but that was a theme of the series and not the goal of the pilot story. I argued that her goal in the pilot story was to find out who killed her brother. That's a good pilot story goal: It's concrete and specific. "Who am I?" is a great question, but it's general and could take a year or ten years or a lifetime to answer. "Who killed my brother?" is more grounded and specific, and something an audience can expect to find a definitive answer to in the near term, like possibly by the end of the pilot. In fact, at the end of the pilot the lead did discover who killed her brother, that her *father* killed her brother, which then posed numerous other questions for the series: *Why* did my father kill my brother? Who helped him? Are other family members complicit in this crime? Ultimately, the payoff to the lead character's pilot story goal framed

her series drive: How can I avenge the death of my brother and bring my powerful father to justice?

Creating a sympathetic, likeable pilot hero provides the viewer with someone to root for. Assigning the hero a concrete goal deepens our rooting interest in the story.

The second important quality of a pilot story goal is that it should be relatable. The audience has to understand why the protagonist would choose that goal, and it has to make sense. At some level we need to be able to think to ourselves, "Yeah, if I were in his shoes, I'd want that too." We might not have the moxie to become a drug dealer or to avenge our brother's death by ourselves, but we understand how someone could. We *believe* in their goal. We may be startled by it, we might not have ever thought of it ourselves, but we believe it, and we believe *in* it. If Walter White had thought to himself, "Hmm, I don't want to die and leave my family in poverty so I'm going to train myself to become a high-priced international hit man," we never would have gotten on board. Becoming a hit man would have been a pie-in-the-sky goal that seemed out of reach and far outside Walter's skillset. There's an inherent logic to him leveraging his academic chemistry knowledge to cook pure meth – that makes sense! It's not only logical, there's an ingenuity to the logic that helps make it even more credible, more relatable to us. We buy into his goal.

The third quality good pilot story goals offer is stakes. (I told you stakes would return to the practice of development in important ways.) There's got to be something at stake if the hero doesn't achieve his goal, or there's not that much to root for. Finding time to eat lunch could be a concrete and relatable goal. But it has no stakes. If he doesn't eat lunch then, he might feel a little hungry, but he'll eat later. There are zero stakes to that goal. "I want to make money so my wife, handicapped son and new baby won't starve when I die" are huge stakes! Gilligan's pilot script goes out of its way to emphasize Skyler's pregnancy and so deepen those stakes. Walter's going to have another mouth to feed! He's got to figure out a way to provide for his family.

Walter's goal to make money by becoming a drug manufacturer and distributor is a great pilot story goal for many reasons, but among them is that there are layers of stakes to it. I count at least four layers of stakes to this goal. Not only will his family be impoverished if he ultimately fails at

the goal, he's also in danger of getting caught by the cops (or, even worse, by his DEA brother-in-law) and being imprisoned. Which brings up a third layer of stakes: He's in danger of getting caught by his family, chiefly his wife. Walter has to hide his criminal career from his wife (and the rest of his family) for years. Family secrets can provide powerful stakes and are common in many pilots, including comedy pilots. A last layer of the stakes of Walter's pilot goal is – as we see dramatized explicitly in the climax of the episode, and as I mentioned in the last chapter – Walter is entering an extremely violent and stakeful world; the criminals he sells his first batch of drugs to turn the tables on him and try to kill him.[6]

Gilligan introduces the stakes initially as emotional family stakes ("if I don't provide for my family, they'll starve") and manages to escalate them within the episode into life-and-death stakes. Walter almost dies, but, thanks to his chemistry expertise, turns the tables on the drug dealers and kills them, and steals the money they brought with them to ostensibly buy the drugs, thus achieving a first victory as per his pilot story goal. That is some very effective pilot story writing.

Before I move on to the other creative goals of pilot scripts, it's worth taking a moment to talk about the power of Walter's family secret. As I just mentioned, Walter keeps his criminal career a secret from his wife. We know now in hindsight that this secret served the series for years. Once that cat was out of the bag, Walter and Skyler kept their secret from the rest of their family, chiefly Skyler's sister's DEA-agent husband, for several seasons more. Here's a point worth repeating: Secrets are enormously powerful in pilots. Secrets are helpful in series, but, specifically during pilot development, secrets can add a powerful layer of jeopardy and stakes, either dramatic or comedic. When I worked as a network development exec and my colleagues and I agreed that a pilot script was reading flat, one of our go-to strategies was, "How can we inject some kind of secret into this story and amp everything up?"

THE BASIC ELEMENTS OF PILOT STORIES

The second creative goal of pilot scripts is to tell a great story. In lieu of a thorough examination of story structure, which could fill many books and already has, let's look at some of the basic structural elements of effective pilot stories.

Giving the lead character a goal results in an important structural element of the pilot script: It drives action. Television is a visual medium. It craves action. The hero's goal informs his action, directs his action toward something specific, relatable and stakeful that we can track and root for. After the hero and his status quo are introduced, an inciting incident propels him to identify a goal. Seeing the drug bust on TV and learning he has terminal cancer propel Walter to decide to become a criminal to provide for his family. That decision propels him into action.

Action results in the next essential structural element of pilot storytelling, conflict. The hero takes action and someone or something (or several someones) tries to stop him. Walter takes action by first identifying a partner in crime, Jesse Pinkman, his former student. Jesse effectively responds: "No, I don't want to be your partner." Walter overcomes Jesse's conflict, they team up, make their first batch of drugs, and try to sell it, immediately resulting in more and greater conflict. The buyers are criminals, criminals are frequently liars and thieves, and the criminals (as mentioned above) try to steal Walter and Jesse's drugs and kill them. Conflict! Visual, physical conflict. Walter turns the tables, which leads to . . .

Resolution. The conflict is resolved and the hero achieves his goal (or not). Pilots are hard to do well because there are so many burdens placed on them. They have to introduce wholly new characters and compel us to root for them. They have to introduce new worlds and make them clear and compelling. They have to dramatize a concept (as I'll discuss in a moment) and demonstrate the potential for many more stories and episodes to come. But they also have to work as a great, singular episode of TV on their own. To do that they ideally need to tell a great story (or six good ones like the *Pretty Little Liars* pilot).

Let's review the simple structural elements I've discussed: Creating great lead characters the audience connects with and roots for; putting the lead characters into action toward a compelling, interesting, stakeful goal; confronting obstacles and conflict that results in even more action; ultimately driving toward a climax that resolves the conflict and the story by answering the question posed by the lead character's goal. Does he achieve his pilot story goal or doesn't he? Ideally, he does or doesn't in a way that's both surprising and yet wholly organic. Walter beating the killers at their own game is surprising because they've got guns and are professional criminals – killing people and stealing their

drugs is what they do for a living and they look pretty good at it, while this is Walter's first foray in crime. But Walter's climactic pilot story "move" is also completely organic within the rules of the world Gilligan has set up.[7] Walter's climactic action is rooted in his chemistry expertise. He knows chemistry backwards and forwards and the fact that he thinks on his feet in a life-or-death moment and uses a chemical reaction to defeat the bad guys makes complete and utter sense. It's both utterly surprising and yet completely true to the character.

PILOT STORY ENDINGS

The ending of the *Breaking Bad* pilot provides a great example of the challenge that endings of pilots almost always pose (as I also mentioned in the last chapter). The trick of pilot endings is that they can't completely resolve the hero's needs or there's no series to follow it. If all the lead characters' problems are resolved, the show's over. Pilot stories that sound like that in pitch form frequently get the "It sounds more like a movie than a TV series" response from development execs. But, at the same time, pilot episodes *do* need to deliver satisfying conclusions, entertaining payoffs. A good ending.

Like just about everything else it did, the *Breaking Bad* pilot handled its ending perfectly. It delivered on its hero's goal – Walter makes money – but we know it's not nearly enough to satisfy his series goal, his series drive, to make *enough* money to provide for his family when he's dead. So the pilot is able to give its lead character a victory, but not a victory that obviates his series drive. We feel satisfaction watching his victory, but we know the cash flapping around Walter's clothes dryer is only a drop in the bucket to achieve his much larger series goal of making enough money to take care of his family.

One of my bosses in development at NBC used to have an expression he applied to many effective pilot endings: "Baby steps." The hero doesn't achieve his series goal (or there's no reason for a series), but in the climax of the pilot story he takes his first baby steps to get there. The viewer sees him make an effort to achieve the skills necessary to demonstrate he has the promise of achieving his series goal, but he only takes his first (often victorious) steps. "Baby steps" is a common pilot story ending strategy.

The ending of the *Transparent* pilot is wonderfully satisfying but in a completely different way. Creator Jill Soloway's half-hour dramedy was about how a middle-aged father's decision to change his life, to transition into a woman, affected his family. The pilot story goal of the lead character, Mort Pfefferman, Jeffrey Tambor's character, was to tell his family about his decision to become a woman.[8] He has a secret with potentially enormous emotional reverberations that he wants to reveal to his adult children. Mort convenes a family dinner to drop his bombshell, but he fails. He doesn't tell them. Why he doesn't highlights one of the interesting and subtle qualities of the kind of storytelling that creator Jill Soloway used for her series. She didn't spell out all the reasons why characters made the choices they made, allowing the reader/viewer to infer their own interpretations. Maybe Mort doesn't tell his children because he sees they're all needier than he is at his own life-altering moment. Initially Mort fails at his pilot goal. But in the climax of the episode his daughter Sarah accidentally discovers his secret when she stumbles onto her dad dressed as a woman while she uses his house as a rendezvous for an adulterous tryst. The ending of the pilot story delivers Mort an unlikely, seemingly accidental victory (he achieved his pilot story goal) in a way that's surprising and yet completely organic to the family of characters and the tone of family dysfunction to which Soloway has introduced us. Characters in *Transparent* don't make ingenious plans and achieve them as a result of their courage and cunning like Walter White. Characters egocentrically self-destruct their way toward accidentally impacting their relatives in ways that unintentionally achieve those relatives' conscious goals. The drama and comedy of family dysfunction generates action and resolution.

In many ways, Soloway's approach to storytelling is fundamentally different from Gilligan's, less goal- or "mission-based." Television development professionals are far more open to untraditional storytelling styles and strategies than ever before. The *Breaking Bad* analysis here offers one common storytelling style, but readers are encouraged to read about, watch and think about others as well.

PROVING THE CONCEPT

The third creative goal of pilot stories is to demonstrate the concept. Not only to demonstrate the concept, but to prove it. One of the reasons some networks make pilots is to see if a concept that sounded great in a pitch

works in actual practice. The pilot episode needs to demonstrate the concept to do that.

What I mean by "demonstrate the concept" is this: There's a version of the *Breaking Bad* pilot that focuses more on Walter White's decision to break bad, the steps that lead him to a life of crime. There's a version of that pilot script that ends with him having the light bulb moment: "I know what I'll do – I'll use my chemistry knowledge to manufacture great drugs and make a lot of money to provide for my family!" That version could have ended like this: Walter goes on the ride-along with his DEA brother-in-law and notices that his former student Jesse Pinkman is one of the criminals who sneaks away from the drug-bust. Walter goes and knocks on Jesse's door. Jesse is surprised and confused to see his former high school teacher, and Walter smiles and asks if he can come in. The audience would be intrigued by the courage and ingenuity of Walter's plan and would possibly look forward to watching him implement his plan in the next episode.

Vince Gilligan didn't design his pilot story that way, though, because he knew he had a responsibility to demonstrate his concept. He needed to show Walter and Jesse actually doing what they would do in episodes of the series, make and sell drugs and encounter all the obstacles that come with the life of crime (and the ingenious answers to those obstacles that spring from the mind of a brilliant scientist and soon-to-be criminal mastermind like Walter). Not only did Gilligan know he needed to dramatize the premise of his series, he needed to give network executives a view of what the series would actually look like beyond the premise so they could evaluate if the concept – a schnooky high school teacher makes and sells drugs – had the potential to work in series. His pilot script succeeded in dramatizing, demonstrating and proving his concept.

Sometimes writers are concerned that "speeding up the story" and having their lead character not only undergo the huge mental transformation to arrive at their new plan but actually to begin implementing that plan will look rushed or inorganic. The *Breaking Bad* pilot is so effective, in great measure, because Gilligan not only was able to persuade us of the logic of Walter's idea, but because he took it further and dramatized Walter implementing his idea for the first time, along with the funny, scary, surprising and satisfying things that occurred as a result. He not only dramatized the logic of his concept, he demonstrated and proved that his

TV concept would work in series: It was believable and entertaining to watch Walter (and his unlikely new partner) attempt and pull off crimes.

Every pilot is different. The people who develop pilots typically assess and prioritize the goals of each unique pilot. In a sense, the *Pretty Little Liars* pilot that I helped develop did not demonstrate the concept in the same way that the *Breaking Bad* pilot did. The *Breaking Bad* series is about Walter making and selling drugs. The pilot showed that and proved it.

To a great extent the *Pretty Little Liars* series (the *series*, not the pilot) was about the four lead girls trying to find out who "A" was and what happened to their dead friend Alison, in other words, the four lead girls actively investigating those mysteries. We didn't do that in the pilot. We didn't prove that. In the case of that project we knew the magic of the series was in the power of the mysteries. We knew that if the pilot stories could hook viewers (and the network executives who are their first surrogates) strongly enough into wanting to know answers to those mysteries, that in itself would earn us a series order.

Because we had four lead characters to introduce (along with all their love interests, friends and family members), we knew we didn't have the dramatic real estate to achieve all the standard pilot goals. Instead, we chose to pursue the first two creative goals of pilot scripts and to hold off on the third. We bonded the audience to the four lead girls in part by demonstrating their victimization at the hands of "A" (the ultimate high school bully) and by giving each girl a concrete, relatable, stakeful goal. We told six good stories. But we didn't try to prove the concept. We didn't show the girls investigating the mysteries. We believed that was our best hope of grabbing the brass ring of a series pickup and building audience interest, and it turns out we guessed right.

PILOT SCRIPT DEVELOPMENT CHECKLIST

I've found that most development professionals build a mental checklist of questions they consider as they read and evaluate pilot scripts. Some execs are compulsive and literally keep lists like this, but most learn to intuitively "feel" these questions as they read and evaluate scripts. Here's my list of some questions I've learned to ask:

- ▶ Do I care?
- ▶ Do I care about anyone or anything?
- ▶ Have I developed a rooting interest in any of these characters?
- ▶ Do I care if they get what they want?
- ▶ If not, why not?
- ▶ If not, is the problem the characters?
- ▶ Or is the problem with the story/ies the characters have been placed in?
- ▶ What are the lead character's (or characters') goals, if any?
- ▶ Are those goals credible and relatable?
- ▶ Do I believe them?
- ▶ Do I root for them?
- ▶ Are there stakes to those goals?
- ▶ Is there any way we can increase the stakes of those goals?
- ▶ Does the story feel like it takes too long to get started?
- ▶ How can we motivate the lead to get his show on the road and take action quicker?
- ▶ Is there conflict?
- ▶ Is there enough conflict?
- ▶ How can we increase the conflict?
- ▶ Is the antagonist a formidable opponent?

- ▶ Is he just a stock "bad guy" or does the opponent actually have a philosophy, an ideology, a darn good reason for opposing the hero?

- ▶ Is there some surprising validity to the antagonist's philosophy/view of the world that I wouldn't have thought of before reading this script (i.e., did I learn something)?

- ▶ Is there action?

- ▶ Is there enough action?

- ▶ Is the action motivated?

- ▶ Are there too many scenes of characters standing around talking?

- ▶ Does the characters' dialogue express text or subtext?

- ▶ Do they tell us what they think and feel, or does the writer show us these things?

- ▶ Is the dialogue "pipey?" ("Pipey" means weighted down with exposition. Writers "lay pipe" of exposition as needed. Some "pipey" dialogue is occasionally unavoidable.)

- ▶ Are there relationships I want to invest in over the course of the show?

- ▶ Will an audience want to invest in these relationships?

- ▶ What's the climax of the pilot story/ies?

- ▶ Is there a climax?

- ▶ Is the climax satisfying?

- ▶ Are the ways the hero got to his climax surprising?

- ▶ Did the hero "earn" his climactic victory or defeat? ("Earning" a climactic victory or defeat means the climax resulted – good or bad

– because of things the hero did. Less satisfying climaxes result because of coincidence or actions other characters took. The most satisfying climaxes occur as a result of choices and actions taken by the hero.)

- ▶ Did the antagonist get any kind of satisfying comeuppance?

- ▶ If not, can he (without damaging his power in series if his role continues in series)?

- ▶ Does the episode succeed in demonstrating and/or proving the concept?

- ▶ If not, can it do a better job?

- ▶ Does the pilot promise a story engine for the series?

- ▶ Is the pilot about something?

- ▶ Are its themes relevant today?

- ▶ Am I entertained?

- ▶ Do I want to find out what happens in Episode 2?

- ▶ Do I care?

At the end of the day, development executives are simply professional TV fans who want to be entertained. As CW development head and Executive Vice President Gaye Hirsch puts it, "That every-once-in-a-while magical script where you forget all about your checklist is probably the one that I really want to do."[9]

NOTES

As mentioned in Chapter 2, the writer delivers a first draft to the producer (which is probably not the writer's actual first draft – the writer rewrites himself until he thinks he's got something worth showing), the producer gives the writer notes and the writer rewrites. Then the studio execs read

and note, and the writer rewrites. Then the network execs read and note, and the writer rewrites. If the network president considers the script a greenlight candidate, the network president notes the pilot script, and the writer rewrites. That's a lot of notes! What are all these notes about?

First, let's look at process, then I'll look at content. Before anyone delivers notes there are typically "pre-notes." A "pre-notes" meeting or call is when the multiple producers or production company development executives gather together in an office or on the phone to compare notes, to discuss and debate their various individual reactions to a script and to decide which notes they want to give as a team. The two or three studio development executives also meet and do their own "pre-notes." The same with the two or three network execs overseeing a pilot script. Each layer of feedback – producers, studio and network – wants its team to be a united front, delivering one consistent set of notes. Receiving contradictory notes from the *different* layers (which sometimes happens) is bad enough; for a group of producers or studio execs to disagree amongst themselves and deliver contradictory notes is confusing and frustrating to the writer.

Pre-notes meetings or calls are then followed by the actual notes meeting or call where the team – producers, studio execs or network execs – deliver the notes to the writer.

Delivering notes to writers (and sometimes to producers and directors) is a large part of the jobs of non-writing development professionals. Even agents sometimes give writer clients notes to help improve pitches or scripts. For most entertainment professionals the goal of delivering notes is to balance critical constructive feedback with encouragement, to motivate the writer to feel positive enough about the project to want to muster the huge resources of energy and emotion to go back and do a lot more work. In general, most producers and executives deliver notes in a style that treats the writer with enormous respect and encouragement.

One strategy producers and execs use is what's known as the "executive sandwich." They begin a notes session by emphasizing the positives the writer has achieved. Then they move on to the actual critical notes. After opening with encouragement and flattery, they might say, "That said, we think there are still some important things to work on...." The actual notes typically comprise the largest section of the session, the meat of the executive sandwich. After the tonnage of notes has put the writer in a state

of despair, the notes givers conclude by re-emphasizing the positives, assuring the writer that everyone knows he's smart, talented and experienced enough that his next draft will be even more brilliant than the first, and they're so excited to see what magic he can work. In other words: flattery, flattery, pain, pain, flattery, flattery.

There are two primary categories of notes: notes and pitches. A note is: "This part of the script isn't working." A pitch is: "Here's a creative suggestion to fix it." It's easier to give notes than to pitch fixes. Good notes givers do both and come up with good creative fixes. Interestingly, some writers actually don't want pitches. They believe that's their job. But most writers appreciate them. If a non-writer can bail them out with a great creative solution that saves them some "heavy lifting," they're all for it.

As skeptical as most creative people are of notes, the goal of most notes givers is purely and simply to try to make the project better. The goal of most producers and development executives is to make the pilot script a richer, more satisfying, more entertaining experience. "How can we make this a better ride? How can we make the viewer enjoy this pilot more? How can we make this a better version of what it's trying to be?" As simple as that is, that's how most producers and development execs think when they approach a pilot script and deliver notes. How can we make the audience care about these characters more? How can we make each character's journey through this story a deeper, more interesting, more compelling and more entertaining one?

Typically notes sessions are divided into two major sections, "headlines" and "page notes." Headlines are overarching notes that affect all or most of the script. "The tone feels a bit off throughout." "We're not finding ourselves rooting for the lead character enough, and we're looking for ways to increase our connection to her overall." After the notes givers deliver headline notes (which might number one or two or as many as a half dozen – if there are more than six headline notes, there are probably very big problems with the script), the notes givers move on to page notes, flipping through the script in order, page by page, to pages that have specific beats, lines of dialogue or scenes that need to be questioned or noted. There might be ten page notes, there might be 60 or more. Notes sessions – calls or face-to-face meetings, although calls are more common these days – can run anywhere from a half-hour to two hours. Frequently the senior-most member of a given team (producers, studio execs or network execs) delivers

the notes, and then a junior member of the team might type them up and email them to the writer by way of follow up.

ABC President Karey Burke tries to follow a rule that one of her mentors, Brandon Stoddard, a former president of ABC himself, taught her at the outset of her career: Only give five notes. Keep the writer focused on the big-picture issues with the pilot script. Those will ultimately have the greatest impact on the project.[10]

Another category of notes producers and execs tend to give are logic and clarity notes. Notes givers highlight points in the story that either don't make sense, don't feel motivated or logical, or that are confusing or unclear. Writers often benefit from an "extra sets of eyes" to help figure out where to draw the line between saying too much and not saying enough, to help the reader (and ultimately the viewer) understand what's going on and why characters do and say what they do, to make sure the reader/viewer stays with and tracks the characters and story.

Writers often find logic notes especially annoying. Writer personalities tend to be more creative and emotional, and producers and execs can tend to be more linear and literal. Writers occasionally believe viewers will understand the meaning or intention of things in the script that executives "bump on." (That's a common notes expression, as in, "I'm bumping on Tom's line on page 37.") Writers are especially resistant when more literal-minded execs ask them to have characters spell out their thoughts, motivations or feelings in dialogue, in other words to turn subtext (which should be clear from the context) into text.

In an ideal world, the development execs and producers who are giving notes and the writers they're giving notes to are in sync about their intentions, are "making the same movie," as industry people often say. *The Handmaid's Tale* and *Fargo* non-writing EP Warren Littlefield has a unique approach to notes:

> What I'm trying to understand first and foremost – either in a pitch or a script – is what's it about? What do you want to say as an artist? Define the thematic because once we're in sync on that we can understand whether the scenes and the stories are supporting and building on that, or whether they're just kind of floating out there and not adding to what it is we're trying to create.[11]

People on the receiving end of notes frequently hold post-mortem conversations after a notes session to try to comprehend the "notes behind the notes." Producers do follow-up calls with writers after studio and network notes sessions to assess the input they've just received and sometimes to calm highly exercised partners. While development professionals are polite and professional to each other as a rule, and writers almost always end notes sessions by thanking the notes givers for their input, behind closed doors cursing and name-calling are not unheard of. If the notes don't appear to make a lot of sense or sound like they're not in sync with what the writer was trying to achieve in the script, the writer and her producer partners might try to figure out what the underlying problem is at the root of the note. What was the real underlying problem the exec was trying to identify and how can we address that problem? Those are the "notes behind the notes." Sometimes this process feels like an attempt at mindreading, but sometimes it's actually fruitful. A good producer can be very effective at calming a confused and angry writer, helping him comprehend the notes behind the notes and working with him to come up with constructive, creative solutions to address them.

Justified creator/showrunner and *Sneaky Pete* showrunner Graham Yost says,

> The trick for me is waiting three days. When I first get them it's, 'These are the stupidest notes I've ever heard.' The second day it's, 'Well, there are a couple we could answer,' and by the third day it's, 'You know what, they got a point there, let's take a look at that.' That doesn't mean there aren't some really stupid notes. The mistake I make at certain points is trying to point that out.[12]

Other notes fall into the category of network brand notes. "Our viewers tend to expect X from our shows," network execs might say, and they try to guide the writer to steer the pilot script toward being more like other shows on the network. These kinds of notes often go toward the tonal range that networks prefer. Network development executives often have in mind the regular viewers who watch their shows and the feedback they get from them. They know their audience's demos, who's watching and what those viewers like and expect from their shows.

The notes process is theoretically a creative one but also inherently a political one. On most projects network development executives and

studio development executives find themselves in creative sync. Both teams identify the same problems with a draft of a script and work together to come up with solutions. Once in a while, the two teams of execs find themselves seeing a draft, or even the entire project, from very different perspectives. Veteran studio development executive Jane Francis, the Executive Vice President of Fox 21, the boutique studio within 20th Television that produces for cable and streaming, says that, like so much else in development, it comes down to relationships. "When you do this for a long time everyone becomes your friend," she says.

> Once you develop those relationships, you can call your friend and figure it out. You're doomed if you don't get along. Who gets caught in the middle? The writer. You have to create an environment where the development experience is great for the writer.[13]

Writers and producers want to demonstrate respect and appreciation for their network and studio partners, but they also want to make sure they're putting their project's best foot forward creatively. This can be tricky. They sometimes have to decide to do a note even if they think it might hurt the script. Ignoring a note risks offending a powerful person, an exec whose personal investment and support is crucial to the project. There's a fear that not doing enough of an executive's notes will alienate that person and turn him off not only the project but the writer's (or producer's) long-term career. Nobody wants to develop a reputation as "difficult to work with" or "not collaborative." In recent years, most writers (even the best and most powerful) work very hard to do as many of their executive partners' notes as possible. Network executives especially are shown enormous respect. In general writers and producers are emotionally closer to their studio executives, but they know that the network holds the ultimate greenlight power and therefore their execs and their notes hold the greatest weight.

A writer once told me that her strategy is to do notes she doesn't agree with as long as they don't damage the dramatic and thematic heart of her script. She said she knows that so much of the work is purely subjective, and she's often comfortable giving an executive their subjective preferences over her own, as long as they don't undermine what her project is fundamentally about and why she thinks it fundamentally works. Television, as I've said throughout, is a team sport, and letting another player shine can often lead to victory.

NOTES

1 Technically, the first episode of a straight-to-series project would be called "episode one" rather than a "pilot" because no pilot will be made. People in the industry still tend to refer to these scripts in conversation as "pilot" scripts (probably out of force of habit).
2 "Beats" are small dramatic units that comprise scenes. A beat is a line of dialogue, an exchange of dialogue among characters or the description of action about one thought or one moment in a scene. When the subject of that one thought is over, the scene moves on to the next beat. Writers, directors and actors typically break scenes down into specific beats to analyze and discuss them.
3 "Facts" of a fictional story may sound paradoxical. The author of a story offers various kinds of description of characters and some of those descriptions are "facts" within the universe of the story. The character is male, he's 35 years old, he works as an accountant. Those are facts of a story. "The character dreams of being rich because he grew up poor," is a psychological description that may have validity – there's a good chance his journey through the story will reveal how valid it is – but it's not a fact of the story like the fact that he's male.
4 In the fifth episode of the series, "Gray Matter," an elaborate backstory is introduced to further deepen Walter's victimization and our rooting interest: As a younger man, Walter helped start a tech company but sold his shares early, missing out on the literal billions of dollars his old friends have made on ideas that were really Walter's. Walter was the victim of his own youthful stupidity, defining yet another layer of his victimization.
5 Eastwood quoted in an interview with French screenwriter Thomas Bidegain, "Why I Said 'Non' to Hollywood," interview by Robbie Collin, *The Telegraph*, November 2, 2012.
6 "Stakeful," like "rootable," is not a word in the real world. They both, however, come in pretty handy in script development.
7 Development professionals frequently look for hero "moves" in pilot scripts. Figuring out a great "move" for the hero lends the pilot surprise at a crucial moment and demonstrates the hero's ingenuity, which suggests he's an entertaining character worth continuing to watch.
8 In the series Mort would become Maura Pfefferman, but in the pilot the character was still known as "Mort."
9 Author interview with Gaye Hirsch.
10 Author interview with Karey Burke. Burke explains that, deeper into the development process, especially when it gets to pilot rough cuts, more detailed notes are necessary. But she does her best to stick to Brandon Stoddard's advice during early script development.
11 Author interview with Warren Littlefield.
12 Author interview with Graham Yost.
13 Author interview with Jane Francis.

9

Packaging and Politics

The Role of Agents in TV Development

Talent agencies and the agents who work there are an essential part of TV development. Agents are the grease that keeps the gears of TV development (and the entire entertainment industry) turning. They are the central link between art and commerce, between the writers (and other talent) they represent and the money that talent needs to get their series produced and distributed.

Agents' first duty is to get jobs for their clients. One of their next most important duties is putting – or helping put – new development together, packaging new pilots and series.

Let's step back for a moment to a macro view of agents and agencies before we zoom in on how agents package development.

The major talent agencies in Los Angeles all have many different departments that employ agents who specialize in different kinds of clients. Agents who represent screenwriters, both TV and feature writers, are called "literary" or "lit" agents. The big agencies have MP lit departments ("motion picture" literary departments) and TV lit departments. Agents in those departments do nothing (for the most part) but rep feature or TV writers. A screenwriter who works in both movies and TV has one MP lit

agent and one TV lit agent (at the one agency that reps her). The movie and TV businesses have grown closer in the past 20 years and have seen much more personnel crossover during that period than before, but the two businesses are still separate businesses and agents focus on one or the other, movies or TV, learning the business practices and creative demands of one or the other, and similarly building extensive networks of relationships with professionals in one or the other business.

The major agencies also have "talent" departments, MP talent and TV talent, that represent actors. The term "talent" has different meanings in Hollywood in different contexts. In some contexts "talent" refers generally to writers, directors and actors. Sometimes producers are considered "talent," sometimes not. In other contexts "talent" refers specifically to actors. "Talent agencies" represent a number of different kinds of talent, and yet they have "talent" departments that specifically represent actors. This is one of the many cases in Hollywood where terminology is fluid, and the specific meaning of the term "talent" needs to be derived from the context.

Other agents specialize in representing only directors, TV directors or movie directors. The major talent agencies also represent book authors, both fiction and non-fiction. The American publishing industry is based in New York, so the book lit departments of the major talent agencies are all in New York, where the largest Hollywood (LA-based) agencies have branches. The big agencies also have book-to-film departments where agents do nothing but sell (and package, more on this in a moment) books and other IP to film and television. When it comes to selling IP to Hollywood, the book lit agent who reps an author typically "co-agents" with a book-to-film agent. The book lit agent is a specialist in selling manuscripts and book proposals to publishing companies; book-to-film agents (sometimes known as "media rights" agents) are specialists in selling IP to Hollywood.

The big agencies also have agents who rep playwrights and actors who focus their careers on acting for the stage, "legit lit" and "legit talent" departments. "Legitimate theatre" or "legit theatre" has always been how Hollywood distinguishes the business of live theatre from film and television. The big agencies also rep musical talent (some Hollywood agencies have branches in Nashville), composers, voice-over talent, stand up comedians and numerous other kinds of talent.

My focus in this book is on TV lit agents, but let's continue the macro view of the agency world before zooming back into TV lit agents' role in development.

There are dozens of talent agencies in LA, but they're dominated by a handful of the biggest and most powerful. CAA (Creative Artist Agency) and WME (William Morris Endeavor, the combination of the oldest talent agency, The William Morris Agency, and a powerful 1990s upstart agency Endeavor, which merged in 2009) are the two largest, most powerful and most successful agencies in Hollywood today. They represent more TV creators, showrunners and more "A-list" feature talent than the other agencies. UTA (United Talent Agency) is considered the next most successful and powerful agency, followed by ICM Partners (International Creative Management Partners). Those four agencies (and their pre-merger iterations) have dominated TV development for decades.

Gersh and Paradigm are next in stature in TV lit. Gersh probably rivals the bigger four agencies in representing actors, its original and most successful business. Beyond these six are many "boutique" agencies, smaller agencies that tend to specialize in repping one kind of talent, lit or talent. Verve, the Kaplan-Stahler Agency, Rothman Brecher, and Writers & Artists Agency are among the many smaller boutique agencies that rep high-level TV writers, creators and showrunners.

Traditionally, writers, directors and actors begin their careers by signing with the "best," most powerful agent and agency that will sign them and then "move up." Sometimes talent decides to part ways with the agents who repped them when they were younger and less successful, and moves up to more powerful, more successful agents. Sometimes talent gets "poached," aggressively seduced by more powerful, successful agents who sell the rising talent on signing with them. Sometimes, though rarely, successful talent stick with the less powerful agents who helped them launch their careers even as the talent becomes very successful themselves.

All of Hollywood is competitive, but the TV industry is surprisingly professional and collegial. The talent agency end of the business, though, tends to be the most competitive, bare-knuckle part of the business. The agencies are extremely competitive with each other and often vie aggressively for top talent. In many ways the agency world tends to be one of the more aggressive and combative sectors of the industry and one more dominated

by men. Internally, the culture of the agencies also tends to be similarly more aggressive and competitive than other businesses in the industry.

TV LIT

As mentioned, agents' first responsibility is to get their clients jobs. In TV lit that primarily means fulltime jobs on the writing staffs of TV series, or freelance jobs writing scripts for series (which represents a small fraction of TV episodes; the great majority of episodic scripts are written by writers on staff[1]), and writing pilots. Traditionally, agencies earn 10% commission on the money their clients are paid, the writer's weekly salary if they're on a staff, their fee for a freelance script or their fee for writing a pilot script. Television series production – along with the writers' rooms that deliver the scripts to feed series production – is now a year-round process, but TV lit agents are busiest each spring during what's known as "staffing season," when the numerous broadcast network TV shows hire, fire, replace, expand and start up their writing staffs. Television lit agents work longer than their normally long hours from March into June to get writer clients staffed on shows, submitting material to showrunners, network and studio current executives, and pushing for their clients to meet those people and get hired. Lit agents might work 12–14-hour days during the height of network staffing season.

Television lit departments also employ "packaging agents" who specialize in development. Packaging agents, as I discussed briefly earlier, specialize in leveraging the huge roster of talent repped by an agency to put new TV development projects together. The example I discussed earlier was the packaging agent who took a new novel written by an author repped by the agency's book lit department and packaged it with a screenwriter and a non-writing EP also both repped by the agency. Or a packaging agent might come up with an original area or concept for a series, then identify a writer and star actor client the agency reps to package into the project. The packaging agent's job is to assemble the pieces the agency represents to create big, sexy development packages that the agency then shops to networks and/or studios. One of the popular buzzwords in Hollywood as of this writing is "undeniable"; packaging agents try to package projects packed with an agency's biggest "A-list talent" that every possible target network buyer will find "undeniable" and will want to bid aggressively and competitively to get.

Television packaging agents historically have been considered more senior and higher status than regular TV lit agents (who traditionally focused primarily on getting writers staffed on shows). Packaging agents were also considered a bit more hands-on creatively. The distinction between packaging agents and other TV lit agents has blurred over the last 15 years, however, as more junior writers (repped by more junior TV lit agents) find more opportunities to pitch development to buyers. Even relatively new TV lit agents perform packaging functions now – mixing and matching different creative elements repped by their firms – to advantage their clients. Some agencies don't even designate packaging agents anymore – all lit agents are packaging agents at those agencies now. Agencies hold regular "packaging meetings" where numerous agents discuss emerging projects and bat around client names to help package one another's projects. One of the goals of most lit agents is to groom every TV writer client to become a series creator.

If an agency sells a package to a network and studio, the agency is compensated in the form of a "package." If an agency earns a package on a TV series, the agency becomes a profit participant, typically earning 10 points (or 10%) of profits if and when a series enters profit. The profitability of TV series is much lower than it was in the broadcast network/syndication model of the twentieth century, but the most successful TV series can still earn hundreds of millions – and in limited cases, billions – of dollars of profit. Commissions constitute a large share of talent agencies' revenue, but packages on hit TV series are the brass ring of most large agencies, the revenue source that separates rich agencies from successful agencies.

Because packages are so valuable, agencies fight over them. However, if one talent agency represents one or two elements of a new piece of development and another agency reps other elements, the two agencies may split the package, each receiving "half a package" and half the backend participation that comes with it. (Remember that, while agencies package projects exclusively with their own clients, other entities package projects too. If a producer or studio exec packages a project, he or she might package talent into the project from two or more different agencies.) Agencies sometimes divide packages into thirds. While the history of agency packaging is based on agencies putting together true packages of multiple creative elements, that quickly devolved to agencies demanding packages or shares of packages if even only one significant element of a package, like a very successful TV writer, a brand-name producer or a piece of hit IP (like a bestselling novel),

participates in the project. Packaging agents, agency senior partners and network and studio business affairs executives (and sometimes other senior network and studio management) negotiate granting packages and shares of packages during the development and series greenlighting and dealmaking phases.

One interesting byproduct of the agency packaging business is that when an agency has a package on a series the agency's other clients who work on that series – writers, actors, directors, etc. – don't have to pay their agency any commissions. The industry would consider an agency to be double-dipping if it received both its share of backend participation while also commissioning its clients' pay on the series.

One way that agents become more powerful and increase their stature (and make more money) is by representing successful creators and showrunners. An agent who signs a young client who works her way up the ranks of TV writers and creates and runs a big hit show gains stature by dint of his client's success. In scenarios like that an agent can 1) develop a reputation for having an eye for spotting talent, 2) use the success of one client to help attract more "hot" talent ("Look at the success I helped her achieve; I can do the same for you!") and 3) leverage the success of his roster of clients both within the agency and externally to network and studio executives. Agencies reward agents who attract and nurture clients that become successful, and always implicit in the agent/agency dynamic is the fear that a successful agent will leave for a rival agency and take her most successful clients (and their earning power and future packaging potential) with her. Network and studio executives notice which agents represent the most talented and successful clients and they treat those agents with special respect in the hope of working with that agent's many rising stars.

Agents and development executives need each other and work hard to build strong relationships. From the perspective of agents, network development execs hold the keys to the kingdom. They are the gatekeepers of the real estate that networks control. Studio development executives are gatekeepers of huge development budgets that are doled out to writers in the form of pilot script fees and development deals. From the perspective of network and studio development execs, on the other hand, they want to win their companies the best, most attractive, most promising development projects and packages and, even more rudimentarily, to be in business with the most talented, most successful and most promising TV writers.

Executives work hard to build positive relationships with agents and vice versa. They need each other and want to build the best possible relationships to position themselves at the best possible advantage versus their competition. Agencies and agents compete with each other to sell their clients to the market of network and studio buyers of talent, and conversely networks and studios compete with each other to attract the most talented and successful writers. The marketplace of TV development goes in one direction, but the marketplace of TV talent is more complex.

Agency TV lit departments have "covering agents" for all the buyers and all the larger studios. All lit agents talk to execs at all networks and studios regularly, but one agent at each agency is assigned to "cover" a specific network and to watch most closely for news and information about that network relevant to his agency and to share his intel with the other agents. Conversely, network and studio execs and producers with studio deals often approach each agency via the covering agent who covers their network or studio.

Entertainment is an extremely social business. People work long hours and transact business over meals, drinks meetings and at parties. Professional relationships can become very intense and intimate. The TV business is actually a relatively small one. Executives, agents and many writers work with each other over and over, year after year, and powerful professional and sometimes personal relationships form.

AGENT REPRESENTATION: AN INDUSTRY REQUIREMENT

Representation by agents is an essential step for all aspiring talent: writers, actors and directors. It's impossible for writers and other talent to get jobs without an agent, including development opportunities. Here's why.

Producers and development execs at networks, studios and production companies can't look at scripts, pitches, treatments or even one-liner ideas unless they're submitted by talent agencies because they're at risk of claims of intellectual property theft against them if the material is unrepresented. Los Angeles talent agencies have agreements with all networks and studios

that material agencies submit for consideration won't be considered evidence of idea theft except in rare cases.

Here's a hypothetical: A network development exec reads a written pitch about an accountant who becomes a superhero, sent to him by an unrepresented writer from Indiana, and he emails the writer back, passing on the pitch. Three years later the network that exec works at orders a series from J.J. Abrams about a superhero who happens to be an accountant and it becomes a hit. The writer in Indiana says to himself, "That was my idea! They stole it from me and gave it to J.J. Abrams, and now everyone is making a fortune on my idea except me!" The writer sues the network and has the email "paper trail" as evidence that not only did he submit his pitch but the network executive read it and replied. The network has to potentially incur the expense of defending against this claim.

If the writer in Indiana had been represented by a talent agency, the network would have been protected. The agent would explain to his frustrated client that ideas aren't protected by the law, only specific executions of ideas are protected by the law. The idea of an accountant-by-day/superhero-by-night is not protected; the specifics of a thorough and detailed execution of that idea – the names of the characters, places they live, specific relationships of the characters, specific plot points of stories, specific dialogue used to tell the story – are protected by the law.

Idea theft does occur in Hollywood, but it's extremely rare. As mentioned earlier, most Hollywood professionals are in the game for the long term. They hope to have long careers. If they develop a reputation as a thief, their careers won't last very long. For one thing, they and their employer may be sued, and, if there's any merit to the claim, the employee won't last long, and word will spread among the people who run companies not to hire him. Second, if an agent gets burned by an exec she does business with, she'll be very reluctant to ever submit anything to that person again. The thief will develop a reputation and become isolated, unable to get a job, hold a job or get his hand on material to do his job. Almost everyone in the industry understands this and, as a result, a fairly high degree of professional integrity is one of the business culture imperatives that is embraced throughout the TV industry.

Aspiring professional writers should never submit material directly to producers, networks, studios or production companies. Agents submit

material and set pitch meetings. Aspiring writers need representation by agents or managers to submit material for them.

The good news for aspiring talent is that agencies have a voracious appetite for talent. That's their business – identifying talent and selling it, monetizing creative abilities – and they are constantly looking for fresh, new talent. Hollywood loves new faces. As a network development exec once put it, "Hollywood loves the shiny penny." Yes, it can be hard for aspiring talent to get signed or even get noticed by Hollywood talent agencies, but there are methods to this madness, which I'll discuss in Chapter 13.

OTHER ROLES OF AGENTS IN TV DEVELOPMENT

Agents are hands-on when their clients begin the process of developing new projects. Agents are frequently the very first development professionals to hear a writer's new idea. They listen to their clients' preliminary ideas and give them initial creative feedback along with an assessment of the idea's potential in the marketplace. Not only is the writer looking for creative and marketplace feedback, she's hoping to get her agent excited about her idea, to motivate her rep to become a champion and advocate for her idea to the industry.

The agent may next propose packaging elements. "Here's a producer who would be great to partner with on your project. She has a track record of success in this area and great relationships with the target buyers." Or, "This idea would be perfect for Star X who the buyers are dying to be in business with. I'll put you in a room with her and you can pitch it to her."[2] After the writer has met with prospective packaging partners and further developed her pitch to incorporate any creative or practical sales input from her agent, the agent creates a sales strategy. Do we want to pitch this project to studios and make a studio deal first? Or do we want to take it straight to networks? Which kinds of networks is this project right for? Once the agent and writer arrive at a sales strategy, the agent calls prospective studio or network buyers, pitches the logline and the writer. If the prospective buyer isn't familiar with the writer's work but responds to the idea, the agent emails writing samples of the client's previous work so the buyer can educate himself on the client and evaluate if the writer's work suggests to him that she's someone he wants to develop with. If the network or studio exec follows up a week or two later and says he likes the writer's material (or

if the exec knew and likes the writer already) and is interested in hearing the pitch, the agent's assistant follows up to schedule a meeting for the client to go to the exec's office to pitch her idea. Hopefully, the agent gets interest from multiple companies and can set a round of pitches, anywhere from two or three to twelve pitch meetings or more.

The agent views all his clients' pitch meetings on a calendar and immediately follows up with the exec after each pitch to gauge response and, if he sees an opening, to do a little selling, to "agent" them as much as possible toward the goal of hearing a "yes" and getting an offer. Agents learn the personalities, styles and idiosyncrasies of the different execs, and the best ways to work with them. Most execs are sellable to a greater or lesser extent, and good agents learn how to tailor their salesmanship to specific buyers' personalities.

If the agent receives multiple offers for a client's pitch, the agent may be in a position to effectively turn the situation into an auction and play one offer against another, bidding each one up as high as possible. If only one buyer responds, the project enters the deal-making phase and the agent works with the client's lawyer (if she has one) to negotiate the deal for the client's services on the project with the network or studio buyer. If no buyer emerges, the agent has the painful task of breaking the sad news to his client and ideally finds some kernel of positive feedback and encouragement to give her as consolation. "They didn't buy this one, but they loved meeting you, loved reading your other material, thought you were great in a room [meaning a good pitcher and pleasant personality] and would be excited to hear your next idea." Agents are a little like doctors; delivering bad news is an important part of their job, and good agents learn how to deliver bad news in a way that doesn't make their clients feel defeated. One common agent motto is: "Deliver bad news fast." In other words, perform the harder aspects of the job with professionalism, don't procrastinate because your job is hard, make sure the client doesn't hear bad news "on the street" and, lastly, the client deserves to hear a polite version of the truth promptly so she can lick her wounds, pick herself up quickly and move on to the next project, the next piece of income-earning business.

If the project sells, the agent effectively stands down once the client's deal is closed. The project is now in the hands of the writer and her various partners. The agent's job at this point is to respect the process and give his client and the development execs and producers room to do their work.

Once a script is in the final stages of development, the agent might resurface to check in with execs and producers and gauge the script's chances of moving forward. The agent may use his agenting wiles to sell the development exec on supporting the project. The agent may also try to get a sense from the exec of the strength of competing projects, the other pilot scripts that will go to the network president for greenlight consideration. (Aside from his own clients' projects, an agent is always gathering intel on the marketplace to share with his agency colleagues.)

Once the client's pilot script is on the network president's iPad along with all the other contenders, an agency typically has one of its senior lit partners, who has a good relationship with that network president, make a call to the president to assess her interest in the agency's various contending scripts and to do a bit of high-level, low-key selling if possible.

If the client's script is greenlighted to production, the agent works on her behalf to get the agency's most sought-after actors and directors interested in considering the project and, on the other hand, coordinates with his agency colleagues to place the agency's other clients at the front of the line for his client's consideration to hire. He helps his client navigate within his agency, and he becomes a seller to his own client. The agent knows full well that the project's success is far too important for his writer client to steer a lead actor or a director to the client's project simply because of agency allegiance. He knows that choosing the right lead actors and director will make or break the pilot's chances, but the agent's job at this point is to do his best to help get his agency's clients in the door, to get them "in the room" so they at least have a chance to show what they've got. The writer/showrunner prepping a pilot is too busy to audition or meet with every candidate and has to be selective, but an agent considers himself effective if he's able to get his firm's best candidates in front of a client pilot showrunner.

Once finished pilots are delivered, the senior agency partner makes another foray to the network president, hoping to gather intelligence on all the pilots' prospects and do whatever little selling he might be able to do to help tip a decision in favor of one of his agency's projects. The agent might try to offer other agency elements to help sweeten a project's prospect. The agent might offer other top writer clients to work on the writing staff or top director clients to direct episodes of the series. Chances are the agency has a package or some share of a

package on his agency's contenders, and the payday seven to ten years down the road if the project gets on the air and becomes a hit is enormous. These moments when network presidents decide which pilots to greenlight are make-or-break moments for projects, and senior agents with any kind of influence on the highest levels of networks do whatever they can to help decisions go their agency's way.

Once series pick ups are announced, the entire agency shifts into staffing mode (a mode it's partly in year-round). The showrunner client might do a call or a meeting with agents at her agency who specialize in directors and go through the list of agency director clients and try to "slot" the firm's best available directors.[3]

ANOTHER ROLE OF AGENTS

While some writers, actors and directors are entrepreneurial and interested in the business side of Hollywood, most talent prefers to stay focused on the creative work and leave the business side of their careers to agents, managers and lawyers. Most TV writers in development look to their agent, producer and studio partners to do the work of assessing the marketplace and identifying the right target buyers for their projects. A common writer attitude is, "I'll worry about coming up with a great idea for a hit show. You study the business and tell me which networks could make the best place for it to have success."

Agents also sometimes are called upon to protect their clients. Executives and writers work carefully to maintain harmony with the delicate process of notes, but sometimes writers feel network executives overstep their roles and become too invasive in the creative process. UTA's head of television Jay Sures has had to have a tough conversation with execs a few times over the years:

> What I'll say is, "Are you open to a little feedback?" They'll say, "Sure," and I'll say, "Your note, whether it's good or bad is subjective. And at the end of the day, if you really want to be in business with this client, you gotta trust them. I'm going to make sure they hear your note – I'm not going to make sure they execute it – I'm going to make sure they acknowledge it, think about it, and then have them do what they think is best for the project. And I hope you're ok with

that, cause that will be better for you, your network and my client in the long run." That approach tends to work pretty well.[4]

Sometimes clients need even more help from agents. One creator/showrunner of a hit series a few years ago fired her long-time and beloved agents for one reason: She needed a more powerful agency to protect her from her own network that she thought was trying to steer her successful show in the wrong direction. The writer didn't have the time, energy or toolset to fight back, and needed a bad cop with a lot of muscle. The most powerful agencies have the muscle to defend a client in cases like this, not only because their senior agents have strong personalities (which they do), but also because the agencies control so much top talent that networks and studios are hesitant to alienate them and risk losing out on attractive future projects.

MANAGERS

Managers are slightly different from agents. In theory, agents help clients get jobs, and managers help clients navigate their careers. California law specifies that managers may not help clients get jobs. That's the agent's purview. The manager is typically considered closer to the client than the agent, almost a professional life coach, helping the client navigate the tortuous twists and turns of a career in a difficult industry. Typically managers have many fewer clients than agents so they can devote more time to each client and deliver more hands-on services. It's not uncommon for young talent to sign with a manager first; one of the manager's key jobs at the outset of a career is to help the young client get signed by the best possible agent.

Managers help groom the talent. How should the client position himself in the industry? Is the client a feature writer or TV writer? Is the client a drama writer or comedy writer? Does the client want to sell development first or staff on a series first? Writers and actors often have both an agent and a manager (their "team") who work together to get the client jobs and/or initiate development, build the client's career and navigate a path toward success. Managers are typically commissioned 15% of a client's pay.[5]

Managers also sometimes become producers, as mentioned earlier. Traditionally, agents could not legally produce content, but managers can and do.

(In our current era of increasing deregulation, however, rules restraining agents from producing are relaxing, and agencies are slowly dipping their toes into producing television. Endeavor Content is a new production company sister division of WME, owned by WME's parent company, and develops and produces *Killing Eve* on BBC America among other new and upcoming series. CAA is also stepping into producing ventures.) The larger management firms package their clients and their own managers as producers to develop, sell and produce series. *Thirteen Reasons Why* was packaged by three managers at the management firm Anonymous Content, and the three managers serve as EPs on the series.

Writers, directors and actors sometimes have pangs of conscience when they fire reps who helped them start their careers and then "trade up" to bigger, more powerful agents and managers.[6] Some talent, on the other hand, are devoted to their agents and managers and stay with them for their lifetime. We've all seen how emotional some actors, writers or directors get thanking their agents or managers at Oscar or Emmy awards for sticking with them through fallow years, believing in them and helping guide them to their success.

A senior partner at a top LA talent agency, who reps many successful and powerful creators and showrunners, once said that despite all his important clients' huge and lucrative successes, his greatest thrill as an agent is getting young clients their very first job in television. "I help change people's lives," he said. "There's nothing better than that."

NOTES

1 We don't call all writers who work on a TV writing staff "staff writers" because "Staff Writer" is actually a job title of one of the several hierarchical levels of writers on a TV writing staff; a Staff Writer is, in fact, the lowest level writer on a writing staff. (See the complete list of hierarchical writing staff titles on page 19 in Chapter 1.)
2 "Put you in a room with..." is de rigueur agent lingo for "I'll schedule a meeting for you with...." Another popular variation on this is, "You know who you should sit with...?"
3 Writers are "staffed" onto series writing staffs, and directors are "slotted" into specific schedule slots (including prep, production and post) for specific episodes, in almost all cases long before anyone has any idea what the content of the episode will be.

4 Author interview with Jay Sures.
5 It's not uncommon for writers, actors and directors to pay 10% to their agents, 15% to their managers and 5% to their entertainment lawyers, who negotiate the detailed terms of their contracts (rather than paying them hourly). Very successful writers, actors and directors also pay business managers (who manage income, expenditures and coordinate with bankers and investment advisors) and publicists.
6 One well-known TV star fired her mom, who'd been her manager for many years and helped her make her way to stardom, only to trade up to a more powerful manager. The mom was an actual professional talent manager with a full roster of clients – as opposed to a "momager," a mother of a successful young actor who reps only her own actor child so the family has legal access (by way of the manager's commission) to some of the child's income while the rest of the earnings are protected until the child turns 18 under the California child labor law known as the Coogan Act.

10
Other Development Strategies

The standard script development process described in Chapter 2 is the most common series development model in American TV today, and the great majority of new series are developed that way. As discussed, new projects are shopped as verbal pitches, networks buy pitches and pay the screenwriter to write a pilot script, finished pilot scripts are evaluated by the networks, the best are greenlighted to pilot production, networks evaluate completed pilots and – in a minority of cases – order them to series.

While this is still the most common process today, there are others as well. I'll look at several in this chapter. I'll also look at the kinds of development deals writers, producers, directors and actors make.

Since 2013 a development trend has emerged that bypasses the traditional piloting process. This alternative is known as "straight-to-series" development. In straight-to-series development, a network buys a new project not to order a script and shoot a pilot, but to commit to one or more full seasons of episodes upon initial acquisition of the project. Netflix began this current trend, and other online distribution companies employ the strategy as well (although most buy pitches in the traditional script-to-pilot model too). HBO, Showtime, Starz and other cable networks continue to primarily

develop pilots but have employed the straight-to-series model in limited cases in recent years.

Straight-to-series orders are not new. Before streaming and cable existed, broadcast networks occasionally made straight-to-series commitments to projects in extremely competitive situations. If a studio shopped a project that all the networks wanted and were willing to pay dearly for, the studio could leverage the interest into a competitive auction situation and demand "13 on the air" or "22 on the air," meaning the network buyer committed to paying 13 or 22 license fees for that many guaranteed episodes along with a slot on its fall schedule. The networks hedged their bets by building several steps into the commitment along with penalties. That means a script for the first episode would be evaluated, and if the network didn't like it, it had the right to end the project. If the network exercised its right to kill a project before it aired, it had to pay a penalty, typically quite a large financial penalty but not nearly as large as 13 or 22 license fees. The network would also typically shoot the first episode during its pilot season and could pull the plug on the project at that stage, before further series production commenced, and pay a different pre-negotiated penalty to the studio.

Most straight-to-series projects at Netflix and other streaming and cable companies today still provide the network with the ability to shut down the project before production commences if the network determines the work is not what they were expecting. Scripts have to be written before episodes are shot, and if the network doesn't like the scripts or doesn't think they're in line with what they thought they bought, the network can pull the plug on the series before production starts. It's not cheap to do that, but it's cheaper than shooting a season of episodes in which the network has no faith.

Netflix began the current straight-to-series model in 2011 with its first original scripted series *House of Cards*.[1] The fact that *House of Cards* was perceived by the industry as both commercially and creatively successful has contributed to straight-to-series becoming more common in the industry.

House of Cards also introduced one of the early hallmarks of straight-to-series development, A-list auspices. "If you deliver an A-list star, writer and/or director," the network seems to have said, "we won't make you jump through the usual development hoops. We'll order your project straight-to-series." When Netflix did it and it worked, the whole town took notice.

Studios, agents and producers looked to other networks for similarly sized commitments, and other networks stepped up.

Networks compete for the best new projects, and they express their level of interest by the level of commitment they offer. They can offer to pay for a pilot script (known as a "script commitment"), they can make a put-pilot commitment or, at the highest level, they can offer a straight-to-series commitment. They can offer a one-season straight-to-series commitment or as many seasons as they want. Most straight-to-series commitments are determined by the marketplace, by how many networks want a project and how much they're willing to commit to get it. Netflix's two-season straight-to-series commitment to *House of Cards* introduced the network to the scripted series development marketplace as an aggressive buyer with deep pockets.

Studios, producers and creators typically consider a second factor when they evaluate competing offers for their projects. Creative control. A central part of Netflix's development strategy is giving A-list talent virtually complete creative control. As I've described, networks have traditionally been very hands-on creatively with their development and current series ("He who pays the piper ..."), and trends in the last 15 years have seen networks only increase their creative control. Netflix said, "No. We'll work with the best people on the best projects and respect them to deliver the work they pitched us."

They guaranteed the producers of *House of Cards* a reported $100 million,[2] and said, "Go make two seasons, and let us know when the first season is done." Total creative control is extraordinarily attractive to top talent, and Netflix has continued to use it as a lure to attract great development.

Netflix altered the Hollywood development process in three significant ways. First by guaranteeing large series commitments and, second, by taking a hands-off approach to the creative side of the development process. Then they escalated the price of development deals by making agreements with two of TV's most successful creator/producers, Shonda Rhimes and Ryan Murphy, for reportedly $150 million and $300 million respectively. Warner Bros. Television responded by locking up one of its most successful creator/producers, Greg Berlanti, in a $300 million six-year extension of his overall deal.[3] Netflix announced itself as an aggressive buyer, maker, owner and distributor of content in its effort to capture as much share of the

streaming media marketplace as possible, at the dawn of that new business. Other networks and studios are stepping up to compete, but so far most other TV companies are not giving artists the same level of creative freedom that Netflix does.

In Chapter 1 I mentioned that Netflix is challenging the traditional distinctions between networks and studios by both producing and distributing series like *Stranger Things, The OA* and others. A new way it's breaking down those traditional boundaries is in its recent deals with writer/producers like Rhimes and Murphy. Traditionally studios made overall deals with writers and producers to own their creative output and the shows that emerged from it. Netflix is not only competing with networks like CBS, HBO and Hulu by distributing TV series, it's competing with TV studios by making overall deals with writers (and compelling studios like Warner Bros. to lock up talent before Netflix lures them away).

ELEMENTS OF STRAIGHT-TO-SERIES

Let's look more closely at how straight-to-series development works. In traditional pilot development writers, producers and studios typically spend several months developing a pitch and then shopping it to networks. With straight-to-series projects sellers spend much more than a few months assembling a substantial and thorough package of creative elements. The *House of Cards* team, for example, spent a year and a half developing the project internally before taking it out to network buyers. One of the first and most important elements of the package is typically a spec pilot script (again, technically it's not a "pilot" script, but an "episode one" script), which, of course, requires the services of a screenwriter. With *House of Cards*, they actually developed scripts for the first three episodes. Next, straight-to-series projects usually incorporate an extensive "series bible," a prose document that states the vision of the series and its creative direction for the life of the series, an outline of story arcs of the first several seasons (or entire series, if possible), and detailed summaries of every story of every episode of the first season or two. Sometimes a shorter version of this document, known as a "format" document, is used. (Series bibles are usually around 30 pages, while format documents might be ten pages.) Next, most straight-to-series contenders are "packaged up": Not only is a writer on board, but also a well-respected non-writing EP and typically

a star actor and/or A-list director are attached. Usually the director is prepared to commit to directing many if not all the episodes of the series. In the case of *House of Cards*, the project famously included a then A-list movie star, an A-list feature director (who had never deigned to direct TV before), a screenwriter and two well-respected non-writing EPs, in addition to three scripts and a series bible.

Typically straight-to-series contenders are shopped to networks by senior studio execs, producers or agents. They call development execs at the targeted networks, pitch the project in logline form along with its (no doubt stellar) auspices and explain that the sellers are looking for a straight-to-series order. If a network exec responds to the pitch, the seller emails the script/s and series bible, and the network execs read the material and determine their level of interest. Given the size of the commitment under consideration, senior network execs often turn to the network president to weigh in. Interested networks notify the sellers and ask for a meeting. Sellers book a round of meetings at interested network buyers and typically the "whole package" shows up en masse, the writer, the star/s, the director, the non-writing EPs and the studio execs, to discuss the materials they submitted, articulate their series vision beyond the bible already delivered, and to field questions or address concerns the network execs raise. To a great extent, the meeting step is useful for networks to assess how committed the high-level auspices attached to the project really are, and, conversely, it's a chance for the selling team to demonstrate their passion and commitment to the project.

Interested buyer networks make offers, and the sellers choose a winner typically based on the size of the financial offer, the size of the series commitment, the prestige of the network, the likelihood of the project's success at the network and, lastly, any possible personal and/or business relationships with senior network personnel. In a competitive situation, the seller picks a winner, and the details of a deal guaranteeing one or two seasons is negotiated.

Instead of writing a pilot script and potentially producing a pilot for network consideration, the sellers get straight to work prepping and producing the first season of episodes. A writing staff is hired, the rest of the series is cast, additional directors (if needed) are slotted, and episodes are produced and delivered to the network.

The creative elements described above are the most common elements of a straight-to-series package, but – as mentioned throughout the book – every project is unique, and a variety of different approaches can earn a straight-to-series order at Netflix, Amazon, Hulu, HBO and other networks. Netflix ordered a season of *Green Eggs and Ham* from a pitch rather than a script and series bible. Writer Jared Stern (who created *Dr. Ken* and wrote several features) pitched detailed stories for the first 13 animated episodes along with a vision for future seasons, and he showed well-developed artwork tailored for each Season One episode. The package also included two important non-writing EP elements, Ellen DeGeneres and feature director David Dobkin.

Netflix also develops using a process known as "script-to-series." Script-to-series development is similar to the traditional piloting development process, but without the pilot. Execs hear a pitch and order a script for the first episode of the series (or in some cases scripts for the first two episodes of the series), and base a series order decision on the scripted material and a series pitch, either oral or in written bible or format form.

Do most creators want to sell their projects to Netflix and enjoy its hands-off creative approach? Why wouldn't every writer and producer want to work for Netflix? To a great extent, they do. But there are reasons why sellers don't always consider Netflix an ideal home.

First, it takes a lot more time, effort and potentially money to build the complete package of elements Netflix looks for in straight-to-series contenders. Studio execs, producers and agents don't believe every new project merits the investment of spec'ing a full pilot script, developing a 30-page series bible and attaching high-level producers, stars and director. Developing a 20-minute pitch with a writer is a lot cheaper and easier, and the risks of failure are much lower.

If a studio wants to develop a straight-to-series contender, it pays a writer to write the script internally at the studio. Pitching projects, on the other hand, usually doesn't require the studio to spend up-front money. If a studio doesn't have a long-term development deal with a writer (which I'll talk about later in this chapter), a studio will typically make what's known as an "if-come deal" with the writer before taking out the pitch. In an if-come deal, a studio guarantees the writer a specific amount of money to write the pilot script *if* a network buys it. In other words, the writer agrees to develop

and shop a pitch on spec with no guaranteed payment. Shopping pitches with if-come writer deals is a lot cheaper for studios than paying to build huge straight-to-series packages.

Second, there's currently less potential upside for sellers in success at Netflix. While there's enormous variation in the deals Netflix makes for new projects, its fundamental approach to distribution differs markedly from industry standards. Netflix typically doesn't license first-window of domestic distribution like most other networks. Rather than paying studios license fees for episodes – allowing studios the ability to reap all ancillary revenues – Netflix often pays what's known as "cost-plus" fees, the cost of production plus a built-in, pre-determined "profit" fee, in exchange for all distribution, worldwide, in perpetuity. The studio is guaranteed profit upfront, but the profits are capped.

Traditionally studios (and their various profit participants, i.e., creators, non-writing EPs, pilot directors and agencies via packages) make more money the more successful a show becomes. The bigger the hit a series becomes, the more international interest, the more domestic after-market distributor interest, the higher the profits a studio and the profit participants can earn. Netflix's cost-plus buyout limits the profits a hit show can earn.

Another reason sellers may be skeptical of Netflix is, ironically, the vast quantity of content it buys. Netflix programs so many shows that it can't give all of them the high level marketing support it gives its top-tier series. Sellers want to produce series that stay on the air, but they also want to produce series that become hits and impact many viewers. Netflix programs so many series that some sellers are concerned their shows – even if given multiple seasons – can get lost in the mix.

One final observation about Netflix: The company is leading the way in using its data to evaluate development. Networks have traditionally incorporated program research into development decisions, as I've discussed throughout the book, and networks have relied on Nielsen ratings to assess series performance on the air. But no networks have ever had the specific performance data to which today's streaming platforms have access. Netflix and other streamers know exactly which viewers are watching what, when they tune a show out and what they binge on for hours on end. Projects pitched to Netflix are typically subject to the company's data-driven

analysis. Netflix uses its data and algorithms to specifically assess if a show about a specific kind of subject matter, set in a specific world with specific actors, will appeal to its audience, and often makes development decisions based on the results of that math.

SPEC PILOT SCRIPTS

Most development designed to earn straight-to-series commitments requires writers to write at least a first episode script on spec (even if they're paid by a studio or production company that's bearing the speculative risk). Demonstrating what an episode looks like on the page, introducing the concept, characters and world in dramatic form, is usually the single most important element of the straight-to-series package. But spec'ing pilot scripts has long been an alternative development strategy for traditional pilot development too. In this scenario, the writer writes a complete pilot script and shops it to networks rather than delivering an oral pitch to potential network buyers. The spec pilot is typically ordered to pilot production and considered alongside other pilots that the network spent months developing. Why? Why would a writer go to all that extra trouble of writing a pilot on spec if he's entering the same pilot process he could have entered with far less effort by developing a pitch?

Before addressing that question, let's put spec pilot scripts in perspective: Aside from projects seeking straight-to-series orders, spec pilot scripts represent a small fraction of TV development today. Buyer trends favoring spec pilots versus pitches ebbs and flows in TV development (subject to trends and fads like everything else in Hollywood), and, as of this writing, spec pilot scripts are not nearly as attractive to networks buyers as pitches.

This is primarily because network execs today tend to want to be more hands-on from the outset of their projects and to enjoy the sense of ownership that goes with it. In many cases network development execs are acting more producorial than before, identifying IP or ideating areas (like *In the Dark*) and, in many cases, packaging their projects themselves. As more companies enter the scripted series business, many are branding themselves very specifically, motivating execs to feel the need to tailor their development within their narrow network identity and for their discrete segment of the audience.

So why do writers and studios ever spec pilot scripts intended for piloting consideration? First, some writers – even successful, in-demand writers who could easily sell pitches – prefer to spec pilots because it allows them greater creative freedom and control of the writing stage of development. Instead of writing multiple drafts of a story outline and a pilot script with network input on every draft, a writer can maintain far more creative control of the writing process if she writes with the intention of shopping a finished script. Almost invariably, the network that buys the script will have creative notes, but it won't have nearly as much input as it would if its execs were present at every stage of the script's creation.

A finished spec pilot script also potentially gives the writer (and his studio and producer partners) more control attaching other talent elements. Actors and directors who are open to projects in development are more open to considering a finished script than a pitch. There's more to go on, more completed work to base decisions about making a commitment on. The writer and his partners therefore may be able to avoid the network casting and pilot director selection processes by packaging those elements before a network joins a project. The risk with this strategy, of course, is that network buyers may like the pilot script but not the other talent elements, meaning the sellers have damaged a valuable project rather than improved it.

Another reason a writer might spec a pilot (or be paid to by a studio or production company) is because sellers fear the concept may be met with skepticism unless it's "proven" in script form. They doubt that even a good pitch can sell a challenging concept, but a strong script can more likely overcome buyer doubts.

ATTACHING TALENT

As mentioned above, one of the reasons writers spec pilot scripts is to have something more concrete than a mere pitch to which to attract talent. The talent that's relevant to TV development, that networks might be interested in, include star actors, pilot directors and showrunners. If a writer doesn't have showrunning experience or doesn't have enough TV series staffing experience to credibly claim to be prepared to run his own show, attaching a showrunner to a spec pilot script, or even in some cases to a pitch, can

provide an extra degree of assurance that there's a writer with the skills to follow through and deliver the series as promised.

Attaching talent to a spec pilot is typically done by the agent who reps the writer or by a producer who has either bought the project or in some way partnered with the writer on the project. The agent or producer reaches out to the agent or manager of the prospective talent (actor, director or showrunner), inquires if the talent is open to considering spec pilot material, floats a logline of the project (and some specifics of the role if it's for an actor), and, if the rep responds, submits the spec pilot script (by emailing it to the rep). The rep reads it and, if he thinks the material suits the client, forwards it on to the client for consideration. The actor, director or showrunner reads the script and decides if he's interested. If he responds to the material, the talent meets the writer (and producer) to hear more about the project, to learn where the series goes and to see if everyone gets along personally. The talent then decides whether to attach himself to the project, which typically takes the form of nothing more than a verbal agreement, a "handshake." The talent and his reps are good for their word. The producer and/or agent can then shop the project to buyers and reference the attachment of the actor, director or showrunner. The newly attached talent may be part of the shopping/pitching process at that point too.

As mentioned earlier, adding a particular piece of talent to a project is a guessing game. Will prospective buyers like that piece of talent and think he adds value to project? In the case of many A-list actors and directors, the answer's pretty clear. When Jennifer Aniston attaches herself to a TV series, her first since *Friends*, it's a big deal and it's safe to say that just about every network would want to have a crack at that project. When Steven Soderbergh attaches himself to direct a TV series, most networks want to be made aware of the project and, at the very least, have a chance to consider making an offer. But, short of obvious A-list names, assessing who the right talent is that will make a difference to network buyers is a guessing game. Sellers run the risk of "packaging away" from their prospective buyers.

Attaching talent is also very hard. Top talent are offered a steady stream of high-level projects, scripts, pitches and go-projects, and therefore have the pick of the litter. Because the TV marketplace is so flush right now and so many projects are being developed and bought, many in-demand actors, directors and showrunners are approached constantly with pilot scripts and pitches to which to consider attaching themselves. Most talent usually say

no. It's easier to say no. Most talent respond first to paying jobs. Because their names may add value in the marketplace, most in-demand talent can afford to be very picky.

Showrunners in particular are especially reluctant to commit to spec pilot scripts or pitches. The showrunner marketplace is driven, like all marketplaces, by supply and demand. Because there are so many shows right now and every show needs a showrunner, experienced showrunners are in huge demand. Most proven showrunners are busy either running shows or considering paying offers and therefore don't need to attach themselves to projects that aren't already "going." Most agents of showrunner clients are skeptical of any projects approaching their clients that aren't already set up at networks. Projects set up at networks are further down the line, closer to production (i.e., closer to paying their clients cash money) than projects that aren't set up at networks. Many agents draw the line at what's referred to as "network interest." "Network interest" is when either a network has officially bought a project or has at least told the producers or studio, "We like this project and will buy it if you find a showrunner we approve who commits to it." Sometimes that's the piece that networks require to feel enough assurance to move forward to commit to a spec pilot script or a pitch from a less-experienced writer. The producer or studio then shops the network interest to attract a showrunner.

Short of network interest, it's very difficult to attach a showrunner these days.

SHOPPING DEVELOPMENT TO NETWORKS VERSUS STUDIOS

Traditionally, most TV projects at the outset of development were set up at a studio before they were shopped to networks. Studios either had a long-term deal with the writer, or the writer and his reps would bring a new pitch to studios and allow them a chance to pay for the privilege of bringing it into networks.

In the last few years it has become more common, however, for agents and producers to shop "freeball" projects, projects that don't already have studio partners. If a network buys a freeball project, it will most likely lay the

project off at its in-house or sister studio division. The reason that going into a network "clean" (without a studio) has become more common is because network parent company ownership of shows has become more and more important. As viewership and ratings continue to decline in every corner of TV (in part due to increased competition, in part due to changing habits and preferences of younger viewers) the value of the first window of distribution is getting smaller and smaller, but the value of long-term ownership of successful shows (their value internationally and to secondary streaming outlets) continues to grow. Therefore, studio ownership becomes more important as the fees from network first-window of distribution rights decreases. This translates into networks placing a higher priority on projects its parent company or sister studio divisions can own than ever before. If an agent or a producer thinks a project is ready to shop – if the writer and pitch are strong, or enough creative elements are in place for the project to appeal to buyers – most agents and freeball producers (producers without studio deals) prefer to approach networks *without* studios and give their prospective network partner the option to own the project.

STUDIO AND NETWORK DEVELOPMENT DEALS

One way that studios (and now some streaming platforms) own content is by "owning" writers' and producers' creative output. Artist ownership in TV takes the form of development deals: overall deals, first-look deals, blind script deals and POD deals.

Television studios make long-term development deals with writers they believe are capable of creating hit shows. The most significant kind of development deals studios make are "overall deals," where the studio pays the writer to own all TV ideas, pitches, pilots and series the writer creates. A step down in level of commitment is a "first-look deal" in which the studio pays a writer only for a first look at the writer's ideas, a first right of refusal of any new series ideas the writer comes up with. If the studio passes on a pitch from a writer with a first-look, the writer is free to shop the pitch to other studios or networks. Overall deals are typically "exclusive" deals, meaning the writer can't develop at any other studio or at any network without her home studio. If a writer in an overall deal comes up with an idea her studio doesn't like, she can't do anything with it for the duration of her deal. Overalls and first-look deals can run anywhere from one to six years, though two- and three-year deals are most common.

In most overall deals and in some first-look deals the writer is not only expected to generate new series development, but is also expected to staff on one of the studio's current series. In the old days (meaning the 1990s and earlier), successful veteran writers with overall deals could be paid millions of dollars to effectively write one or two pilot scripts a year. Around the turn of the millennium studios began looking for ways to mine additional value from their overall development deals and began requiring writers under overalls to staff on one of the studio's shows (though usually not to run them; that workload would distract them from their primary development responsibilities).

A lower-level deal a studio might make with a TV writer is a "blind script deal." This kind of deal is per unit of work (one or two pilot scripts typically) rather than for a period of years. In a blind script deal, a studio guarantees payment to a writer for one or two pilot scripts without hearing pitches for any specific ideas (that's the "blind" part). If an in-demand writer without a deal pitches an idea to a studio that the studio likes and wants to shop to networks, the studio's first instinct will usually be to try to craft an if-come deal. The writer's agent may argue that the writer's experience merits guaranteed upfront money. A compromise solution might be a blind script deal. The guaranteed script fee will apply to the new pitch if it sells, but, if it doesn't sell, the writer will develop another pitch and another pitch until she sets up a pilot with the studio and the blind script fee is applied to the pilot script the writer finally sells and writes. Commitments of one or two script fees are typical in blind script deals.

Agents who used to pass on if-come deal offers and fight for blind script deals look more approvingly at if-come deals these days. Because network ownership is so important now, agents may be wary of tying a writer to a studio with a blind script deal if the project at hand doesn't sell.

As mentioned in Chapter 1, studios also make overall and first-look deals with non-writing EPs (and their production companies) known as "POD deals" (producer overhead or overall deal). Producers with POD deals are sometimes referred to as "pods." "Do you know Glittering Media?" a studio exec might ask. "They're one of our pods." Production companies with POD deals can range from one or two producers and one assistant to large companies led by a producer with several development execs, current execs, in-house casting executives and numerous assistants.

Deals with actors, known as "talent holding deals," used to be common but have become rare in recent years. Interestingly, while studios traditionally make deals with writers and producers, it was networks that made talent holding deals. In 2014 ABC signed the actress Priyanka Chopra to a talent holding deal, developed pilot scripts for her that didn't move forward, and cast her in *Quantico*, a pilot that was developed with no particular actors in mind. More and more experienced and in-demand actors are looking to produce TV series as well as act these days, and many turn to studios for production company development deals rather than talent holding deals. Sometimes the two are combined. The actress Sophia Bush signed a holding deal/POD deal with 20th Television in 2017. The deal allows her to develop shows to render only EP services on but not star in, and also to star in a project developed at the studio, by her company or others.

Directors are unofficially divided into two categories in the TV industry, episodic directors and pilot directors. Pilot directors by and large tend to be the most successful episodic directors who are chosen by showrunners, networks and studios to direct pilots. Most pilot directors work as episodic directors between pilot gigs. (Many active feature directors also direct pilots these days, but rarely episodes of current series, unless they're episodes of high-level projects the director helped develop and EPs.) Some of the most in-demand pilot directors command studio deals. Most of these deals require the director to direct only pilots from the studio paying her deal. Other top directors command overall or first-look deals for their production companies. In this scenario, as mentioned earlier, the director is effectively functioning as a non-writing EP (and will usually receive EP credit and fees) and works with partners to develop a pilot that she is then expected to also direct. In some cases a director who developed a pilot may not be available when it comes time to direct the pilot, in which case the director only receives her EP credit and another director is hired to direct the project. If the pilots a director developed with a studio don't move forward to production, the director is usually expected or, in some cases, contractually required, to direct one or more of the studio's other pilots.

The yin and the yang of studio (and now streaming platform) deals tend to involve two factors, money and relationships. If an artist has success with a studio and works there for several years, he may form deep relationships with its executives. Those relationships can run very deep. Trust between people working at very high levels of the industry can be highly valued. Money, however, often trumps relationships. Talent is portable and, for the

right number, many artists are willing to move their talents to new companies where they hope new trustful relationships blossom.

NOTES

1 *House of Cards* didn't premiere until 2013, but Netflix bought it in 2011. Technically *Lillyhammer* was Netflix's first scripted series in 2012, but Netflix didn't develop *Lillyhammer*; it acquired the completed series. *Lillyhammer* was "original" to Netflix (as the network promoted it) only in the sense that Netflix was the show's first American distributor.
2 Many facts of the original *House of Cards* Netflix deal cited here were documented in a Harvard Business School case study by Anita Elberse, "MRC's House of Cards," Harvard Business School Publishing, January 16, 2015.
3 Rhimes' Netflix deal is reportedly for four years and Murphy's for five years.

11

Case Study
The Tortuous Five-Year Development of One Hit Show

"Development hell" is a phrase usually associated with the feature side of the entertainment business. Movies often undergo long and arduous development as studio management regimes rise and fall, as writers are hired and fired, some doing significant "page one" rewrites, and as genres and subject matter heat up or cool off in the marketplace. Stories of features that spend ten years or more in development are not uncommon. Television development is usually much quicker, sometimes as brief as nine months or a year. Development is hard, though, and, even in TV, success often takes a long time and follows a circuitous path. *Pretty Little Liars*, which I developed and produced, spent five years from ideation to series premiere, surviving three different networks, three different teams of development execs and three different writers until we got it right. This chapter chronicles the development of *Pretty Little Liars* as a case study to illustrate the tortuous five-year development of one successful show.

Pretty Little Liars was conceived in the development department of Alloy Entertainment, the company that produced *Gossip Girl*, *The Vampire Diaries* and numerous other shows along with *Pretty Little Liars*. Alloy Entertainment is a book packaging company that's effectively an entertainment concept think tank that creates ideas ripe for transmedia exploitation in books, TV and film. It creates smart, commercial concepts – typically

221

aimed at its publishing demographic sweet spot, YA fiction (books for and about teenage girls) – then partners with young novelists who execute Alloy's ideas as books, in many cases toward the goal of producing the books into TV series and movies.

IDEATION

Like *Gossip Girl* and most of Alloy's other shows and movies, *Pretty Little Liars* began as a book series. When Alloy created the idea for *Gossip Girl* in 2000 it planned a series of books, and the success of the books created the opportunity for the TV series (which, like *Pretty Little Liars* a few years later, also took three different attempts with three different writers at three different companies). By 2005 when *Pretty Little Liars* was conceived, Alloy had opened an LA office and begun creating ideas for books that were actually designed as TV concepts. *Pretty Little Liars* (*PLL*) was sold as a book series first, but it was also created with a TV version in mind.

The ideation strategy that resulted in the *PLL* concept involved looking at another successful show and examining how Alloy could mine the hit show's underlying conceptual formula for a completely different audience. In 2005 we looked at the newest, hottest hit show on TV, *Desperate Housewives*, and wondered what a teen version of that show would look like.

Desperate Housewives was a primetime soap with a fun, fresh tone. The series also began with a strong mystery hook. It premiered in the fall of 2004 and immediately blew up. When Alloy's development staff sat down in January 2005 to begin looking at new ideas for the upcoming TV development season, *Desperate Housewives* was the highest rated show on American TV and the hottest thing in American popular culture. Alloy's TV development unit worked with the company's book development group to see if we could crack "teen *Desperate Housewives*."

First, we looked closely at what *Desperate Housewives* was and how it worked. At its core *Desperate Housewives* was about four married women in their 30s attempting to figure out why their fifth best friend committed suicide. (That "why" constituted the initial series mystery.) Along with that mystery, which revolved around an event in the recent past (the fifth friend commits suicide in a prologue sequence that occurs before the pilot's main action begins), each of the four lead characters had her own present-day

secret, soapy storyline. The four housewives were friends and lived in the idyllic world of Wisteria Lane. Those were the essential conceptual elements we focused on.

First, it was easy and intuitive to transpose the four 30-something married lead characters into four 16-year-old girls. When we worked on the inciting backstory event – what happened to the fifth best friend, what's the mystery? – we began thinking too literally, batting around concepts involving a fifth friend who committed suicide. That not only felt too imitative, it felt wrong for the fun, soapy tone we aimed for. After a few months of brainstorming, the idea of a girl who went missing dawned on us, which we quickly realized created even more potential mysteries than our source of inspiration. If our missing teen girl, whom we named Alison, has been gone for some time, it's natural to begin to wonder if she's not just missing but, in fact, dead. Once we locked on to the idea of a friend gone missing, the idea emerged of "A," the anonymous, mysterious character who arrives well after Alison went missing and taunts the four remaining friends with information only Alison could have known. Was "A" Alison? Was Alison actually still alive after all this time missing? If "A" was Alison, where had Alison been and why was she threatening her old friends? If "A" wasn't Alison, was Alison dead and, if so, who killed her and why? And who was "A," how did she know things only Alison could have known and why was she terrorizing Alison's best friends?

The ideation process lasted several months of brainstorming among a handful of Alloy employees, bouncing ideas off each other, one member of the team keying off another's idea, to create the fully realized *PLL* concept. Because Alloy Entertainment is a company and its employees' jobs are to ideate new concepts, the company owns the idea.

THE BOOKS

Once the company had fleshed out enough of the core concept, it followed the path of its unique business model to first target the publishing industry and produce *PLL* as a book series. The Alloy book development staff identified a young novelist it had worked with once before and pitched her the emerging *PLL* concept. Twenty-seven-year-old Sara Shepard responded to the idea and agreed to spec a book proposal in collaboration with the Alloy staff. In TV, as we know, pitches are oral presentations delivered in

network conference rooms. In the publishing industry pitches are written documents known as "book proposals." Working with the Alloy book development unit, Shepard wrote a 70-page book proposal outlining the concept, the story of the first book (in what was originally designed as a four-book series), the overarching stories of the four books, and she wrote the first several chapters to give prospective publishers a sample of how the books would read.

Alloy shopped the *PLL* book proposal to publishers in the summer of 2005 and received an enthusiastic response. HarperCollins won the rights to publish *PLL* in a competitive situation among several publishing houses.

TV SALE

Once a publishing deal was in hand, the project shifted to Alloy's west coast office in LA which I ran at the time. We had a first-look POD deal with Warner Bros. Television studio, and the development execs at the studio agreed that the new book could make a great show. With just the book proposal and new publishing deal in hand, Alloy and the Warner Bros. development execs pitched the project to the studio's sister network, the old WB network, and the network development execs responded to the concept enthusiastically and bought it over the phone.

The top development exec at the WB knew exactly who she wanted to write the pilot, a writer she'd worked with the previous development season. The network development exec asked the studio and producers if they were on board and, after reading the writer's sample material and feeling inclined to defer to the network's preference, the studio and producers signed off on the writer.

FIRST NETWORK DEVELOPMENT: THE WB

With a TV writer on board, Alloy had two writers writing two separate versions of *PLL* on two coasts in the summer and fall of 2005, one in New York (Sara Shepard actually lived and worked in Philadelphia, near where she had chosen to set the story in the fictional idyllic Rosewood, Pennsylvania) and one in LA. We sent the TV writer Sara Shepard's successful book proposal and a detailed outline of the story for the first

book Shepard had written after the publishing deal closed. Then an interesting thing happened: The TV writer reviewed Shepard's materials and decided she wanted to create her own mythology, different from the books. Where Shepard's book proposal outlined the answers to the books' many mysteries and explained what happened to Alison (and how and why she was – spoiler alert – murdered), the TV writer said she preferred a completely different backstory in which Alison was alive and had decided to run away. (Ironically, books five–eight in the series, ordered by the publisher several years later, pursued a similar story twist, but that wasn't imagined on the book side at the project's outset.)

Here's where a producer's job gets tricky. On the one hand, we didn't agree with the screenwriter's creative instincts. We didn't believe that the mythology the screenwriter created for Alison's backstory was as interesting and entertaining as the one Sara Shepard created for the book. On the other hand, a producer's job is to empower his writer. The screenwriter has to find a strong personal connection to her material, a deep wellspring of belief in what she's working on. What I learned as a producer at Alloy, focusing primarily on adaptation, was that TV writers need to have ownership of the ideas they're working on if they're going to imbue them with a genuinely creative and artistic spirit. Their job wasn't merely to translate the original author's vision to the screen. The screenwriter needed to own it and make it hers. We realized that, at the end of the day, our job was to support and empower the writer, and we gave her as much encouragement as we could. She wrote a strong pilot script, despite its differences from the book Shepard was still writing, and we crossed our fingers that it would be a contender for a pilot pickup.

The project then encountered a twist no one saw coming. The WB's parent company announced the WB was folding, merging with the UPN network, forming a new network, the CW, which would unite the WB's and UPN's networks of stations.

The WB's entire season of development was tossed out and written off.

PLL was dead.

For the moment.

SECOND TV DEVELOPMENT: THE CW

Although they rarely use them, TV networks typically get two cracks at developing projects once they buy them. These are known as "bites." If a network buys a project, develops a script it doesn't like or even shoots a pilot it doesn't order to series, the network gets a second bite on the project, allowing the network a contractual option to develop the project a second time the next development season. Networks rarely take a second bite on development. Failure leaves a bad taste in execs' mouths, and they're usually eager to move on and explore new concepts.

When the CW began in the summer of 2006, a new team of executives was hired, including an entirely new team of development execs. The first thing the new CW development team did was to look at the projects the WB and UPN had developed the prior year, and, after that process, they decided to take the second bite on *Pretty Little Liars* and to develop a new script with a new writer. We, the producers, didn't have a say in the matter – the CW was contractually due a second bite by dint of inheriting the WB's projects – and we were excited to keep the project alive and get a second chance at bat.

Then the CW threw us a curve ball: The network announced a surprising development strategy. They weren't going to be the teen-oriented network the WB had been, they said. They were going to be a 20-something network, focusing on shows with 20-something lead characters. The CW development execs told us their plan was to age up the four 16-year-old girls at the center of *PLL* to 20-something women and some of them, they suggested, should be married. We producers secretly knew the inspiration for *PLL* was *Desperate Housewives*; now the CW execs were asking us to turn *PLL* back into a kind of poor man's *Desperate Housewives*. It didn't feel organic to the *PLL* concept, and we struggled to wrap our heads around it.

The four lead characters of *PLL*, the titular "liars," hide the truth about crimes they've been tangentially involved in (among other things). Their sense of complicity in those crimes is essential to the concept. An audience can understand teenage girls lying to cover up a sense of guilt, but we feared that an audience wouldn't be as sympathetic to adult women behaving so immaturely. The CW was due its second bite, though, and we crossed our fingers that we were wrong and the 20-something *PLL* would be better than we feared. The studio recommended a writer who embraced the rejiggered concept and she did her best to wrestle the pilot script into shape.

While we were developing the 20-something *PLL* at the CW, progress continued on the east coast. The first book was published. And blew up. Sara Shepard's first *Pretty Little Liars* book became a hit, making the *New York Times*' best-seller list. We got a call from a sharp-eyed development exec at ABC Family (now Freeform) who spotted the book on the best-seller list, read it, loved it and wondered if it was available to develop. I had to tell her it was already in development at her competitor. "Good luck at the CW," she said, "but if it doesn't work out, let me know. We'd be interested."

Our doubts about the CW's creative adjustments to our concept were realized and, come January 2007, when the CW announced its first round of network pilot pickups, *PLL* did not make the cut.[1]

PLL was dead again.

For the moment.

THIRD TV DEVELOPMENT: ABC FAMILY

Once the CW passed on *PLL*, the rights to the underlying book reverted back to Alloy Entertainment, and we let ABC Family know the book was available again. The exec who had called months earlier said they definitely wanted it. The books were continuing to blow up in the publishing world, though, and we no longer just had a great book proposal with a catchy title or one best seller, we had a huge best-selling series of books, a much more valuable and attractive commodity. A second bidder emerged, MTV. Since its first scripted series in 1999, *Undressed*, MTV had vacillated between committing to scripted series programming and backing away from it, focusing instead on its core unscripted programming. In the spring of 2007 MTV had revamped its scripted development department once again and was aggressively chasing new projects for its teen demo target. They entered a bidding war for *PLL* against ABC Family, and, after a couple of months of back and forth, ABC Family won, and *PLL* was in development at a third network.

At ABC Family the project was again an open writing assignment.[2] We implemented a bake-off and brought in three writers who pitched their takes on the books to the network.[3] ABC Family passed on all of them. Meanwhile, the network development execs had a general with Marlene

King, a feature writer one of the top ABC Family execs had developed a pilot with when she worked at the WB a decade earlier (King's one prior TV experience). The network execs gave King a copy of the *Pretty Little Liars* book at that meeting, she took it home and loved it. Our development execs at Warner Horizon, the division of Warner Bros. Television that produces for basic cable, the division our project had shifted to upon the sale to ABC Family, asked us to meet with King and hear her thoughts on the adaption.

We met with King, and she articulated her strategy simply: "I love the book, and I just want to do the book." Her take was simply to write a pilot as faithful to the book as possible. After our previous two development experiences that was music to our ears. With the network, studio and producers on board, a deal for King to write the pilot script was made and work began.

From her very first story outline, we could tell that King was locked in. She chose to cut important characters from the book, like Noel Kahn, and to cut significant events like the big field party that climaxes the first book, a set piece our modest basic cable pilot budget never could have done justice to, and to focus the pilot instead on introducing the four lead characters and the mysterious, offscreen "A." Our challenges were daunting: to introduce four lead characters, make the audience care about them, and also to introduce the layers of series mysteries. As King said at her first meetings on the project, she chose to trust the books and not try to reinvent the wheel. We knew if we succeeded in telling enough of each lead girl's "dirty secret" personal story, we could develop a strong viewer connection to them.

There were three romantic stories and one family story. Aria fell for her new English teacher, Mr. Fitz, and wanted a relationship with him despite the obstacles. Spencer fell for her older sister's fiancé, Wren. Emily fell for the "new girl" Maya, calling into question her entire identity and opening the door to embracing her truer self. Hanna got busted for shoplifting (a cry for her absentee father's attention?), and her mom had to make a self-sacrificing gesture to protect her daughter. Each girl's story was sexy, a little naughty and secret. As discussed earlier in this book, secrets are a powerful device in pilots, and *PLL* was nothing if not layers and layers of secrets, lies and mysteries.

The second major goal, after introducing the four lead girls and their secret foreground stories, was introducing the overarching mystery of Alison's

disappearance and murder, and introducing "A," the is-she-or-isn't-she-Alison offscreen character who haunts the four girls. We knew if we could hook the viewers into the concept's central mysteries (along with making them care about the four lead characters), we had them. Who killed Alison and why? Who was "A" and how did she know things only Alison could have known? If the viewers finished the pilot episode and wanted to know the answers to those questions, we knew they would want to come back for episode two, the goal of every pilot. Along with the five main stories the pilot told (five stories!), another undercurrent of a story emerged, the reconnection of the four best friends. In the pilot the arrival of "A" and the discovery that Alison has died reunites the four friends and bonds their friendship forever. In King's telling, that emerged as a sixth pilot story.

We gave King minimal notes on her first draft, notes aimed mostly at bringing to the surface the girls' fear of "A" and doubts about whether "A" could possibly be Alison (whom they hoped, until the end, might still be alive), and, after a quick rewrite, we delivered the pilot script to the studio. The studio gave an interesting set of notes: King's initial drafts compartmentalized the four girls' stories into separate acts, and the studio said the girls felt too disconnected from each other and from the core ensemble. They said the script played too episodic, rather than establishing a world of interconnected relationships. King responded by finding ways to intercut the four girls' stories more smoothly, connecting the girls structurally if not actually interacting in scenes (unlike most friendship stories, the PLL girls couldn't talk about their stories with each other because each girl's story needed to stay secret). The studio was pleased with the rewrite and delivered it to the network.

The script sailed through the network development process with minimal input and arrived on the desk of its then president, Paul Lee. We heard that Lee loved it but had notes. Lee suggested that we reset the crucial Alison-goes-missing backstory event from three years in the past (as it is in the books) to one year in the past. His thinking was that the difference of two years didn't matter to the effect it had on the girls' drifting apart from each other. The past was the past. Because the pilot needed to show the event of Alison's disappearance – along with other flashbacks to the time before Alison disappeared – it would be easier for our actresses to play 15-year-olds rather than pre-adolescent 13-year-olds. We knew we'd cast actresses older than 16, and asking an actress in her early 20s to play 13 risked stretching the audience's credibility. Great note! The original drafts had

begun with a scene-setting montage of Rosewood; Lee urged us to cut it and begin by introducing the audience to our characters and to start the story as soon as possible. Another good note! We knew that would save us time and money in production, and starting the story sooner is almost always a smart strategy (and a very common development note!).

After King made Lee's changes, he greenlighted the pilot. King and I jumped into pre-production (I was coordinating our work with my fellow Executive Producer and my boss at Alloy Entertainment, Leslie Morgenstein, who was based in New York). At the suggestion of the studio and network casting departments, we hired Zane/Pillsbury, a casting company with a great reputation. Gayle Pillsbury, one of the company's two principals, took the reins and dove into writing breakdowns and compiling lists of actresses for each character. Gayle had been an assistant in the casting department at NBC 15 years earlier when I was a rookie network programming exec, and it was fun to reconnect after so many years and at such different levels of the industry. Careers in the entertainment industry are rife with interweaving, overlapping connections like that – one of the industry's many exciting qualities.

A couple of days after Pillsbury was on board I got a call from a talent manager I'd worked with before. She represented Lucy Hale and said Lucy had read the pilot script, loved it and was interested in joining the cast. I was thrilled. I had worked with Lucy on the short-lived CW series *Privileged* and knew how talented she was. I called Marlene, who didn't know Lucy's work, and Gayle, who loved Lucy and said she would take the network and studio's temperature while also getting Marlene tape on Lucy so she could get up to speed. Gayle called us back and told us that not only did the network and studio love Lucy for *PLL*, but that the network had been trying to get Lucy to sign a talent holding deal, and they officially approved her for any role she wanted in our pilot. Things were suddenly moving fast.

Marlene viewed Lucy's tape and agreed she was awesome. I called Lucy's manager back and told her we all loved Lucy for the pilot and she was approved by the network and studio. I asked if Lucy knew which character she wanted to play, and was told Lucy was interested in Aria or Hanna. I told Marlene, Gayle and Les, and we agreed we'd ask Lucy if she was comfortable coming into Gayle's office and reading both roles so we could see which role felt best and she could get a better sense of which role felt most comfortable to her. Via her manager, Lucy agreed.

It was a fun, super-low-pressure session chiefly because it wasn't an audition. She already had the job. It was just the people making the pilot figuring out which role suited her best. Lucy read the sides for both Aria and Hanna opposite Gayle, and she was great. We thanked Lucy for coming in, she left, and Marlene, Gayle and I immediately agreed she was much more of an Aria than a Hanna. We called Lucy's manager and said we preferred Lucy as Aria, and if Lucy was comfortable with that we would let the network and studio know. Lucy's manager said, yes, absolutely, Lucy felt completely comfortable reading Aria, and that was it. We'd barely begun the casting process and we had one of our four leads already on board with a brilliant young actress every member of the project's extended team loved. The rest of casting would not be nearly as effortless.

As Gayle did her pre-reads, Marlene, Les and I began talking to the network and studio about potential directors. Meanwhile, the studio physical production department began looking for the best place to shoot the pilot. We heard from the studio that they wanted to shoot the pilot in Vancouver, British Columbia, because of the generous Canadian tax incentives, but that if the pilot were ordered to series we would receive a California rebate that would allow it to shoot in LA, on the Warner Bros. lot. We were entering the fall of 2009, and we knew Vancouver would be cold and most likely rainy when we had to shoot the pilot, but if we could survive the Canadian pilot production, the cast and crew would enjoy sunny Burbank ever after.

Troian Bellisario came in and auditioned for Spencer Hastings in the first week of producer sessions and gave one of the most powerful, confident auditions I've ever seen. Troian had only recently graduated from USC's theatre school and had only one TV credit under her belt, but we knew she was the real deal. When the door closed behind her, Marlene, Gayle and I looked at each other and said, "Test!"

We brought Troian and three other Spencers into the studio test, and they signed off on our top three choices. We brought them into the network, and the network immediately loved Troian and approved her as Spencer. Two down!

We continued our search for Emily. We had a strong suspicion Hanna would be cast with a blonde actress, so we assumed we would ultimately cast a white actress to play Hanna. We always intended to cast an ethnically diverse ensemble, which meant that, with Lucy and Troian on board and

Hanna probably going to be a white actress, we had to make an extra effort to look for minority actresses to play Emily. We found a really strong African American actress that we liked a lot for Emily, but realized we needed to go into the studio and network with more than one good option. We read Shay Mitchell, who's part Filipino, and we liked her and thought that she would make a good runner-up to the African American actress who was our top choice. We brought the two actresses into the studio, and, true to our expectations, the studio said they preferred the African American actress but that Shay was a good second option. Then we went to the network test where the unexpected happened. Shay blew the other actress out of the water. Even though we were prepared to say that the African American actress was our strong preference, we had to admit that Shay had given a much stronger audition on the day it mattered, and we thought she would make a great Emily. Paul Lee agreed, said they loved Shay for Emily, and we had our third liar. You walk into a network test thinking one way, and you never know who you're going to walk out with.

As casting continued, Marlene and I met with director candidates. One of the first names on the list was Lesli Linka Glatter who had directed the first movie that Marlene had written, *Now and Then*, in 1995. Marlene and Lesli had bonded professionally on that project, and Marlene thought Lesli would make a great choice. Marlene and I met Lesli for coffee in Sherman Oaks, and we all hit it off. Lesli articulated the themes of the pilot script that drew her interest, that "what appears to be isn't," and her intention to shoot the pilot as cinematically as possible, and we realized we were all in sync. Marlene, Les and I spoke afterwards and agreed Lesli was a great candidate. We expressed our preference to the network and studio, and they signed off enthusiastically. We now had our director on board, and Lesli jumped into casting sessions along with Marlene, Gayle and me.

Our production start-date was looming and we didn't have a Hanna. We started getting nervous. As we were coming down to the wire Marlene, Lesli and I walked into Gayle's offices for yet another casting session and noticed Gayle was unusually excited. She told us that *Eastwick*, a TV update on John Updike's novel *Witches of Eastwick* starring Rebecca Romijn, had just been cancelled by ABC, and Gayle had scheduled one of its series regulars to come in and read for Hanna. I'd never seen Ashley Benson before but Gayle had high hopes. Ashley came in literally the day after her other show was cancelled and auditioned. Marlene, Gayle, Lesli and I all breathed a sigh of relief. Ashley *was* Hanna, and we knew we had our fourth liar. Studio and

Case Study 233

network tests were set, and Ashley sailed through. Everyone agreed she was the perfect Hanna. We had a pilot.

The pilot table read was set for the evening before we were all scheduled to fly to Vancouver to start production. The network and studio executives, Marlene, Lesli, Gayle and I sat down in a Warner Bros. conference room to watch our full cast, dressed in their street clothes, read the pilot together for the first time, seated at a long table, their scripts open in front of them. I was optimistic but terrified.

The script played great. Just about everything seemed to work. Lucy had a great chemistry from the very beginning with Ian Harding, whom we'd cast as Ezra Fitz. Troian, fresh from her theatre training, commanded the room every time she opened her mouth. There was a palpable excitement in the room as the stories unfolded. Our one concern was Ashley. Her performance felt "under" everyone else's, quiet, internalized and lacking the energy and dynamism all the other actors brought to the reading. We knew she was beautiful and had done great work before, and we crossed our fingers that she was just feeling shy in the crowded, executive-filled conference room.

Throughout prep it rained non-stop in Vancouver. The pilot was set in Pennsylvania, the week after Labor Day, and Lesli tried to figure out any way she could to make cold, wet, early-December Canada look like sunny, late-summer Pennsylvania. We couldn't put green leaves back on the barren trees, but Lesli ordered bags of fall leaves to dress exterior sets so at least pops of color could brighten the shots.

At the final production meeting the night before we commenced shooting the forecast indicated the rain would finally break. Our grizzled, local gaffer informed us that that meant that instead of rain cold would set in, and my heart sank. We had a ton of exteriors and a couple of night shoots that I realized could get very cold. You couldn't see the cold on screen like you could the rain, though, so it was still a trade up.

Production went smoothly and as each girl began playing her role on camera our confidence in the pilot grew. On our third day Ashley worked for the first time. It was the sequence at the police station with her mom and Detective Wilden. When we moved the camera inside Hanna's mom's car, Lesli zoomed in tight on singles of Ashley and Laura Leighton playing her

mom. Marlene and I sat in the video village, watching the performances on the monitor, and, as Laura hit her character's a-ha moment, "This is about your father, isn't it? You think this is going to get his attention?" Ashley's face radiated all the hurt and shame a girl could possibly feel at being abandoned by her father. Ashley's big blue eyes told her entire story without her needing to say a word. Marlene and I squeezed each other's hand as we realized how much the camera loved Ashley, and that the table read in Burbank simply didn't allow us to get close enough to the actress to see everything she was feeling and playing as the camera can. Ashley was brilliant, and we realized what an amazing ensemble we had.

The only problem was the cold. In the scene where the four girls stand on the street and watch Alison's body loaded into the coroner's van (which we shot at four in the morning), it was so cold that Lucy couldn't stop shivering. In post we had to have all the girls come in and ADR their dialogue because Lucy's chattering teeth ruined every take. When we shot the flashback of Spencer and Alison arguing outside Spencer's house in their bikinis it was 29 degrees. The grips had to construct a shelter of translucent white scrim over Troian and Sasha Pieterse to keep a dusting of snowflakes from falling on their bare shoulders, ruining the "summer" scene. The girls wore calf-high Ugg boots just below the frame of the shot, and the moment Lesli called cut wardrobe dressers ran in with full-length down coats to wrap the actresses, rubbing warmth into their arms between takes. To their amazing credit, none of the girls ever complained.

In post-production, Marlene and I discovered how good Lesli's work really was. She had taken Marlene's deliciously soapy, mysterious pilot script and made it visually bigger and bolder than we had ever imagined. As we worked through the pilot with our editor, combing every take of every performance for the richest performance beats, we found layers of emotion we hadn't noticed while shooting. During production Shay and Bianca Lawson didn't appear to have the chemistry we needed Emily and Maya to have (unlike with Lucy and Ian or Troian and Julian Morris who played Wren), but it was there in spades once we cut back and forth between their singles in the edit room.

When Marlene King watched the scene of the four lead girls reconnecting as Alison's body is loaded into the coroner's van (after fixing Lucy's chattering-teeth dialogue) her hair stood on end. After more than a year of work on the project, it was at that moment that she truly discovered what

the most important themes of her show really were. "I realized from that scene," she says now, "that this was a wish-fulfillment show about friendship. These four girls become family and love each other unconditionally."[4] She says the edit room discovery that the show was really about the power of friendship guided her execution of the series for the next seven years.

After we delivered our producers' cut to our studio execs, the studio hired a research company to test it before they delivered it to the network. The test audience was a group of about 25 girls and women ranging from teens to late 30s. They liked the pilot but nearly unanimously tripped on one scene. In the bar scene in Act I, Aria meets Ezra, and he assumes she's a college student because she's sitting in a college bar. As the scene was written and shot (straight out of the book), Aria orders a beer and sips it as Ezra orders a whiskey, another cue that suggests to him she must be of age. The test audience said the scene didn't make any sense, a bartender would never serve beer to a 16-year-old girl, and the apparent lack of realism prevented them from enjoying the rest of the pilot. The scene as shot made perfect sense to us. Small town college bars aren't always as scrupulous as they should be, Aria carries herself with maturity and confidence ... it seemed perfectly plausible to us.

The studio insisted we figure out a way to fix the scene and remove the beer. Marlene and I hated making the change, but the studio was convinced the test audience's reaction might trip up the network (and *its* potential test audience), and they insisted we make the change. We went back into the edit room and figured out a way to cut Aria's lines ordering the beer and the shots of her sipping it. We brought Lucy back in to ADR new dialogue ordering "a cheeseburger" and did our best to cut around shots of the glass of beer. None of it was as elegant or as fun and naughty as the original scene, but it played.

The day after the studio delivered the cut to the network, Marlene and I got a call from the network development exec, the same exec who three years earlier called me while the project was in development at the CW. The exec told us everyone at ABC Family loved the pilot and had zero notes. We were thrilled. And relieved.

Five years of work – creating the concept, fleshing out the story in book form, selling it to one network and failing, developing it at another network and failing, getting a third attempt at a third network, and surviving a tricky

casting process and some harsh Canadian cold – had all paid off. Marlene's vision of Sara Shepard's book, her uniquely "delicious" tone, proved to be great TV.

All we can do, I realized, is the best we can do. None of us in the crazy, sometimes chaotic development process can ever control everything. It's a collaboration of artists, creative executives and business people, there are so many voices, ideas and opinions and so many opportunities for error, you just have to get lucky and hope the dice roll your way some of the time. If you have something you believe in, a story, a concept, a property that you know in your heart is a TV show, all you can do is patiently, methodically push forward, rolling the boulder up the hill like Sisyphus, hoping it doesn't roll back down and crush you, but when it does, stand up again, and roll the boulder back up the hill again and again, until you get it right.

NOTES

1 Almost all of the CW's development slate that year was in line with the network's initial 20-something lead mandate. Our other project in development there that year, *Gossip Girl*, was one of the few exceptions. It wound up being the first pilot greenlighted to production and, once ordered to series and on the air, branded the CW as the new WB, the broadcast network built on teen characters and stories. Several years later, when a new management regime was installed, the network succeeded in aging-up its programming to the 20-something game plan that was originally intended.
2 An "open writing assignment," usually referred to in emails as an "OWA," is a project in active development at a network that's looking for a writer because it was bought without a TV writer attached; e.g., in this case Alloy set up the *Pretty Little Liars* books at ABC Family as an OWA without a TV writer attached.
3 A "bake-off," one of my favorite expressions in TV development, refers to the competitive filling of an open writing assignment. In a bake-off, at least two writers go into a network and vie for the chance to fill an open writing assignment by pitching their takes on the project. The network, usually in consultation with the producer who brought the takes in, picks its favorite take. That writer wins the job and fills the OWA.
4 Author interview with Marlene King.

12
The Culture of TV Development

So far I've talked about the processes and creative strategies of TV development. A big question remains: What's TV development in Hollywood *really* like? What are the people who actually do it really like? How do they think, communicate and behave? What are the goals that drive them? In short, what's the culture of Hollywood TV development?

Contrary to my own worst fears when I moved to LA many years ago, the culture of the TV business in Hollywood is dominated by an ethic of professionalism. The tenor of most development meetings and calls is one of friendliness, respectfulness and professionalism. People are generally warm and positive. The attitude seems to be, "We all have a lot of hard work to do – let's treat each other with respect and try to get through the day with a smile on our faces." So much of TV development is ultimately subjective, and people generally work very hard to find polite and diplomatic ways to disagree with each other's opinions. The best words to describe the culture of the day-to-day work of TV development are professional and collegial.

As I've mentioned, the culture of the industry is smart but not intellectual. Most development professionals approach their work with a sense of pragmatism rather than a philosophical or intellectual curiosity. Non-

writing TV development professionals in Hollywood tend to think of their work primarily as a business. To the extent that they're conscious of their work product as part of American culture, they think of it more as popular culture than art. In general, most talent – writers, directors and actors – do think of their work as an art. They have to. They have to find a personal, artistic connection to their work to harness their creative energies and do their jobs. Most non-writing development professionals are sensitive to this and support the artistic integrity of their creative teammates.

The best TV development executive I ever saw was utterly brilliant but completely non-intellectual. She had a high entertainment IQ, had great TV taste, knew what a good TV concept was, how to take a good TV idea and make it better, how to crack a story better than most writers, how to work the system to advantage her projects, and yet she completely lacked any intellectual curiosity about her work. She found it a waste of time, an annoying distraction from the business of making good shows.

The most successful people in TV tend to be the most open to good ideas from others. Lesli Linka Glatter, the producing-director EP of *Homeland* and the director of the *Gilmore Girls* and *Pretty Little Liars* pilots, refers to this as "The best idea wins" approach.[1] "This is an art that we do with many people," she says. "I don't need to be the smartest person in the room. I want to be in the room with the smartest people."[2]

It's often the second-rate who think they know all the answers and don't need to listen to the opinions of others. The best listeners tend to look for pragmatic creative solutions, though, rather than intellectual observations and analysis. If they can *use* it, it's valuable. If they can't use it, they don't have time for it.

Television is a very hierarchical industry. It's easy to be misled, though, because what you notice first is Hollywood's loose and friendly vibe. The youngest assistant calls the network president by her first name. There are no "Mr.s" or "Ms.s" in TV. Work discussions are often punctuated by four-letter words. But underlying the casual dynamic is a strong sense of hierarchy. The pecking order of organizations and meetings is understood by all participants. Everyone has a place and everyone is generally treated respectfully, but some people have standing to articulate their opinions and some do not. Everyone is keenly attuned to the pecking order of any group situation, and junior people wait for senior people to express their thoughts

first, then typically fall in line with the opinions of those senior to them or find very delicate and respectful ways to express dissent. Development is hierarchical but production is even more hierarchical. When I'm on set as an EP on pilots or episodes in production crew members call me "sir," which I still find startling after many years. But that's the culture of production.

The goals of development professionals tend to vary by their different roles, but, at the end of the day, they are all ultimately more similar than dissimilar. Everyone is aware that Hollywood is a business. The ultimate goal of all of Hollywood is to make money. Television networks exist to make money. Television studios exist to make money. Talent agencies exist to make money. What this translates into for many stakeholders in development, however, is a more prominent instinct to try to create shows that *work*, shows that work creatively (that make sense, are entertaining, that achieve their intended creative goals) and shows that succeed in attracting their intended audience. The goal for most TV professionals is to make shows that last and that have an impact on their audience, that resonate in American society and within the entertainment industry.

Writers and their agents are dissimilar in many ways. Writers are artists and agents are not. But they both want to participate in creating shows that work, that attract, hold and entertain the audience to whom they were designed to appeal. They want to help create shows that last and that touch many viewers' lives. The same is true for executives – network execs, studio execs and production company development execs. Everybody wants to be involved with projects and shows that are "good." But "good" is subjective. In general, industry professionals tend to think more in terms of effective than good. Does a show work? Does it succeed at being an effective version of the kind of show it's designed to be? Does it appeal to enough of the audience it was made for, as defined by the network that developed and programmed it, for it to last?

The goal of most writers working in television is to create a show that lasts, that allows them to execute their vision and tell many stories over many episodes and seasons that perpetuates that vision in a deep and impactful way. That's a show that works. If the show lasts a long time and touches many viewers' lives, that is to say commands high enough ratings for a long time, the show also makes a lot of money for the writer who created it, the talent agency that helped put it together (via their package), other talent

agencies that place their clients in various jobs on the show, the network that sells ads or subscriptions because people want to see it, and the studio that earns all the ancillary financial benefits of the show's long-term appeal. Shows that last make money. And shows that last have the power to have a real cultural impact on our society.

Michelle Nader, a veteran broadcast network comedy writer (*Spin City, Dharma and Greg*), showrunner (*Two Broke Girls*) and creator (*Kath and Kim*), articulates the aspiration of many working TV writers: "My goal is to create something memorable."[3]

Being part of the development of a hit show also increases the standing, power and financial value of its various development professionals. Writers who create successful shows get more power, creative control, freedom and money on their next projects. Execs and agents win promotions, raises and more industry standing and respect.

In the old days, in the twentieth century, there was one simple, bottom-line definition of success: ratings. Writers and development execs were judged by how many people watched the shows, and, if a lot of people watched, a series could last a long time and make a lot of money for all involved. Ratings were all that mattered.

Since the 2000s, since the beginning of the proliferation of scripted series on cable, satellite and streaming channels, a second standard of success emerged: shows that make a significant cultural impact despite low ratings. *Girls* never had high ratings, but lasted six seasons on HBO primarily because it was widely respected by cultural tastemakers and was nominated for awards. It lent cultural and branding value to HBO, if not necessarily direct financial value. *Girls*, despite its small audience, is considered a development success. In truth, the ratings for *Gossip Girl* were never very big. But the show had great value to its network and studio and also lasted six seasons. Yet another category of TV success exists today: shows that achieve both cultural impact *and* high ratings. These are the unicorns of TV today, and the kind of shows most development professionals aspire to help create. *The Sopranos, Game of Thrones*, to some extent *The Walking Dead* and, in certain ways, *This is Us* are all examples of this lofty status, and they've made all their companies a lot of money and increased the value and status of all the many development professionals who helped originate them.

Another notable aspect of the culture of TV development is that it's very demanding work. Almost all development professionals work extremely long hours and carry enormous workloads. Writers in development often juggle several projects, sometimes while also staffing. Most TV series writing staffs work long, creatively demanding hours. The reading load for execs and agents is vast and seemingly endless – pitches, story outlines, scripts and writing samples – not to mention IP: books, plays, longform essays, comic books and graphic novels.

One reason TV development workloads tend to be so demanding is because the business at every level has to factor in an enormous rate of failure. Success requires playing a numbers game, casting a wide net in recognition of the fact that most projects will fail. Entertainment companies know they have to pan a lot of silt to find a few nuggets of gold, and they contain costs by employing a relatively small number of people to do all that work searching for and honing the nuggets. Development execs and agents work long weekday hours and spend hours more reading at home on evenings and weekends.

A COMMON MISCONCEPTION

One of the many romantic myths of Hollywood sounds a little like this: "I've got a great idea for a TV show, and if I could just get my idea to the right people, it could be a huge hit and make a fortune." There are a couple of reasons why this is a myth and not a reality. First, TV development, as it's actually practiced, places as much or more emphasis on the writer's ability to execute a concept into script form than on the concept itself. When a network buys a project, yes, they're buying the concept, but just as importantly and often more importantly, they're buying the writer's demonstrated ability to execute that concept at the highest level.

Writers demonstrate that ability to execute at the highest levels before they're granted the opportunity to pitch their ideas to networks. They do this either through years of work in the industry, serving on shows, writing numerous episodes and other pilots, or by demonstrating a unique voice and creative vision with work in ancillary fields of writing that demonstrate extraordinary talent, like Lena Dunham did with her indie feature *Tiny Furniture*.

Julie Plec, the co-creator of *The Vampire Diaries* and *The Originals* and the creator of *Legacies*, offers a healthy warning to young writers:

> By and large, there are no new ideas. If you come into the room as a young writer thinking you've got the thing no one's ever heard, they probably heard it Tuesday. If you walk into a room and pitch that idea that isn't as fresh as you think it is, and they say, "Actually, we just heard ten pitches like that," and then a week later Shonda Rhimes sets up a show with that pitch, they didn't steal it from you. They want to be in business with Shonda Rhimes. They'll do anything Shonda Rhimes wants to do. Shonda Rhimes taking on an old idea becomes *Grey's Anatomy*. Because Shonda Rhimes is the voice, and she is the visionary. And when all is said and done, TV writing is about being a voice. The idea is the least important part of the process. The voice is the most.[4]

But what about Lloyd Braun who inspired *Lost* simply by saying, "Let's do TV ensemble *Cast Away*?" Isn't that just an idea that someone pitched that turned into a hit? Yes, but that was Lloyd Braun's job; he was the president of ABC. He earned the standing to pitch that idea and developed the insight to arrive at precisely the correct and unique combination of cultural phenomena that would become a hit show as a result of years of work in entertainment. He had insider status at the highest levels within the industry because he had earned it. Many network presidents and development executives pitch similar ideas that go nowhere, that float into a room as momentary bubbles then burst and disappear in seconds. The challenge for people with great ideas for TV shows is to earn their own standing in Hollywood by committing to years of hard work, climbing the ladder of TV development, observing what works and what doesn't, and creating the opportunity to have your ideas heard and taken seriously.

DEVELOPMENT PERSONALITIES

Television development professionals come from differing backgrounds, but certain personality types tend to find success.

Because development is such a team sport, people who thrive tend to have a strong social intelligence. They're comfortable speaking and working in groups and are good at "reading the room," sensing how others are thinking

and feeling and finding ways to adjust their own behavior and communication to work with disparate, sometimes even difficult colleagues. Another level of sophistication most have is a political intelligence, an ability to assess people's differing personalities, power statuses and egos, and to calculate a strategy to manage colleagues and collaborators to achieve their own agenda. There's a "three-dimensional chess" aspect to development, and people who can navigate layers of multipronged relationships and competing agendas while managing to stay true to their own personalities, values and creative instincts tend to thrive.

Most people who succeed in development are process-oriented. They're doers who understand the intricacies of a challenging process like development (of the infinite variations of which this book can only scratch the surface), and can stay organized, focused and even-tempered throughout the marathon process of moving their projects forward inch-by-inch to success.

The best development professionals have a high entertainment IQ. They get what works. They have good storytelling taste. They understand what other people find entertaining, they have an eye for material, can imagine how a pitch will translate into an actual series, and can read a script and visualize it on its feet and dramatized on the screen. They understand stories and story structure and can figure out why a story doesn't work and how to make it work better. They can take a raw concept and work with a writer or other development professionals to figure out how to make it a stronger concept that can last for many seasons on TV.

THE CLUB

To a great and surprising extent, the world of development professionals who guide the creation of TV series in Hollywood is very much like a club, a large exclusive club with a strict admissions policy. To pitch a show to a network you have to be a member of the club – or at the very least be guided in by an established member of the club. To have your calls and emails returned by working TV development professionals you need to be a member of the club. Within the club there exists a hierarchy of power and success, but, once you're in the club, by and large, all other members acknowledge one another, provide each other with access and treat each other with respect. While the club is largely sealed off from the rest of the

world and its gates can appear daunting to outsiders, the good news is that the club welcomes new members all the time. The next chapter explores how people earn entrée to the club, get their first jobs and climb their way up the hierarchy of the club.

Members of the club buy and sell to each other and seek out various forms of partnerships. Because the demands required to succeed in TV development are so high, and therefore development professionals' lives are typically so consumed by work, work relationships – social, romantic and family relationships – that begin or exist within the world of the TV industry club are an inevitable and organic outgrowth of working in development. The head of original content at YouTube is married to the creator of *The Office*. The head of development at National Geographic is married to one of the heads of programming at FX. A partner at WME is the daughter of one of the founders of ICM.

The walled-off nature of the club of TV development professionals has its drawbacks. The community is in many ways a bubble that echoes its own ideas, values and views of the world. Hollywood has traditionally not been a very diverse community, and this is finally beginning to change. People of varying backgrounds and life experiences are gaining seats at the table. Like many industries, Hollywood traditionally tended toward various forms of nepotism. Scarce development slots sometimes tilted toward projects because of friendships, romantic relationships or sheer familiarity, to the exclusion of potentially more fresh ideas and voices. Today, finally, more fresh ideas and voices are being welcomed than ever before.

The increasing trend toward ethnic diversity of character ensembles on screen on American TV in the past 20 years isn't only the result of Hollywood liberal do-gooderness. It's also the result of a business imperative: The shows needed to reflect the diversity of its changing audiences to attract viewers to watch them. Slowly, Hollywood is similarly realizing that to serve increasingly diverse viewers it needs to empower more diverse voices in positions of power and creative control behind the camera, at the head of writers' rooms and in the executive suites of networks and studios. Diverse faces and voices not only reflect the demographics of a changing audience, they also offer new ways to reinvent tried and true stories.

For people from all backgrounds and life experiences the community of Hollywood development professionals can be hugely exciting. The one

factor that unites the disparate people who work and thrive in Hollywood is their passion for entertainment. They love it, appreciate it and consume vast quantities of it. The work is too hard, the hours too long, the personal sacrifices too many and the frequency of failure too high. If you're in the TV development club, you're there because you love TV and are dedicated to making stuff that lasts. The experience of sharing a very challenging task with like-minded colleagues, and surmounting the odds to see your work, your ideas or your vision entertain the world, can be utterly thrilling.

NOTES

1 The "producing-director" role has become an increasingly common one in recent years as many series pursue cinematic aspirations. Where most directors are freelancers who move from series to series, directing one episode here and another there, a producing-director is hired as a fulltime producer on a series to book and oversee all the directors of a season's episodes to ensure the look and tone is consistent with the series' standards. Often credited as an Executive Producer or Co-Executive Producer, the producing-director typically directs several episodes of her series per season herself.
2 Author interview with Lesli Linka Glatter.
3 Author interview with Michelle Nader.
4 Author interview with Julie Plec.

13
Preparing for Careers in TV Development

It's easy to be intimidated by the prospect of pursuing a career in Hollywood. I was. That fear delayed my decision to move to Los Angeles for several years, and I regret it. If you're interested in a career in TV development (or any other Hollywood career) and prepared for an adventure, go for it. The earlier you are in your career, the younger and less encumbered you are, the better.

The TV business in Hollywood is a thriving, exciting, booming business. America makes scripted television for the world, and Hollywood is where almost all of it is developed. Yes, Hollywood in general and TV development in particular are very competitive fields, but the TV business is so vibrant (and always has been) that there's an overwhelming demand for labor and talent at every level. There's a steady demand for fresh blood and entry-level labor. It's difficult to get a toe in the water, but it's doable.

The paths to careers as talent (writers, directors and actors) are different from the paths to executive roles (network, studio and production company development executives, producers and agents). It's possible for talent to zoom to the top of their chosen fields at very young ages. Lena Dunham wrote, directed, EP'd and starred in the *Girls* pilot when she was 25. (She wrote, directed, produced and starred in her first indie feature *Tiny*

Furniture when she was only 23, winning the best screenplay award at the Independent Spirit Awards and attracting the attention of HBO's development execs.) Josh Schwartz created his first TV series, *The O.C.*, when he was 26. It's virtually impossible, on the other hand, for people that young to enter the senior executive ranks of development without climbing the hierarchical rungs of the executive ladder first. I'll tackle the executive jobs first and then talk about career paths for talent.

In this chapter I'll look at two primary strategies to pursue careers as development execs at networks, studios and production companies. The most common pathway is to enter the business as an assistant to a development exec or at a talent agency. This strategy is most useful to young people fresh out of school or a bit later. I'm going to devote the next several pages to describing those assistant jobs for three reasons: 1) to illustrate why they're such effective launch pads to executive careers, 2) to prepare readers to pursue those jobs and 3) to expand our picture of the culture of Hollywood. Assistants are ubiquitous to development; seeing it from their perspective will hopefully add another dimension to the portrait of that world. Then I'll talk about a second strategy for aspiring non-writing development professionals that can be more useful to people older than their early to mid-20s.

DEVELOPMENT EXEC CAREER STRATEGY ONE: THE ASSISTANT ROUTE

Most people who work as development execs or agents in television today began their careers as assistants. Just about every development exec at every network, studio and production company has an assistant, and those jobs are great entryways to careers in development. I'll talk about those jobs and who gets them in a moment, but the job that's widely considered the single best entrée to TV development is a job as an assistant at a talent agency, specifically as an assistant in an agency's TV lit department.

The goals of any entry-level job in TV development are: 1) to learn how TV development is practiced, 2) to build a network of relationships among development professionals at as many levels of the field as possible and 3) to begin to establish a knowledge base of TV literary talent, in other words to

begin to get to know TV writers. These three goals are probably best accomplished by working as an assistant to a lit agent.

Before I explain why working as a lit agent's assistant is the best entry-level job for aspiring development professionals, let's look generally at what almost all development assistants (including lit agents' assistants) do. Assistants in TV development in Hollywood all: 1) answer and screen their boss's calls, 2) keep their boss's calendars (agents' assistants also keep calendars of their boss's clients, but I'll talk more about that in a moment), 3) manage the inflow and outflow of material – scripts, outlines, pitches, treatments, series bibles, and IP like books, magazine articles, comic books, etc., and 4) in most cases, read all the material that goes through their boss's office.

The fun and fascinating part of the first assistant responsibility just mentioned is that it's Hollywood SOP (standard operating procedure) for assistants to monitor their boss's calls, to listen in on everything. Just about everybody does this, and it's awesome. The practice is largely practical. Assistants are expected to be 100% up-to-speed on their boss's business, and monitoring the boss's day-to-day, minute-by-minute transactions is the best way to do that. Additionally, assistants typically take notes for their bosses during calls. Assistants note names, dates, numbers, script or show titles so the boss is free to focus on the conversation and not fumble with a notepad or keyboard. The learning opportunity offered to aspiring development execs by monitoring calls is limitless. Lit agents often make dozens and dozens of calls per day, which offers the chance for assistants to closely observe their bosses' business conversations with countless development professionals at various levels – development execs, producers, writer clients and other agents – and is an invaluable education. Not only does the assistant hear up-close and first-hand how the business of TV development is transacted, the assistant also learns the business styles, personalities and habits of hundreds, potentially thousands of working development professionals.

The agency assistant (and most other development assistants) answers and screens incoming calls, and the assistant also "rolls" calls for his boss. The boss rattles off a list of six, eight, ten names to call as the assistant writes them down, then the assistant calls the offices of those names one at a time, in order, announces the boss to the assistant answering the phone and connects the call if the callee takes the call or "leaves word" if the callee has

to return the call. After each call the assistant moves down the list to the next name, continuing the process. An agent might roll calls (from her office, her car, an airport lounge in London, anywhere) for hours on end, while the assistant listens in, taking notes for her boss (and herself) and learning, learning, learning (while also fielding incoming calls – juggling non-stop!).

Agency assistants and other assistants throughout the development business keep phone sheets, logs of calls owed, callers left word for, and people to call.[1] Agents and development execs frequently have dozens and dozens of names and numbers on their phone sheets at any given moment, and it's the assistant's job to make sure they're up to date and 100% accurate. ("Dropping a call," forgetting to return a call, because of an assistant screw-up infuriates agents and executives.)

An agency assistant's second responsibility is keeping his boss's calendar and coordinating with other assistants to schedule events. An agent's schedule includes internal company meetings, external meetings at networks, studios and elsewhere, meal and drinks meetings, conference calls, table readings, tapings and screenings, not to mention occasional travel. A half-dozen assistants might coordinate via email to schedule a conference call that works for all their bosses' schedules. Schedules are constantly in flux and change all the time, resulting in assistants all over LA scrambling at the last minute to reschedule.

Not only do agency assistants keep their boss's calendar, lit agent assistants coordinate and keep schedules for all their boss's clients. Only writers who have studio development deals, working showrunners and senior-level writers on writing staffs have their own assistants to keep their calendars. For all the other TV writers someone has to set meetings and keep them coordinated. That someone is typically the writer's agent's assistant. This is one facet of the agency assistant job that's different from most development exec assistant jobs – a development exec's assistant keeps his boss's schedule but that's it; there isn't a roster of clients to keep schedules for as well.

The agency assistant coordinates a massive inflow and outflow of material, submitting client writing samples to execs, producers and showrunners, and receiving submissions (books, articles, etc.) for the agent's and her many clients' consideration, keeping everything logged and heading in the right direction.

Working as an assistant at a talent agency is a difficult job that requires very long hours. Agency assistants often get into the office as early as 8:00 am (or earlier) so they're on hand to roll calls as their boss drives to her breakfast meeting, and then they stay as late as 8:00 pm (or later) to ensure the boss has arrived comfortably at her dinner meeting (rolling calls until the moment she arrives), then they finish up on the long checklist of tasks now that the boss has tucked into her dinner and the assistant finally has a few moments of peace and quiet at his desk.

Assistants keep up with as much of their boss's reading as possible so they can follow the specifics of work conversations (which often are about material) that they're privileged to overhear. Material is the lifeblood of the business, and, while the clerical responsibilities of the job are the assistant's first responsibility, keeping up with the creative content of the office offers him the best possible education and experience.

Why is being an agency assistant the best entry-level job for aspiring development executives? The assistant desk at a thriving talent agency offers the widest possible window onto the entire business. Talent agencies deal on a daily basis with every TV network and studio and many production companies. Assistants at talent agencies have an opportunity to observe and interact with the widest possible range of development professionals, representing the widest possible range of kinds of companies. Assistants at TV networks don't typically interact professionally with other networks. Assistants at agencies talk to everyone.

Agencies are also closest to talent, the life force of the entertainment business. The writer is at the center of all development, and writers, directors and actors are central to all production. Watching skilled, experienced agents work with talent is a great educational opportunity. Agency assistants also begin to build their own direct relationships with clients, and learn the specific qualities that agencies look for in prospective clients.

In addition to the invaluable education assistants get from their view of the industry, there's something even more valuable: relationships. Hollywood in general and TV development in particular is personal. Business is about relationships. It's about confidence, trust and comfort. "I know you, like you, and trust you – I want to do business with you." Unlike many other businesses, Hollywood doesn't care as much about resumes and college pedigrees as it cares about first-hand, trustful relationships and personal

recommendations. If Executive A hears from long-respected Agent B that Job Applicant C is a trusted, valued employee with great potential, *that's what matters*. Agent B places his personal and professional stamp onto Job Applicant C and if Agent B is a trusted, respected member of the professional community, that personal stamp of approval is invaluable.

Agents sell people and their talents. That's what they do for a living. Agents also typically run a pro-bono sideline practice in helping people get jobs. Agents kibitz on the phone all day, talking to development professionals. In addition to information pertinent to their clients, they always have their ears open for news of job openings. Agents are the ultimate professional yentas – that's their job! When they hear an executive job is opening, they run through their mental checklist (or actual list) of potential candidates they like and want to help, and "put up" candidates for the job. When an agent hears of a job opening, she calls a candidate friend who comes to mind, asks him if he's interested, and, if he is, calls the hiring exec and pitches or "puts up" the candidate for the job. If the hiring exec is open to that idea, the agent helps put the parties together to meet. The agent receives no pay for this, but almost every agent at every level does this for two reasons. One, they do it out of genuine friendship. They enjoy helping people they like and respect. Second, they earn something that's sometimes even more important than money, indebtedness. The professional friend whom they helped get a great new job owes them a favor and might look extra kindly on the agents' clients in the future. If the hiring exec is happy with her new employee, she's also grateful to the agent for making the introduction and will look for ways to help the agent in return. "Placing" an executive friend in a new job is also a way of extending the agent's personal network into that office, that department or that company, deepening his network of extra-professional relationships throughout the industry.

Most entry-level development assistants hope to move up from being assistants after a year or two of assistant work. Being an assistant at a talent agency creates potentially very strong ties to exactly the people in the development business with the greatest chance of helping place a young person into their first executive job. Many agency assistants stay in the agency business and work their way up to become agents themselves. But many agency assistants aspire to become development execs and, when they prove themselves to their agent bosses, when they've "paid their dues," the agent boss is the ideal person to help that aspiring development exec find her first exec job. Talent agency assistant desks are a pipeline for junior

executive talent throughout the business. That's why so many agency assistants put up with low pay, punishing hours and the occasional difficult boss. It's a great stepping-stone out of the entry-level ranks and into the executive ranks.

An agency assistant desk is also a fantastic networking opportunity in and of itself. Because agency assistants are interacting with so many other assistants at so many companies in so many corners of TV development, the agency assistant builds strong professional and extra-professional relationships. As assistants get their first promotions and become executives they typically stay connected to their "class" of assistants with whom they've bonded over the years, and they tend to look out for each other. A former assistant who's now a junior exec might hear of a great job opening up and text an assistant friend to jump on the opportunity. In this way, generations of assistants have helped pull each other up, leap-frogging each other up the rungs of the industry ladder. Importantly, this I'll-keep-an-eye-out-for-you-if-you-do-the-same-for-me behavior tends to continue throughout entire careers. Agency senior partners help network presidents and vice versa, a dynamic of both friendship and professional support that in many cases began decades earlier when the two were overworked entry-level assistants. The strength of these kinds of extra-professional relationships is one of the many facets of Hollywood and TV development that make it such a strong, vibrant and exciting business.

If the life of the agency assistant doesn't sound difficult enough, the assistant job often isn't even the first rung on the ladder. At many major talent agencies young people are promoted to assistant after time spent working in the mailroom. Yes, some Hollywood talent agencies still have mailrooms that employ college-educated, business-attired people in their early to mid-20s who work to impress their bosses in the hope of getting promoted to become assistants. Mailroom trainees literally sort mail and walk the halls of talent agencies pushing mail carts, delivering mail (or, more likely these days, Amazon packages) to agents and assistants. Successful mailroom trainees are promoted first to become "floaters," rookie assistants who move from desk to desk, filling in for fulltime assistants while they're away on vacations, personal days, sick days and doctor's appointments. Floaters have the challenging task of proving themselves to agents they report to temporarily, hoping to impress them and get a fulltime assignment when another assistant gets promoted to agent, gets a job as a junior exec at another company or gives up and quits the business.

Preparing for Careers in TV Development 253

Leaving an agency assistant desk to land a job as junior network, studio or production company development exec is ideal, but the next best thing for many in that position is moving laterally at the assistant level to a desk at a company closer to their career goal, working in the development suite of a network, studio or production company. Agency assistants who choose not to become agents might realize that moving to a network, studio or production company is preferable to staying at an agency, even if it means continuing to work as an assistant for another year or two (or more).

Some assistants at networks, studios and production companies find those jobs after working as an intern, sometimes within the development department, sometimes at the company but in another department. NBC continues to offer its NBC Page program. Pages are navy-blazer-wearing young people who guide tours and welcome guests to the company's offices in LA and New York. NBC pages are occasionally promoted to become assistants within the company. Meeting a senior exec or producer, one still occasionally hears the biographical factoid, "I began my career as an NBC page."

Another strategy for aspiring development assistants (and hopeful development execs) is to get into a network or studio wherever possible and then strategize movement within the company into the development suite. Networks and studios are huge companies, and often jobs in the departments that don't deal directly with programming are much easier to break into than the more "glamorous" and competitive programming suites.

One of the great things about the culture of Hollywood is that ambition is encouraged and rewarded. Hollywood admires chutzpah. Everyone working in TV development has an eye out for their next job up the ladder, and everyone else knows it and respects it. Everyone knows that just about every assistant wants to get promoted to junior exec, and everyone knows that every head of development wants to get promoted to run the company. And every rung of the ladder in between. Everyone has to work their butts off at their current jobs, take those jobs seriously and deliver results, but in Hollywood it's ok and even respected to have ambition, to want to move up and not have to hide it.

The best career strategy in the entertainment industry, especially at the lower levels, is to be awesome. Young people should tackle their first jobs with everything they have, plan to prioritize their lives to devote almost every waking hour to their jobs, arriving at work early, staying late, being

friendly, positive, courteous, happy, eager, dedicated, and grateful all day every day to earn the respect of their boss and other senior colleagues. Young people working in their first jobs in entertainment should be "the awesome guy," the young man or woman who always has a cheerful attitude, who's always ready to volunteer for assignments (even the most menial, least glamorous ones), and, most importantly, who gets the job done right and on time with no drama and with a positive disposition.

Here's a funny thing: College educations are often about developing smart, sophisticated opinions. Liberal arts majors write papers arguing their opinions about literature, philosophy and history. We come out of college as highly developed opinion makers. Then young people get entry-level entertainment jobs and suffer the painful discovery that all their great opinionating skills aren't appreciated. Interns and assistants have task-oriented expectations not opinion-oriented expectations. The culture of Hollywood admires chutzpah, but the culture is also, as discussed earlier, hierarchical. In the hierarchical culture of TV development, people earn the standing to have opinions over time. When an assistant proves he is thoroughly competent and can efficiently deliver results to his boss, the boss might ask his opinion about a script or an idea. Junior development execs are expected to have opinions, but they're also expected to read the room, honor the pecking order of the people they're working with and defer to senior execs. Interestingly (and frustratingly) it's not uncommon for younger interns to be asked their opinion before fulltime assistants. Interns are short-term guests who are there to learn. Assistants are members of the family who are there to do hard, laborious, unglamorous work and demonstrate competence, professionalism and a positive attitude to earn the privilege to move up into a role that asks their opinion. Once assistants work their way up, their ideas and opinions become valued, and their futures largely depend on the power, imagination and taste of those ideas and opinions. But everyone in entertainment has to earn that opportunity. It's a good strategy for young people to understand the hierarchy, put their nose to the grindstone and read the room for appropriate moments to chime in while working their way up the ladder.

As I mentioned earlier, getting that first entertainment job, that first toe in the water, is often difficult but not impossible. The first truism of getting first jobs is that you have to be here. It's almost impossible to get a first job in Hollywood from a long distance. It's too competitive. There are too many people vying for those opportunities, and most employers will give

preference to people who are already here and ready to go immediately. In part, it's construed as a testament to a prospective employee's seriousness. Moving your life to Los Angeles is a big commitment, but it conveys to future employers that you mean it and that you're committing your future to the industry. In most cases, employers will think to themselves, "There are thousands of people who *are* here; I'll go with one of them first."

The best strategy for landing a first job is: 1) move to LA and 2) hustle. Be proactive. Meet people. Put yourself out there. Ask everyone you know in Los Angeles if they know people who work in the area of entertainment you want to work in. If they do, ask if they'd be comfortable making an introduction. If new contacts are young and employed at a lower level, offer to buy them a cup of coffee or a beer for the chance to introduce yourself and pick their brain. If the contacts are older and at a more senior level, ask if they'd be open to an "information interview." An information interview is where a young person visits an entertainment professional's office for 15 to 20 minutes to ask questions about the senior person's field, company and career, but not in the context of a job interview (as there's no job to interview for). It's an opportunity to learn information about the person and his work.

Whether it's meeting for a beer or an information interview, the information the person shares is important, but more important is the personal contact, the beginning of a personal and professional relationship. You transition from being a name on a possible resume or the daughter of a friend of a friend, and you become a person with a face and a personality. Someone who's bright and eager and has a positive, committed, respectful and appreciative personality. At the end of the drink or info interview, it's ok to ask, "Do you happen to know of any jobs open right now that could make sense for an entry-level person like me?" Chances are the person will say no, and the crucial next step is to politely say, "Is it ok if I check back with you in a few months?" Very few people will say no to that question. Put it in your calendar for three months later: "Check in with John Smith." Three months later: "Hi there, I'm meeting great people but still looking for that first job. Do you happen to know of any opportunities open right now or opening soon?"

Hearing, "I'm sorry, no, I don't know of any openings," time after time can get discouraging. But think of it this way: It's a numbers game. It's math. If you meet enough people, cast your net wide enough, keep hustling, keep

following up, it's only a matter of time before an email inquiry happens to coincide with someone who knows of a new opening. Keep hustling, keep meeting people, and chances are that, eventually, the timing will work out.

Use whatever network of contacts you have to meet people, ask for help and inquire about job leads. If you're a college graduate, there's a great chance that there are alumni of your school working in Hollywood. Get that list of people. *Make* that list of people if you have to. Most alumni feel a degree of loyalty to their school and will help a young, fellow alumnus get on his feet. Are there people in entertainment from your hometown? People often feel a kinship and loyalty to people who come from where they come from. Use it! Chutzpah is respected in Hollywood. If you're bashful and fearful of cold-emailing or cold-calling strangers with tangential connections to you or your family, get over it!

If you know what you want to do, if you know you want to work in TV development, target those jobs most intensively. But be open to other opportunities. There are many talent agencies in LA, from CAA and WME at the top, down to very small firms. Aim as high as you can and take the best you can get. A year may seem like a long time when you're young, but working at a small agency or a tiny production company that doesn't seem to have a lot going on can still be a positive learning experience and can still serve to help begin building a network of industry contacts. You're not bound to stay there forever. Your first job will be about learning and it will afford you an opportunity to see a clearer professional path in front of you.

Most larger entertainment companies like networks and studios have Human Resources departments. Make an appointment and fill out an application. It may not lead to a job in the programming department, but it might get you in the door. Charm the HR people while you're there. There are numerous temp agencies in LA that cater to Hollywood. Do your research when you hit the ground and apply at every temp agency. Getting in the door as a temp can lead to fulltime staff jobs – it's all about building relationships once you're in the building.

It may be necessary to consider internships if fulltime or even temp jobs aren't available. Do whatever it takes to get a foot in the door. A low-paying internship – if you can afford to do it – literally gets you in the door, gives you access to people, gives you entrée to developing relationships that can

Preparing for Careers in TV Development 257

lead to real jobs, at the company where you're interning or by recommendation to another company from someone you're interning with.

If you aspire to a career in entertainment, here's another tip: Come when you're young. Hollywood places a premium on youth. I delayed my move to Los Angeles for several years because I was intimidated by many of the myths of Hollywood, and, in retrospect, it was a mistake. It was a mistake because my fears were exaggerated and ultimately just plain wrong, and it was a mistake because Hollywood values youth and the young. Hollywood loves young, cheap labor. Take advantage of it. Your first jobs in entertainment aren't about the pay, they're about the experience and the relationships they allow you to build. Plan to live cheaply, bite the bullet and know that you will work your butt off for very little short-term financial reward. The reward is in the long term. Your financial payoff will occur in the long run. If you can make it into the business and up the first couple of rungs of the ladder, the pay for mid-level and upper-level executives is excellent. A successful, lucrative 30-year career is worth suffering for financially in your first few years if you can make it work.

I counsel students to arrive prepared to execute the Three Ps: persistence, politeness and patience. It's ok to be persistent. To get my very first job in Hollywood I had to bug a contact five times before he agreed to meet with me – and he was the best friend of a best friend. As long as you're persistent in a polite way, persistence is respected (just like chutzpah). Hollywood "weeds out" the people who aren't committed enough to be persistent and lack the discipline and organization to follow up in a timely fashion. But be patient. It's not ok to follow up and ask about job openings a day or a week after a first meeting. Develop good judgment for a polite and patient timeline of follow up, then follow up. Be respectful. There's a fine line between being politely persistent and being in someone's face and annoying them. Err on the side of patient and polite.

It's harder to get that first job in TV development if you're not young, if you're not in your 20s. Getting a foot in the door as an intern or an assistant is very unlikely once you're in your 30s. Even if an older person is open to starting at the bottom, employers are reluctant to give older people jobs that normally go to much younger workers. This reality steers me to the second major strategy for getting a job as a development exec, one that can be useful to people who are older than early to mid-20s.

DEVELOPMENT EXEC CAREER STRATEGY TWO: LATERAL MOVE ROUTE

The second strategy is for people to establish themselves in other careers first and then leverage the other career to move laterally into a job in development. This scenario typically involves getting a job in an ancillary department at a network, studio or production company. Execs can move into development (or network or studio current) as established professionals in ancillary fields. The most common ancillary fields that execs move laterally from into development are publicity, casting, advertising and promotion, research and business affairs.

Jeff Ingold, who's now a production company development exec and non-writing EP (*Rush Hour, Whiskey Cavalier*), worked as a network development exec for many years after transitioning within the network from its program research department. Julie Pernworth, the Executive Vice President of Comedy Development at CBS, began her career in casting. After realizing that as much as she enjoyed casting her real interests lay in helping writers and producers create new series, she set her sights on moving into development, patiently waited for an opportunity, and, when given an opportunity, built a career that led her to run her own network development department.

I began my career in Hollywood in a network advertising and promotion department. After four years in that job I transitioned into the programming suite as a current and development exec. Literally everyone I worked with in development at NBC when I started had begun their careers as assistants at networks, studios or talent agencies, had paid their dues in development straight out of college and had graduated up to the executive ranks by their mid-20s. Because I had delayed moving to LA until my late 20s and had worked in an ancillary field for four years before transitioning into development, all my development peers were younger than I was and every boss I worked for was younger than I was. It was a modest blow to my ego, but I quickly realized I had an enormous amount to learn from their experience, and I was lucky to have the opportunity.

Moving into programming laterally within a network or studio is difficult. Accepting a job in a network's ancillary department offers no guarantee that a path to development will ever emerge. The best approaches to a lateral move within a large entertainment company are as follows.

First, excel in your department. Be a star. Make it clear from your contributions to the company that you are destined for a bright career. Second, have a candid conversation with your supervisor about your goal to move into the company's programming department and ask for his or her support and assistance. In most cases, you should find that person supportive. (Have I mentioned that Hollywood admires chutzpah?) If your supervisor is supportive, he or she should offer to have a conversation about you with his management counterparts in current and development and share your ambition. If there happens to be a job opening in programming, your supervisor should help you to get an interview. If there isn't a job opening, your supervisor should offer to arrange a general meeting for you with the managers of current and development so you're on their radar if and when openings do arise. Third, you should reach out to the current and development execs at your level, invite them to lunch or for a drink after work and pick their brains, inquire about their work and about their career journeys. Build relationships, create allies. Win over your future colleagues to help your present cause. Continue to stay in touch with as many people in current and development as possible, and ask your supervisor to keep his or her ear to the ground for openings in those departments. Keep your eye on the ball, be great at your job and inspire people to *want* to help you. Big companies love to hire from within, to promote homegrown talent and groom future stars. It gives senior management a sense of pride, and they also know it serves as inspiration to everyone else in the company. Be that star and earn your way to a great new career.

PATHS TO BECOMING A PRODUCER

Most scripted series producers, as I've discussed throughout the book, are writers. Not only do creators and head writers serve as showrunners (and are credited as EPs), other senior-level and mid-level writers on series writing staffs get producing credits (Co-Executive Producer, Supervising Producer and Producer) because they're delegated producing responsibilities – in addition to their primary writing responsibilities – by their showrunner. The paths to these writing/producing jobs will be discussed in the next section on writing careers. This section will focus on non-writing EPs.

Most non-writing EPs enter the producing ranks via careers as development execs (at networks, studios or production companies) or as

talent reps (agents or managers). Non-writing EPs tend to be highly experienced development professionals who effectively graduate up to producing careers. After 10, 15 or 20 years as a development exec or talent rep, they've accrued the development experience, command of the industry's politics and processes, depth of industry relationships and industry respect, and often, critically, the financial security to launch a career as a producer.

Development execs, agents and managers have steady jobs and salaries. They typically have long-term contracts (two, four or five years) that provide them with the security of a regular income and benefits. Producers, as we've discussed, aren't paid anything for development, and while producing fees and backend profit participation can be very lucrative, they only bear financial fruit when a producer succeeds and gets a show on the air that stays on the air for several years.

Ironically, sometimes industry pros become producers against their own wishes. They get fired from a high-level network or studio development job and are awarded a "golden parachute" producing deal as a face-saving gesture. Most people in this situation probably would prefer not to be fired and remain in their steady, high-paying senior exec position. Receiving a two-year producing deal (including a guaranteed income for those two years) to attempt to launch a new career as a producer is the next best thing though. Some new producers in this situation make the most of the opportunity and become successful non-writing EPs, either developing a hit show they're attached to as EP, or they have enough development success short of a hit series to earn another POD deal after their initial golden parachute expires.

Most non-writing EPs find the career very hard going, and many people who try it (either by choice or via a golden parachute) run out of patience waiting for their first hit show, run out of money (many of them have family financial responsibilities) or simply come to the realization that they prefer their earlier career choice and return to the executive ranks. Susanne Daniels was a career TV development exec who rose up to the rank of President of the WB network in the 1990s, then left to become a producer, EP'd a handful of short-lived shows, and returned to the executive ranks at Lifetime, then MTV, and she runs YouTube's TV development and programming as Global Head of Original Content as of this writing.

Many non-writing EPs cushion their transition from careers as execs or representatives with studio POD deals that provide an office, an assistant, sometimes a staff of junior development execs, and significantly a couple of years of guaranteed income. Other non-writing EPs eschew the security of studio deals and remain independent, or freeball. One of the most successful non-writing EPs today is Aaron Kaplan, who worked as a TV lit agent at the William Morris Agency (before its merger with Endeavor in 2009 forming WME) for 16 years. Kaplan had earned enough financial resources as a veteran agent to launch a producing career without a studio POD deal, and found success early enough to remain freeball. After putting 19 series on the air in the first seven years of his self-financed producing career, Kaplan agreed to sell a share of his company to CBS Corp. In effect, Kaplan's self-financed production company has succeeded so well that he's partnered with CBS Corp. to become his own mini-studio, which will potentially allow him much greater ownership of shows he produces.

Another route to become a non-writing EP in television is a successful career producing features. (Obviously this isn't an entry-level career path, but it's worth being aware of.) Unlike in TV, most feature producers aren't writers. They're career producers. Because the demand for TV content has grown so much in recent years, many successful feature producers have expanded their portfolios to include TV. Two very successful non-writing TV EPs in the last 20 years were successful feature producers first. Jerry Bruckheimer produced a number of blockbuster movies in the 1980s and 1990s like *Flashdance, Beverly Hills Cop* and *Armageddon*, then expanded into TV, having a great run in the early 2000s with the *CSI* franchise, *Without a Trace, Cold Case* and *The Amazing Race* on the unscripted side. Mark Gordon produced the features *Saving Private Ryan* and *A Simple Plan* (among many others) in the 1990s, then expanded into TV in the 2000s with *Grey's Anatomy, Criminal Minds* and *Ray Donovan*. More recently, the successful feature producer Jason Blum has expanded his business into scripted television.

The last pathway to a non-writing EP career worth discussing, ironically, is writing. Some of the most prolific non-writing EPs today are producers who are first and foremost writer/creators. Shonda Rhimes and Greg Berlanti rose through the ranks as TV writers, wrote on the staffs of other creators' shows, and eventually created their own hit series. Ryan Murphy skipped staffing on other writers' shows and began creating his own series in 1999. Rhimes, of course, created and ran *Grey's Anatomy*, Berlanti created

Everwood and Murphy created *Nip/Tuck*. All three then defied the TV odds and went on to create more hit shows, ultimately becoming such successful and prolific creators that they were able to expand into rendering producing services – ideating new shows, identifying IP, developing shows with other writers – that expanded their portfolio of projects beyond their own writing/creating/showrunning limitations and into effectively becoming non-writing EPs. Unlike non-writing EPs who were never writers, these writer/non-writing EPs work with writer/creators in a more creative and intimate way, but they are still effectively working as non-writing EPs.

PATHS TO BECOMING WRITERS

The goal of many aspiring development professionals today is to create and run their own shows. In the old days, as I've described, writers served for years on the writing staffs of other creators' shows before they earned the opportunity to pitch networks and create their own series. The world is different now. Lena Dunham, as mentioned repeatedly throughout this book, created, EP'd and co-ran her own show when she was 25 without any prior TV experience. How did she do it, and what paths do others take to become TV writers and get the chance to develop their own series?

Arriving in LA in your early to mid-20s as an award-winning indie feature filmmaker and fully formed artist like Lena Dunham is truly exceptional, but young writers and fresh voices have a greater opportunity in TV development today than ever before. *The Handmaid's Tale* non-writing EP Warren Littlefield says that TV development today is "about powerhouse creators and new voices."[2] The "powerhouse creators" he's talking about are writers and producers with huge development deals like Shonda Rhimes and Ryan Murphy, or with long histories of successful series like David E. Kelley and Damon Lindelof. The "new voices" he's referring to, though, are often young writers with limited TV experience.

Though Hollywood is more open to fresh voices than ever before, young writers still need official entrée through the gates of power – they need access to networks to pitch their ideas, and that's still only possible with representation at Hollywood talent agencies. In Hollywood even the gatekeepers have gatekeepers. Young writers can earn the opportunity to pitch networks, but they need to get signed by an agent first.

Aspiring screenwriters can find a wealth of advice about how to begin TV careers from numerous books, blogs, podcasts and videos. For the purposes of this book, I want to focus on one pathway to TV writing careers that many working writers recommend. Traditionally, aspiring TV writers arrived in Hollywood and hoped agents would read their portfolio of writing samples (I'll talk about writing samples a bit later). This route to representation still works, but it's difficult. Most legitimate agents don't take time to read "over the transom" submissions (unsolicited submissions lacking a personal referral). Newcomers who have connections can get their material to agents and sometimes get that material read. If an agent reads a sample and likes the writing, she may consider signing a baby writer for representation. It still happens.

Many agents, however, say they focus on new writers that are referred to them by existing clients. So how does an aspiring writer get a professional writer to refer them to his agent? One strategy young writers use is to get entry-level jobs working alongside writers, which then allows them to build those relationships. These aren't writing jobs, but jobs that can lead to writing careers. Showrunner and creator Michelle Nader tells aspiring writers, "Try to work on a TV show. Get as close to the action as possible. You need someone to advocate for you that's inside of it."[3]

Television shows all have entry-level positions, assistant and PA (production assistant) jobs. Many senior writers and producers on shows have executive assistants who answer phones, coordinate schedules and perform other clerical tasks like development assistants. Shows also employ numerous kinds of PAs: on-set PAs, office PAs, prep PAs, post PAs and writers' PAs. Want to guess what the main responsibility of the writers' PA is? Getting lunch for the writers. The writers' PA takes lunch orders, picks up the food and delivers it to the writers' room. It's low-level scut work, but it allows the young person a chance to know working writers, and it can lead to the single best job in all of television for aspiring TV writers, the writers' room assistant.

Just about every TV show has a writing staff of anywhere from four to 20 writers, and every writing staff has one (sometimes two) writers' assistants. A writers' assistant sits at the table in the writers' room along with all the writers on the staff and enters into a computer just about everything that every writer says (that's relevant to the work at hand). Every time a writer articulates any kind of pitch – a story pitch, an adjustment to a part of a

story, a line of dialogue – the writers' assistant enters it into his notes so the idea won't be lost. Writers' assistants process, collate and distribute all the work of the writers' room at the end of each day and distribute their notes to the rest of the writing staff and other EPs. If the writers' day ends at 7:00 pm, the writers' assistant might stay for several more hours, cleaning up and distributing her notes.

An even higher level of assistant in writers' rooms is the script coordinator (TV is so hierarchical there's even a hierarchy of assistants). Script coordinators proofread and edit scripts, watchdog continuity and timelines of events in scripts, coordinate all the many drafts and rewrites of episodes and distribute finished scripts to staff, crew, studio and network personnel.

Writers' PAs who are liked get promoted to be writers' assistants, and writers' assistants who are liked get promoted to be script coordinators. Needless to say, most people who want these jobs, and get these jobs and are good at these jobs, are aspiring writers. Writers' assistants and script coordinators often are assigned by showrunners to write an episode or two of a series and eventually they can be promoted to writers on the staff. These three jobs all allow young people to build close working relationships with writers and producers, insiders who can become the young writers' advocates to whom Michelle Nader referred.

When Kateland Brown graduated from college she knew she wanted to be a TV writer. She moved to LA, but didn't know how to get a foot in the door. She got a job waiting tables to cover her bills and enrolled in a screenwriting class at UCLA Extension (UCLA's evening classes for adults). She knew she could work on improving her writing skills while trying to figure out how to get her career off the ground. Kateland loved the class and hit it off with her teacher, who became a mentor.

When the teacher saw a TV internship posted on her own college alumni website, she recommended it to Kateland who applied and got it, working three days a week on the second-to-last season of *Smallville*. Kateland loved it and kept the internship for a year and a half. When the series was ending, she asked people on the show if they knew of other jobs. A writing team told Kateland that their *Melrose Place* reboot had just been picked up to pilot and offered her a job. When the pilot got ordered to series Kateland was offered a job as a PA. On her first day on the series, she was assigned to help the new line producer set up her office, the two hit it off and Kateland found

herself spending the season as the assistant to the line producer of *Melrose Place.*

Melrose Place was cancelled after that first season, but Kateland's boss got a new job on *Pretty Little Liars* and brought Kateland with her. After the first two years of the show, the writers' room assistant got promoted to the writing staff, and Kateland moved from the line producer's assistant desk to the writers' room. *Pretty Little Liars* actually split the writers' PA and writers' assistant jobs between two people at the time, and, after two seasons sharing that arrangement, Kateland was promoted to script coordinator. Throughout her years as an executive assistant and writers' assistant Kateland continued working on her own writing on her own time, improving her portfolio of material.

In her first season as script coordinator she was assigned to co-write an episode with another writer, and in her second season she was assigned to write an episode on her own and got signed by UTA. When *PLL* creator Marlene King got a new show *Famous in Love* ordered to series, King hired Kateland as a fulltime writer. After her circuitous journey from waitress to intern to PA to assistant to script coordinator, Kateland was finally a professional writer. When *Famous in Love* got a second season order, Kateland was hired back, and her career as a professional writer was off and running.

What lessons does Kateland Brown draw from her circuitous journey? First, to seek out mentors. The UCLA Extension teacher, the *Pretty Little Liars* line producer and Marlene King all became mentors, they encouraged her and opened doors for her. Once she earned the trust and respect of writers on *PLL*, she asked if they would look at her scripts and offer advice. She was always candid about her ambition to become a writer at every step of her career. The line producer was happy to reward Kateland's hard work as her assistant by helping Kateland navigate her way to achieve her dream. Kateland says that, among TV assistants and PAs, *not* having a dream and *not* taking advantage of an entry-level stepping stone to a better career is frowned upon. Kateland stresses that building relationships is key to progressing up the rungs of the ladder. As she puts it, it's about "being cool, not being crazy, not having an ego and working really hard."

The last lesson Kateland draws from her journey is something she wishes she'd done but didn't. She recommends that students who know where

their entertainment interests lie get internships as close to those career goals as early in college as possible. Because the industry is so relationship-based, working with professionals early on expands career opportunities upon graduation.

As I was writing this book a new graduate of my old college moved to LA and invited me for coffee. I was about to make a call on her behalf a few days later when she emailed to say that she no longer needed my help. She'd done a six-week summer internship on a TV series shooting in Atlanta the previous summer, and an assistant director she met there, now working in LA, invited her to fill in for a sick PA for a couple of days, and it wound up leading to a fulltime job on the show. A summer internship paved the way to her finding a first job in Hollywood within a month of her arrival in LA.

It's not always that easy. Kateland Brown was lucky that a teacher tipped her off to an internship that began her long journey. The first step is relocating to LA, and the second step is circulating among people with similar interests and aspirations. Taking an extension class is one way. Writers' groups (weekly meetings of aspiring and working writers who share and critique each other's scripts) are another. Lijah Barasz, another writers' assistant turned professional writer, jokes that when she first moved to LA and heard of entertainment networking opportunities she assumed they were "gross and schmoozy," but when she actually went she found them supportive and stimulating. "You have to come out of your shell and meet people," she says. Lijah is a Co-Producer on *The Bold Type* as of this writing, she is repped by CAA, and has already sold her first pilot script.

Entry-level jobs on shows are so competitive that they're quickly filled by word of mouth. If you haven't done internships that might lead to hearing about those jobs, find any way you can to any job at a TV studio, then figure out a route to meeting the people who work on the shows. Start at studios' Human Resources offices and temp agencies if necessary, set your sights on getting onto a studio lot, navigate your way to a show and begin building relationships.

As Kateland Brown's story illustrates, this path to TV writing careers can take several years, but it's fun, exciting and vastly educational along the way. Writers like Kateland and Lijah didn't struggle to get their writing samples read by agents. They chose another path. They got their first professional writing assignments by earning the respect of showrunners through years of

hard work, and those credits and the relationships they made with other working writers got them signed at top agencies.

WRITING SAMPLES

Whether aspiring writers can get their material in front of agents or try to work their way into entry-level jobs on shows in the hope of earning freelance writing assignments, they need great TV writing samples to demonstrate their talents and prove they can write at the highest levels. Baby writers typically need at least two great TV writing samples, a spec pilot and a spec episode. I've talked about spec pilots in the context of producers and studios packaging and shopping them to networks, but this is a different kind of spec pilot. Aspiring writers write spec pilots primarily as writing samples, as proof that they can create new characters with original voices. Yes, every young writer dreams that his spec pilot will sell to a network and get made into a hit series, but most know the script will only serve as a calling card to demonstrate his talents, to get signed by an agent and hopefully staffed on a series.

The second script agents want to see is a spec episode, usually referred to simply as a "spec." The writer chooses a series currently on the air, ideally the kind of show that snobby Hollywood people watch and love, and writes an original episode of that series with stories that *could* happen on that show. Agents and ultimately showrunners want to see that a young writer is adept at writing voices of existing characters and can capture the tone and style of series that are already up and running. Some showrunners and executives prefer to read spec pilots, some prefer to read spec episodes, some insist on reading both, so every young writer needs at least one great sample of both types of scripts to get signed and staffed.

Once in a blue moon a young writer's writing sample spec pilot *does* get made. And when that happens, it changes the writer's life forever.

In the fall of her senior year at the University of North Carolina School of the Arts, Vera Herbert got an internship in LA on the show *Awkward*. At the end of her internship the showrunner offered her a full-time job as her assistant, but Vera had to get back to North Carolina to finish her degree. Not wanting to let a great opportunity slip away, though, she worked out an arrangement with UNCSA to finish up school long distance and took the job. While an assistant on *Awkward*, Vera wrote a spec comedy pilot and one of

her screenwriting professors in North Carolina got the script to agents at Gersh, who loved it and signed Vera. Days after signing with her new agents, she drove cross-country to walk her graduation in North Carolina.

She returned to *Awkward*, got promoted to writers' assistant and kept working on new material of her own. She wrote another spec pilot, a dark half-hour dramedy called *Blink* about a teenage girl whose family is disrupted when her father suffers a serious accident and ends up in a long-term coma. Part of the story was told from the point of view of the father, who couldn't move or speak, but who was aware of his family's life going on around him. Vera thought *Blink* was a solid writing sample and hoped it would help her get staffed, but her agent thought it was even better than that. The agent pitched *Blink* to the CW, and the execs there read it, loved it and bought it on Vera's birthday. A non-writing EP was brought in to work with her to redevelop the script into a one-hour drama, and that winter the project was ordered to pilot production. At 23, Vera was the Supervising Producer of her own go pilot.

Blink didn't get picked up to series, but Vera was a produced writer, a phenom the entire industry took notice of. She sold another pilot pitch to the CW, then one to NBC and, the following year, another to Fox. None of them moved forward, and Vera began thinking about staffing instead of focusing on development.

She read a pilot she loved and asked to meet on it. The pilot got ordered to series and the showrunner hired Vera to join the first writing staff of *This is Us*. That winter an episode Vera wrote won the prestigious Writers Guild of America award for Best Episodic Drama, cementing her status as not only one of the best *new* TV writers, but one of the best writers working in television today. As of this writing, Vera's at work on Season 3 of *This is Us* as the show's Co-Executive Producer.

Dreams sometimes do come true.[4]

PREPARING FOR CAREERS IN DEVELOPMENT WHILE IN SCHOOL

What can students do to prepare for careers in development while they're still in school? Students can do three things: 1) discover where your creative

interests and passion lie, 2) practice your passion and start building a portfolio of work that demonstrates your talents, and 3) begin to establish a network of real-world Hollywood relationships to prepare yourself to get representation and work upon graduation.

The first two goals above translate into one thing: Do the work. Tell stories. Make films. Make TV. Make web series. Make plays. Make stuff. If you know you're interested in entertainment but you're not sure in what capacity, make stuff and find out. Write. Direct. Produce. Act. Do it with your friends and at school however you can. Do it on your smartphone, with a cheap or borrowed video camera and with laptop post production software. You're luckier than earlier generations; you can make filmed stories much more cheaply than ever before.

For people who find themselves gravitating toward careers as writers, directors and actors, it's about building a resume and a portfolio that demonstrate your talent and gets you attention, preferably in the form of student festival awards, film festival awards and other acclaim. Many film festivals have short film categories and there are even some festivals exclusively devoted to short films.

If you've read this book and discovered your calling is more as a producer, agent or development exec, is there anything you can do while you're still in school? First, study TV and films. Watch the old stuff and learn the history of TV and film genres. And watch as much of today's vast amount of content as possible. Watch everything.

Non-writing EP Warren Littlefield expects young people he interviews at his production company to speak thoughtfully about the shows they love:

> Know the content! You need to tell me what you're watching and why. What excites you? In a sophisticated, detailed analysis, you need to tell me why that show resonates for you. What brought you into it, what connected you to it?[5]

Read friends' scripts and give them notes. Reread my chapter on Developing the Pilot Script and apply the checklist of questions to every script you read. Add to that list or change it to emphasize the things you look for in entertainment, the things that are important to the stories you love. Begin to apply that checklist and your own gut instincts to evaluating written

dramatic material and practice writing notes memos. In clear, constructive, encouraging language, articulate what's not working in a script, why and how to fix it. Seek out schoolmate filmmakers and help develop their short films and web series.

The third goal listed above is to begin making your own real-world Hollywood relationships. That means internships. If you're in college or grad school think about summer internships in LA. If LA's out of reach but you live near one of North America's production centers – New York, Chicago, Atlanta, New Orleans, Vancouver, Toronto or Montreal – reach out to shows shooting there and see if you can get a summer internship. For students who aspire to more executive careers, search Human Resource offices at the dozens of networks, studios and talent agencies in LA and explore their internships. As Kateland Brown said, doing internships with working Hollywood professionals as early as possible will expand your career opportunities enormously when you graduate. It's all about building personal relationships, winning people over and earning their respect.

As much as this book and this chapter focuses on TV and entertainment in general, CBS Executive Vice President Thom Sherman offers an important reminder:

> Live life! At the beginning of your career you're going to be a PA or an assistant. In order for you to get that job it's not enough to show your resume and say, "This is what I've done in college." The first thing that a lot of people in this business and I are going to look at is the bottom of your resume. What are the interesting things you've done? *Did* you do anything interesting in your life? Did you spend six months at sea? Those are the things I'm going to want to talk about. Creativity comes from interesting people with interesting stories to tell.[6]

Consume as much television as you can, but don't forget to live some interesting stories of your own.

NOTES

1 "Phone sheets" are distinct, of course, from "call sheets," the daily bible of the production side of the business, which lists the schedule of work to be shot on a

given day of production along with the cast and crew required, location details, props, etc.
2 Author interview with Warren Littlefield.
3 Author interview with Michelle Nader.
4 The year the *Blink* pilot was produced Vera's agent, Margaret Mendelson, moved to CAA. Vera moved with her and has been repped there ever since.
5 Author interview with Warren Littlefield.
6 Author interview with Thom Sherman. Sherman was the head of drama development at ABC in 2003, the exec who took Lloyd Braun's "TV ensemble *Cast Away*" pitch and developed it into *Lost*.

14

Applying TV Development Strategies to Other Forms of Filmed Storytelling

The primary goal of this book is to introduce aspiring and entry-level development professionals to the processes of Hollywood TV development. The hope, however, is that strategies described here will have application beyond Hollywood, in other media and other industries. Specific steps that I've discussed in this book – like concept ideation, pitching and pilot story development – can hopefully inspire and inform approaches to storytelling in other formats, media and industries. In this chapter, I'll look at four themes from Hollywood's industrial process of TV development that readers can potentially apply to non-Hollywood storytelling, as well as in other fields like marketing, advertising and public relations.

CREATIVE COLLABORATION

Many of us have a romantic image of artistic creativity. We picture a Victorian novelist, alone, hunched over a wooden desk, her quill pen dancing in the candlelight, filling the page with a work of lasting genius. Creative genius, true artistry, has, of course, always existed. But it's rare.

When Hollywood finds an artistic genius and does its job well, it protects that genius, and shares her vision with the world. David E. Kelley wrote all the episodes of *Big Little Lies* by himself. Nic Pizzolatto wrote all the episodes of *True Detective* Season One alone. One artist, Cary Joji Fukunaga, directed all of them.

But there's a scarcity of artistic genius, and Hollywood has a lot of hours of television to fill. In lieu of artistic genius it employs the next best thing, creative collaboration. Groups of people working together to create compelling characters, fascinating worlds and stories that entertain millions. One person has an idea, a second person finds inspiration in that idea and improves it and the first person, who never would have imagined the change by himself, elevates it even further.

Hollywood has evolved numerous industrial processes of creative collaboration. The television development process and the TV writers' room are two of the most successful and lasting. Can you benefit from the processes of creative collaboration that Hollywood uses every day? Many of us who aren't Lena Dunham or David E. Kelley can look to the lessons of Hollywood and apply some of its collaborative strategies to performing the hard work of creativity. (And of course Dunham and Kelley also required numerous collaborators at many levels to realize their vision and share it with the world. No one in entertainment can do it alone.)

Many young people endeavoring in their first creative projects look for freedom and space. "Let me do my thing, then I'll show it to you when I'm done and ask for your feedback." That's how I thought when I was young. But young people aspiring to work in Hollywood might want to consider adjusting their approach, and welcome and even seek input early and throughout their creative process.

Small teams of people, three or four, or larger classes of students, can give themselves development assignments. Use some of the ideation techniques described in Chapter 5 or define your own ideation challenges. Create an assignment where everyone has to show up with three ideas, everyone's got to pitch, then brainstorm together as a room, bouncing ideas off each other to develop and improve each pitch. Make a list of the five most interesting, exciting ideas that emerge from that process and convene a second meeting to further develop and flesh them out. One of the tricks to making this process work is a good leader (what the TV writers' room calls the "room

runner," usually but not always the showrunner) who directs the room toward the best ideas without shutting anybody down and making them feel bad about ideas that don't rise to the top.

When people ask me what's my favorite part of my job, the answer is easy: creative collaboration. Two or three or twelve people bouncing creative ideas off each other, pitching and fixing and upping each other's game. The best part of my job is being part of a creative session where ideas emerge from a group that never would have emerged from one individual in that group. It happens all the time. "That's great, but what if we ...?"

If you're a young person making your first short films or your first scripted web series, and you know your concept and stories, great. Do it. But if you're looking for ideas then consider implementing this kind of process. Bring smart, creative friends together and brainstorm. Teachers, devote class time to your own "development retreats," provide development assignments and use the classroom for pitching and brainstorming. Other story-based professionals are probably already using team brainstorming processes, but are you using them to brainstorm stories? What stories are your marketing, advertising and PR messages telling, and can you use your staff to ideate more compelling stories that tap more deeply into the Zeitgeist?

Hollywood screenwriters grouse about notes all the time. No one gets excited about rewriting an outline or a script over and over. Some Hollywood development professionals give lousy notes on occasion (I'm sure I have). But the industry is set up the way it is, as dispiriting as it can sometimes be for writers, because it works. Notes usually make the story and the script better. If you're a young person making a short film or a web series, are you using the smart people you know to give you feedback on your material at every step? If not, do it. Get used to it. They're not paying you, so you don't *have* to take their notes, but you should learn to be open to notes, open to feedback, be open to constructive criticism. Look for the "note beneath the note." Is more than one person identifying a problem area in your outline, script or rough cut? Even if they're not articulating the problem exactly right, are they helping you identify there's a problem that needs to be addressed? Your loyalty isn't to your ego, your loyalty is to your work, to your project. Overcome your doubts, fears and insecurities and open yourself to input. You owe it to your project, and you owe it to yourself to learn to listen and accept constructive criticism. Use criticism proactively. Incorporate it into your process to make the work better before you shoot and before you finish

your cut. You're in control; you don't have to take every note. Figuring out which notes to take, what the underlying problem is that inarticulate notes are trying to identify and then translating them into good creative fixes, is part of the creative process and part of the job in Hollywood.

Producers and directors of feature films typically convene "friends and family screenings" of their films before they show a rough cut to studio execs. They want to tap the fresh eyes and smart opinions of respected friends and colleagues to make their work as good as they can. Most writers, directors and producers of pilots do the same thing in a more informal way. Learn to seek and incorporate input at the pitching stage, story development stage, script stage and rough cut stage.

Television writers joke about "anticipating notes." Before showrunners deliver story outlines and drafts of scripts to network and studio current execs, they'll ask the writers' room, "What notes are they going to give us?" Do your own "anticipate the notes" process. What do you think people are going to say, and can you either fix it first or brainstorm creative solutions so you're ready if the feedback you're expecting comes? Seek out collaborative processes that make your work better.

USE WHAT CAME BEFORE YOU

As I've discussed throughout the book, TV development is about reiteration, variation and experimentation. What came before, what worked before, and how can we change it enough to make it different and more contemporary? That's what Hollywood development professionals do every day.

How can you do that? Whatever creative medium or format you're working with, what are the best and most successful examples that came before you, how did they work, and how can you reinvent them for a new audience, a new generation of consumers, and how can you express the timeless underlying ideas and messages in a new way and with a fresh voice?

Identifying and exploiting universal themes is at the heart of the power of most successful TV. *The Sopranos* and *Breaking Bad* were both about family and masculinity and the tension between them. *Gossip Girl* was about female friendship and romantic love and the tension between them. *Game*

of Thrones is about family and power and the tension between them. What are the universal themes at the heart of your creative work?

Study the past. What worked before? Just about every successful Hollywood writer I've worked with is a student of TV, knows TV history and has studied what worked before and why. They analyze genres so they know how they work and what's essential to keep and what they can change and don't need in their new re-imagining of it.

If you know what's worked in the past and have an idea how to reinvent it, but you don't have the skills or facility to express your reinvention yourself, who does? Who can you hire or partner with to lend contemporary voice to an idea that's ripe for reinvention? This is what producers and development execs do. They're not writers, but they have an eye for how to reboot the best old ideas, and they have an eye for talent to identify the best artists to execute a reinvention in the most contemporary ways possible. Be honest and critical of your strengths and talents. If you have good ideas but not the best skills to express your ideas, bring your great ideas to someone who does and sell them on your vision and the idea of partnering with you. Become a producer.

THE FAILURE FACTOR

Remember Graham Yost's "Pyramid of Death?" Most pitches don't sell, most scripts don't get shot, most pilots don't get picked up to series and most new series don't last. Most development fails. TV is hard. Creativity is hard.

Hollywood has devised business models to factor failure into the process. A lot of failure. Even those rare true geniuses fail from time to time. Creativity involves risk. Hollywood hedges risk with reiteration. But even then there's got to be some creative variation that itself involves risk. The few hits pay for the many failures. Factor failure into your creative process. Don't limit creativity because it's rife with failure. Factor failure into the cost of successful creativity. Most ideation sessions don't generate anything usable. Keep going. Come up with new development assignments. Teach your team to pitch and to brainstorm. You're panning for gold; those nuggets are few and far between.

If you're a young artist, grieve your failures, lick your wounds, then pick yourself up and learn from your mistakes. If you're not failing from time to time, you're not being creative.

NEW TECHNOLOGIES, NEW ENTERTAINMENT FORMATS

The proliferation of TV technology as a commercial medium in the US in the late 1940s inspired the creation of new entertainment formats. Early TV programmers appropriated radio formats and transposed them to the new medium. The American radio industry had created regularly scheduled scripted series formats in the 1920s, formats inspired by serialized newspaper comic strips. Early TV writers, producers and TV programming executives also invented new formats to exploit opportunities presented by the new medium. Lucille Ball and Desi Arnaz worked with directors and cinematographers to create the multi-camera half-hour TV format in 1951. The first TV drama format was a 30-minute format, the length of radio drama formats. Television writers and producers discovered that the visual medium of television could sustain viewer interest for longer than 30 minutes, and that stories could be told more impactfully at longer length. In 1957 the half-hour TV drama format evolved into the one-hour drama format we know today.

As new content distribution technologies emerge and assume commercial prominence, what new formats can complement or supplant existing formats? Jeffrey Katzenberg and Meg Whitman's Quibi launches in 2019 with 15-minute scripted series formats. Who else will invent new TV formats? What will they look like?

The web series format, short episodes often produced on low budgets with typically low production values, have proliferated since practically the advent of YouTube in 2005.

For now, it appears the goal of most web series creators is to get their work optioned by large media companies and conform their work to traditional TV formats (like *High Maintenance*), or to propel a writer or performer (or both) into an opportunity to create her own new series for a media company and conform their work to traditional TV formats (like *The Misadventures of Awkward Black Girl*).

Will programmers at Netflix, Amazon or CBS All Access invent TV formats and exploit new opportunities suggested by online distribution? Or will non-Hollywood scripted series creators lead the way? Indie content creators and marketing companies financing branded content have experimented with

short-form web series during the past decade. Yet no single series has truly broken out and captured a mass audience. No true web series hit has succeeded in defining a new format. *I Love Lucy* succeeded in creating a new entertainment format because it worked, because it attracted a large audience. Hollywood imitates success. The world is waiting for a true breakout hit scripted series from a grassroots, non-Hollywood creator that can lay claim to inventing a new TV format. When that happens, the rest of Hollywood will follow and the scripted series TV industry will yet again be transformed.

15
What's Next
TV Development in the Age of Media Disruption

There are more networks – broadcast, cable, satellite and streaming – developing and programming more scripted series on American TV than ever before.[1] What this translates into for people like you and me is that there are more opportunities for writers to create new series and more jobs for TV development professionals in Hollywood than ever before. In short, these are boom times in TV development.

Not only is there extraordinary demand for the product of development professionals today, there's an extraordinary opportunity for professionals to do great and exciting work.

While some industry skeptics contend that there are too many shows and that the industry can't sustain the current pace of productivity, there is no indication that an end to these heady days is anywhere in sight.[2] Disney launches its streaming service, designed to compete with Netflix, in late 2019. WarnerMedia has also announced plans to launch its own streaming service. Media mogul Jeffrey Katzenberg and Meg Whitman have raised a billion dollars to create Quibi, the streaming service designed for viewers who consume content on their mobile devices, also slated to launch in late 2019. More and more competitors to Netflix and Amazon continue to come online, and more cable and satellite channels continue to add scripted series

to their programming portfolios (while a smaller number of cable channels shutter their scripted divisions). As long as tech giants like Apple and Facebook continue to battle Netflix, Amazon and Hulu to establish online video as the next dominant TV distribution technology and to compete with each other for market share of that business, and as long as – on the other end of the technological spectrum – the legacy broadcast networks continue to operate in some form or fashion, there will continue to be more and more shows to make and consume.

Not only are we living in an era of enormous volume of TV development and programming, we're living in an era of extraordinarily high quality. Freeing development professionals from the mandate of targeting mass audiences has allowed TV creators to make shows that no longer need to appeal to the lowest common denominator. Newer distribution business models allow for shows that appeal to smaller, more targeted audiences. Many TV networks are content to develop and program quality shows that command relatively small audiences, but that elevate the brand and the value of the overall network and all its other programming. These factors combine to allow writers, producers, development execs and agents to focus on more original ideas and more sophisticated execution of TV content than ever before.

This is all a long-winded way of saying that now is a great time for young people who love entertainment and love television to come to LA to pursue their TV development dreams. For clear-eyed aspiring TV professionals prepared to approach their careers with realism and pragmatism (and tons of hard work and awesome ideas), now is a great time to go for it. There are more jobs and more opportunities in TV development than ever before. Television is a thriving, healthy, dynamic industry and there is no indication that that vibrancy will decline anytime soon.

As I first mentioned in the introduction to this book, the distribution of TV is being disrupted in enormous ways, but the development of TV isn't. Of course there are evolutionary adjustments to the process, and new trends that I'll look at more in a moment, but the fundamental practice of TV development is relatively unchanged. Development professionals still need to find or create great ideas and great concepts for shows. They need to translate those ideas into pitches, oral or written. They need to dramatize those ideas and pitches in the form of scripts, whether the title page refers to the script as a "pilot" or "episode one." A vision for a series consisting of

many stories and seasons beyond that first episode needs to be imagined and articulated. Ideas, pitches, stories and scripts have always been, currently are and will continue to be the primary work of development. Working with material, verbal, written material, is the heart of TV development. One of the two words that designate the medium of "scripted series" is essential to all development. As long as "scripted" continues to be part of "scripted series," development will continue to focus on the traditional, essential focus of development, creating scripts that serve as the blueprint of a series.

For the foreseeable future, development professionals are winners in the massive sea change of TV that swirls and storms around us today. Development professionals who cut their teeth in the 1990s when broadcast TV still dominated, who helped create the first generation of cable scripted hits, have enormous value to new media businesses that develop, program and distribute scripted series TV. Younger people aspiring to enter the ranks of TV development, or who are currently taking their first steps up the entry levels of the TV industry, will continue to have more and more opportunities for entrance to and upward mobility in Hollywood development suites as more and more companies open them.

TRENDS IN TV DEVELOPMENT

There are two kinds of TV development trends worth looking at today: process trends and creative trends. Let's look at process first.

I've already highlighted two of the most important process trends, the proliferation of straight-to-series commitments and adaptation. Netflix introduced the current trend of straight-to-series development when it acquired *House of Cards* in 2011. Other streaming channels also began making straight-to-series orders, though not all of them do it all of the time, and cable and broadcast networks have begun making more straight-to-series projects than they used to. There are a couple of motivations for this trend. First, the networks that are using the strategy most often are the newer networks that need large volumes of programming to deliver to consumers as quickly as possible. Ordering a project straight to series produces episodes much more quickly than traditional pilot development. Those networks were and are looking for projects tee'd up and ready to go that don't require months or years of careful development. The Netflixes

and Apples of the world wanted to hit the marketplace with big, splashy, star-driven content. They have the deep pockets to afford the gamble and straight-to-series orders are one quick way to do it. A second factor motivating this trend is the heightened competition for big new development packages. As more A-list feature talent gravitate to the creative and financial opportunities afforded by the flourishing TV landscape, straight-to-series commitments are a direct result of competition for the biggest and sexiest TV packages. In a highly competitive marketplace, the sexiest new packages attract the top tier of TV buyers, and bidding wars quickly escalate the price from pilot script commitments to straight-to-series commitments.

While most straight-to-series projects avoid the piloting process, they still undergo the rigors of development. Netflix is effectively shifting the primary burden of development from its network development execs to studio development execs, producers, agents and managers. Rather than developing the pilot script at the network, most projects designed for the straight-to-series marketplace develop the pilot script within a studio or among producers. The Episode One script in these packages is rigorously developed, air-tight and ready to win a straight-to-series order. The Episode One script and the vision for the series are just as highly developed as they would be in traditional pilot development – the steps just happen earlier in the process and with a slightly different team of development professionals.

The odds are that the gravitational pull of the costs of TV development will eventually lower the number of straight-to-series orders. Once Netflix and Apple and other major streaming channels have bulked up their programming slates and have fully stocked shelves to offer eager customers, they may choose to exercise more creative control over the projects they spend huge sums of money to buy, just as other distributors traditionally have. This may lead to more hands-on development at those companies and slower, more careful processes.

The trend of adapting IP to TV series continues to flourish, as it has for the past 10–15 years. More shows than ever before are based on pre-existing IP. Pre-sold brands hedge development risk and theoretically decrease the money and manpower it takes networks to market new series. In Chapter 10 I talked about how the parent companies of networks (or in some cases the newer networks themselves) want more ownership of the shows, making the networks more interested in buying from studios within their corporate families, or, in the case of Netflix, averse to buying from studios altogether.

This trend compels existing studios to find projects that network buyers absolutely need them for, and one way they can do this is by leveraging their ownership of branded IP. Warner Bros. owns DC Comics. Disney owns Marvel, and its TV studio, ABC Studios, divvies up that IP with its sister feature division. Paramount Television owns a library of hit movie brands that it now translates to TV series like *Tom Clancy's Jack Ryan* and *First Wives Club*. Offering networks branded IP is a strategy studios employ to stay relevant in a world where networks want to own as much content as possible.

Aggregating, packaging and selling IP is a growing area in TV development. Storied Media Group, founded in 2013, licenses pipelines of IP, then brokers and produces it for TV and film. Another entrant in this growing wing of TV development is Vince Gerardis, a Co-Executive Producer of *Game of Thrones*. Gerardis helped package *Game of Thrones* and has relationships with book agents to package their clients' IP for other TV and film ventures. Gerardis recently signed a deal with Amazon to funnel IP he controls into series development for the streaming giant. Finding sources of IP and figuring out how to control and leverage it for TV exploitation is a growing opportunity for new development professionals.

CREATIVE TRENDS

The most dominant trend in TV development during the past 20 years has been the trend toward increasingly dark, mature, sophisticated subject matter, tone and overall execution. Since *The Sopranos* in 1999, the antihero has reigned and development professionals have built scores of new series centering on deeply flawed lead characters, even in traditional TV genres, as we've seen with *True Detective, Bosch, The Knick* and even *Bull*. Networks have sought out mature, sensitive and challenging subject matter that they never would have considered just a few years earlier, like *Transparent* for example. In 2018 Amazon ordered a one-hour drama series, *This is Jane*, set in an underground abortion clinic, a subject networks have avoided for generations.

The success of *This is Us* in 2016 was seen by many as a reaction against this trend, turning the tide toward brighter, more earnest, warmer and more hopeful shows. The success of *The Good Doctor* a year later is interpreted as confirmation of the new direction. These examples are both in the

broadcast network space, which has always tilted towards brighter and warmer than cable and streaming, but the buzz among agents and other sellers appears to suggest that the success of those shows has prompted some of their cable and streaming competitors to consider lighter, more hopeful concepts as well.

Genre experimentation and avoidance have been a corollary feature of the trend toward darker and more sophisticated shows. Shows like *Turn: Washington's Spies* and *Halt and Catch Fire* have no genre antecedents and never would have been considered for development in earlier years. Network development executives across the spectrum continue to look for untraditional concepts and styles of storytelling for development. At the same time, fresh ways to reinvent tried and true TV genres like the traditional one-hour drama procedurals continue to be in demand in all sectors of the market.

Diversity and inclusion have been vital trends in recent years and have grown even more central to the entire industry's focus in the last couple of years. Building shows around ensembles that feature diversity of ethnicity, sexual orientation, physical challenges and body shapes has become a priority in TV development throughout the industry. Giving voice to creators and other writers who were traditionally underrepresented in television is a priority at most networks and studios. Hiring executives from diverse backgrounds at every level has become central to the policies and practices at networks and studios as never before.

As the world around them changes, development professionals continue to challenge themselves with the basic questions of TV development: What's in the Zeitgeist? What's going on in our society? Who are we? They're looking for concepts and shows that don't simply answer these questions in direct and literal ways, but attempt to address them in poetic, allegorical or metaphorical ways. *The Handmaid's Tale* surprised even its own creators, studio and network in being more immediately relevant than anyone imagined.

THE FUTURE OF TV DEVELOPMENT

The American television industry today is as healthy and vibrant as it has ever been. There is more work, more opportunities for success and more creative openness and experimentation than ever before. The TV industry

still has its gatekeepers and codes of conduct, but newer and less experienced voices are being heard and gaining more access than ever before. Aspiring writers and other development professionals who temper their creative ambition and optimism with pragmatism, realism and diligence have unlimited opportunities for success.

Despite the industry's increasingly voracious appetite for new shows and more shows, TV development remains incredibly hard. Most pitches fail. Most development fails. Most new series fail. The smartest, most talented and experienced development professionals use their best judgment and instincts at every step, take their best guesses and make the best decisions they can, and they're wrong more often than they're right. In many ways, as genuinely dedicated, creative and thoughtful as most TV development professionals are, the work is ultimately a kind of alchemy. The stars need to align, the timing needs to be right, the TV gods need to smile down in ways no one can predict and control. In those rare instances when it works, though, when a show emerges from development and thrives, it almost feels like magic.

NOTES

1 According to FX Network Research, there were 487 scripted TV series in 2017, up from 288 five years earlier. Joe Otterson, "487 Scripted Series Aired in 2017, FX Chief John Landgraf Says," *Variety*, January 5, 2018, https://variety.com/2018/tv/news/2017-scripted-tv-series-fx-john-landgraf-1202653856.
2 In 2015 FX network president John Landgraf famously predicted the number of scripted series would peak in 2016. He has revised that estimate over the years and now agrees that the number will continue to rise. Joe Lynch, "Peak TV Is Still 'a Ways' From Peaking, FX's John Landgraf Says," *Adweek*, August 3, 2018, www.adweek.com/tv-video/no-relief-in-sight-peak-tv-is-still-a-ways-from-peaking-fxs-john-landgraf-says.

Appendix
Glossary of TV Development Terminology

auspices

the creative team behind a development project, which may include the writer, non-writing producer, director and author/s of underlying IP (intellectual property); e.g., when an agent calls a network development exec to ask if he's interested in hearing a pitch, the agent will pitch the project's logline and auspices.

backend

profits derived from the many forms of revenue a TV series earns that a studio shares with profit participants.

blind script deal

a deal in which a studio guarantees a writer payment for a pilot script or scripts, the creative of which will be determined by the writer and studio at a future date.

breakdown

a description of a pilot or series acting role, written by a casting director and approved by producers, which is disseminated via the Breakdown Service to talent agents and managers so reps know what roles are being cast.

business affairs executive

an executive at a network, studio or other entertainment company who is a full-time negotiator of entertainment deals; typically negotiates with entertainment lawyers and agents.

closed-ended storytelling

the practice of telling stories that begin and end within individual episodes of a series, as opposed to serialized or open-ended storytelling.

creator

the writer who wrote the pilot or first episode of a TV series that defines the concept, characters, world and type of storytelling of a series.

current executive

a network or studio programming executive who represents his or her company's interest in a show currently in production and on the air.

development

the process of creating new movies and TV series; the process of originating and improving scripted material to serve as a blueprint for a TV pilot, series or feature film; the process of identifying commercial ideas and concepts and assembling the creative elements that turn those ideas into finished filmed entertainment.

development executive

a network, studio or production company executive who works with writers and producers to develop new pilots and series.

domestic comedy

a family comedy series.

first-look deal

a long-term deal (anywhere from one to five years) in which a studio guarantees a writer or producer regular payment in exchange for the first right of refusal of any and all TV projects the writer or producer creates or develops; if the studio passes on a project, the writer is free to take it to another studio or directly to networks.

format

1. the conceptual and storytelling elements (concept, characters and their relationships, world, story engines) that legally comprise and define a TV series that is owned by a company or individual and can be sold to producers in other territories for adaption and exploitation; e.g., *Homeland* is based on an Israeli TV format that was licensed to Fox 21 to develop and produce an American version for Showtime.
2. a shorter version of a series bible, typically around ten pages.

franchise

1. the central element of a concept – frequently a vocation or avocation (i.e., a job or a hobby) – that generates a number of stories and implies standard story structures (e.g., a cop gets assigned a case, the cop investigates the case, the cop solves the case); a kind of story engine.
2. a brand of multiple TV series unified by title, concept and structural elements programmed by one network (*CSI* and *NCIS* were/are TV franchises).

genre show

a category of series that include some kind of supernatural element.

goal

a specific, concrete thing a character takes action to get in a story or series.

holding deal or holding money

a deal typically made by networks to guarantee an actor is available to star in one of the network's new pilots and/or series.

housekeeping deal

a long-term deal (usually one or two years) in which a studio provides a producer with an office, an assistant and nominal or no regular payment in exchange for a first look or exclusive ownership of the producer's new TV development.

if-come deal

a deal with a studio in which a writer agrees to prep and shop a pitch to networks but will only receive payment from the studio if the project sells.

lay off

to steer a new development project a network has just acquired to a TV studio, typically to a sister-studio division owned by the same parent company as the network.

look-book

a visual presentation of images (usually delivered as a PDF document) that suggests to network and studio executives the director's and producers' visual design for a pilot or series; images are typically a combination of inspiration images "borrowed" from books, magazines or the internet and photos taken of actual locations, props, set decoration and wardrobe.

material

the written basis of development; scripts, pitches, treatments, series bibles, formats and IP (intellectual property).

network needs

official list of a network's creative development targets for a given development cycle that's disseminated to studios, talent agencies and writers.

network script coverage

the small share a network pays a writer to write a pilot that goes toward the studio's typically larger share of payment to the writer.

non-writing EP

an executive producer (the highest-ranking producer on a TV project) who is not a screenwriter; frequently partners with writers during the development process.

notes

creative suggestions given to writers, directors or actors by development executives or producers.

open-ended storytelling

the practice of telling stories over the course of multiple episodes or multiple seasons of a series.

open writing assignment (often referred to in writing by its abbreviation OWA)

a project in active development at a network that's looking for a writer because it was bought without a writer attached; e.g., a producer might set up a book at a network (creating an OWA) and then find the best writer to adapt the book.

overall deal

a long-term deal (anywhere from one to five years or longer) in which a studio guarantees a writer or producer regular payment in exchange for every TV project the writer or producer creates or develops.

package

1. the creative elements of a piece of development, the end result of packaging (e.g., a package might include a book that serves as source material for a series, a writer with a vision for adapting the book to television, a producer and a director).
2. a talent agency's share of backend participation of a TV series typically equal to ten points (10%) of ownership of profits awarded for packaging the key creative elements of a project.

packaging

the process of assembling the creative elements of development for a project such as an idea, a writer, a producer and other potential elements.

pilot

the first episode of a series produced as a test episode to determine if a project is worth ordering to series; the pilot typically is the first episode of a series to air.

pilot season

the period from February through April when broadcast network pilots are cast and shot.

POD

a non-writing EP and/or production company with a "POD" deal (short for producer overhead or overall deal) at a TV studio; pronounced like "pod" in "peapod."

pre-notes

a call or meeting in which people on the same team preview their notes with each other and agree on which notes to deliver so the group delivers a unified, consistent set of notes.

procedural

1. a traditional category of one-hour drama series that includes cop shows, medical shows, legal shows and PI (private investigator) shows.
2. a kind of show that emphasizes the process of how characters do a complicated job or task; e.g., *CSI: Crime Scene Investigation* was a police/science procedural and *Breaking Bad* incorporated elements of a criminal procedural.

production company

a company owned and operated by a producer that develops and produces TV series.

programming executives

a network's management personnel who work in development, current or program scheduling.

put pilot

a pilot with a guaranteed network production commitment upon initial purchase (pronounced like "put the cake in the oven").

rooting interest

a wishful feeling a viewer or reader has that a specific outcome befalls a character or story.

serialized storytelling

stories told over the course of multiple episodes or multiple seasons.

series drive

a storytelling device that assigns a goal to a lead character that will take the character many seasons, or potentially an entire series, to achieve.

spec pilot script

a pilot script a writer writes without any network commitment, sometimes written on the speculation that a network may want to buy it, but often written simply as a sample of a writer's abilities; often known simply as a "spec pilot" (though technically a true "spec pilot" refers to a produced pilot a studio produces without a network commitment that the studio believes it can sell to a network, which is rare but does occasionally occur).

stakes

what's at risk for a character if he doesn't get what he wants or doesn't achieve his goal.

story area

a short prose document describing the beginning, middle and end of a pilot story for network approval before the writer is commenced to write the more detailed pilot story outline or pilot script.

story engine

the mechanism at the heart of a series concept that generates many new stories and episodes such as a franchise or series drive.

straight-to-series

a network commitment in which the network buys a piece of development and orders it straight to series rather than developing a pilot script or pilot episode.

table read

a read-through of the pilot script by the cast (typically dressed in civilian clothes) to allow producers, director, network and studio executives to hear the entire episode performed in sequence by the actual actors for the first time before production of the pilot or first episode begins.

take

a preliminary idea to translate a creative thing into another form or version; e.g., a writer pitches a take on how she would turn a book into a TV series or an actor discusses his take on bringing a character to life on film.

test

a final audition for a pilot or series lead role held first at the studio to narrow the short list of actors in contention and then at the network to decide which actor is cast in the role.

test deal

a contract an actor signs before a studio or network test that includes the actor's fees per episode should he or she get the part.

upfronts

presentations made by networks announcing their new programming slates and/or schedules to advertisers and entertainment media in New York City each spring; considered the end of the broadcast network development cycle.

world

the setting and time period of a series.

Zeitgeist

from the German meaning "ghost of the time" or "spirit of the age"; the deepest social and cultural undercurrents of a society at a given moment in time.

Acknowledgments

When David Craig, Clinical Assistant Professor at USC's Annenberg School for Communication and Journalism, invited me to co-teach a course on visual storytelling with him in 2013, he asked me to cover TV development. I was excited to teach my first college class and told him I'd be happy to do it. "There isn't a textbook on TV development we can assign, though," David warned. "The book doesn't exist." When I expressed my surprise, he said, half-kiddingly, "You should write it." The thought always stuck in my mind.

David has continued to be a teacher, mentor and friend, and I'm extraordinarily grateful for everything he's done to help me not only begin my teaching career, but to realize this book. It would not exist without his help.

Neil Landau, Assistant Dean, Dean's Special Programs and Co-Director of the MFA graduate screenwriting program at UCLA's School of Theatre, Film and Television, introduced me to Focal Press, and has generously continued to serve as an advisor and friend, and I'm grateful for his support.

Also at UCLA, Barbara Boyle, Denise Mann and Glenn Williamson have been supporters, and I greatly appreciate their guidance and encouragement. Much of the material in this book is based on courses I've taught at UCLA and Cal State, Northridge. At CSUN, I owe a debt of gratitude to Robert Gustafson, Jon Stahl and Ted Frank (to whom I owe a lifetime of thanks).

Anita Elberse, Lincoln Filene Professor of Business Administration at Harvard Business School, generously shared her time with me to expand upon her case study of the development of *House of Cards*, and I'm grateful for her expertise.

Many entertainment professionals welcomed me into their offices or shared their experience and wisdom by phone or email as I researched this book. I'm enormously grateful to all of them: Glenn Adilman, Lijah Barasz, Kateland Brown, Karey Burke, Helga Bryndis Ernudottir, Bruce Evans, Jason Feuerstein, Jane Francis, Lesli Linka Glatter, Vera Herbert, Gaye Hirsch, Gregg Hurwitz, David Janollari, Marlene King, Jonell Lennon, Warren Littlefield, Kristin Lowe, Leslie Morgenstein, Michelle Nader, Robert Palm, Julie Pernworth, Julie Plec, Elizabeth Allen Rosenbaum, Susan Rovner, Thom Sherman, Jay Sures, Reed Van Dyk and Graham Yost.

My cousins Judy and Lee Shulman offered early and consistent encouragement of this endeavor, and I'm deeply appreciative of their love and support.

The chapter in this book on pitching was adapted from a paper I wrote and a lecture I gave to students of UNIJAPAN in Tokyo. I'm grateful to Satoshi Kiyota and Taiga Kato of UNIJAPAN for that opportunity.

Brenna Galvin worked diligently as a contributing researcher and proofreader, and I thank her for her eagle eye.

Simon Jacobs and John Makowski are my editors at Focal Press, and I can't express enough thanks for the opportunity they've given me and for their guidance and patience.

Lastly, I'm enormously appreciative to all the colleagues, collaborators, and creative partners I've had in television in Hollywood during the past 25 years. Most of what is in this book I learned from them.

Index

$#! *My Dad Says* 8
20th Television *see* Twentieth Century Fox Television *24* 158

"A" (*Pretty Little Liars*) 149, 181, 223, 229
A&E 115
A&E Studios 33
ABC 7, 12, 18, 33, 57–58, 102, 107, 114, 116–117, 122, 187, 219, 232, 242
ABC Family 113–114, 227–228, 235
ABC Studios 18, 33, 58, 283
Abrams, J.J. 21, 198
actors 2, 6–9, 21, 23, 26, 37, 41–49, 52–53, 56, 60, 63, 71, 104,118, 121,144–145, 152, 192–194, 196–197, 201–204, 206, 210, 213–215, 219, 233, 238, 246, 250, 269
Adventures of Ozzie and Harriet 83
agents 2, 11, 21, 25–26, 28, 30, 32, 34, 40–43, 46–47, 60–63, 66, 100, 102–104, 108, 110–113, 121, 128, 153, 158, 185, 191–205, 208, 210–211, 215–218, 239–241, 246–253, 260–261, 263, 266–269, 280, 282–284
Alison (*Pretty Little Liars*) *see* DiLaurentis, Alison
Alloy Entertainment 101, 105, 221–225, 227, 230
Ally McBeal 70
Amazing Race, The 261
Amazon 12, 18, 83, 114, 119–120, 122, 211, 252, 277, 279–280, 283
AMC 12, 15, 40, 114, 118, 122, 126–127
American Beauty 137
American Horror Story 71
Amos 'n' Andy 116

Andi Mack 125
Andy Griffith Show, The 69
Animal Kingdom 128
Aniston, Jennifer 215
Anonymous Content 204
anti-heroes 83–84, 173
Apple 2, 18, 114, 119, 122, 280, 282
Archibald, Nate (*Gossip Girl*) 146
areas 102–105, 107–112, 194, 213
areas, story *see* story areas
Aria (*Pretty Little Liars*) *see* Montgomery, Aria
Armageddon 261
Arnaz, Desi 277
Arrow 114
Atlanta 70
auspices 29, 207, 210
Awkward 267–268

Back in the Game 107
backend 32–33, 195–196, 260
Ball, Lucille 277
Band of Brothers 71
Barasz, Lijah 266
Baretta 81
Bass, Chuck (*Gossip Girl*) 142, 154
Bates Motel 115
BBC America 115, 118, 122, 204
Bean, Sean 154
Bellisario, Troian 231, 233–234
Benson, Ashley 232–234
Berlanti, Greg 25, 208, 261
Beverly Hills 90210 76
Beverly Hills Cop 261
Bewitched 69
Big Bang Theory, The 69
Big Little Lies 273

298 Index

bites 226
Black Mirror 71, 139
Black-ish 78
Blacklist, The 82
Blair (*Gossip Girl*) see Waldorf, Blair
blind script deals 217–218
Blink 268
Blum, Jason 261
Bochco, Steven 81
Bold Type, The 114, 266
Bolton, Ramsey (*Game of Thrones*) 87
Bosch 83, 283
Braun, Lloyd 102, 106, 242
Breakdown Service 42, 44
Breaking Bad 40, 80, 82, 84, 86, 96–97, 133–136, 147–152, 154–156, 171, 174, 178–181, 275
Brooklyn Nine-Nine 18
Brown, Kateland 264–266, 270
Bruckheimer, Jerry 25, 261
Buffy the Vampire Slayer 93, 155
Bull 20, 283
Burke, Karey 7, 57, 187
Bush, Sophia 219
business affairs executives 32, 37, 47, 120, 196, 258
Byron (*Pretty Little Liars*) see Montgomery, Byron

C.K., Louis 70
CAA (Creative Artists Agency) 193, 204, 256, 266
cable: basic 12–14, 27, 39, 59–61, 82, 113–114, 117–118, 121, 123, 126, 130, 189, 228, 240, 279–281, 284; premium 12, 68, 76, 118–119, 121, 123, 130, 189, 206–207, 240, 279, 281, 284
Carnegie Hall 59
Carr, Rachel (*Gossip Girl*) 154
Cast Away 102, 242
casting concept calls 42, 44
casting directors 41–45, 47–49, 52, 63
casting executives 41–42, 44, 47–49, 218
CBS 8, 12, 20, 21, 92, 94, 115–119, 122, 209, 258, 270
CBS All-Access 115, 119, 122, 277
CBS Corp. 261
CBS Television Studios 107

Chase, David 173
Chicago P.D. 75
Chopra, Priyanka 219
Clarke, Emily (*Revenge*) 98
Clegane, Sandor (*Game of Thrones*) 96
Clooney, George 74
closed-ended storytelling 77
Cold Case 261
comedies 35, 38, 43, 53, 62, 67–74, 78, 83, 94, 122, 125, 147, 163, 170, 176, 203, 240; multi-camera 53, 68–70, 72, 123, 277; single-camera 53, 68–69, 72
Comcast 18
cop shows 73–79, 81–83, 85–86, 92–96, 98, 128, 155–158
Cosby Show, The 69
cost-plus 212
Counterpart 15
Crane, David see Kaufman, Marta & Crane, David
Crazy Ex-Girlfriend 107
creators 22–23, 25, 32, 40, 58, 99–100, 116, 121, 193, 195–196, 204, 208, 211–212, 259, 261–262, 277–278, 280, 284
Criminal Minds 261
CSI: Crime Scene Investigation 86, 155, 157, 261
current executives 13–14, 17, 22–23, 99, 194, 218, 258–259, 275
CW, the 12, 107, 113–115, 116–118, 123, 184, 225–227, 230, 235, 268

Dallas (1978-91) 76
Dallas (2012-14) 128
Daniels, Susanne 260
Dawson's Creek 76
DC Comics 283
DeGeneres, Ellen 211
demographics 55, 88, 123–126, 188
Desperate Housewives 156, 222, 226
development: assistants 29, 128, 238, 247–254, 257–258, 261, 263, 270; executives 1, 2, 6–8, 11, 13–15, 17–18, 20–21, 23–26, 28–31, 34–35, 37–41, 43, 45–49, 52–53, 55–58, 60–63, 66–68, 83, 91, 95, 99, 101–104, 107–112, 120–122, 124–131, 137, 139–142, 145, 147, 150–151, 153–154, 156–161, 168–170, 176, 178, 180–181, 184–189, 194–203,

210–211, 213–214, 218–219, 221, 224, 226–228, 230, 233, 235–236, 238–244, 246–254, 257–261, 265, 267–268, 270, 275–277, 280, 282, 284; professionals 24–26, 29–30, 43, 59, 64–68, 73–74, 78–79, 81–83, 88, 93–95, 97, 101, 103–104, 106–109, 124, 127–128, 130, 164, 168–170, 179, 181, 185, 188, 199, 237–244, 247–248, 250–252, 260, 262, 272, 274–275, 279–285; retreats 61–62, 102–104, 107, 274
Dexter 82
Dharma and Greg 240
Dick Van Dyke Show, The 69
DiLaurentis, Alison (*Pretty Little Liars*) 36, 99, 181, 223, 225, 228–229, 234
directors 1, 2, 7–10, 19–21, 26, 32, 37, 41, 43, 46–49, 52–54, 59, 104, 109, 121, 185, 192–193, 196–197, 201–202, 204, 206, 210–212, 214–215, 219, 231–232, 238, 246, 250, 269, 275, 277
Directors Guild of America (DGA) 54
Disney 11, 18, 57–58, 115, 124, 173, 279, 283
Disney+ 115, 120, 122
Disney Channel 114, 119, 121–123, 125–126
Dobkin, David 211
doctor shows *see* medical shows
Dr. Ken 211
Dr. Kildare 76
Dragnet 70, 81, 98
dramas 35, 38, 53, 62, 67–68, 70–77, 82, 91, 93–94, 96, 110, 122–123, 126–128, 147, 163, 170, 203, 268, 277, 283–284
dramedies 70, 72, 107, 123, 179, 268
Dunham, Lena 120, 241, 245, 262, 273

Eastwick 232
Eastwood, Clint 173
Ella (*Pretty Little Liars*) *see* Montgomery, Ella
Emily (*Pretty Little Liars*) *see* Fields, Emily
Empire 96
Endeavor 193, 261
Endeavor Content 204
ER 76, 156
Everwood 262

Facebook 2, 18, 280
Facebook Watch 114, 120
Fake Empire 109
Famous in Love 265
Fargo 8, 71, 187
Farrow, Mia 76
Father Knows Best 69, 83
FCC (Federal Communications Commission) 117
Fields, Emily (*Pretty Little Liars*) 36, 142, 148, 228, 231–232, 234
Financial Interest and Syndication Rules ("fin syn rules") 18
First Wives Club 283
first-look deals 217–219, 224
Fitz, Ezra (*Pretty Little Liars*) 149–150, 233, 235
Flashdance 261
Flesh and Bone 72
formats 65–72, 76, 81, 93, 95, 101, 115, 120, 122–123, 125–126, 128, 151, 209, 211, 277–278
Fox (network) 12, 18, 76, 114, 116–118, 122, 268
Fox 21 72, 189
franchises 87, 91–98
Francis, Jane 189
Freeform 58, 114, 118, 122, 124, 227
Friday Night Lights 96, 127
Friday, Detective Joe (*Dragnet*) 98
Friends 16–17, 69, 146, 215
Fring, Gus (*Breaking Bad*) 154–155
Fukunaga, Cary Joji 273
FX 12, 40, 71–72, 115, 118, 122, 127, 244

Game of Thrones 84–85, 87, 96–97, 101, 154, 240, 283
Geller, Ross (*Friends*) 146
generals 104, 109, 227, 259
genres 65–67, 72–78, 81–83, 86, 91–93, 95, 97, 100–101, 103, 106, 127–128, 156, 269, 276, 283, 284
genre shows 78
Gerardis, Vince 283
Gersh 193, 268
Gilligan, Vince 86, 133, 136, 154–155, 172–173, 175–176, 178–180
Gilligan's Island 69
Gilmore Girls 238
Girls 240, 246
Glatter, Lesli Linka 232–234, 238

Index 299

goals 79–80, 85, 97–98, 135–137, 138–141, 150–152, 170, 173–179, 181–182
Godfather, The 82
Goldbergs, The 78
Good Doctor, The 75, 283
Good Fight, The 75
Good Wife, The 95
Gordon, Mark 25, 261
Gosling, Ryan 144
Gossip Girl 1, 2, 76–77, 105–106, 109, 114, 142, 146, 154, 221–222, 240, 275
Grant, Lou (*The Mary Tyler Moore Show, Lou Grant*) 94
Green Eggs and Ham 211
Green, Rachel (*Friends*) 146
Grey's Anatomy 74, 156, 242, 261
Guide Dogs of America 107

Hale, Lucy 230–231, 233–235
Halt and Catch Fire 284
handles 142–43
Handmaid's Tale, The 8, 21, 187, 262, 284
Hanks, Tom 102
Hanna (*Pretty Little Liars*) see Marin, Hanna
Harding, Ian (*Pretty Little Liars*) 233
HarperCollins 224
Hart, Kevin 145
Hastings, Melissa (*Pretty Little Liars*) 143
Hastings, Spencer (*Pretty Little Liars*) 142–144, 148, 228, 231, 234
Hawaii-Five-O (1967-80) 81
Herbert, Vera 267–268
High Maintenance 120, 277
Hill Street Blues 81–82, 95
Hirsch, Gaye 184
Homeland 72, 238
Honeymooners, The 69
"Hound, The" (*Game of Thrones*) see Clegane, Sandor
House of Cards 15, 101, 207–210
Hulu 2, 12, 16, 115, 120, 122, 209, 211, 280
Humphrey, Dan (*Gossip Girl*) 154

I Dream of Jeannie 69
I Love Lucy 69, 278
IP (intellectual property) 7–8, 10, 20, 24, 28–29, 97, 100–101, 104, 109–112, 114, 192, 195, 213, 241, 248, 262, 282–283
ICM Partners (International Creative Management Partners) 193, 244
if-come deals 211–212, 218
In the Dark 108, 213
Ingold, Jeff 258
Insecure 120

James Bond 92
Jane the Virgin 70, 101, 107
Jessica Jones 20
Judge, Mike 21
Justified 6, 188

Kahn, Noel (*Pretty Little Liars*) 228
Kaplan-Stahler Agency 193
Kaplan, Aaron 21, 261
Kath and Kim 240
Katzenberg, Jeffrey 277, 279
Kaufman, Marta & Crane, David 16
Kelley, David E. 262, 273
Killing Eve 204
King, I. Marlene 35–36, 39, 137, 139–140, 142, 144, 148–149, 155–156, 161, 227, 230–236, 265
Kingsbury, Corinne 107
Kingston, Wren (*Pretty Little Liars*) 228, 234
Knick, The 76, 283
Kojak 81

Lannister family (*Game of Thrones*) 96
Lawrence, Jennifer 144–145
Lawson, Bianca 234
Leave it to Beaver 69
Lee, Paul 229–230, 232
Legacies 242
legal shows 73, 75, 86, 93–96, 127
Leighton, Laura 233
Levi-Strauss, Claude 79, 108
license fees 13, 16–17, 33, 39, 121, 207, 212
Life in Pieces 21
Lifetime 33, 115, 119, 123, 260
limited series 71–72, 122–123
Lindelof, Damon 262
Lionsgate 15, 18
Littlefield, Warren 8, 21, 187, 262, 269
Loeb, Jeph 20
look-books 49–51

Lost 102, 242
Lou Grant 94
Lucky Louie 70

Mad Men 15, 84, 127, 138
Magnum P.I. (1980-88) 75
Magnum P.I. (2018-) 76
Malcolm in the Middle 69
managers 21, 25–26, 41, 199, 202, 203–204, 260, 282
Mannix 75
Marcus Welby, M.D. 76
Marin, Hanna (*Pretty Little Liars*) 142–144, 148, 228, 230–233
marketplace: of television development 87, 112–129, 199, 201–202, 208–209, 215–216, 282; of talent 197
Marvel Entertainment 20, 283
Mary Tyler Moore Show, The 69, 94
McG 109–110
McQuarrie, Christopher 31
medical shows 73–77, 85–86, 93–94, 98, 155–156
Melfi, Dr. Jennnifer (*The Sopranos*) 173
Melissa (*Pretty Little Liars*) *see* Hastings, Melissa
Melrose Place (2009-10) 264–265
Meredith (*Pretty Little Liars*) *see* Sorenson, Meredith
Miller, Bruce 21
mini-series 71
Mis-Adventures of Awkward Black Girl, The 120, 277
"mission-based" storytelling 179
Mission: Impossible - Fallout 31
Mitchell, Shay 232, 234
Modern Family 69, 78
Mom 78
Montgomery, Aria (*Pretty Little Liars*) 142, 148–150, 152, 155, 164, 228, 230–231, 235
Montgomery, Byron (*Pretty Little Liars*) 155
Montgomery, Ella (*Pretty Little Liars*) 155
Moonlighting 75
Morgenstein, Leslie 101, 230–232
Morris, Julian 234
MOW (movie-of-the-week) 68
MRC (Media Rights Capital) 15
MTV 115, 119, 123, 227, 260

multi-camera comedies *see* comedies, multi-camera
Murphy (*In the Dark*) 107
Murphy, Ryan 208–209, 261–262

Nader, Michelle 240, 263–264
Name of the Game, The 94
Nate (*Gossip Girl*) *see* Archibald, Nate
National Geographic 115, 244
NBC 1, 2, 12–13, 15–18, 21, 31, 56, 94, 115–117, 123, 127, 178, 230, 253, 258, 268
NBC Page program 253
NCIS 92
Netflix 12, 15–18, 20, 115–116, 120–121, 123–125, 206–209, 211–213, 277, 279–282
network: interest 216; needs 61–62, 103–104, 107, 128; presidents 23, 39–41, 44, 48–49, 52, 56–58, 60–63, 95, 99, 102, 114, 185, 201–202, 210, 238, 242, 252; research 55, 57–58, 212, 258; tests 47–48, 52, 63, 231–233
networks 1–3, 6–7, 9–19, 21–35, 37–49, 52–53, 55–64, 67–72, 80, 82, 87–88, 99, 101–104, 112–128, 130–132, 137, 151, 154, 159, 161, 168–170, 179, 185, 188–189, 194–199, 202–203, 206–219, 221, 224, 226, 235, 239–241, 243–244, 249–250, 253, 256, 258–259, 262, 264, 267, 270, 279–284
Newsroom, The 94–95, 107
Nickelodeon 115, 119, 121–22
Nielsen 123–24, 126, 212
Nip/Tuck 127, 262
non-writing EPs 20–22, 24, 40, 187, 194, 209–212, 218–219, 259–262, 268–269
notes 1–2, 22–23, 28–29, 31, 35, 39–40, 52–53, 55–56, 62, 169, 184–189, 202, 214, 229, 235, 269–270, 274–275
Now and Then 232
Nurse Jackie 70

OA, The 18, 209
O.C., The 109, 247
O'Neal, Ryan 76
Office, The 244
on-the-air commitments 132
One Tree Hill 76
one-hour dramas *see* dramas
one-hour dramedies *see* dramedies

online video distribution 12–14, 16, 18, 27, 39, 59–61, 68, 76, 113, 115, 118–121, 130, 132, 189, 207, 206–207, 209, 212, 217, 219, 240, 277, 279–284
Orange is the New Black 18, 70
Originals, The 242
Outsiders, The 115
overall deals 208–209, 217–219

PI (private investigator) shows 73, 75, 93, 106
packages: agency 33, 61, 195–196, 201–202, 212, 239; development 10–11, 25, 29, 128, 169, 191–192, 194, 209–213, 282
packaging agents 194–196
Paradigm 193
Paramount Network 114, 119, 122
Paramount Television 283
Parenthood 96
PAs (production assistants) 263–265, 270
Pepper Dennis 94
Pernworth, Julie 258
Peyton Place 76
Pieterse, Sasha 234
Pillsbury, Gayle 230–233
pilot commitments 131–132
pilot season 42–43, 63, 207
pilot table reads 49, 52–53, 233–234, 249
Pinkman, Jesse (*Breaking Bad*) 177, 180
pitches 1, 3, 7, 9–12, 14, 16, 27–35, 61–62, 80, 83, 91, 95, 97, 101, 103–104, 108–109, 113, 121, 130–167, 178–179, 185, 187, 197–198, 200, 206, 209, 211–218, 223–224, 227, 241–243, 248, 263, 268, 273, 276, 280–281, 285
Pitt, Brad 21
Pizzolatto, Nic 273
Plec, Julie 242
prep (pre-production) 6, 40–52, 54, 233, 263
Pretty Little Liars 2, 35–36, 39, 45, 98, 114, 137, 139, 142–144, 148–150, 155–156, 177, 181, 221–236, 238, 265
primetime soaps 70, 77–79, 109, 128, 157, 222
Prisoners of War 72
Privileged 230
procedurals 73, 81, 85–86, 96, 155, 284

producers 2, 5, 8-12, 14, 19-21, 23-26, 28-35, 37, 39-49, 52-56, 59-63, 68, 83, 99-104, 108-110, 112-113, 121-123, 126, 128, 130-132, 135, 139, 141, 145, 151, 153, 159, 161 164–165, 168–169, 184–189, 192, 195, 197–204, 206, 208–211, 214–219, 224–226, 228, 230–231, 235, 246, 248–249, 253, 258–269, 275–277, 280, 282–283
production assistants *see* PAs
production companies 9, 24–26, 29–30, 43, 101, 104, 107–109, 112, 168–169, 197–198, 204, 213–214, 218–219, 239, 250, 253, 256, 258, 261, 269
profit participants 32–33, 195–196, 212, 260
programming executives 13–14, 125, 230, 277
Public Enemy 82
put pilots 132, 208

Q, Maggie 145
Quantico 219
Quibi 115, 277, 279

Rachel (*Friends*) *see* Green, Rachel
Rae, Issa 120
Ray Donovan 261
Red Hour Films 107
Revenge 98–99
Rhimes, Shonda 25, 208, 242, 261–262
Riley, Kevin 127–128
Rizzoli & Isles 128
Rockford Files, The 75
Room 222 69
room runners 273–274
rooting interest 85–87, 97–99, 142, 144, 150, 170–171, 173–175, 177, 182, 186
Ross (*Friends*) *see* Geller, Ross
Ross, Dr. Doug (*ER*) 74
Rotenberg, Michael 21
Rothman-Brecher 193
Rovner, Susan 37
Rush Hour 258

Salamanca, Tuco (*Breaking Bad*) 155
Salem 115
Savage, Stephanie 109
Saving Private Ryan 261
Scandal 101
Schwartz, Josh 109–110, 247

Scott, Ridley 21
screenwriters 1–2, 5, 7–12, 14, 18–40, 43–44, 48–49, 58, 61–63, 66–68, 81, 83, 93, 95, 100–104, 107–113, 121, 123, 130–141, 144–145, 147–148, 150–166, 168–170, 172, 180, 183–189, 191–207, 209–219, 221–222, 224–228, 236, 238–244, 246, 248–250, 258–259, 261–269, 273–277, 279–280, 284–285
script-to-series 211
Secret Life of an American Teenager, The 114
secrets (as a story device) 77, 142–146, 176, 179, 223, 228–229
Seinfeld 69
Serena (*Gossip Girl*) *see* van der Woodsen, Serena
serialized storytelling 76–77, 82
series bibles 7, 72, 209–211, 248
series drives 97–99, 169, 174–175, 178
Series of Unfortunate Events, A 101
Sesame Street 125
Shameless 70
Shepard, Sara 223–225, 227, 236
Sherlock 75
Sherman, Thom 270
Shield, The 82, 127
showrunners 20–23, 25, 40, 44–45, 48–49, 81, 99–100, 193–194, 196, 201–204, 214–216, 219, 249, 259, 264, 266–267, 274–275
Showtime 12, 72, 114, 119, 121–123, 125–126, 206
Siega, Marcos 47, 50–51
Silicon Valley 21
Silverman, Sarah 52
Simple Plan, A 261
Simpsons, The 138
single-camera comedies *see* comedies, single-camera
Skyler (*Breaking Bad*) *see* White, Skyler
Smallville 264
SMILF 125
Sneaky Pete 188
Snow White 174
Snow, Jon (*Game of Thrones*) 96
Soderbergh, Steven 76, 215
Soloway, Jill 179
"Some Day My Prince will Come" 174
Sons of Anarchy 87

Sony Pictures Television 40
Soprano, Tony (*The Sopranos*) 96, 173
Sopranos, The 82–83, 96, 156, 173, 240, 275, 283
Sorenson, Meredith (*Pretty Little Liars*) 155
Sorkin, Aaron 95
spec pilot scripts 10, 168, 209, 213–216, 267–268
Speechless 78
Spencer (*Pretty Little Liars*) *see* Hastings, Spencer
Spielberg, Steven 20
Spin City 240
stakes 74–75, 77, 94, 175–177, 181–182
Star Trek 87, 138
Stark, Arya (*Game of Thrones*) 96
Stark, Eddard (*Game of Thrones*) 154
Stark family (*Game of Thrones*) 96
Starz 12, 15, 72, 115, 119, 122, 206
Stern, Jared 211
Stiller, Ben 107
Stoddard, Brandon 187
Storied Media Group 283
story areas 34
story engines 91–92, 97–99, 184
story outlines 22, 34–38, 97, 169, 214, 228, 241, 248, 274–275
straight-to-series 10, 28, 72, 132, 168, 206–13, 281–82
Stranger Things 18, 209
streaming platforms *see* online video distribution
studio tests 47, 231
studios 1, 3, 6, 9–19, 21–35, 37, 39–50, 53–56, 58–63, 67, 69, 72, 74, 80, 99, 101, 107, 109, 112–113, 120–122, 128, 168, 185, 188–189, 194–200, 202–203, 207–214, 216–219, 221, 224, 226, 228–233, 235, 239–240, 244, 249–250, 253, 258, 260–261, 264, 266–267, 270, 275, 282–284
Suits 127
Superman 74
Supernatural 93
Sures, Jay 116, 202
Survivor 102

takes 108–111, 227–228
television industry: culture of 3, 38, 66, 193–194, 198, 237–245, 247,

253–254; history of 3, 15, 17, 66, 68–78, 81–83, 95–97, 100–102, 116–118, 276; preparing for careers in 246–271 themes 86, 131, 134, 136–140, 166, 174, 184, 232, 235, 275–276
Thirteen Reasons Why 204
This is Jane 283
This is Us 13, 15, 18, 96, 240, 268, 283
Thorne, Amanda (*Revenge*) 98
Tiny Furniture 120, 241
TNT 12, 115, 118–119, 123, 127–128
Tom Clancy's Jack Ryan 283
Transparent 70, 83, 179, 283
True Detective 71, 273, 283
Tuco (*Breaking Bad*) *see* Salamanca, Tuco
Turn: Washington's Spies 284
TV industry *see* television industry
Twentieth Century Fox Television (also known as 20th Television) 15, 18, 189, 219
Twilight Zone 71
Two Broke Girls 240

UCLA Extension 264–265
Underground 115, 145
Undressed 227
Unforgettable 115
Universal Pictures 11
Universal Television 18
University of North Carolina School of the Arts 267
Updike, John 232
upfronts 59–61, 63
UPN 117, 225–226
USA Network 115, 119, 123, 126–27
USC (University of Southern California) 109, 231
UTA (United Talent Agency) 116, 193, 202, 265

Vampire Diaries, The 2, 46, 50–51, 56, 221, 242
van der Woodsen, Serena (*Gossip Girl*) 142, 146
Vegas 81
Verve 193
victimization 144, 148, 170–174, 181

Waldorf, Blair (*Gossip Girl*) 96, 142, 146, 154
Walking Dead, The 101, 127, 240
Walter Jr. (*Breaking Bad*) *see* White, Walter Jr.
Warner Bros. Pictures 12, 15
Warner Bros. Television 15–17, 37, 101, 208, 224, 228
Warner Horizon 228
WarnerMedia 279
Weeds 70
Westworld 139
WGA Minimum Basic Agreement 22
WGN America 115
Whiskey Cavalier 258
White, Skyler (*Breaking Bad*) 172, 175–176
White, Walter (*Breaking Bad*) 96–98, 147–152, 154–155, 163, 169, 171–172, 174–181
White, Walter Jr. (*Breaking Bad*) 172
Whitman, Meg 277, 279
Wilden, Detective Darren (*Pretty Little Liars*) 233
William Morris Agency 21, 193, 261
Witches of Eastwick 232
Without a Trace 261
WME (William Morris Endeavor) 193, 204, 244, 256, 261
Wonderland Sound and Vision 109
Wren (*Pretty Little Liars*) *see* Kingston, Wren
writers *see* screenwriters
Writers & Artists Agency 193
Writers Guild of America 22, 268
writers' assistants 263–266, 268

X-Men 92

Ygritte (*Game of Thrones*) 96
Yost, Graham 6, 188, 276
YouTube 2, 18, 244, 260, 277

Zane/Pillsbury Casting 45, 230
Zeitgeist 104–106, 137–138, 274, 284
zeitgeisty 137–138